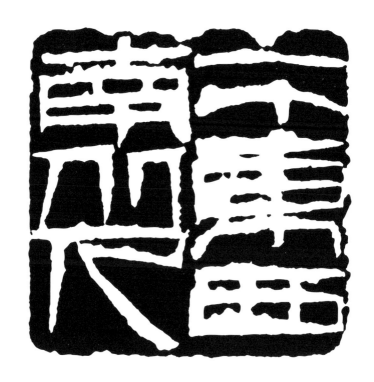

劉國松
80回顧展
Liu Kuo-Sung
80th Birthday Retrospective Exhibition

策展人：李君毅 / Curator: Chun-Yi Lee

2012/03/17-06/17

攝影　柯錫杰 ｜ Photo　Ko Si Chi

右聯：

法非法非非法

金剛般若波羅密經變文法尚應舍何況非濾生語

國松賢弟參之即近衛矣

左聯：

常元常元元常

東坡又物元常形而又常理之論然而若見諸相匪相即見如米也

甲戌盛暑紫金山人張隆延寄身寶應寺皆年八十又五

書法：張隆延

目錄　Contents

館長序

劉國松先生祖籍山東，1932 年生於安徽蚌埠，於 1949 年隻身隨國民革命軍遺族學校遷移到台灣，進入師範大學美術系後，在東方美學薰陶，及西方藝術思潮與繪畫技法的激盪下，走上繪畫革新的道路，為傳統國畫注入新生命，是現代水墨運動重要的推手。他標舉傳統，而不附麗於西方，對盲目求新與全盤西化的作為，抱持著嚴肅批判的態度，堅信繪畫若捨棄傳統，乃是違背藝術創作的本質。他與「五月畫會」同道們，致力於歐美藝術新觀念與技巧的引入，以發揚我國悠久深遠的繪畫傳統為己任，成功地引領水墨畫的現代轉化，享有「水墨現代化之父」美譽，不僅在世界各地舉辦過上百次的展覽，更獲多項國際性大展及殊榮，藝術成就斐然，蜚聲國際。

「一個東西南北人」是劉國松先生對人生與藝術的自況之辭，他無畏地面對有關東方與西方、大陸與台灣，甚至傳統與現代等文化課題的艱鉅挑戰，故能激越出精采的藝術火花。學院派出身，集藝術家、藝評家、教育家、思想家於一身的他，具豐富學養，孕育出對多元媒材的靈活運用能力，並建構出繽紛多彩的藝術風貌。他致力於繪畫探索逾一甲子，繪畫猶如他的生命符碼，而水墨畫更是他的創作主軸。他深受傳統儒、釋、道哲學思想的影響，重視天人合一，人與自然和諧的宇宙觀，內化至其藝術生命中，開拓他創作的視野及內涵，淬鍊出具時代性與獨特性的藝術創作。

本展以六大主題呈現：一、學生時期；二、狂草抽象系列；三、太空系列；四、水拓系列；五、漬墨系列；六、西藏組曲系列。不論人物或靜物；寫實或寫意；具象或抽象；山水或風景，在創作表現上，可窺見他以中華文化為底蘊，深受中國文人畫影響，師法自然，講求氣蘊，不僅在於寫物之形，更著重於表達個人獨特心緒；而在西方現代思潮的激盪下，走向抽象與創新的變革，是他繪畫創作過程中的必然。他不斷地鑽研、探索、醞釀及轉化，無論風格、技法及媒材如何轉變，既是理性的感悟，也是他對創作的熾熱投注，將傳統水墨畫與西方繪畫理念巧妙地融合，形塑出具深度與廣度的創作，譜寫一幅幅非凡作品，綻放出璀璨的藝術光芒。

本次展出的百餘件作品，具體而微地呈顯劉國松先生的創作脈絡，彰顯他深厚的美學內涵和人文素養，及對藝術的探索與執著。本館期盼透過本次展出，他作品深邃意蘊及獨特而鮮明的美學風格得以傳播，觀者在與作品精彩對話中，體驗中西藝術跌宕融合下的獨特魅力。

黃才郎

國立台灣美術館 館長

Director's Preface

Liu Kuo-Sung, from a family originating in Shandong, was born in Bangbu, Anhui province, in 1932. After arriving alone in Taiwan in 1949 as a member of the National Revolutionary Military Orphan School, he entered the Department of Fine Arts at National Taiwan Normal University. There, he was immersed in Oriental artistic aesthetics and trained in Western artistic thinking and techniques. This set Liu upon the path as a reformer, injecting new life into traditional Chinese painting and setting the foundation for becoming an instrumental force in the modern Chinese ink painting movement. A champion of tradition, he has never slavishly pursued novelty or total Westernization. Always ready to criticize when appropriate, Liu believes that without tradition art betrays its essential creative nature. Together with his colleagues in the Fifth Moon Group, he devoted himself to the introduction of new concepts and techniques from the West in service of bringing out the far-reaching traditions of Chinese painting. Known as the Father of Chinese Ink Painting Modernization, he has participated in well over one hundred exhibitions, received numerous major international honors, and established a tremendous reputation around the world.

A self-described "man of east, west, south and north" in life and art, Liu Kuo-Sung fearlessly confronted the challenges of Asia and the West, China and Taiwan, and the traditional and modern to gather powerful artistic inspiration. The product of the academic school, he is a Renaissance man accomplished as an artist, critic, educator, and thinker. Extensive training and absorption of diverse concepts honed his ability to skillfully employ various media in a commanding, colorful artistic style. Dedicated to exploring the intricacies of painting for over half a century, for him painting is symbolic of life, and ink painting is the thread that runs throughout his body of work. Strongly influenced by Confucian, Buddhist, and Taoist thinking, Liu emphasizes the unity of man and the universe and humanity's oneness with nature, assimilating these values into his artistic life to assert his artistic vision and refine an artistic approach that is wholly contemporary and distinctively his own.

The exhibition consists of six themes, namely: 1) student period; 2) calligraphic abstraction series; 3) space series; 4) water rubbing; 5) steeped ink; 6) and Tibetan suite series. Whether in human characters or still lifes; realistic or impressionistic, figurative or abstract, landscapes and vistas, Liu's various forms of creative expression reveal the underpinning of Chinese culture that grounds his work, the deep influence of Chinese literati painting, and inspiration from the rhythms of nature. In addition to the description of forms, Liu places greater emphasis on the expression of distinct personal moods. Under the influence of modern Western thinking, Liu's work moved towards abstraction and innovation, an inevitable shift in his creative process. Always studying, probing, incubating, and transforming, every change in style, technique and media is rational and considered and infused with creative energy, so that the clever fusion of traditional Chinese ink painting and Western painting approaches forges works invested with greater depth and breadth sparkling with artistic brilliance.

The over 100 works presented in this exhibition closely detail the creative ebb and flow of Liu Kuo-Sung's career path, highlighting his deep aesthetic inner qualities and cultural cultivation as well as his tireless inquisitiveness and commitment. With this exhibition the National Taiwan Museum of Fine Arts has endeavored to showcase his refined and distinctive aesthetic style, so that viewers can experience the distinctive charms of the unrestrained flow and intermingling of East and West in dialogue with his brilliant works.

Director, National Taiwan Museum of Fine Arts

Tsai-Lang Huang

專文 Essays

一個東西南北人
劉國松六十年的藝術探索

策展人：李君毅

劉國松常用的一方青田石印上，以白文鐫刻著「一個東西南北人」的字句。[1] 這個印文具體而微地反映了在其藝術創作的漫長歷程中，他所面對有關「東方」與「西方」、「大陸」與「台灣」，以及「傳統」與「現代」等文化課題的挑戰。從劉國松超過一甲子的繪畫創作及藝術論述可見，他以堅定的信念與無畏的氣魄作出高掌遠蹠的回應，不但為個人的作品確立了文化身份的定位，並且成功地引領與創建水墨畫興滅舉廢的現代轉化。

——

原籍山東的劉國松，1932 年生於安徽蚌埠。由於擔任國民黨少校營長的父親在抗日戰爭中犧牲，他從小就跟著母親四處顛沛流離。經過多年戰亂的苦難生活，作為一個北方人的他，於 1949 年隻身隨國民革命軍遺族學校遷移到南方的台灣。劉國松自師範大學美術系畢業後，在當時面對西方現代文化衝擊的這個南方島嶼上，義無反顧地走上繪畫革新的道路。他勇於挑戰當時主宰藝壇的保守勢力，成為了台灣現代美術運動的領導人物。劉國松及其五月畫會的同道們，不遺餘力地引入歐美的藝術新觀念與技巧，以求踵武發揚中國悠久深遠的繪畫傳統。

劉國松早期的繪畫創作與藝術論述，皆濡染了西方現代主義的觀念，諸如對當下的執著、個人主義的浪漫情懷、歷史進化論的信念、嶄新科技的追求，以及人文主義的個性解放。[2]

但不同於五四新文化運動的先驅們，他對盲目求新與全盤西化的作為，抱持著嚴肅批判的態度。劉國松通過深刻的自我反省，於五十年代末六十年代初就作出回歸傳統的抉擇，並提出精闢的見解：「模仿新的，不能代替模仿舊的；抄襲西洋的，不能代替抄襲中國的。」[3] 他堅信若捨棄傳統而附麗於西方，乃是違背藝術創作的本質。因此他不但對保守陣營展開攻擊，更經常把批評的矛頭指向那些跟隨歐美現代藝術風潮起舞者，痛責他們的模仿行為及崇洋心態。

對於 50、60 年代風行於歐美的抽象藝術，劉國松也是站在中國文化的本位出發，從理論建構與創作實踐兩方面來加以肯定。他運用了高識遠度的論述策略，援引大量古代畫論為據，力圖把抽象畫架構於中國藝術傳統之中，並藉此以消解當代中國藝術對西方主導性文化的依附。[4] 劉國松這種帶有強烈民族意識的言論，與當前後殖民主義所強調的「對抗性論述」可謂一脈相通。[5] 他意識到西方文化對當代中國藝術家的宰制作用，遂在被遺忘的傳統中重新發掘民族固有的藝術特質，以確立中國現代繪畫的自主性價值；因此其關於抽象畫的創作與論述，實具有抗衡西方殖民文化霸權支配的象徵意義。

二

劉國松矢志創造一種革新的繪畫風格，於 1957 年就開始嘗試在石膏鋪底的畫布上，以稀釋的油彩及墨汁來表現水墨畫

1. 此青田印章 10.3 公分長，2.5 公分見方，乃山東同鄉藝友陳丹誠（1919-2009）應劉國松的請求而刻送的。印章側另刻有款文：「國松道兄久客他鄉，囑予刻石，曰：『一個東西南北人』。乙巳冬月陳丹誠並記。」而「一個東西南北人」的印文乃是仿傚徐渭（1521-2593）於故屋自題「幾間東倒西歪屋，一個南腔北調人」的楹聯。另劉曾作對聯一副以自嘲：「幾張亂七八糟畫，一個東西南北人」，見楊識宏，〈一個東西南北人 — 劉國松〉，《藝術家》第 40 期（1978 年 9 月），頁 78。
2. 見李君毅，〈一個東西南北人 — 劉國松繪畫的現代主義精神〉，載李君毅編，《劉國松研究文選》（台北：國立歷史博物館，1996），頁 211-216。
3. 劉國松於 1959 年時寫下這句話，並視作個人的座右銘。見劉國松，〈我個人繪畫發展的軌跡〉，《雄獅美術》第 5 期（1971 年 7 月），頁 21。
4. 當時劉國松闡述其抽象繪畫觀的文章包括：〈現代繪畫的本質問題 — 答方其先生〉，《筆匯》1.12（1960 年 4 月）：17-20；〈論抽象繪畫〉，《文星》6.4（1960 年 8 月），頁 23-24；〈論抽象繪畫〉，《筆匯》2.3（1960 年 10 月），頁 22-32。
5. 有關「對抗性論述」所具有顛覆殖民主義理論與實踐的象徵意義，見Bill Ashcroft, Gareth Griffiths and Helen Tiffin, *Key Concepts in Post-Colonial Studies*（London: Routledge, 1988），頁 56-57。

暈染的效果。他更借取一些古代經典名作為構圖範本，以便探索抽象的繪畫形式。可是不久後劉國松發現，他用西方油畫的媒材來追求傳統國畫的意趣，其實是自欺欺人的作假行為。[6] 所以他毅然絕然地放棄已駕馭純熟的西畫媒材，改而直接使用中國傳統的紙筆墨來進行創作。1963 年時在偶然的情況下，他發現一種帶有紙筋用作糊燈籠的紙，經過筆墨處理後會產生富於天趣的白色紋路，可以加強其作品的肌理質感。[7] 他於是靈機一動而發明了「劉國松紙」以及所謂的「抽筋剝皮皴」，從而創造出令人耳目一新的繪畫風格。劉國松這一段時期帶有傳統書法性抽象意趣的作品，可說祖述宋代石恪（活躍約 965-975）和梁楷（約 1140-1210）等狂草入畫的作風。他先以大筆揮寫出饒有動感的書法線條，然後在筆觸上敷以粉藍或黃綠，再配上墨色渲染以及紙筋飛白的處理，使簡潔有力的畫面不乏肌理與質感的變化。

事實上劉國松對傳統的標榜，以及他選擇水墨畫的媒材進行創作，涉及到如何界定現代「中國」藝術的問題。自一個世紀多以來，中國經歷了西方現代文明的衝擊，傳統的社會結構與文化價值瀕於崩潰，從而導致嚴重的認同危機。不少 20 世紀的中國知識份子就是抱著「尊西人若帝天，視西籍如神聖」的心態，意圖從西方的價值體系找尋中國的現代認同。[8] 中國藝術家也在一種文化身份失落的狀況下，競相採用西洋繪畫的媒材技巧，乞靈於歐美現代藝術以求取個人創

作的肯定。劉國松堅持中國紙筆墨的傳統繪畫材料，其實跟林風眠（1900-1991）、朱屺瞻（1892-1996）、李可染（1907-1989）、丁衍庸（1902-1978）等前輩畫家所走過的藝術道路不謀而合。他們都是在學院接受西洋畫的訓練後，不約而同地放棄了油畫而轉用水墨的媒材，結果成功創造出具有現代意義的中國繪畫風格。

劉國松強調傳統的紙筆墨，以求確立對中國文化身份的認同。不過他對待傳統的態度卻截然不同於所謂的「民粹主義者」，而是帶有強烈的批判意識去認識與繼承傳統。因此他曾寫道：「認識傳統即是反傳統的一個過程，也是為達到創造的一種準備。」[9] 劉國松通過繪畫技巧的實驗與抽象形式的探索，成功地創造一種既中國又現代的藝術表現方式。在其第一本出版的藝術文集《中國現代畫的路》中，他就將個人秉持的藝術追求比喻為一把「兩面利刃」。他寫道：

> 我的創建「中國現代畫」的理想與主張，是一把指向這目標的劍，「中國的」與「現代的」就是這劍的兩面利刃，它會刺傷「西化派」，同時也刺傷「國粹派」。[10]

誠如余光中的分析，劉國松是在株守傳統的「國粹派」與好新慕洋的「西化派」以外，另覓一條「入傳統而復出，吞潮流而復吐」的藝術道路。[11] 他的繪畫創作所採取的「第三條路」，在思想立場上與文化論者巴巴（Homi K. Bhabha）

6. 1961 年的秋天，劉國松在一場座談會中，聽到有關使用現代建材仿造古建築結構的討論，有學者批評以鋼筋水泥做成木造斗拱的樣式，乃是違反現代藝術精神的作假行為。這猶如一記當頭棒喝，讓他反省自己以油畫材料來仿傚水墨畫的趣味，其實也犯了同樣的錯誤。見劉國松，〈重回我的紙墨世界 — 我創作水墨畫的艱苦歷程〉，《中國時報》1978 年 7 月 26 日。

7. 1963 年的某一天，劉國松偶然看到一張反置在桌上的畫作，使用的是一種拿來糊燈籠的紙，由於紙內含有大量紙筋，因此從畫的背面看去，斑駁的墨跡中隱隱浮現無數游絲狀的白色紋路，類似傳統書法筆觸中的飛白線條。他覺得這種偶得的畫面效果，可以用來豐富其作品的肌理與質感，於是便向台北的紙廠特別訂製一種表面附有粗紙筋的棉紙，後來這種紙就被稱為「劉國松紙」。見劉國松，《我個人繪畫發展的軌跡》，頁22。

8. 有關20世紀中國知識份子的文化認同危機，見余英時，《歷史人物與文化危機》（台北：東大圖書，1995），頁 1-32、187-196、209-216

9. 劉國松，《臨摹‧寫生‧創造》（台北：文星書店，1966），頁 19。

10. 劉國松，《中國現代畫的路》（台北：文星書店，1965），頁 4。

11. 見余光中，《雲開見月 — 初論劉國松的藝術》，《文林》第 4 期（1973 年3月），頁30-31。

所提出的「第三空間」觀點，實有不少共通的地方。劉國松意圖從中國與西方、傳統與現代等價值觀念的衝突中，創造一種具有文化主體性的「中國現代畫」，既足以抗拒西方殖民主義的霸權支配，也能夠抵禦中國民粹主義的威權控制。而他這種來自「第三空間」而具有「中間性」特色的文化生產，正如巴巴的論述所言，於各樣差異之間的夾縫中尋求超越對立的固有範疇，從而實現文化意義的重新建構。[12]

三

劉國松於 1966 年春經美術史學者李鑄晉的推薦，獲取洛克斐勒三世基金會的環球旅行獎金，遂得以飽覽歐美各國重要的美術館及博物館，親炙西方的古典與現代藝術。雖然環球旅行的成功讓劉國松得以躋身國際藝壇，並成為紐約諾德勒斯畫廊（Lee Nordness Galleries）的代理畫家，但他卻沒有藉此機會移居海外，而是於 1967 年秋回到台灣。[13] 誠如李鑄晉的觀察，兩年周遊各國的經歷，並未使劉國松在思想立場或繪畫風格上作出重大的改變，反而更激起他的國家意識與民族情感，增強其推動中國繪畫革新的熱忱及信心。[14] 為了踵武發揚具有民族性的水墨畫傳統，劉國松更聯合一批志同道合的台灣畫家，於 1968 年 11 月 12 日的「中華文化復興節」那天成立了「中國水墨畫學會」，並由他擔任會長。他將這個新畫會冠上「中國水墨畫」的名稱，而並非其一貫強調的「中國現代畫」，顯見他刻意規避「現代」一詞而張揚傳統的「水墨畫」。

至於劉國松個人的藝術創作，在 60 年代末又出現了新的突破。他於 1968 年的年底，從電視螢幕及報章雜誌上看到了美國太空船「阿波羅八號」自月球背面拍攝的地球映像。劉國松於是靈機一觸，在長方的畫幅中經營出正圓與弧形的結構，而於 1969 年初開始了所謂「太空畫」的創作階段。劉國松利用幾何形的方圓配置所構成的畫面，雖說蒙受西方

歐普與硬邊藝術的影響，但其主要的靈感來源還是中國元宵花燈的造形。[15] 其實方與圓這兩種基本視覺元素的巧思妙用，在中國藝術傳統中可謂屢見不鮮。從商周玉琮外方內圓的造形、漢朝銅鏡外圓內方的紋飾，到歷代明堂上圓下方的結構，在在反映出中國傳統文化裡「天圓地方」的觀念。[16] 因此劉國松的「太空畫」創作，雖然運用了方圓的幾何造形，卻能契合傳統藝術的美學思想。他成功地把空間意識的「天」與「地」跟藝術造形的「圓」與「方」統合於作品中，達到了中國傳統所謂「方象地形，圓應無窮」的文化內涵及美學特點。

劉國松「太空畫」時期的創作，由於相當理性地描繪具體而實在的宇宙星體，迴然不同於前一時期那種富表現性的抽象繪畫風格，因此他在 70 年代初修正了其藝術觀念，改變以往所堅持繪畫發展的終極目標為抽象境界的看法。他如此寫道：

> 我認為無論東方或西方的美術史的發展，都走著同一的道路，那就是由工筆（寫實）經過寫意（變形）而最後達到抽象意境的自由表現。[17]

而劉國松強調民族文化傳統重要性的基本思想立場卻始終如一，他認為在中國繪畫的歷史長流中，宋代梁楷等畫家的寫意風格曾遙遙領先西方藝術達六百多年。劉國松並樂觀地相信，只要能溫中國傳統文化之故而知西方現代藝術之新，中國繪畫將可實現振衰起蔽的復興。

在劉國松眾多的「太空畫」中，特別值得一提的是 1971 至 72 年創作的《一個東西南北人》系列。此系列的標題取自其印章上的文字，是他對人生與藝術的自況之辭。這批作品中的圓球星體，都是從一張德國博物館展覽的海報裁下拼貼而成，上有特寫處理的「一個東西南北人」的紅底白字印文。劉國松似乎藉此巧妙的剪貼手法自喻為高升的紅日，那

12. 見 Homi K. Bhabha, *The Location of Culture*（London: Routledge,1994），頁 1-3、36-39.

13. 劉國松基於對國家民族與文化藝術的使命感，故執意在環球旅行後返回台灣。見林銓居，〈建立廿世紀中國繪畫的新傳統 — 劉國松答客問〉，《典藏雜誌》，第 10 期（1993 年 7 月），頁 156 。

14. 見 Chu-tsing Li, *Liu Kuo-sung: The Growth of a Modern Chinese Artist*（Taipei, National Gallery of Art and Museum of History, 1969），50. 環球旅行讓劉國松深入了解當代西方藝術的發展狀況，甚至還有機會造訪著名藝術家如沃霍爾（1928-1987）的工作室，但他並未因此而在創作上隨波逐流。這主要是因為不同於無數到海外取經的中國藝術家，劉國松早在出國前已創造出個人的繪畫風格，同時確立了堅定不移的藝術理念。

15. 見劉國松，〈我個人繪畫發展的軌跡〉，頁 24；Chu-tsing Li, *Liu Kuo-sung*, p.56.

16. 「天圓地方」的觀念早在中國漢代時已形成。《周髀算經》首節云：「方屬天，圓屬地；天圓，地方。」《呂氏春秋‧圓道》也有「天道圓，地道方」的說法。

17. 劉國松，〈認清並把握住繪畫史發展的方向〉，《中華文化復興月刊》4.5（1971 年 5 月），頁 14。

份光耀普世的狂傲與自信可說躍然紙上。整個畫面在眩目的紅色調子烘托下，比起任何中國前代畫家的自畫像，更為強烈地展現出一種個人中心主義的豪情壯志。[18] 或許由於過分強調個人的主體意識，使他自覺「太空畫」偏離了中國傳統中人與自然的親和關係，因此於 1972 年底開始對其創作的方向作出調整。[19]

四

1971年秋劉國松又得到李鑄晉的引薦，前往香港中文大學新亞書院藝術系任教。[20] 香港新亞書院原為錢穆（1895-1990）、唐君毅（1909-1978）和張丕介（1905-1970）等人於 1949 年所創立，建校的宗旨乃是發揚中國傳統文化，後成為了新儒學運動發展的大本營。[21] 當劉國松赴中大新亞書院任教時，雖然錢穆已離任院長，但仍有唐君毅和牟宗三（1909-1995）等新儒學大師為該書院教授，而且他更與曾是筆仗對手的徐復觀（1904-1982）成為了同事。[22] 劉國松在這種濃厚新儒家學術氣氛的薰染下，加上 1972 年秋天又接任藝術系系主任的職務，負責執行系內課程的改革，其思想立場自然更為偏向中國傳統文化。他當時於《新亞藝術》期刊上發表的文章，開篇便引用石濤（1642-1707）的話曰：「識拘於似則不廣，故君子惟借古以開今。」[23] 因此難怪他於 1972 年底開始覺得其「太空畫」有過於西化之嫌，而意圖在創作上回歸傳統並發展新的繪畫風格。

劉國松當時嘗試新的水拓技法，基本的步驟乃是把墨或顏料滴入水中，取其於水面飄浮游散的效果，以紙吸附後再進行畫面的加工處理。不過這種技巧有很大的隨機性，他經過了數年的琢磨，才逐漸掌握其中的竅門而能適度地控制浮移於水面的墨與色。誠如劉國松自己所言，他的「太空畫」要求事先的構思佈局，屬於「胸有成竹」的創作；而「水拓畫」則需因應拓印出來的效果去塑造意境，所以是運用「畫若佈弈」的理論與方法。[24]

劉國松的「太空畫」與「水拓畫」創作，其實還有一個重要的區別，那就是畫面所表現出來「人工」與「自然」的不同意趣。他在 70 年代研究的水拓技法，跟 60 年代開發的拓印或撕紙筋方法，都是要追求一種傳統筆墨所無法做到的自然效果。中國藝術向來就強調這種「自然」的意蘊，而水墨畫的創作更是崇尚得之自然的美學思想。唐代王維（701-761）《畫學秘訣》即云：「夫畫道之中，水墨最為上，肇自然之性，成造化之功。」[25] 前代不少洞鑒玄機的水墨畫家，正是為了追求這種出於自然的旨趣，遂無所不用其極地探尋各樣可行的創作方式，並把繪畫的規矩繩墨置諸度外。像畫史中王默的「潑墨」、郭熙的「影壁」或宋迪的「張素敗牆」等，他們的創作雖然悖於常法，但由於畫中天機自動的藝術效果契合了自然的規律與變化，因而得到歷代畫學論著的肯定。[26]

劉國松深深了解中國藝術所講求「自然」的意蘊，因此他曾說道：

> 我最滿意水拓畫的系列作品，在比率上，它自然多，人工少 … 中國人講究「氣韻生動」，人工太多便生刻板，只有自然，才能生動，也只有生動，才見氣韻。[27]

18. 見李君毅，《一個東西南北人》，頁 212-213。

19. 劉國松曾談到：「因為後來的太空畫愈來愈遠離中國傳統，太接近西方的現代風格了，這樣的發展不但不是我追求的目標，也不是我最初所能預料得到的。所以我懸崖勒馬，不願掉進西方現代繪畫的陷阱中…」見葉維廉，〈與虛實推移、與素材佈弈 — 劉國松的抽象水墨畫〉《藝術家》第 89 期（1982 年 10 月），頁 242。

20. 由於劉國松在台灣一直任職於大學建築系，因此香港的新工作可讓其一圓到藝術系教書的願望。另外他也藉此機會申請大陸的母親至香港團聚，可是劉母並不能適應香港的生活，在短短四個月後就遷回武漢。

21. 1963年在香港政府的主導下，香港的新亞、崇基及聯合三所私立書院合併，成立聯邦制的香港中文大學，而原新亞藝術系則仍保留於該書院。

22. 劉國松與徐復觀於 1961 年時為現代藝術的相關問題而展開激烈的論辯。見蕭瓊瑞，《劉國松研究》（台北：國立歷史博物館，1996），頁 67-77。

23. 劉國松，〈由中西繪畫史的發展來看中國現代畫家應走的方向〉，《新亞藝術》9/10（1972年7月），頁 11。

24. 劉國松，〈我的思想歷程〉，《現代美術》第 29 期（1990 年 4 月），頁 23。

25. 王維，《畫學秘訣》，載於安瀾編，《畫論叢刊》上卷（北京：人民美術出版社，1960），頁 4。

26. 唐代張彥遠（815-907）的《歷代名畫記》中處處推重「自然」，他指出：「夫失於自然而後神，失於神而後妙，失於妙而成謹細。自然者，為上品之上」。 張彥遠的此一論述對後來文人畫的發展產生了深遠的影響，宋代黃休復（活躍於998前）和明季董其昌（1555-1636）等皆一脈相傳此美學思想，遂特別標榜以「自然」為宗的「逸品」，並對不拘常法而得之自然的藝術創作推崇備至。見李君毅，《得之自然 — 中國現代水墨畫美學初探》，載李君毅等編，《開創新世紀 — 港台水墨畫聯展》（香港：香港現代水墨畫協會，2000），頁 17-18。

27. 林銓居，《建立廿世紀中國繪畫的新傳統》，頁 162。

他更發現自己追求自然效果的各種創新技法，竟與古代「影壁」或「張素敗牆」的作畫方式不謀而合。劉國松逐於 1976 年發表〈談繪畫的技巧〉一文，援引歷代畫史畫論中不拘常法的創作為例證，來支持他對水墨畫創新技法的倡導。[28] 他甚至大膽地提出：

> 我們這一代的中國畫家，如欲將中國繪畫由這一牛角尖或臨摹的惡習中解放出來，就必須來一次驚天動地的革命，革誰的命？就是革「中鋒」的命，革「筆」的命！[29]

事實上不少 20 世紀的中國畫家正是同聲相應地進行這種革故鼎新的繪畫創作，像張大千（1899-1983）的「潑墨潑彩」或王己千（1907-2003）的「紙拓山水」，如同劉國松所開發的多種半自動性技巧一樣，都是要藉由自然偶得的痕跡來觸發靈機妙緒，再因勢利導地作出順乎心意的畫面處理，最後完成自然天成的作品。水拓技法所產生千變萬化的自然效果，正是提供劉國松源源不絕的創作靈感，讓他在機神湊會而畫思泉湧的狀態下，順應自然地將心中意緒發於筆端，妙手完成恍若天工的佳作。

五

劉國松早在 70 年代初就開始使用「現代水墨畫」一詞，以強調中國繪畫的現代轉化必須建立在傳統水墨畫的基礎上。[30] 他通過個人多年的創作與教學實踐，歸結出有關「現代水墨畫」的鮮明主張，80 年代時引起了中國大陸藝壇的激烈迴響。劉國松雖然重視水墨畫的傳統，卻反對筆墨陳規的狹隘思想，他於是提出了「筆即是點與線，墨即是色與面」以及「皴就是肌理」的概念。[31] 劉國松指出作為繪畫基本元素的點線色面與肌理，不但可以用傳統的筆墨皴法做到，若以現代水墨畫的種種創新技巧來經營，則能達到更為豐富多采的畫面效果。

此外劉國松又否定臨摹的學習方法，他指出古人的皴法只是傳統用筆技巧的基礎，而創新的繪畫則有其本身的技法規範。因此從事現代水墨畫的創作，必須把握「先異再好」的方針，根本不需要耗費時間精力在枯燥乏味的臨摹上。他指出：

> 畫畫要「先求異，再求好」。一開始就要畫的與眾不同，然後再反覆的練習，把它畫好來。[32]

對於傳統國畫墨守繩規的學習與創作方法，劉國松一再提出批評並加以糾正。他常在其文章中引述石濤「無法而法，乃為至法」或「筆不筆，墨不墨，畫不畫，自有我在」等語，來支持自己有關現代水墨畫技法革新的主張。[33] 劉國松更進一步地強調用特殊的技法來「製作」繪畫的觀念，以徹底顛覆傳統筆墨所建構的價值體系。[34]

劉國松 80 年代中以來致力發展的「漬墨畫」技巧，正是他所說的「製作」性繪畫的最佳例證。這種「漬墨畫」的做法乃是把相疊的兩張紙弄濕而令紙間出現氣泡，再於氣泡邊緣加墨滴彩，使之滲入紙中與水交混相融，然後待紙乾透即可產生濃淡變化豐富的水墨肌理。在劉國松大量的「漬墨畫」創作中，最特別的是 1999 年完成的一件由三角形畫面組合成的作品，題為《藝術的摩天大樓》。這一年他從台南藝術學院（現更名台南藝術大學）造形藝術研究所所長職位退休，正式結束其超過半世紀為人師表的生涯，因此有感而發地利用這件畫作來表達個人的教學理念。[35] 劉國松否定了傳統國畫那種「為學如同金字塔」的教育觀，認為過分講求基

28. 劉國松，〈談繪畫的技巧〉，《星島日報》1976 年 11 月 17-19 日。此文乃改寫自 1965 年《文星》刊載之〈談繪畫的技法〉，原文的用辭溫和，在當時並未引起太大的反應。

29. 同上註，11 月 19 日。

30. 劉國松在台灣發起成立的「水墨畫學會」，於1970年便以「現代水墨畫」為展覽標題。1973 年他又於香港中文大學校外進修部開創「現代水墨畫課程」，而該課程的結業學員其後在他的誘掖下成立「現代水墨畫協會」。

31. 見劉國松，《當前中國畫的觀念問題》，載林朴編，《北京國際水墨畫展論文匯編》（北京：中國畫研究院，1988），頁 65-66。

32. 劉國松，〈先求異、再求好 — 解開國畫的死結〉，《台灣新生報》1992 年 5 月 17 日。

33. 石濤語見《石濤畫語錄》，俞劍華標點註釋（北京：人民美術出版社，1959），頁 4、7。 劉國松引用石濤這些言論的文章，包括1965年的〈談繪畫的技法〉，1975年的〈談繪畫的技巧〉，1999 年的〈先求異、再求好〉等。

34. 劉國松，〈先求異、再求好 — 從事美術教育四十年的一點體悟〉，《榮寶齋》第1期（1999 年10月），頁 98。

35. 劉國松 1992 年自香港中文大學退休後，便遷回台灣定居，於台中東海大學美術系任教。1996 年在新成立的台南藝術學院校長漢寶德的力邀下，轉任該校造形藝術研究所所長。

本功的訓練，徒扼殺學生藝術創造力的發揮，於是他反其道而提出「學畫像摩天大樓」的主張。他這樣解釋道：

> 現代的建築的地基是往下扎的，只求深，不求廣。地基打得愈深，大樓就建得愈高。所以現代的畫家，不在於甚麼都會畫，而在於你畫得與別人不同。你的技法愈獨創、愈個人，再加上不停地重覆的鍛鍊，你的個人風格就愈強，畫得也就愈精深，地位自然建得愈高、愈出人頭地了。[36]

六

在當前所謂的「中國人世紀」，劉國松認為當代的中國藝術家必須堅決否定西方唯我獨尊的文化霸權，因而重新探究並發揚傳統的真正價值成為了當務之急。看到華人社會在國際舞台上的地位不斷提升，劉國松更加深他對現代水墨畫發展的信心。他在數年前的一篇文章中這樣寫道：

> 如果21世紀果真成為華人的世界，經濟上去了，軍事增強了，政治影響力加大了，中國的文化也將會受到世界的注意與重視……我們仍然有信心相信，曾經有過輝煌燦爛歷史的東方畫系的水墨畫，還會再次攀登上另一高峰，不但可以與西方平起平坐，還有可能再度超前。[37]

劉國松認為在這個新世紀裡，歐美帝國主義的殖民侵略雖已成為歷史，但中國文化仍將持續面對西方的衝擊與挑戰。對於那些盲從西化的中國「前衛」藝術家，他一再提醒他們向西方邯鄲學步的做法，乃是以喪失固有的文化傳統與民族意識為代價，意圖求取所謂「國際」的認可；如此將使中國的當代藝術失其故行，無法建立自我身分的認同，最終淪為西方所主宰的國際藝壇上無足輕重的點綴物。

劉國松創建中國水墨畫新傳統的樂觀信念，顯然帶有濃厚的民族思想及愛國精神。他本著中國知識分子所具有的歷史責任與文化使命，矢志不渝地倡導現代水墨畫的創作，以期建立一個既富民族精神又有時代意義的中國新繪畫傳統，並進而使之代表東方畫系來與西方藝術相抗衡。劉國松此一己達達人的藝術主張，充分反映其內心強烈的國家意識與民族情感。他像中國傳統的知識分子那般抱有任重道遠的人生目標，並且把推廣現代水墨畫看成是「為往聖繼絕學」的崇高理想。

在其六十年的藝術創作生涯中，劉國松一直秉持改革與復興水墨畫傳統的理念。他60年代發展的半抽象山水，即利用抽象性的書法元素使其作品兼具中國與現代的特質。而他描繪宇宙星體的所謂「太空畫系列」創作，則踰越了俗世中東方與西方的界限，賦予其獨創性的視覺語言普遍性的藝術價值。劉國松後期的作品，利用饒有天趣的水拓法與漬墨法，進一步融合傳統有關自然的哲學與美學觀念以及當代的環保意識。

作為一個藝術創作者與美術教育家，劉國松享有崇高的名聲及深遠的影響。他激發起新一代中國藝術家創造意識的覺醒，特別是孕育了水墨畫如百花齊放的實驗及創新。劉國松2007年於北京故宮博物院與2011年於中國美術館的兩次盛大展覽，乃是大陸美術與學術界對其六十年創作生涯的肯定及推崇。如今國立台灣美術館特別舉辦此一隆重的回顧展，彰顯他橫跨東方與西方、傲視大陸與台灣、融合傳統與現代的藝術成就。目睹中國大陸與台灣在世界舞台上的地位日增，他更堅信伴隨「中國世紀」的到來，水墨畫必可建構輝煌燦爛的新傳統。將屆杖朝之年的劉國松，其堅守傳統而勇於革新的藝術追求，將繼續成為21世紀中國水墨畫除舊布新的動力泉源。

36. 劉國松，〈我對美術教育改革問題的思考與實踐〉，載潘耀昌編，《20世紀中國美術教育》（上海：上海書畫出版社，1999），頁104-105。

37. 劉國松，〈21世紀東方畫系的新展望〉，載林麗真編，《心墨無法》（高雄：高雄市立美術館，2004），頁22。

A Man of East, West, South and North
Liu Guosong's Sixty Years of Artistic Exploration

Curator / Chun-yi Lee

One of the seals Liu Guosong (Liu Kuo-sung) frequently uses bears the phrase *Yige dong xi nan bei ren*, which literally means "a man of east, west, South and North." [1] As an absolute epitome of his artistic exploration, the inscription on the seal pointedly suggests the cultural dilemmas he confronted concerning questions and conflicts between "East" and "West," "China" and "Taiwan," as well as "tradition" and "modernity." Liu Guosong's critical and insightful responses to these challenges, as reflected in both his paintings and writings, contribute to his artistic triumph in shaping the cultural identity of his work and in revitalizing the ink painting tradition.

I

Liu Guosong, a native of Shandong, was born in Bangbu, Anhui province in 1932. The Sino-Japanese War took the life of his father, a Kuomintang major, and left him and his mother helpless. After years of deprivation in wartime China, as a *beifang ren* (man from the north), Liu Guosong moved southwards to Taiwan with the National Revolutionary Military Orphan School in 1949. He completed his art training at the Taiwan Normal University and became a pivotal figure in the modern art movement that strived to overthrow the prevailing conservatism in the art world of Taiwan. Liu Kuo-sung and his Wuyue Huahui (Fifth Moon Group) comrades were enthusiastic in introducing new artistic ideas and techniques from the West to enrich the tradition of Chinese painting.

Liu Guosong's paintings and writings from the early stage of his artistic career bear the imprint of the familiar notions of Western modernism, such as a preoccupation with the present, the romantic affirmation of the self, the positivist belief in the forward movement of history, the confidence in the beneficial possibilities of new technologies, and the ideal of freedom defined within the framework of a broad humanism.[2] But unlike many of his modernist predecessors from the May Forth Movement, Liu Kuo-sung took a critical attitude towards an indiscriminate search for "newness" from the West. Through an in-depth self-examination, he determined to return to tradition and made the strong statement: "To imitate the new cannot substitute for imitating the old; and to copy the West cannot substitute for copying the Chinese."[3] Liu Guosong's assertion was that the Chinese artists who embraced the novelties of Western art without reflecting on their own tradition violated the principles of artistic creativity. Therefore he not only maintained an antagonistic attitude towards the conservative camp but directed his criticisms at the timeservers of modern art, denouncing their "modernity" as second-hand imitations of Western art trends and ideas.

Liu Guosong's support for the American and European abstract art of the 1950s and 60s, through both theoretical and artistic practices, was also based on his emphasis on Chinese tradition. His writings had an insightful discourse strategy. He cited a large number of ancient discussions

1 This Qingtian seal was carved by Chen Dancheng (1919-2009), who was also a native of Shandong, in 1965 at the request of Liu Guosong. The side inscription reads: "My brother Guosong, who is far away from his homeland, asked me to carve this seal, which bears 'a man of east, west, south and north.' In the winter of the year yisi. Chen Danchen recorded this."

The scripts on the seal were indebted to a couplet inscribed by the Ming painter Xu Wei (1521-1593), which reads: "Several tottering houses, and a man with mixed accent of north and south." Liu Guosong also executed a calligraphic couplet as a self-mockery, which says: "Several awful paintings, and a man of east, west, south and north." See Yang Chihong, "A Man of East, West, South and North," *Artists* 40 (September 1978): 78.

2 See Chun-yi Lee, "A Man of East, West, South and North: The Spirit of Modernism in Liu Guosong's painting," in Chun-yi Lee ed., *Collected Essays on the Study of Liu Guosong* (Taipei: National Museum of History, 1996), 211-216.

3 Liu Guosong put forward this artistic statement in 1959, which could be considered his motto. See Liu Guosong, "The Trajectory of My Personal Artistic Development," *Hsiung Shih Art Monthly* 5 (July 1971): 21.

on art as evidence and strove to integrate the structure of abstract painting into the Chinese art tradition.[4] In order to try to dispel modern Chinese art's idolatry and reliance on a dominating Western culture, Liu Guosong's strongly nationalistic discourse is in accordance with the post-colonial theory of "counter-discourse."[5] He recognized the subjugating effect Western culture had over contemporary Chinese artists and sought to rediscover the unique elements in the forgotten culture with the aim of solidifying the autonomy and value of "modern Chinese painting." As a result, his discourse about abstract paintings actually challenged Western colonial supremacy.

II

Liu Guosong devoted to the creation of an innovative art form. He started his artistic exploration in 1957 by employing diluted oil paints and Chinese ink on plastered canvas to capture the traditional ink wash effects. He even reinterpreted several of the famous ancient paintings, exploring the formal qualities of abstract painting within the painting's original structure. However, after a short while, he re-examined his use of oil media to imitate the characteristics of ink painting and believed it was actually an act of fakery.[6] Liu Guosong, as a result, abandoned Western painting materials and began to use traditional Chinese paper, brush and ink instead. One day in 1963, by chance he noticed that a sheet of paper, which contained coarse fibres and was used for making paper lanterns, had countless springy white lines amidst the mottled ink marks that could be used to enrich the texture of his work.[7] He was inspired by the appealing effects and thus invented "Liu Guosong Paper" as well as the so-called "Stripping the Tendons and Peeling off the Skin Brushwork," to create a stunning new painting style. His work from this period, which is characterized by its abstract qualities of calligraphic brushwork, revived the painting style pioneered by the Song painters Shi Ke (active ca. 965-975) and Liang Kai (ca.1140-1210). In these paintings, Liu Guosong first uses a large brush to compose rhythmic and stirring calligraphic lines, then he covers the brushstrokes slightly with some indigo, yellow or green colours. He accompanies that with some light ink washes and finally pulls off the fibres to achieve the *feibai* effect, resulting in a clean composition with no shortage of changing textures.

Facing the long-standing question that deals with the cultural identification of modern "Chinese" art, Liu Guosong's emphasis on and adoption of the ink painting media illuminates his commitment and dedication to tradition. For the past century or so the Chinese have gone through an identity crisis that is the result from the disintegration of traditional social structures and cultural

4 The articles Liu Guosong published to elucidate the theory and practice behind his abstract painting include: "The Essence of Modern Painting – A Reply to Mr. Fang Qi," *Pen Review* 1.12 (April 1960): 17-20; "The Appreciation of Abstract Painting," *Apollo Magazine* 6.4 (August 1960), 23-24; "Abstract Painting," *Pen Review* 2.3 (October 1960): 22-32

5 For discussion of "counter-discourse," see Bill Ashcroft, Gareth Griffiths and Helen Tiffin, *Key Concepts in Post-Colonial Studies* (London, Routledge, 1998), 56-57.

6 At a conference in the autumn of 1961, Liu Guosong heard a discussion on the use of modern construction materials to imitate ancient architecture. Some scholars criticized the use of concrete and cement to imitate classical wooden brackets as fakery that violated the modern artistic spirit. This caused Liu to reflect on his own artistic creation. See Liu Guosong, "Return to My World of Ink and Paper: The Difficult Course of My Ink Painting Creation,' *China Times*, July 26, 1978.

7 One day in the autumn of 1963, by chance Liu Guosong saw a painting lying face down on a table. The paper, which was of the type used for making paper lanterns, contained coarse fibres on the surface. So when viewed from the back amidst the mottled ink marks, there were countless springy white lines. Liu thought that this unexpected effect had a natural appeal, which was rich in variations and could be used to enrich the texture of his work. Therefore, he ordered a special kind of cotton paper that is rich in coarse fibres from a Taipei paper manufacturer and later the paper was called "Liu Guosong Paper." Regarding the invention of the special paper named after the artist, see Liu Guosong, "The Trajectory of My Personal Artistic Development," 22.

values. Many intellectuals embraced an attitude that "respected Westerners like Gods, and regarded Western learning as sacred," in the aim to find a place for China within modernity using a Western value system.[8] The problems of self-identity also baffled many artists in China, causing them to vacillate between the Western oil and Chinese ink. Liu Guosong's response to the problems was not different from those of Lin Fengmian (1900-1991), Zhu Qizhan (1892-1996), Li Keran (1907-1989), Ding Yanyong (1902-1978), and many others. They were all artists who were trained in Western painting in the academy, but abandoned oil painting in favour of the medium of Chinese ink on paper only to succeed in creating a style of Chinese painting that had a modern sensibility.

Liu Kuo-sung glorified the use of the ink, brush and paper in his search for a Chinese identity. However, his attitude towards tradition is different from what can be described as "populism." Liu Guosong carried a strongly critical attitude in his understanding and inheritance of tradition. Hence, he also wrote: "In my personal artistic life, the understanding of tradition is a process in my displacement of tradition, in order to fully prepare for the process of creation."[9] Liu Guosong devoted himself to the creation of an art form that is both Chinese and modern, engaging in a dialogue with tradition through experimentation on the technical means of media and exploration of abstraction. In his first book of collected writings on art, *Whither Chinese Modern Painting*, he used a metaphor of double-edged sword to illustrate the difficult situation of his artistic creation. He wrote:

> My ideals and positions on "Chinese modern painting" is a sword pointing at the direction of its goal. "Chinese" and "Modern" make up the two sides of this double-edged sword. It will pierce "the Westernization Sect," and at the same time it will also pierce the "National Essence Movement Sect."[10]

As Yu Guangzhong analyzed, Liu Guosong stood outside of both the populists, who were inclined towards tradition, and the supporters of Westernization, who were in favour of Western culture. He was on an artistic path where one "enters tradition from which one emerges, swallowing trends where they would be regurgitated."[11] His artistic creation called for a "third path" that is quite similar ideologically to postcolonial scholar Homi K. Bhabha's idea of "The Third Space." Liu Guosong intended to create a principle cultural entity that is "Chinese modern painting" amidst the conflicts between China and the West, tradition and modernity, and other comparative values. He believed that this new cultural entity has the power to resist the hegemonic control of Western colonialism, and would be able to withstand the authoritative control of stubborn populism. This cultural production that stems from "The Third Space," which possesses the characteristic of "in-betweeness," overcomes oppositional categories by surpassing them through discovering what is found narrowly in between those oppositions. In this way, it actualizes the rebuilding of cultural meaning.[12]

III

In the spring of 1966, under renowned art historian Chu-tsing Li's enthusiastic recommendation, Liu Guosong received an award from the John D. Rockefeller III Fund. The award gave him the opportunity to visit various countries around the world, enriching his knowledge of the ancient and contemporary masterpieces in the collections of renowned museums as well as the current art trends in the West. This pushed Liu Guosong onto the global art stage, with representation by Lee Nordness Galleries of New York. Nevertheless, his success did not give him reason to emigrate overseas. In the autumn of 1967, he returned to Taiwan.[13] According to Chu-tsing Li's observations, the experience of travelling for two years around the world did not create significant changes in Liu Guosong's artistic belief and painting

8 Concerning 20th century Chinese intellectual's crisis of cultural identity, see Yu Yingshi *Histoical Figures and Cultural Crises*, (Taipei, Dongda Publishing Co, 1995), 1-32; 187-196; 209-216.

9 Liu Guosong, *Copying, Drawing, Creating* (Taipei, Books World Co., 1966), 19.

10 Liu Guosong, *Whither Chinese Modern Painting* (Taipei, Books World Co., 1965), 4.

11 See Yu Guangzhong, "The Clouds Part and the Moon Revealed: Preliminary Study on Liu Guosong's Art," Wenling 4 (March 1973): 30–31.

12 See Homi K. Bhabha, *The Location of Culture* (London, Routledge, 1994), 1–3; 36–39.

13 Because of his commitment to Chinese culture and art, Liu Guosong chose to return to Taiwan after the trip around the world. See Lin Quanju, "Establishing the New Tradition of Chinese Painting of the 20th Century: Interview with Liu Guosong," *Art & Collection* 10 (July 1993): 156.

style. On the contrary, it aroused his national awareness and nationalistic feelings even more strongly, and enhanced his passion and confidence in moving modern Chinese painting forward.[14] In order to promote the ink painting tradition that is full of national spirit, Liu Guosong united a group of artists with common interests, and on November 12, 1968, the day of the "Chinese Cultural Revival Festival," founded the "Chinese Ink Painting Society," assuming the role of its president. His decision to give this new society the prefix of "Chinese Ink Painting" was a deliberate attempt to steer it away from "Chinese modern painting." Hence, the emphasis was placed on "ink painting" and not on "modern."

There was a new development in Liu Guosong's art in the late 1960s. At the end of 1968, he saw on television, newspapers and magazines pictures taken of the earth from behind the moon by the American spaceship Apollo 8. He was suddenly struck with inspiration and created a composition with square, circle and arc in response to the various images that he had seen of the earth and the moon. In early 1969 he started his "space painting" period. Liu Guosong's use of geometric shapes may have been influenced by Hard Edge Painting and Op Art in the West, but its principle inspiration is the Chinese festival lantern.[15] In fact, the magical effect that comes from combining those two basic visual forms, the square and the circle, is not new in traditional Chinese art. From jade cong of the Shang and Zhou dynasties with a square exterior and a circular interior, to Han dynasty bronze mirrors with a circular exterior and a square interior, to imperial luminous halls where the overall structure is made up of a circular top sitting on a square bottom, the traditional Chinese concept of "the sky is round and the earth is square" could be reflected in all these cases.[16] Therefore, this series of works by Liu Guosong, with festivals as the subject matter, connected traditional aesthetic thought with the use of square and circular shapes. He succeeded in uniting the spatial entities of "sky" and "earth" with the artistic forms of "circle" and "square," achieving the cultural depth and

aesthetic characteristic that is shown by the traditional concept of "the square is the form of the earth, the circle is that of infinity."

Liu Guosong's "space painting" period objectively depicted the celestial bodies of the universe. It differed from the expressive abstract painting style of an earlier time. As a result, in the early 1970's, he amended his standpoint that abstraction should be the objective of one's painting development. He wrote:

> I think, whether it is the development of Eastern art history or Western art history, ultimately they are going on the same path. That is a movement from gongbi (realistic depiction) to xieyi (free style) and finally arriving at a liberal representation of abstraction.[17]

Liu Guosong's emphasis on cultural tradition, however, remained consistent. He believed that in the flow of history of Chinese painting, the xieyi style of Song dynasty painters, such as Liang Kai, predated Western art by over six hundred years. Liu Guosong optimistically held that, as long as one is knowledgeable about the history of traditional Chinese art and is aware of the youth of Western modern art, then Chinese painting can undergo a modern transformation, in which what appeared to have perished or abandoned would be renewed.

Among Liu Guosong's many "space paintings," A Man of East, West, South and North created during 1971 to 1972 is particularly worthy of mention. The title of this series took its name from the characters of a seal that belongs to Liu Guosong; it has also become Liu's motto for the feeling he has towards his life and art. The spherical celestial bodies in these works are made up of a collage produced from a German museum's exhibition poster, whose design features an enlarged image of the seal script "A Man of East, West, South and North." Liu Guosong seems to use this clever collage technique to symbolize the rising sun, a glowing pride

14 See Chu-tsing Li, Liu Kuo-sung sung: The Growth of a Modern Chinese Artist (Taipei, National Gallery of Art and Museum of History, 1969), 50. Liu Guosong's journey around the world allowed him to further understand the development of modern Western art. He even had the opportunity to visit the studios of famous artists like Andy Warhol (1928-1987), but he did not allow himself to become influenced artistically. Unlike many Chinese artists who went abroad to study Western art, Liu Guosong had already established his own individual style before he left his country.

15 See Liu, "The Trajectory of My Personal Artistic Development," 24; Li, Liu Kuo-sung, 56.

16 The concept of "the sky is round and the ground is square" was formed during the early Han dynasty. In the first chapter of Zhou Bi Suan Jing, it says, "Square belongs to the earth, and circle belongs to the heaven, so the heaven is round and the earth is square in shape;" and "The Dao of Circle" of The Spring and Autumn Annals of Mr. Lu, it also says, "The Dao of heaven is circle and that of earth is square."

17 Liu Guosong, "Understanding and Grasping the Direction of the Development of Art History," Chinese Cultural Renaissance 4.5 (May 1971): 14.

and confidence that vividly manifest on paper. The dazzling red tones that set off the picture demonstrate lofty determination and strong personal ideals more powerfully than any self-portrait painted by a Chinese artist from a previous generation.[18] Perhaps due to an over emphasis on individuality, Liu Guosong's "space paintings" gradually diverged from the Chinese traditional notion of a harmonious relationship between man and nature. Thus, at the end of 1972, he decided to change his creative direction.[19]

IV

In the autumn of 1971, again under the recommendation of Chu-tsing Li, Liu Guosong went to teach in the fine arts department at the New Asia College of the Chinese University of Hong Kong.[20] New Asia College was originally founded in 1949 by a group of scholars that included Qian Mu (1895-1990), Tang Junyi (1909-1978) and Zhang Pijie (1905-1970), and the purpose of the school was to promote traditional Chinese culture; it would later become the headquarters for the development of the Neo-Confucianist movement.[21] When Liu Guosong went to teach there, Qian Mu had already left as the College Head; however, Tang Junyi, Mou Zongsan (1909-1995) and other Neo-Confucian scholars were still teaching there. He even became a colleague of his old opponent Xu Fuguan (1904-1982).[22] This dense Neo-Confucian scholarly atmosphere influenced Liu Guosong. In the autumn of 1972, he became head of the fine arts department, responsible for reforming the curriculum. Naturally, his intellectual stance leaned further towards traditional Chinese culture. In the New Asia Art periodical, he published an essay quoting Shitao (1642-1707)in the opening: "If one cannot be freed from established theory and techniques, one's vision is limited. For this reason, wise men borrow the

old and use it to open up the present."[23] Thus it is no wonder that towards the end of 1972 he began to view his "space paintings" as being too Western, and intended to turn back to tradition and develop a new painting style.

At that time, Liu Guosong was experimenting with the new technique called "water rubbing." The technique is achieved by dripping ink or colour pigments into water, where it would float on the water and produce its effect. After the paper absorbed the ink or colours, the paper surface was further worked on. This technique is highly spontaneous, and Liu Guosong came to master it only after several years of practice, by which time he could control the ink and colour that float on the water surface. As he said, his "space paintings" required the overall conception to exist in advance, and is the type of creation where one would already have a "well thought-out strategy." In contrast, "water rubbing paintings" has to respond to the final rubbing effect in order to fulfil its artistic conception, so it uses a theory and method akin to playing chess.[24]

There is another important difference between Liu Guosong's "space paintings" and "water rubbing paintings," and that is the variation between the appearance of "artifice" and "nature." The water rubbing technique that he experimented with in the 1970s along with the ink rubbing or fibre techniques of the 1960s were all in pursuit of a kind of naturalistic effect that cannot be achieved using traditional brush and ink techniques. Chinese art has always emphasized this nuance of "naturalness," and ink painting is also an aesthetic thought that venerates nature. Wang Wei (699-759), the Tang dynasty artist said in his "Secrets of Painting Study": "Ink painting, the best among Chinese paintings, is full of the quality of nature and achieves the merit that

18 See Lee, "A Man of East, West, South, North," 212–213.

19 Liu Guosong said: "Due to later space paintings becoming more and more removed from the Chinese tradition, and was becoming too closely aligned with a modern Western style, this kind of development was not my objective, and it also was not what I had initially anticipated. Therefore I am reining in my horse just before reaching the cliff, as I do not wish to fall into the trap of Western modern painting See Ye Weilian, "Pushing Against Void and Solid, Playing Chess with Media: Liu Guosong's Abstract Ink Painting," Artists 89 (October 1982): 242.

20 In Taiwan, Liu Guosong had always taught in the department of architecture. His new job fulfilled a dream of teaching in a department of fine arts. He also hoped, by means of this opportunity, to apply for his mother to join him in Hong Kong. However, his mother could not cope with the new environment and returned to Wuhan after staying in Hong Kong for only 4 months.

21 In 1963, the Hong Kong government merged New Asia College, Chung Chi College and United College together to establish the Chinese University of Hong Kong. The Fine Arts department of New Asia College remained in its college.

22 A fierce debate on modern art involving Liu Guosong and Xu Fuguan broke out in 1961. See Xiao Qiongrui, Study on Liu Guosong (Taipei: National Museum of History, 1996), 67-77.

23 Liu Guosong, "From Chinese and Western Art Histories to See the Correct Direction of Modern Chinese Artists," New Asia Art 9/10 (July 1972): 11.

24 Liu, "The Development of My Thought," 23.

is the creation of nature."[25] In the past, many ink painters sought this kind of natural intent. They explored various innovative techniques while pushing the rules and regulations of painting beyond all limits. Examples include Wang Mo's (d. 805) "*po mo*" (splashed ink painting technique), Guo Xi's "Shadow Mural" technique or Song Di's (active ca. 11th C.) "Silk Upon Eroded Wall." Although their creative works used unconventional methods, they gained historical and academic recognition because their art was individualistic and infused with the principles and changes of nature.[26]

Liu Guosong deeply understood the nuance of what Chinese art stresses as "natural." Hence, he once said:

> I am most satisfied with my series of water rubbing paintings. In terms of ratio, they are abundant in the natural and lacking in the artificial…Chinese people strives for "spirit resonance and liveliness". If there is too much of the human touch, then the work becomes stiff. Only the natural can be lively, and only liveliness can reveal spirit-resonance. [27]

He also discovered that the different techniques that he introduced in pursuit of nature were akin to the ancient painting techniques of "Shadow Mural" and "Silk Upon Eroded Wall." In 1976, Liu Guosong published the article "A Discussion on Painting Techniques," in which he backed his advocacy for new ink painting techniques with evidence of the use of unconventional techniques found in historical art theories.[28] He even put forth daringly:

> As this generation's Chinese artists, if we want to liberate Chinese painting from this dead end or from the bad habit of emulation, then we must at

once throw a revolution that frightens the heavens and shakes the earth. A revolution against what? Against the 'centre tip,' against the 'brush'! [29]

The reality is that there were many twentieth century Chinese painters who also introduced revolutionary innovations in painting, such as Zhang Daqian's (1899-1983) "splashed ink, splashed colours" method and Wang Jiqian's (1907-2003) "paper rubbing landscapes." Like the many semi-autonomous techniques developed by Liu Guosong, these techniques were all inspired by nature's markings, and those markings would be improved upon by the artist, ultimately creating a work that is as natural as it can be. The range of natural effects that are producible by the water rubbing technique provided Liu Guosong with an unending source of creative inspiration, allowing him to naturally express his inner feelings and thoughts in a state of intense concentration and artistic inspiration, resulting in wonderful works seemingly created with heavenly hands.

V

In the early 1970s Liu Guosong had begun to use the term "modern ink painting" to emphasize the idea that the modern transformation of Chinese painting must be built upon the foundation of traditional ink painting.[30] Through years of creation and teaching practice, he formulated his position related to "modern ink painting," igniting reactions within the art world in China in the 1980s. Despite Liu Guosong's stress on tradition, he maintained a critical attitude towards the narrow ideological confines of traditional brush and ink, and so he proposed the idea that "the brush is the dots and lines, the ink is the surface

25 Wang Wei, "Secrets of Painting Study," in Yu Anlan ed., *Compendium of Painting Theories* vol. 1 (Beijing: Renmin Meishu Chubanshe, 1993), 4.

26 Zhang Yanyuan's (ca. 815-ca. 877)*Record of Famous Paintings from Past Dynasties* from the Tang dynasty pushed for "naturalness in all respects. He wrote, "If one misses the natural, then the painting falls into the divine class. If one misses the divine, the painting falls into the fascinating class. If one misses the fascinating, the painting falls into the class of finely executed things, which have the weakness of being too cautious and minute. The natural is the uppermost class. Zhang Yanyuan's discussion had a profound influence on the development of later literati painting. Song Dynasty's Huang Xiufu (active ca. late 10th C.)and Ming dynasty's Dong Qichang (1555-1636), along with many others, inherited and passed on this aesthetic philosophy. They especially praised the outstanding works that upheld "nature as its model. Furthermore, they held in highest esteem the creative works that achieve nature without confining themselves to conventional techniques. See Lee Chun-yi, The Naturalness: A Tentative Study of the Aesthetics of Modern Chinese Ink Painting," in Lee Chun-yi et al. ed., *The New Century of Chinese Ink Painting: The Exhibition of Chinese Ink Painting from Hong Kong and Taiwan* (Hong Kong: Hong Kong Modern Chinese Ink Painting Association, 2000), 17.

27 Lin, "Establishing the New Tradition," 162.

28 Liu Guosong, "Discussion on Painting Techniques," *Sing Dao Daily News*, November 17–19, 1976. This article was rewritten from an early one published in *Apollo Magazine* in 1965 titled "The Method of Painting." The original article was mild in its tone, so it did not receive much attention.

29 Ibid, November 19.

30 Liu Guosong established the "Ink Painting Society" in Taiwan, and he gave an exhibition in 1970 the title "Modern Chinese Ink Painting." He set up the "Modern Ink Painting Course" at the extramural department of the Chinese University of Hong Kong in 1973, and the students graduated from the course later formed the "Modern Chinese Ink Painting Association."

and colours" as well as the idea that "*cun* is texture."[31] Liu Guosong emphasized that the fundamental painting elements of dot, line, colour, surface and texture can be achieved not only through traditional *cun* techniques, but richer painting effects can be attained through new techniques in modern ink painting.

In addition, Liu Guosong challenged the practice of copying masters' works. He pointed out that the ancients' *cun* techniques are only the basis for traditional brush techniques, while innovative paintings have their own technical standards. Therefore, in creating modern ink paintings, one must grasp the guiding principle of "first be different and then be refined." Therefore, time and energy should not be wasted on the practice of copying. Liu Guosong said:

> The learning of painting should "first be different and then be refined." One must begin to paint what is unique from the norm, and then practice it repeatedly until it becomes good.[32]

Regarding the methods of traditional Chinese painting, Liu Guosong once again offered his criticisms. In order to support his point of view regarding the innovation of modern ink painting techniques, he often quoted Shitao in his writings, namely, "No method is the method, which is the consummate method," or "The brush is not brush, ink is not ink, painting is not painting. There is only myself."[33] Liu Guosong further emphasized the concept of using special techniques to "produce" a painting, thoroughly subverting the established system of traditional brush and ink.[34]

The concept of "producing" a painting is best demonstrated in Liu Guosong's "steeped ink paintings," which he started to develop in the mid-1980s. This method involves wetting two pieces of overlapping paper to allow air bubbles to form between the sheets; then ink and colours are added along the periphery of the bubble, which soaks into the paper to mix with the water. After the paper dries, interesting colour gradations and textural effects form. Of this group of new paintings by Liu Guosong, the most extraordinary is one completed in 1999, which is composed of many small triangular panels joined together and is entitled *Skyscraper of Art*. That year, Liu Guosong retired as the director of the Research Institute of Plastic Art at Tainan Art Institute (now named Tainan Art University), officially ending his 50-year long teaching career.[35] Overwhelmed with emotions he expressed through the painting his pedagogical ideology. Liu Guosong did not agree with traditional painting education in which "learning is like a pyramid;" he believed that an overemphasis on the training of basic techniques smothers a student's creative development. Hence, he offered an alternative model of "learning is like a skyscraper."

> The foundation of modern buildings is laid underground, only seeking depth, not seeking vastness. The deeper the foundation, the taller the building. Therefore, the modern artist does not need to know how to paint everything, but it is important that you are painting something different. The more innovative your techniques, the more individualistic your techniques, and with continual repeated practice, your individual style will become more distinct, and your paintings will become more refined and deep. Your position will naturally move up and you will rise above.[36]

VI

At the present moment of the so-called "Chinese century," Liu Guosong believes that contemporary Chinese artists need to reject Western hegemonic culture, and that it is top priority that they rediscover and propagate the real values of tradition. Seeing the Chinese people and their governments became increasingly important on the world

31 See Liu Guosong, "The Conceptual Problem of Contemporary Chinese Painting," in Lin Pu ed., *Collected Essays of the Beijing International Ink Painting Exhibition* (Beijing, Research Institute of Traditional Chinese Painting, 1988), 65–66.

32 Liu Guosong, "First Be Different, Then Be Refined: Breaking the Deadlock of Chinese Painting," *Shin Sheng Daily News*, May 17, 1992.

33 See Shitao, *Collection of Commentaries on Paintings*, 4, 7. The quotations from Shitao appear in Liu Guosong's essays, including "The Method of Painting" of 1965, "Discussions on Painting Techniques" of 1975, and "First Be Different, Then Be Refined" of 1999.

34 Liu Guosong, "First Be Different, Then Be Refined: Learning from My 40-Year Teaching Experience," *Rong Bao Zhai* 1 (October 1999): 98

35 In 1992 Liu Guosong retired from the Chinese University of Hong Kong, and moved back to Taiwan to teach at Tunghai University in Taichung. In 1996 he was recruited by Han Baode to assume the position as the director of the Research Institute of Plastic Art at Tainan Art Institute.

36 Liu Guosong, "My Thought and Practice in the Reform of Art Education," in Pan Yaochang ed., *Art Education in the 20th Century China* (Shanghai, Shanghai Shuhua Chubanshe, 1999), 104–105.

stage, his confidence in the development of modern ink painting continues to deepen. In an essay he wrote a few years ago:

> If the 21st century really becomes a world led by the Chinese, the economy will go up, the military will strengthen, political influence will increase, and Chinese culture will receive the world's attention and respect…We still have the confidence to believe that ink painting, the Eastern painting system that had once experienced a magnificent history, will once again climb atop a new peak. Not only can it be equal to what is in the West, it can possibly surpass and take the lead once again. [37]

Liu Guosong believes that in this new century, even though European and American imperialism and colonial invasion have become history, Chinese culture will still face challenges from the West. He reminds Chinese "avant-garde" artists who blindly follow the West in order to attain "international approval" would cost them their own cultural tradition and national consciousness. In this way, China's contemporary art would lose touch with its tradition, and become unable to build its own identity, and end up as a weightless accessory in an international art scene dominated by the West.

Liu Guosong, in carrying a Chinese intellectual's historical duty and cultural mission, vows to always be a proponent of modern ink painting, in order to build a new Chinese painting tradition that is rich in national spirit and modern significance; and furthermore to develop this tradition as a representative of an Eastern painting system to challenge Western art. His strong inner national consciousness is evident in his intention to encourage a full understanding of the situation. Like classical Chinese intellectuals, Liu Guosong feels a heavy responsibility and sees the building of modern ink painting as a lofty ideal akin to the Confucian ideal of continuing, inheriting, reviving and promoting China's cultural heritage by tracing it back to its origin.

Liu Kuo-sung's initiative and drive to contribute to the revitalization and revalidation of ink painting tradition dominated over sixties years of artistic creativity. In his semi-abstract landscapes of the 1960s, he demonstrates how the calligraphic qualities of abstraction make his works both "Chinese" and "modern." His artistic approach of viewing the planets from outer space in his so-called "Space Series," also allows him to transcend the earthly boundaries of "East" and "West" while infusing his original and personal style of ink painting with a new universal appeal. Later works by Liu Kuo-sung that utilize the intriguing "water rubbing" and "steeped ink" techniques, further explore the representational possibilities of the ink painting media, through which he incorporates traditional philosophical and aesthetic concept of naturalness with modern-day environmental concerns.

As an artist and an art educator, Liu Kuo-sung enjoys widespread fame and influence in China. He inspires young generations of Chinese artists to explore new creative directions, and in particular, he fosters the emergence of exciting experiments and innovations in ink painting. His retrospective exhibitions at the Beijing Palace Museum in 2007 and the National Art Museum of China in 2011 demonstrated the honour and esteem he received in mainland China. Now the National Taiwan Museum of Fine Arts also organizes this important retrospective exhibition. It marks the high point of his sixty years of artistic career, which has spanned from the East to the West, and from Taiwan to China. Acknowledging the rise of Taiwan and China as rising powers on the world stage, Liu Kuo-sung affirms his belief that a new tradition of ink painting will prevail with the arrival of the "Chinese Century." Now soon approaching eighty years of age, his artistic endeavors and creative pursuits remain important sources of inspiration for the continual process of renewal and invigoration of Chinese ink painting in the 21st century

37 Liu Guosong, "New Prospects of the Eastern Painting Lineage in the 21st Century," in Lin Lizhen ed., *Ink and Mind: Creation Without Limits* (Kaoshiung, Kaoshiung Museum of Fine Arts, 2004), 22.

一個東西南北人
劉國松80回顧展序

中央美術學院教授 / 薛永年

在 20 世紀裡，劉國松先生是有大成就的畫家，是有強烈愛國精神的畫家，是有高漲創造意識的畫家，是善於在創作上特立獨行的畫家，是敢於在理論上標新立異的畫家，是多年來對兩岸藝術交流做出積極貢獻的畫家。這次展覽是個規模盛大的回顧展，回溯了劉先生80年來的藝術歷程，展出了他各個時期的代表性作品：從求學時代的水彩畫、油彩畫、傳統形態的水墨畫，到走上創作道路以來的綜合媒材繪畫和大量的水墨畫。題材上極為廣泛，也包括近十年的「西藏系列」「九寨溝系列」，畫法涵括了一系列實驗。至於美的意象與境界，則有具象的感悟，有抽象的情思，有理性的光輝，也有感性的悸動，可以說是他畢生成就的薈萃。走近他這個展覽，玩味他的藝術美，追尋他的藝術道路，有幾個富於啟示的特點。

其一，善於以反傳統的勇氣建立新的傳統。中國繪畫走向現代，是一個多世紀以來的重大課題。走向現代不是被動地回應西方，更不是盲目地效法西方，但是必須把中國繪畫的發展納入到世界的語境中去，必須善於借助他山之石，甚至採取外國良規。走向現代不是盲目地反水墨，更不是盲目地反傳統，但是必須反掉那些喪失生命力的僵化圖式和八股技巧，以便從根本上繼承獨具特色歷劫不磨的傳統文化精神。劉國松先生是 50 年前在臺灣高舉反傳統大旗的創將，但他所反的傳統恰恰是把傳統簡化和僵化的惰性傳統，並在此基礎上，首先把抽象表現主義因素與山水精神有所結合，初步創造了中國水墨畫的新傳統。上世紀 60 年代，李鑄晉先生美國策劃了為期兩年的「中國山水畫的新傳統」巡迴展，使他作為中國畫新傳統的代表影響了西方。

其二，以天人合一的精神發展水墨語言。他不是簡單地搬用西方藝術語彙，而是深入理解中國繪畫的語言特色，研究中國畫材料與語言的關係，語言與中國人思維方式的關係。劉國松為了擴大中國畫表現力，善於圍繞水墨材料進行試驗，他所發明的技巧，無論撕紙筋、拓墨、狂草、水拓、漬墨，

無不發揮了中國材料的優勢，無不符合中國「天人合一」的精神，無不是古代筆墨語言之外的自然天成的水墨語言。他回歸的傳統，不是傳統之跡，而是傳統之心。他的半抽象的水墨語言成功地表現了「惟恍惟惚，其中有象」的宇宙觀和「一陰一陽之謂道」的文化精神，這是一種超越小我與天地精神相往來的宇宙心印的文化精神。他的藝術具有鮮明的走向現代的自覺，這種自覺表現為：既是現代形態的，又是中國特色的，既是民族的，又是在世界語境中便於溝通的。

其三，以「可貴者膽」實現「所要者魂」。中國書畫的走向現代，沒有固定的模式，道路十分寬廣，可以有條條道路。但要闖新路，就要有膽量。沒有膽量，走不出新路，光有膽量也不夠，還要有靈魂，沒有民族靈魂，也就沒了身份，就不能在世界上顯出特色。劉國松畢幾十年之功，走出了一條大道，他的勇敢、執著和智慧，給我們的啟示，就像李可染講的那樣「可貴者膽，所要者魂」。「可貴者膽」就是要大膽地突破，大膽地創造，模仿新的，不同於模仿舊的，但本質上還是模仿；抄襲西洋的，不同於抄襲中國的，但本質上絕非創造！所謂。「所要者魂」就是要表現民族的現代的精神魂魄。

20 世紀是西學東漸的世紀，是在工業文明與資訊文明中中華民族開始振興的世紀，還是中國水墨畫在向現代轉型中實現復興的世紀。「士不可以不弘毅，任重而道遠」劉先生本著這種文化使命感，一往無前地倡導並實踐著現代水墨畫的創作，他的作品標示著已經建立起來的既富於民族精神又有當代意識的水墨畫新傳統，而且正以其彰顯東方畫系所具有的天人合一的精神美味。這次畫展名為「一個東南西北人」不僅說明了劉先生閱歷與視野的開闊，或者也表明他以自己的藝術奉獻于萬國四方共用的美好心願。祝劉先生健康長壽，祝八十回顧展圓滿成功。

A Man of East, West, South and North
Liu Kuo-Sung 80th Birthday Retrospective Exhibition

Yongnian Xue / Central Academy of Fine Arts, Beijing

Liu Kuo-Sung is an extraordinarily accomplished artist of the twentieth century – a strongly patriotic artist, an artist with a surging creative consciousness, skilled at forging a unique creative path, who dares to break new theoretical ground, and who has made tremendous contributions to cross-strait art exchange over the years.

This retrospective exhibition is sweeping in scope, covering Liu's 80 years in life and art and featuring selected representative works from each of his major creative periods: from watercolors, oil paintings, and conventional ink paintings dating from his student period, to mixed media painting and prolific ink painting output conceived since he embarked upon his formal career in art. Subject matter is equally expansive, including the Tibetan and Jiuzhaigou series of nearly the past decade, rendered in a series of experimental approaches. As for images and evocations of beauty, there is representational appreciation, abstract emotion, rational brilliance, as well as emotional resonance that together offer a summation of the finest efforts of his long career. Encountering the exhibition, considering the beauty of his art, and tracing his artistic path, several illuminating aspects are especially worth noting.

First is Liu Kuo-Sung's uncanny ability to courageously oppose tradition and establish new traditions. Chinese painting's march towards modernization has been a major issue spanning centuries. Moving into the modern does not mean passively responding to the West, nor slavishly imitating the West, but necessitates incorporating the development of Chinese painting into the world's vernacular, which requires learning from and building upon the achievements of others and adopting fine Western practices when appropriate. Modern progress does not mean blindly opposing ink painting, let alone blindly opposing tradition, but it does require opposing stilted graphic forms and hackneyed techniques devoid of life so as to elevate the unique spirit of lasting traditional culture. An innovator that raised the banner in opposition to tradition half a century ago in Taiwan, Liu Kuo-Sung opposed the lazy conventions of oversimplifying and ossifying tradition. It was on this foundation that he first joined elements of Abstract Expressionism and landscape painting to forge an incipient new Chinese ink painting tradition. Through the New Traditions in Chinese Ink Painting Exhibition presented by Mr. Li Zhujin over a two-year period in the United States in the 1960s, Liu Kuo-Sung ascended to the position as the leading figure of the new Chinese painting tradition, in turn making his mark on the Western world.

Second, Liu Kuo-Sung developed a language of ink painting that embraces the unity of man and the universe. Instead of merely adapting the language of Western art, he delved deeply in the linguistic attributes of Chinese painting, studying the relationships between the materials and languages employed in Chinese painting, and between language and methods of Chinese thinking.

In the effort to expand Chinese painting's power of expression, Liu Kuo-Sung readily engaged in experimentation surrounding conventional ink painting media. Whether tearing off strips of paper cord, ink rubbing, rhapsodic calligraphy, water rubbing, or ink steeping, he invented techniques that highlighted the strengths of Chinese media, natural outgrowths of the ink painting language beyond the strict ancient language of ink and brushes. Rather than revisiting the traces of tradition, he returned to its heart. His semi-abstract ink painting language successfully expressed the universal view of "something distinguishable within the nebulous," and the cultural spirit of "the Dao comprised of one *yin* and one *yang*" – a cultural spirit that transcends the bond between the ego and the universe. His art exhibits a palpable self-aware drive towards the modern that is manifest as modern forms and distinctly Chinese at the same time, as well as belonging to a certain people while facilitating communication within the realm of universal language.

Third, Liu has achieved a desirable spirit with rare courage. China's transition into the modern follows no set model; the way is wide open, with many roads to take, but blazing new trails takes guts. Without guts no new paths can be blazed, but guts alone are not enough without spirit; without national spirit one cannot have identity, and cannot display one's uniqueness in the world. Liu Kuo-Sung has traveled his own route over the past several decades, and his courage, commitment and wisdom give us inspiration. As the noted artist Li Keran observed, his rare courage helped gird his breakthroughs, to boldly innovate, imitate the new, not the old, which in essence nonetheless remained imitation; copying the West is not the same as copying China, but neither is it innovation. The "desirable spirit" of which Li spoke referred to expression of the nation's modern spirit.

The twentieth century saw the introduction of Western learning to the East, an era during which Chinese civilization began its rise amidst the industrial and information civilizations, as well as an era in which Chinese ink painting staged a revival as it moved towards modernization. Liu Kuo-Sung embodies the sense of cultural mission in the Chinese saying, "An educated gentleman cannot but be resolute and broad-minded, for he has a heavy responsibility and a long road to travel." Both an advocate for and practitioner of modern ink painting, his works signify the existing spirit that runs richly throughout Chinese civilization while manifesting the new tradition of ink painting invested with contemporary consciousness – one that exemplifies the beauty of man's unity with the universe inherent in Oriental painting. The title of this retrospective exhibition, *A Man of East, West, South and North*, not only illustrates the breadth of Liu Kuo-Sung's learning and vision, but perhaps also expresses his noble desire to devote his art for the edification of the entire world. May Liu Kuo-Sung continue to enjoy good health and live a long life, and best wishes for a successful retrospective exhibition on the occasion of his eightieth birthday.

舞躍九霄遊目八極
劉國松與現代西方藝術的對話

加州大學文學系榮休教授（卓越榮譽教授）／葉維廉

說在前面：因為我在我的《與當代藝術家的對話》一書裏，對劉國松每個階段的風格變化、個人思想及歷史場合相應風格和策略，包括選擇水墨、油畫的因緣與美學的意義，都已經有詳細的檢視和論評的追蹤，劉國松也有相當詳盡的剖白，本文專注中國傳統與西方現代碰撞下蛻變的一些美學意義。有興趣的讀者可以把另文找來一併看。

一、異質爭戰的共生與雙／多向思維運作的感思胸懷

現代中國畫家都曾表示受到西方現代藝術家的啟發，但現代中國文化、文學藝術作品無可避免的，是本源感性與外來意識型態碰撞下爭戰協商下極其複雜的共生，借生物學裏的用語說，可稱之為 Antagonistic Symbioses，異質分子處於鬥爭下的多種共生。藝術家們詩人們在其間作出雙／多向思維的運作，引發詭奇多樣有意識、無意識的迎拒，包括互相滲透變化與發明。這裏，我們應該有這樣基本的了解：即在明顯受西方影響的作品裏，我們仍然不能假定原模和移植成品之間的美學構成與意義完全一樣。在移植的過程中，總是會有本土因素的牽制。我們應該要問：中國現代的藝術家，是在怎樣的一種文化氣候、政治社會狀態下發現類似西方現代主義的觀物態度和表現策略呢？或者，換個方式問：他們在西方現代繪畫中吸取了什麼適合於表現他們特有的文化和心理情態呢？要答覆這些問題，我們先要明辨中國與西方文化各自獨特不同的境遇，才可以迹出兩條理路相交相離的實際情況和產生它們不同的歷史危機。這種「文化境遇」的展示，也可以幫我們辨認出一些別的重要的問題來。我們現在應該問：是什麼歷史需要逼使中國作家抗拒傳統的典範而接受某種外來的意識型態呢？在接受過程中，他們在本源文化中找出怎樣的美學根據來支持他們的做法？在兩種不同意識型態必然產生的爭戰與對峙中，他們又做了怎樣的調整使外來的美學意念本土化？他們口頭上雖然向傳統宣戰，但下意識裡，本源文化裡又有何種思想美學的迷戀與記憶—這裡包括歷史哲學和思想習慣—在左右著、調劑著他們對西方理論和策略的揚棄呢？

我們打算凸顯劉國松現代抽象水墨畫裏一個項目—書法的應用—來探討兩種藝術傳統相疊相分的實質意義與美學潛能，可以同時看到他早期試探的蛛絲馬跡和往後回歸傳統的特定意義。

先談書法（圖1）書法之能成為一種獨立藝術，是通過線條的舞躍來體現氣的進行。書法論者常將之比作行止，下筆前如跑步前的凝氣，下筆時如氣舒出去或衝出去；或比作流水，遇石時轉曲，力道受阻時如水紋旋曲畢現，有時一筆很快飛過去，即所謂飛白，中間紙不沾墨，但筆似斷而氣未斷，因為我們確切感到氣曾貫通過去。這些書法的筆觸筆意，也是畫竹畫蘭的基礎。其實，中國畫裏講的筆墨，廣義的來說，都源自書法，亦即所謂書畫同源。簡單的說，沒有書法的基本訓練，便不能自如地筆隨意行；同樣，如果畫中能做到意到筆到的，反過來寫字也必不差。禪畫如玉澗、梁楷、石恪以及其後的石濤、八大，在線條上進行的不假思索、無心的恣意塗抹，都依存在筆墨的跳躍，一如書法的氣行氣動。書法在我們眼前，尤其是行書狂草，是線條本身的緩急、收放、擊澱、騰躍，超乎外相而以精神的激盪為藝術的美感客體。書論中由衛夫人的《筆陣圖》到孫過庭的《書譜》，張懷瓘的《書議》到姜夔的《續書譜》講的都是這些，茲擇一二以見一斑，「如高峰墜石，磕磕然如崩也……，如崩浪雷奔」（衛夫人）；「觀夫懸針垂露之異，奔雷墜石之奇，鴻飛獸駭之姿，鸞舞蛇驚

圖 Fig. 1

之態……，或重若崩雲，輕如蟬翼，導之則泉注，頓之則山安；纖纖乎似初月之出天涯，落落乎猶眾星之列河漢……」（孫過庭）又譬如張旭：「見公主與挑夫爭道而得筆意，聞鼓吹而得其法，觀公孫大娘舞劍器而得其神。」著實說明了筆墨以輕重緩急在自然大幕前橫絕太空的舞躍。書法取法自然的流跡，啟目可見，放眼門外，河流不方不正，隨物賦形，曲曲折折，直是一種舞蹈，或見驚濤拍岸，「卷」起千堆雪。樹枝倒吊成鈎，繞石成抱。或從夏威夷大島高空上看下來，紅紅的岩漿的流動，猶如一只看不見的大手，執著一支大筆，迂迴起伏的大紅線，破山建山破谷建谷。無怪乎抽象表現主義者承著梵谷的「線條本身即可表達感情」和康定斯基的色、線發出的「精神的顫動」「內在的迴響」而在大畫布前如面對無垠太空作線條恣意的揮發，對中國書法情有獨鍾。

在 1910 年左右，英國美學家法萊（Roger Fry）看了中國銅器和中國畫的一個展覽，寫了一篇文章，認為中國藝術之先進，非西方畫家可以項背，只有義大利文藝復興時期一些作品差強可以比擬。其中他特別認為線條在中國的藝術成就最高。法萊同時也是介紹後期印象派得力的美學家。在〈後期印象派〉（1911）[1] 一文中，他對線條有如下的縷述：

> 某些線條獨有的律動和某些顏色獨有的和聲之間某種精神上的應和，它們會喚起某些特定的感情……律動是繪畫最基本最生動的元素，律動也是一切藝術最基本最生動的元素。

他的發現代表西方背離他們傳統模擬論的一個重要的轉變。線條喚起精神的應和之說，無疑是承著梵谷與康定斯基而來。即前者認為線條顏色本身就可以表達情感，後者延伸為「精神的顫動」。法萊無意中觸及中國古代和西方現代美學的交匯點是耐人尋索的。這裏不是說法萊從學理上認識到中國自鐘鼎、金石、碑文到書法的整套美學，而是他在其中發現到，西方苦苦要掙脫外形來尋索的新美學，在古代的中國早已是主流。他提到的「精神的迴響」和「線條是最生動的元素」和我們的「氣韻生動」在內涵上雖然有相當的差距，但美學上的向度頗有對話的機緣：兩者都求神韻不求形似。

所謂背離西方傳統的模擬論，是西方對 Energy（氣、力、精力、精神）的一些理論的興起。我們試從赫爾德（Herder 1744-1803）對萊辛（G.E.Lessing 1729-1781）有關詩與畫之媒介表達潛能限制基本差異的批評說起。萊辛提出的差異，簡單的說，詩，用語言，只能呈現漸次進展的動作（事件），是時間的藝術；畫，用色、線、點、面，只能呈現靜態的物體，是空間的藝術。畫，因為是空間排出物體的藝術，它無法表現一連串事物繼次發生的事件，它只能以一點時間（一瞬）來暗示事件的前後；詩，因為是通過語言符號來傳達，雖然也描摹物體，但只能通過動作或事件來暗示。我曾在《出位之思：媒體及超媒體的美學》[2] 一文中用中國詩和中國畫之兼含二者來批評其西方主導、尤其是以史詩傳統為主導的理論的偏差，在此不贅。赫爾德認為萊辛沒有了解美感客體（aesthetic object）之所在。他說：

1. Roger Fry (1866fi1934), 在1901年為倫敦的 Grafton Galleries 組織包括梵谷、塞向等的 Manet and the Post-Impressionists 大展。〈後期印象派〉一詞是他在該文中首次鑄造。
2. 見我的《比較詩學》（臺北，1983），頁193-244。

「事物依次進展」只不過是「動作」一半的意義,「動作」是事物通過 Kraft(氣、力)依次進展。動作」是事物通過時間一次進展的實體,是一個物質跟著一個物質通過 Kraft 的變化。我敢說,如果詩的目標是「動作」,這個目標絕對不可以用機械化的「依次進展」的觀念來決定;Kraft才是詩的中心。

也就是說,畫之為畫與詩之為詩,都要它們能發放衍生的氣脈為基準。現代詩人龐德(Ezra Pound)說:[西方](現行的)每一種藝術裏,都被判塞死在模仿論裏;「動力」的演出幾乎完全被人忘記了……我們會慢慢體認到,藝術中最重要的是一種「氣 / energy」,一種多多少少像電力或放射性的活動,一種滲透、鎔接、統合的力量。……詩是天馬,構思,布字 [葉按:在繪畫就是色線的佈置]……以充沛氣力,充沛感覺和音樂那樣跳躍的能力。(1912)[3]

試看梵谷的《星空夜》(圖2),整個類似暈眩的震盪,都是透過線條的漩動表出,不完全依賴事物的形狀。在 1888 年11 月 16 日梵谷給他最小的妹妹 Wilhelmina 的信中說:「我不知道妳能不能理解顏色的安排佈置可以構成一首詩一如音樂可以說出一些安詳的話語。同樣,怪異的線條,刻意的選擇作多線的覆疊,宛轉穿過畫面,也許不能給花園一個粗俗的相像的面貌,但呈現在我們的腦海中彷彿在夢中的心象,帶有個性,而同時比在現實中的更之奇異。」顏色、線條本身足夠表達情感的弦動。是梵谷這樣的畫的線與顏色的運作,引發了後來的野獸派和表現主義畫派的生發如馬諦斯的 *Le Bonneur de Vivre*《生之幸福》和 Edvard Munch(1865-1944)的 *Skrik*《呼喊》,到了抽象表現主義,再進一步放棄具象直接以線條的塗抹表現為繪畫客體。

這裏,我們先看一個曾經在上海和日本學過書法而影響過波洛克(Jackson Pollock)的馬克·托爾貝(Mark Tobey 1890-

1976)的 white writing / 白色書寫 / 畫(圖3-5)[4],他回顧時曾這樣說:

「有人說我那時在找尋新的技巧,沒有那回事。我實在是在享受試著做我喜歡的東西。當我從英國回來……我開始在畫布上塗畫,我對結果有些不解—幾條白線,一些藍條—看來像扭曲的鳥巢,我感到不安,沒想到我在東方學到的東西對我影響如此之大。這是一種新的方法,我無法甩掉它。我必須吸收它,不然它把我全然吞噬。沒有多久白色書寫便出現,我對繪畫有了全新的觀念。東方給了我最大的影響。」[5] 這段話必須要和下面一段話同時看始見其在西方的意義:「有人貶我為一個具有東方色彩畫家……但事實上,我在日本和中國(學書法)時便知道,當我努力與水墨和毛筆搏鬥。試著了解他們書法的藝術時,便知道我終究是個西方的藝術家,也就是在這種知覺裏,我獲得了書法的本能而把我的作品帶到新的領域,用了書法(線條)的(表現力)表現現代城市瘋狂的旋律,表現被網在城市中的光流與人流的交織。」[6]

我們從劉國松早期的畫裏,知道他模仿過印象派和後期印象派包括野獸派等諸多重要西方畫家。跟我們今天的課題最切合的是抽象表現主義的畫。不但他坦言受了法蘭茲·克萊因(Franz

圖 Fig. 2

圖 Fig.3

3. 我的 Ezra Pound's Cathay (Princeton, NJ, 1969)

4. 1944 年托爾貝的朋友Elisabeth Bayley Willis 把托爾貝的 Bars and Flails 帶給波洛克看,波洛克細心研究後就畫出他的名畫 Blue Poles。 HistoryLink.org Essay 5217, Tobey, Mark (1890-1976): The Old Master of the Young American Painting. 該文並記錄了波洛克對托爾貝密密麻麻白線構成 網狀的白線畫印象深刻,並曾說只有紐約才可以讓這樣真正的畫出現。

5. 見前文。

6. 托爾貝的例子是我的學生高乙立跟我研究「氣的美學」時提供的。可惜她罹患了癌症早逝。

Kline）的類似書法的筆觸的粗大黑線的畫的啟發，他還曾摹寫過一張波洛克潑、拋、滴、流的顏彩的線織造的巨型油畫。波洛克他們的抽象表現主義畫，亦稱「行動繪畫」（Action Painting）。這裏我以為「發生藝術」（Happening）始創人卡普羅（Allan Kaprow）的說明，最能透出「氣」「力」美學運動發展的高潮。

卡氏在他那本影響巨大的有關「發生」藝術的選本 Assemblages，Environments & Happenings（New York: Abrams, 1966）裡強調現代藝術不斷解框的美學意識。現在的藝術史上都專注於卡氏就行動繪畫（Action Painting）家波洛克的滴潑大畫的創作過程作了獨特的見解而打開了「發生」的運動這一條線去思考。卡氏是這樣說的：

> ……畫家彷彿在作一種祭儀。在一大幅令人敬畏的白畫布前面，一個被「存在」所驅使的畫家，像一個獨立的烈士，在一個巨大的鬥獸場中，每一個動作（每一揮彩）都是一種存在的宣言。畫家面臨著一種危機，他一筆一點都表示著自我的信念……（我想到）「行動」與「繪畫」是可以分開的：如果行動繪畫是一種行動的繪畫，一種或幾種高度重要儀式的行為的繪畫，那麼我們為什麼不直接轉向「行動」本身。如此，好像更直接，而行動繪畫留下來的「痕跡」反而是二手的。[7]

這種描述與書法論調的故事極有相似之處，見前述。事實上，劉國松有一次講演，就舉出一位醉後僧人書法家，隨手

抓一把甘蔗渣蘸墨往紙運力一砸，力道全現。這裏含有即興自發性、意外性和沒有思侵或未經思想調停的原始動力生發的留痕演化的經驗。可見他當時對這條線的發展，有高度的認可，雖然未必對其演化的複雜性有充分的認識和檢驗。譬如，他在他的〈繪畫的狹谷─從十五屆全省美展國畫部談起〉（1960）[8] 裏用相當肯定的口吻說：

> 歐洲經過兩次大戰……文化信仰混亂苦悶。現代畫瘋狂地反叛學院的傳統風格，追求新的繪畫觀念與一種與傳統純然絕緣的全新形式，正像形而上學哲學家追求最終實在一樣，最終實在找不到，卻找到了內心的深度。同樣的，與傳統純然絕緣的全新形式沒找著，現代畫家卻找到了對形式的新感覺。這兩個真理是事實。它們拼命地破壞自然原形，旨在企圖建立起絕對主觀的抽象面目，一個統一的世界性的新文化信仰。於是搜尋的眼光由非洲來到東方，中國的書法藝術即可滿足他們的此一欲望，因此，手寫的抽象畫隨即產生，東西繪畫的合流是不可避免的。世界性的新的文化信仰即產生在此一合流中。

事實上，在兩個文化的碰撞下，理性的整理和感性的創作的蛻變比此複雜得多。他下意識的運作和涵蘊的視野往往超過他理念的自白。我們現在把波洛克的兩張畫，一張是墨汁滴流的試驗作品，另一張就是托爾貝啟發下的宇宙感的巨製以及克

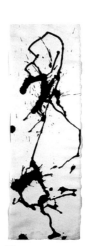

圖 Fig.6

圖 Fig. 4

圖 Fig. 5

圖 Fig.7

7. 卡氏這段話雖然是歷史重要的文件。在他跟我合作的時段裏，他曾提供另一種更重要的來源，與道家、禪宗的契奇（John Cage）有關，見我的《道家、禪宗與美國前衛藝術：契奇與卡普羅》。

8. 文載《文星》7卷3期，1961/1/1。

萊因的兩張畫和劉國松受到他們刺激下的創作《神韻之舞》
（1964，圖6-10）並排，就感到其間兩個文化弓張弦緊的
對話。

圖 Fig.8

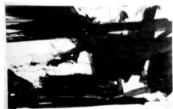

圖 Fig.9

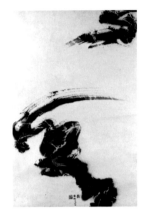

圖 Fig.10

劉國松這張畫顯然受了他們，尤其是克萊因的啟示，但他
們，沒有一個人可以畫出劉國松的畫裏涵蘊的視野。這是因
為他們沒有累積的書法藝術的歷練的關係，如本文開端的討
論，筆墨是線條的舞躍來體現氣的進行，有時一筆很快飛過
去，即所謂飛白，中間紙不沾墨，但筆似斷而氣未斷等。
這裏並不是說他們應該像中國畫家一樣做日以繼夜的浸染學
書法，前面托爾貝與學來的中國書法搏鬥後最後回到利用書
法的本能畫寫城市的光流與人流的故事也說明了中西繪畫不
同指向和各自歷史美學學養的感知胸懷之差異。媒介的差異
也決定了成品不同的魅力，毛筆、水墨 包括含墨的濃淡、
乾濕和高度流動性和吸水度高的綿紙的挑戰，尤其是寫狂
草時，不可遲疑，因為墨多太慢可能引發墨水滲污，所以下
筆有一定的自發性，水墨一般來說是不能回頭再改的，但油
畫不但可以刮掉再塗，是堆疊建構而成的，很少能做到流動

性。所以中國畫家接受油彩做媒介來表達中國畫的意境，就
必須克服這個困難。我曾就媒體的不同性能就問王無邪和莊
喆，他們的回答可以讓我們了解現代畫家面對的問題。

王無邪說，油彩水墨都是大媒介。「大媒介的意思是：它含
有廣泛不同的表現的可能性，小媒介則不然，譬如，鉛筆是
小媒介，水彩也是。油彩的特點是膏狀，富于粘性，色彩鮮
明度冠于其他媒介，薄的時候可以透明而造成豐富的層次，
厚的時候可以產生觸覺感。照我的看法，中國畫家一般都拙
于觸覺感（但在外國長期居停的除外）。所以很多中國畫家
將油彩當作廣告彩那樣處理，沒有很好的層次……能真正掌
握這些觸覺和層次空間的不多，所以很多中國畫家寫了多年
的西畫後便轉寫水墨，這些例子很多，如徐悲鴻、劉海粟、
關良…等。關於水墨，先將水墨和水彩作一比較。西方水彩
畫用的是一種不吸水的紙，水彩在紙上形成一層薄膜。著色
時不能過分積疊，積疊一多就會產生汙濁感。水墨用的是吸
水的紙或絹，墨色滲透纖維之內，並有濃淡乾濕的變化，不
同的筆，不同的筆法更可造成不同的效果，由于水墨流暢，
由是一筆可以求得多種墨度或色度。中國畫的筆墨技巧，需
要長期得鍛煉……近年有些現代水墨畫家還用移印、拓印、
噴灑、拼貼等技巧，更可證明水墨表現的廣闊性。」關於媒
介，莊喆主張有一種前瞻性的看法，基本上他認為，「棉紙
的性能和水墨（不敷彩）到了傅抱石已發揮到極致，他捨棄
了顏色，而顏色在我們這個時代時扮演越來越重要的角色。
這恐怕是我們如果一旦闖進敦煌石窟必然對那色彩繽紛的壁
畫產生震撼的感受……一般人強調水墨的浸染，其實，從
五十年代早期美國滴浸的一派，如紐約的霍夫曼、路易士、
法蘭西斯，這些人已經把油彩使用得像水彩一般，若說油彩
的特性是厚重有粘性，那麼這些人的畫如何解釋呢？這不是
證明它有更廣泛的特性嗎？何況現在更有壓克力色彩，這顏
料更有新鮮的、快乾的優越性，能厚能薄，能用在紙上也能
用在布上，能用在任何其他的物質像金屬、木材等等。我不
以為非水墨不能代表中國這種看法，現在正是向前試驗，積
極吸取大量媒介表現的時代。」[9]事實上用油畫媒介建構中
國意境的畫家另外打出一片天地，不可忽視。[10]

9. 見我的《與當代藝術家的對話》王無邪章和莊喆章。

10. 同書，見趙無極、蕭勤和莊喆章節畫例。

所以我以為劉國松的《神韻之舞》，除了書法藝術給他的筆墨韻行之外，另有較深層的道家思域所形成的胸懷。他這張畫乍看是一種水墨的抽象表現主義的畫，起碼是他們的一種迴響，但它同時可以是繼承蘇東坡所本的道家開出來的南宋雲山煙水傳統的一張空濛雲山（水）畫。

二、雲山煙水與消融邊際的美學策略

這裏我必須重述道家對封建制度用語言框限權力傷害到人的真質本樣的批判。老子認為商周以來的名制（天子、君臣、父子、夫婦的尊卑關係），為了鞏固權力而圈定範圍，完全是為了某種政治利益而發明，是一種語言的建構，至於每個人生下來作為自然體的存在的本能本樣，都受到偏限與歪曲。道家對語言的質疑，對語言與權力關係的重新考慮，完全是出自這種人性危機的警覺。所以說，道家精神的投向，既是美學的也是政治的。政治上，他們要破解封建制度下圈定的「道」（王道、天道）和名制下種種不同的語言建構，好讓被壓抑、逐離、隔絕的自然體（天賦的本能本樣）的其他記憶復甦，引向全面人性、整體生命世界的收復。

道家對語言的政治批判同時打開了更大的哲學、美學的觀照。從一開始，他們便認知到，宇宙現象、自然萬物、人際經驗存在和演化生成的全部是無盡的，萬變萬化地繼續不斷地推向我們無法預知和界定的「整體性」，當我們用語言、概念這些框限的活動時，我們已經開始失去了具體現象生成活動的接觸。整體的自然生命世界，無需人管理，無需人解釋，完全是活生生的，自生，自律，自化，自成，自足（無言獨化）的運作。道家這一視矚有更根本的一種體認，那就是：人只是萬象中之一體，是有限的，不應視為萬物的主宰者，更不應視為宇宙萬象秩序的賦給者。要重現物我無礙、自由興發的原真狀態，首先要了悟到人在萬物運作中原有的位置，人既然只是萬千存在物之一，我們沒有理由給人以特權去類分、分解天機。物各具其性，各得其所，我們應任其自然自發，我們怎能以此為主，以彼為賓呢？我們怎能以「我」的觀點強加在別的存在體上，以「我」的觀點為正確的觀點，甚至是唯一正確的觀點呢？「彼是（此）莫得其偶，謂之道樞，樞始得其環中，以應無窮……是以……和之以是非，休乎天鈞，是為兩行。」

我們不難知道：只從「此」出發看「彼」有盲點，從「彼」出發看「此」，也有盲點。我們應該同時從「此」「彼」兩方面馳行（兩行），能「兩行」則有待我們不死守、不被鎖定在一種立場。由是，只有當主體（自我）虛位，從宰制的位置退卻，我們才能讓素樸的天機回其活潑的興現。

這也是為什麼中國山水畫都讓觀者自由無礙地同時浮游移動在鳥瞰、騰空平視、地面平視、仰視等等角度，不鎖定在單一的透視。西方奉為經典的透視，其實是人根據他的主觀情見決定的一個定點，是定位、定向的片面觀看，是一種設限的觀看。中國畫家不認為這是全象。中國的畫家，不光是站著看，他要進出山裏游觀很多次，從近處看，從遠處看，從高山上看，有雲時看，不同的季節看，才有總體山的個性的體認。

不被鎖定在單一的透視，也就是不被鎖死在名的框現的美學的體現。中國山水畫裏的所謂透視，是不定向、不定位的透視，有時稱散點透視或迴遊透視，前山後山、前村後村、前灣後灣都能同時看見。這種視覺經驗，是畫家不讓觀者偏執於一個角度和一種距離，而讓他不斷換位去消解視限，讓幾種認知的變化可以同時交匯在觀者的感受網中。

我們試舉范寬的《谿山行旅》為例（圖11），在這一幅垂直的大掛軸的右下方，我們可以看見一隊行旅的人，很細小，後面樹群也不大，這表示我們從遠方看來，可是這個景後面的一個應該是很遠很遠的山，現在卻龐大突向我們的眼前，甚至壓向我們，這個安排使我們同時在幾種不同的距離和幾種不同的高度前前後後上下游動的看。那橫在前景與後景（後景彷彿是前景，前景彷彿是後景）中間的雲霧（一個合乎現實狀態的實體）所造成的白

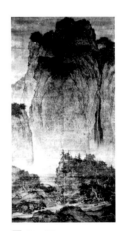

圖 Fig. 11

「虛」，這既「虛」且「實」的「白」的作用把我們平常的距離感消解了，我們再不被鎖定在一種距離裏，而產生一種自由浮動的印記活動。我們會同時注意到右下角的「人物」（行旅的人）不但沒有主宰自然，反而近似溶入並成為萬象全面運作、構成的一部分。這一個策略在中國山水畫中比比皆是。試看這一景，事物的線條彷彿指向類似西方那種透

圖 Fig. 12　　　　　圖 Fig. 13

視，我們的眼睛甚且凝定在門前的人，但這一景只不過是圖12、13裡的一個細節的顯影。

全畫仿如置身自然的萬象橫展，引向無限，原先的顯影部分，在全圖中完全不佔任何主宰主導的位置，觀者層層游動高高低低遠遠近近冥合萬有。我們希望大家記著看看張畫的經驗，記著我們美學中講的「境界」，文化中講的「風範」「胸懷」都與這種不被鎖死的心的活動與大有大無的自然契合有關。它們的前提必須是解框後自由的活動。要能冥合萬有，一如我們前面所說，必須自我虛位，萬物才可以歸懷，畫中之「空」作為一種負面的空間，一種冥寂沉思的狀態，任萬物素樸而宏麗地興現，在中國山水畫中佔極重要的位置，尤其在禪畫如牧溪、玉澗畫的瀟湘八景裏更為雄渾。

蘇東坡所本的道家開出來的美學對宋代以來的山水畫提供了用雲霧來消解距離視覺的限制，有兩條線路的發展，第一條線，是蘇東坡圈內畫友米芾（1012-1107）及兒子米友仁（1082-1165）的所謂米氏雲山，前者的《春山瑞松圖》裡（圖14）前景松亭與後景的山之間一大片仿佛湧動中的雲霧，使原是

圖 Fig. 14

很遠的三個山峰感覺得很近，後者的《雲山圖》《瀟湘奇觀圖卷》長卷和現存于美國克裏夫蘭美術館的《雲山圖》的雲霧占畫的空間一半強，湧動入無垠，雲霧在畫面上是蘇東坡所說的「杳靄」是蘇氏常掛在口邊的王維句「山色有無中」，感覺就是一種空，一種顛覆性的空，消融了界線的定位定向（如西方的透視)的框限，我們可以同時既近且遠既遠仍近地來來回回，冥思聽靜的出神（同時是入神）的狀態。第二條線，藝術史上稱之為「馬一角」的策略，因馬遠（約1150-1225）的風格而得名，而夏圭進一步發展，所以又稱馬夏傳統。最出名的是大家熟識的馬遠的《山徑春行》（圖15）他把景物放在一角，利用山的線形由深到淺到無，我們仿佛看見仿佛看不見，感覺也是山色有無中，隨著圖中的觀者（這些全在一角，占全畫四分之一弱）引向橫絕太空的雄渾的逗人冥思的大無。

圖 Fig. 15

到了禪畫家牧谿與玉潤的瀟湘八景，雲霧空濛擴大到全畫的四分之三，把空、寂提升為主要的美學客體對象。在牧谿的《遠浦歸帆》（圖16）畫中幾乎沒有一般熟識的山水，除了一角前岸幾株黑樹影，剩下是無盡空間的延展，遠山逐漸，不，仿佛繼續溶入霧裏，應該說被霧溶化，只覺得有一種氣韻在浮動，我們忽見微影小舟二葉，又好像看不見，隱隱約約，得而復失，失而復得，說看見不如說感著，有風起，霍霍的昏黃，把杳靄捲入巨大無垠的空無裏。或如玉潤的《山市晴嵐》（圖17）實物如樹、橋、村、人，以快速、不假思索、用近乎二十世紀表現主義及抽象表象主義的筆觸，恣意塗抹，捕捉物象的姿勢氣象骨風。利用簡略而暗示性強烈的明澈的片段烘托出空寂的充盈（也就是老子所說的「少則得」「大音稀聲」）。這種「空盈」大大的抓住

圖 Fig. 16

圖 Fig. 17

日本室町時代水墨畫家的想像，如 圖18《雪舟》（1420-1505）、默庵、愚谿、雪村等。他們也大大發揮了玉澗破墨表現主義的筆觸[11]。

「空盈」的另一種弦動，是，中國畫家，把空無／空濛變為美學凝注的更重要的對象，正如所有的中國山水畫都以如大鵬高飛九霄遊目萬物萬象引向無限，這裏的所謂筆到意到，除了氣貫／通線條以外，墨的舞動必須與空白的宣紙或畫布調協，

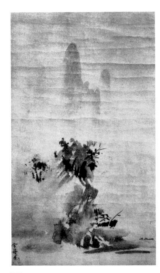

圖 Fig. 18

使到空白成為貫徹天地的氣流，玉澗的《山市晴嵐》裏，就是沒有題目和題詩，觀者都會感到空濛雨意，這是著墨的策略把沒有著墨的紙白絹白提昇為天地之氣豐發／風發的一種負面／陰性的創造，我們稱之為空靈，是西方繪畫，包括波洛克與克萊因的思域裏所沒有的，如果有也是罕見的感知胸懷，波洛克發射出來的是個人幾乎憤怒的爆炸性的氣的流迹，克萊因的畫筆的橫直粗線，令人想起鋼鐵工業世界的架構；兩者，其實大部分的同代畫家，都沒有利用黑（實）白（虛）的調協來托現白（虛）的宇宙生命世界；兩者都沒有利用高空的比較能全面網取的靈活浮動的透視。我們稱一般人認為空無的空間為空靈，是因為這空白已經蛻變為宇宙生命

的神韻的弦動。劉國松的《神韻之舞》可以說是繼承玉澗這一發展進一步的推進、蛻變。玉澗用書法快筆一兩筆而成橋成村，劉國松用不帶實物形狀的書法，墨行墨舞在空無的大氣裏以飛白的墨斷氣未斷的流迹，把白紙／布化作自然茫茫的白霧。我們把《神韻之舞》和其前後的書法抽象表現主義畫一同看，就更清楚天地之氣動氣沖氣流或霧或雲或雪或水鏡或瀑流[12]的雄渾之象，譬如 1969 年的《寒山平遠》（圖19）的左右兩扉構成的長卷所見。

圖 Fig. 19

另外有同題同意的長卷 1965 Michigan Warren Cohen 教授夫婦收藏，筆法略有不同。

另一張《河山頌》（1968）更能表現白色（是霧？是水？是瀑？是雪？湧溢山石？崖岸？峭壁？）（圖20）。這裏的疑決性產生自氣貫線條的抽象性。用抽象的書法作為畫象發揮，這應該是西方現代畫，也就是抽象表現主義畫作的觸媒。長久以來中國書法自成藝術，但並不被視為水墨畫，雖然有些書法的筆觸被挪用為肌理，畫蘭、畫竹、畫人像（如石恪畫

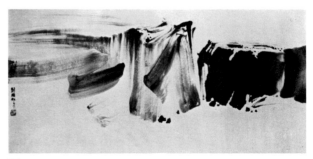

圖 Fig. 20

11. 在美國介紹禪宗流行的書籍裏，玉澗的畫和雪舟的畫佔主要位置，對美國的詩人藝術家曾有很大的影響。關於禪畫、馬夏傳日的巨大影響，請參看我的《龐德與瀟湘八景》一書。

12. 他 1967 年有一張也是黑白互玩的畫題正可說明其留白的多樣暗示：「雲耶？霧耶？」。

佛袍袖摺的一些線條）、畫皺摺的奇石的一些肌理，但在傳統水墨畫裏，都要依附與某種外形（模糊些也可以），但把狂草的一部分看成是一張完整的抽象畫，是在與西方現代藝術碰撞下的新的啓悟。劉國松對與具象的傳統水墨和西方油畫告別後的抽象水墨畫曾有這樣的宣說：「事實上，我沒有在畫山水，而畫中卻有山水的感覺。」（見我的《與當代藝術家的對話》（頁238）。也就是說，他畫的是以書法的塗抹的流迹的一種構成。這是重要的決定，因為無意求山水之形的書法的「一抹沈黑」（也是他畫題之一1964）或橫揮，或斜掃，或水漩，或如柱沖下，或如壁牆齒切，或風轉成鈎，反而能棄形骸而作自由塗抹、揮發，又因墨黑與紙白的筆戲（對話）活潑了虛白裏的氣動氣流，而使我們在抽象書法舞躍的流迹裏彷彷隱隱見山水弦動，這就是《河山頌》《寒山平遠》喚起的近似南宋及禪畫的空濛山水，不是觀看而是感著，在肉眼之外，在心眼之中，騰騰然作九霄之遊目四聘。劉國松這個階段線條的舞躍與霧白雲白水白雪白的韻動的畫作，最為豐富，譬如《五月的意象》《雲深不知處》《墨象之舞》（1963），《灑落的山音》〈神韻之舞〉《寒山雪霽》《嶺上白雲》（1964），《秋之即興》（1965），《不停的迴旋》《秋之旅》《金秋之歌》《雪石圖》《黃山》（1966），《臨流直下》《府庫出風》，《出峽過灘》《魔月之歌》《風之孤寂》（1967），《河山頌》（1968），《寒山平遠》（1969）等。其間《墨象之舞》、《灑落的山音》、《神韻之舞》、《秋之即興》、《金秋之歌》、《府庫出風》等把書法線條的舞動變為全畫的主體。（這些書法自成墨象的畫象，也經常放在他後來他設計意味很濃的上下兩方塊互玩的下層或上層來調和設計的平淡機械化。）

這裏的畫題有些吊詭。西方的抽象畫往往不著題目加號碼如 Untitled 1, Untitled 2。意是要人從畫中色線構成的氣氛去感覺、感受一種類似詩意的東西，也就是梵谷信裏所說的：「顏色的安排佈置可以構成一首詩一如音樂可以說出一些安詳的話語」（見前）。劉國松畢竟是個寫意的畫家，當他宣說：「事實上，我沒有在畫山水，而畫中卻有山水的感覺」之際，他並沒有想到他胸懷裏積聚了許多傳統詩與畫的記憶，他出發的確是沒有藍圖，但詩意、畫意，包括某

些筆墨在有些畫裏的效果，某些肌理的意趣／異趣／逸趣，某些虛實空間的部署比例，當然也包括黑白的互玩的空盈，都一直左右著畫家的構圖，則以油畫的媒介作畫的抽象畫家如趙無極、蕭勤和莊喆也一樣擋不住這些記憶的參與創造。事實上，在劉國松的情況，他打從 1960 前後的石膏抽象畫開始，便受了這些記憶的引帶，試看一些詩句的畫題：《滾滾黃河天上來》《我來此地聞天語》《如歌如泣的泉聲》就是希望借助文字喚起的感覺、境界來看他的畫。在這些早期的試驗裏，也有利用顏色、形狀和空間的延展來構成一種氣氛，如那張《春花秋月何時了》，主調是綠色，一種很特別的綠，令人感到某種古代的陶瓷（李後主詞裏的「雕欄玉砌」？）的綠，但這陶瓷般的綠，並不附於一個器皿上，而是在一個宇宙式的空間裏延展，使人沈入一種古代的懷思。1963 年以來一大批書法線條舞躍的畫題，亦步亦趨的也要給自己、給觀者一種文化記憶的提示，好處是，給原來對抽象畫就有「不知在畫甚麼」的疑問的觀者一種引帶；壞處是減限了他們想像自由的活動。這些畫題裏，有不少是傳統畫裏用了又用的題旨，《寒山平遠》就是一例。劉國松有一天請我到他台灣的家裡吃飯，飯後說，有一批新畫，需要題目，叫我取題，那應該是 70 年代初，那個時候我大概正在用比較前衛的語言方式寫過一些山水詩，總題為〈天興〉，其中一首是：

突然
自沉默亮起
山
光
被疾風吹皺了

我就為他的一張畫取了《吹皺的山光》為題。我另外又為他其他的畫取了《灑落的山音》[13] 和《月裏是山山裏月》（也是來自我的〈天興〉）等等。先不說我是不是貼題，但他確然知道和覺得舊的畫題，或常用的畫題，易於落入俗套。才希望透過新詩捕捉新的想像空間。其實，舊詩新詩裏的「意」，一直是他的畫要喚起的感覺，這一點是毫無疑問的。他是一個新的寫意畫家。

13. 出現在 1964 的〈灑落的山音〉應該是把七十年代的畫題的移用。在最近的一次我一本書的發表會裏，我提到此事，他坦承喜歡那些題目，在他的其他的畫上用過很多次。

三、拼貼山水：肌理的發掘、層疊的建構

對於「抽象」為畫，已經經過一個多世紀了，很多人還是抗拒。其實「象」或者「意」這個字在文字上大家都能接受如「氣象」「風象」「水意」「秋意」「暖意……但這些「象」，這些「意」可以看見嗎？但絕對可以感覺。可感而超乎「肉眼」之「象」就不是「象」嗎？我們常說「風雨欲來」，「欲來」就是還沒有見風雨而風雨彷彿在目前。事實上文字的「山」或「山勢」，在讀者裏並沒有定型，腦海裏沒有「實際模樣」，都憑每個人各自看過山的經驗去想像。這個不黏於特定外形的「山勢」反而增加了讀者自由想像的空間。但說西方抽象畫，也是從自然取意，不是沒有，譬如Turner，譬如蒙內的蓮花大畫，但進入全然以色線為主的抽象畫，其產生的一條主軸是反自然的，重理知而反對把自然可辨認的形狀再現。康定斯基說：「一張畫應該是『情緒』的圖表……不是實物具象的呈現。」塞尚、庫普卡（Kupka）和蒙德里安都強調概念的建構勝於外形的重現。塞尚說：「通過圓柱、圓錐、圓形，或其他適當的透視，使到一件物象的每一面都能導向一個中心點。」這是非具象畫—包括非具象前的立體主義—和後來的建構主義的一個重要的起點。但光是結構或集合思維不足以完成一張畫，帶動後來的立體主義的塞尚另外提供「調升」色澤（moduler），使所有的顏色通過並列，調整提昇到某種高度與濃度，一面產生一種重實感，一面因為顏色與顏色間遞次繼續調升而由複雜趨於統一。譬如他畫的《聖維多爾山》（Mont Ste Victoire）圖 21。

圖 Fig. 21

因為抽象繪畫，不管西方或是東方，首要面臨的是組織。一個大問題常常是，抽象畫只有色線的展開或聚疊，甚麼時候才叫完成，不可以加，不可以減，好像沒有甚麼準則。趙無極說「你會感覺氣是不是順暢」，滿主觀的，很多畫家也都這樣說。我上面說的文化記憶在無意識裏引帶著，有時也真的使人感著，這些多半與傳統畫的記憶的湧動有關。但劉

國松進入抽象繪畫後所有色線肌理的製造／織造和部署，可以說操作全部跟隨西方的理念，這裡包括新肌理的發掘與發明。第一次肌理的試驗，應該是 1962 年的《造物主五月的工作》和《春醒的零時時分》，在我個人有參與的香港的現代文學美術協會的第二次沙龍上出現，並獲得首獎。我們當時都對他利用摺痕構成灰與留白不規則的互玩，彷彿暗示／喚起某種岩石在斜光下光影明暗的樣式，然後，另用手掌把紙頭緊握成不規則的皺狀，蘸墨印疊其上，效果是層次凹凸厚重的感覺。跟著就是劉國松可以說是註冊商標的利用宣紙紙筋著墨後抽離留下的意外形成的、也就是說是屬於自然本有的肌理。這種肌理解放後的流跡，實在無法刻意用筆畫成，在某個意義上，還可以算是一種「俯拾即是的藝術」，畢加索拼湊藝術裏所說的 "found art"。這個發現／發明，請聽劉國松興奮的敘述：

> 當我從西畫轉回國畫時，我曾花了兩年時間去找不同的紙來畫，來試驗。這樣做是因為不想用傳統畫家所用的材料來畫畫。我試用新材料的想法也是來自西方的。我是用過很多不同的紙……最後終於試驗研究出我以後特用的綿紙來。在1962年，我曾用過一種糊燈籠的紙來試畫。在偶然的情況下使我大為驚奇，這發現與康定斯基的故事有點類似。有一天我從外面回到畫室，見到原來放在桌上的畫被吹到地上，畫的反面朝上。當時用糊燈籠的，主要是想利用他的肌理。這張由反面看的畫，上面有許多白線；而這些白線是由於墨不能透過紙筋而形成的。這就啟發了我由紙的反面來畫。畫了很多以後，又覺得不方便；同時由反面畫，筆痕與造型都不能很清楚地表現出來，畫面也顯不出力量來……[他找到一個造紙的人把筋放在紙正面而且替他放上更大的筋]……當我用這種紙畫畫時，首先要看紙筋分佈的情形，然後決定那裏著墨。因為我要利用紙筋，就用大草書式的筆法畫上去。
>
> 那時我用的筆……是用來刷炮筒的刷子。這刷子是豬鬃毛做的，一筆下去，很不好控制，甚至會分叉。這分叉，在傳統書法家或畫家看來，可能是一種缺點，可是在我的畫中，卻變成特點之一了……下一步，就用染……常常染出山水的感覺來。[14]

14.《與當代藝術家的對話》，頁 263-4。

《神韻之舞》那一批以書法為主角的畫，就是這樣完成。但誰看見都會驚歎而好奇他如何在書法氣動墨不離紙的同時給與線條這麼多變化的肌理。所以我在前面說這是「發現」也是「發明」。線條上有肌理，在觀看上是要求貼近看，而整個舞躍或霧中隱隱可見的山脊（以《神韻之舞》為例）卻把觀者放在高空浮游時遠近時高時低地環看八極，迴響著本文第 2 節從范寬到玉澗的雲山煙水與消融邊際的所需的胸懷。

圖 Fig. 22　　　　圖 Fig. 23

在這個豐富得如泉湧的創作階段，他利用新得的肌理作出種種的試驗，前面塗墨，後面塗墨，然後撕成山石的形狀，或以白色為主，或以黑色為主，有時加彩，或撕成一列山石與大山群疊現，中間一抹霞雲濛光，或層疊入密谷，或與不同肌理不同距離若連若斷入遠天。一如塞尚把點彩派的點擴大為色塊並列提昇到某種高度與濃度，一種重實感指向立體主義的生成，劉國松意外拾來的肌理互持互滲的畫塊的拼貼，也就是不同時間某些記憶片斷湧動的流跡的並置疊置，提昇入自然從未透光的神祕情狀（圖 22-25）。

圖 Fig. 24

圖 Fig. 25

四、科學、太空之眼、數理設計思維

1968 年因為無人駕駛的太空船進入太空預定軌道環行，船上遙控的照相機發回一千多張照片激發劉國松畫了一批太空畫，加上次年愛姆斯壯登陸月球透過電視傳回來月球表面的荒涼乾涸的景色，完全顛覆了傳統對月球的想像和描摹，而我們貼身地生死與共的地球，現在只不過是流浪在太空的另一個月亮。這個陌生化是一種驚悟，用大家常掛在口邊的話說，是另一種驚艷，這個艷是過去沒有經驗過的沉雄、更踏實的「橫絕太空」的雄渾、崇高。科學打開的視野與創作的激發真是急不及待，在西方文學史上，加利略用望遠鏡發現了木星環繞太陽，推翻地球中心說，並打開宇宙更大的視野（為此他被皇庭判罪）大大影響了詩人們，這包括了寫《失樂園》彌爾頓，利用望遠鏡（the optick glass）這個新名詞寫下從最高點觀看的崇偉的大山大水。飛機的經驗讓陳其寬畫出一頭是太陽另一頭是月亮的山水。　陳庭詩的墨印畫也要大鵬高飛得更高更遠的天宇來環視游視／思，從〈環繞太陽的船〉（他的一張畫畫題）環視／游思，劉國松受到了這個科學打開的太空的新視野的　發，畫下不少崇高磅礡的大畫，受到西方的讚賞認可。我們日日生養的世界從太空九霄的角度看是如此陌生。很自然的會激起玄思。上上世紀末，1865 年，斐德（Walter Pater）指出現代思維所追求的是「相對性」而非古代所肯定的「絕對性」。古代哲人力求為物象找出「一個永久的輪廓，一種永遠不變的形而上的東西（葉按：即柏拉圖的羅格斯／Logos）。斐德認為現代人所發現的正是與這種人為的假設相反：「事物無從得知，我們只能在有限度的情形下略知而已……生命的每一刻都是獨特的，偶然的一句話、一瞥、一觸都有不同的變化，經驗給我們的是這些相對的關係，是層層變化的世界而不是永恆的輪廓對事物作一次解決的真理。」（Pater, Appreciations 68）

休默（T. E. Hulme）承著斐德的哲思所作的反思最能切入柏氏的問題：

> 古人是完全知道世界是流動的，是變動不居的……但他們雖然認識到這個事實，卻又懼怕這個事實，而設法逃避它，設法建造永久不變的東西，希望可以在他們所懼怕的宇宙之流中立定。他們得了這個病，這種追求「永恆、不朽」的激情。他們希望建造一些東西，好讓他們大言不慚地說，他們，人，是不朽的。這種病的形式不

下千種，有物可見的如金字塔，精神性的如宗教的教條
和柏拉圖的理體世界。（Sam Hynes,ed.70-71）.

而尼采宣稱「上帝已死」之後，西方的哲思已有類似的宣說[15]。
我們現在對著這個新的宇宙的運作如何去冥思呢。劉國松
和他的「月球漫步」和同年（1969）的一系列的《地球何
許？》，可不就是他以視覺藝術對宇宙的玄思嗎？

從太空艙看出去彷彿無盡空的延展裏的宇宙，竟然應驗了塞
尚的話，一切都是圓形，事實上，太空裏運行的只有圓球，
而地球上的大山長河森林巨無霸的建築，現在看來都只是劉
國松抽象畫中墨抹的流迹。無獨有偶，蒙特里安（Mondrian）
的四方的色塊的畫作，原是從一張紅樹的畫數度蛻變而來，
彷彿當我們把照片作無限大地放大，我們只看見一片黑點
一樣。劉國松先是集中在圓形，裏面是他快筆書法線條舞躍
的畫跡，後來方圓[16]合併作了相當多的變調，都可以看作
對宇宙玄思的試探。我在這裡覺得他的情況詩人想起蒙特里
安。後者的四方色塊的設計，在六、七十年代影響了美國建
築界，到處都很喜歡用他的顏色方塊作牆壁的裝飾，也許觸
發了劉國松方圓的互玩。蒙特里安，從情感澎湃的表現主義
筆觸的紅樹一步一步蛻變到冷靜理性的方塊之後，回頭看，
覺得太靜態了，沒有氣、力的
表現，就畫了一張有動感的
boogie woogie broadway，想
捕捉城市閃爍左右上下移動的
燈光（圖26）。

圖　Fig. 26

不管劉國松方圓的設計有沒有
受到蒙特里安的提醒，有一點
是很清楚的，他這段風格的轉變也是靜態理性的，雖然他應
用了書法的舞躍和帶有紙筋抽離後的肌理（也可以看成記憶
湧溢的片斷）打破機械化的單調。也許畫得太多了，雖然都
有變化，感覺都差不多，他也要把動感帶回來，我們可以從
他其中一張畫的畫題《動耶？靜耶？》看出他的心跡。他有

圖　Fig. 27

不少張大畫都用了電影停格的手法捕捉太陽或月亮的移動，
如《上升的太陽》《日升的感覺》《月蝕》《子夜的太陽》
《午夜的太陽》《月的律動》等。我們可以舉《午夜的太
陽》（1985，圖27）為例。這是橫開 184.5 x 632.5 cm 的長
卷，佔畫紙三分之一弱微微弧狀的伸向兩方，上面是我們熟
識的墨塗抹後把紙筋抽掉留下的空白不規則的肌理，其間透
氣的灰色和沈黑的筆觸給我們黑夜的感覺，觀者幾乎爬在這
個在太空運轉的地球的上面，因為只有地球整個圓的 1% 都
不到，觀者無法站在遠處看地球，但要能夠只看見整個地球
的一小段的弧度，觀者彷彿只能在太空船上，停在太空中望
過去，但好像也不可能，觀者既離開地球一段其實應該滿遠
的距離看過去，又同時貼近地球、貼近地球的命運。弧邊有
微光從後面顫顫微震。然後上面是一片橘黃土黃的大氣裏有
七個太陽劃分為七個不同的瞬間的靈顯，彷彿計算好的照相
機的分鏡，咔嚓咔嚓七次，這樣的安排要我們給與每一個瞬
間足夠沈思的時間，因為每一個瞬間，請注意，這是太空的
運作在我們彷彿伸手可觸的距離發生，我們幾乎可以溶入天
作之機樞，而在壯麗的太空面前震慄。無怪乎劉國松傲然把
他的印章「一個東西南北人」呆呆懸掛在高空上。

作為一個藝術家，劉國松不斷越界，不斷把外來的藝思與策
略轉化、本土化，不斷把傳統顛覆，陌生化，而賦予新生。
我們可以看見，在回歸的路上，他不斷地試驗新的肌理的織
造，真是目不暇給，紙筋法，裱貼法，轉印法，噴霧法，紙
拓法，水拓法，板拓法，滲墨法，漬墨法不一而足[17]。他後
來的畫不刻意逃避傳統山水畫的部署，因為在他豐富的肌理
的運作下，幾乎已經做到化腐朽為神奇。

2012.02.13

15. 見葉維廉，《道家美學》《中國詩與美國現代詩》，（中外文學，31卷7期，2002）。
16. 古代有天圓地方說，《周髀算經》中提到「方屬地、圓屬天，天圓地方」，這是聊備一格，並不是說劉國松與這個理論有關，但有些畫說不定可以如是觀。
17. 按照蕭瓊瑞分類。

Dances in the Empyrean & Eye-excursion through the Eight Limits
Liu Guosong's Tensional Dialogues with the Modernists in the West

Wai-lim Yip
Professor Emeritus (Distinguished Professor)
Department of Literature University of California, San Diego

1. Antagonistic symbioses and Double / Multiple Perception

The present essay proposes to examine Liu Guosong's art in the midst of traditional Chinese culture's confrontation and negotiation with the West, with special emphasis on Chinese calligraphy as an entrance into his complex aesthetic encounter with Western modernists.

Many modern Chinese artists have confessed that their works were ignited by the theories and practices of modern Western painters. But, modern Chinese paintings, like modern Chinese culture in general, emerged in the wake of the Opium War and the following colonizing activities of the Western powers causing a series of inevitable conflicts between native sensibility and the intruding ideologies. From the very beginning, modern Chinese culture has intertwined, multifaceted dialectical metamorphoses from various aggressions of the West. The tensional dialogues in modern Chinese paintings represent various dimensions of confrontation, negotiation and modification within this dialectical process. We witness various kinds of convergences and divergences between traditional Chinese aesthetic horizon and Western modern orientations at work, engendering new syntheses as well as intercultural subversions and interactive inventions or reinventions. In the case of Liu, his negotiations with the works of Abstract Expressionists, are particularly acute and complex. However, we must, first, have this understanding: even in works that bear a clear stamp of influence from the West, we cannot assume that what is true of the source-model must also be true of its transplanted product. There are always native elements that will condition the process of transplantation. We must further ask this question: under what cultural climate or political and social conditions did the Chinese artists discover perspectives and strategies compatible with those of the Western modernists? Or, to slightly modify the question: what did they get from Western modernism that filled their need to express the specific cultural and psychological conditions in which they found themselves? To answer this first set of questions is to identify the unique *situatedness* of both the Western and the Chinese cultural phenomena so as to map out the exact ways in which the two trajectories converged and diverged, and for what historical exigencies. The unfolding of this *situatedness* will allow us to identify other significant issues .We must now ask: what kind of historical necessity prompted the Chinese artists to reject traditional canons and accept a certain alien ideology? In the course of the acceptance, what native ideological aesthetic models were resorted to (albeit unconsciously) for support and justification? What kind of modification was being made in the midst of ideological tensions in order to localize a given alien model for native acceptance? What intellectual and aesthetic obsessions or memories in the native world view, including a theory of history and mental habits (again, albeit open denunciation of them) had conditioned their rejection of certain dimensions of an imported theory or strategy?

Now, a few words about the abstract art of Chinese calligraphy (Fig.1). Chinese calligraphy became an independent art form since ancient time by the sheer fact that it embodies the movement of life's energy, both as energy-constructs and the energy-discharges[1], through the dance of the line. Chinese calligraphy has often been compared to walking or running. Before the execution of the brush, it is like holding the breath before starting to run. Executing the brush is like discharging the breath, unfurling or rushing forward. Chinese calligraphy is also compared to running water: it turns with mountains and rocks and shapes itself according to the object it encounters; we see lines or sinews whirling and twirling when the water hits a rock

1 terms borrowed from Charles Olson and Robert Creeley's "Projective Verse"; as we will see later, this idea was indebted to Ezra Pound.

or a series of rocks. Sometimes, one unhesitating, quickly executed stroke--as can be understood, with the fluidity of the Chinese ink and the fast absorbance of the rice paper, almost all the strokes have to be done spontaneously and without hesitation--such a stroke can sometimes skip part of the paper before ending onto another part, leaving a middle portion without any ink--and this is called *feibai* or "flying -white". However, what is broken is only the brush-stroke, the material dimension, so to speak, the energy that drives the stroke has never been disrupted; the energy runs right through it. These calligraphic strokes are the foundation for bamboo and orchid paintings. In a larger sense, all Chinese paintings can be said to have derived their strength from the brushstrokes and the ink-feelings of Chinese calligraphy. This is particularly true in the works of Chan or Zen painters like Yu Jian, Liang Kai, Shi Ke and later painters like Shi Tao and Zhu Da, all of whom transcend the external form by grasping the fastness and slowness, the taking-in and throwing-out, the attacking and splashing, the rising and frisking of the line, brimming of spiritual vibration, executed , as it were, almost mindlessly unhesitating. Witness the following descriptions: Here a drop of crystal dew hanging on the tip of a needle; there, the rumbling of thunder down a shower of stone. Now, flocks of queen-swans floating on their wings or a sinuous serpent wriggles in fright. Such images highlight precisely the movement of energy within the line. Step outside and open our eyes: No river is straight. It twists and turns, twists and turns and shapes itself according to the objects it encounters, curving into a beautiful form, twisting into a unique dance. The surf pounds upon the rocks, *curling* up rolls and rolls of spindrift. Branches long and short-- some hang into hooks, some wind around rocks with embraces. From the high sky in Big Island in Hawaii, we see slowly flowing lava, like a brush held by an invisible hand driving a line of molten red flames, now rising up, now splashing down, breaking mountains, making mountains, breaking valleys, making valleys. It is not an accident that the abstract expressionists, following the suggestions of Van Gogh and Kandinsky that colors and lines are self-expressive, are forms of spiritual vibration, fall in love with Chinese calligraphic strokes.This rhythmic vital energy movement (*qi, or qiyun shengdong*) has been the staple of all Chinese arts and literature and the mainstay of Chinese aesthetics.

It is not an accident that the British art critic Roger Fry [2], after his visits to exhibits of Chinese bronzes and paintings, should notice, and highly praise the uniqueness of the Chinese brush-strokes. In his essay, "Post -Impressionism" in 1911, an essay aimed at a large presentation "Manet and the post-Impressionists", among them, Van Gogh and Cezanne:

> Particular rhythms of line and particular harmonies of colour have their spiritual correspondences and tend to arouse one set of feelings, now another...Rhythm ...is the fundamental and vital quality of painting, as of all the arts.

This discovery represents an important turn in Western art's departure from mimetic theory. The claim in these words, "Particular rhythms of line and particular harmonies of colour have their spiritual correspondences" derived from Van Gogh and Kandinsky. With these words, he touched upon the convergence between ancient Chinese and modern Western aesthetics. This is intriguing. Here, we are not saying that he had a studied understanding of the entire gamut of calligraphy from bronzes, seals, to calligraphy proper, but

2 Roger Fry(1866-1934). In 1901,Fry organized for Grpften Galleries in London a big exhibit that showcased the new artists *Manet and the Post-Impressionist*, which included Van Gogh and Cezanne. He was the first that coined the name Post-Impressionists. Fry's knowledge of Chinese art and his ways of lifting elements out of Chinese art, highlighting them in terms that speak to Modernist obsessions was a rich source, should not be overlooked. See the recent work of Lin Hsiu-ling, *Reconciling Bloomsbury's Aesthetic of Formalism with politics of Anti-Imperialism:Roger Fry's and Clive Bell's Interpretation of Chinese Art.* Concentric: Studies in English Literature and Linguistics, 271 (Jan. 2001) 149-190.

it is of particular interest to us that the new aesthetic turn to shake away the likeness of external form to achieve spiritual vibration has long been the mainstream in traditional Chinese art. While at root his claims might have different tangents from the Chinese dictum of *qiyunshengdong* (breath/rhythm/vital/ alive), they provide a dialogic opportunity; both aim at spiritual vibration beyond external form.

This important turn can be seen as the rise of the importance of theories on *Energy or Kraft* in art. We can begin with Herder's critique of Lessing's defining the arts by way of mediumistic differences, namely, poetry, using language, can only present actions (events), is a time art; painting, using colors and lines, can only present static objects, is a space art. Because painting is an art that arranges objects in space, it cannot present objects in succession (event/s); it can only choose a point of time (one moment) to suggest the before and after of an event. Because poetry communicates with language signs, it also deals with objects, but it does so only by suggestion through actions. In my essay, "*Andersstreben: Conception of Media and Intermedia*,"[3] using examples from both Chinese poetry and paintings that often possess both mediumistic characteristics, I challenge Lessing's distinction, and his use of epic (or narrative poetry) as his primary model. But let us look at Herder's response to Lessing:

> The concept of succession is only half the idea of action. Action is *succession* through *Kraft*. I think of an entity which operates through temporal succession. I think of transformations which through *Kraft* of one substance are consequent upon another :this is how action occurs. And I bet that if action is the object of poetry, this object can never be determined from the dry concept to succession: *Kraft* is the center of the sphere...

In and around 1910, Ezra Pound criticizes the *mimetic* and advances the *dynamic*:

> The spirit of the arts is *dynamic* (1910, *Spirit of Romance*, 234) Rodin's belief that *energy* is beauty holds thus far, namely, that all our ideas of beauty of line are in some way connected with our idea of *swiftness* or easy power of *motion* (1910, *Translations*,

23) In every art I can think of we are damned and clogged by the mimetic: *dynamic* acting is nearly forgotten.(*New Age*,X.16, Feb. 15, 1912,p.370)...the thing that matters in art is a sort of energy, something more or less like electricity or radioactivity, a force transfusing, welding, and unifying (1912, *Literary Essays of Ezra Pound*, 49)
> Poetry is a centaur. The thinking, word-arranging (Yip: in painting, the deployment of color and line), clarifying faculty must *move* and *leap* with the *energizing* , sentient, musical faculties (1912, *Literary Essays*,52)

This shift has, of course, given rise Charles Olson and Robert Creeley's *Projective Verse*.

Let us now look at Van Gogh's *Starry Night* (Fig. 2)The entire vertigo and *tremelo* feeling was achieved through the whirling and twirling of colors and lines; it did not depend on the likeness of the external forms. In November 16, 1888, in a letter to his youngest sister Wilhelmina, he said:

> I don't know whether you can understand that one may make a poem by arranging colors alone, in the same way that you can say comforting things in music. In a similar manner , the bizarre lines, purposely selected and multiplied, meandering all through the picture, may fail to give the garden a vulgar resemblance, but may present it to our minds as seen in a dream, depicting its character, and, at the same time, stranger than it is in reality.

Colors or lines by themselves are adequate to express the *tremelo* of feeling. It was these expressive colors and lines that gave rise to Fauvism, such as Matisse's *Le Bonneur de Vivre* and to Expressionism, such as Edvard Munch's (1865-1944) *Skrik*.

Following Van Gogh, Cezanne in 1904, and Kandinsky in 1911 and 1912 went so far as to say that lines and colors can emit a "corresponding spiritual vibration", an "inner resonance", leading later to the view of pure expression through the linear medium, and lines alone, such as the abstract Expressionists, Jackson Pollock, Franz Kline, and Mark Tobey, etc. many of whom have had inspiration from, or directly studied or practiced Chinese / Japanese calligraphy.

3 *Chinese-Western Comparative Literature: Theory and Strategy* ed. John J. Deeney (Hong Kong: Chinese University Press, 1980)pp.155-178.

Here, let us look at the works of Mark Tobey (1890-1976) who had studied Chinese calligraphy in Shanghai and Japan, and whose *white writing* paintings were once models for Jackson Pollock (Fig. 3-5) [4]. Looking back he reminisces "It's been said I was searching for new techniques. Nothing of the sort. I was really enjoying myself, learning to do things that interested me. When I returned to England I was disturbed. I began to daub on a canvas and I was puzzled by the result. A few streaks of white, some blue streaks. Looked like a distorted nest. It bothered me. What I had learned in the Orient had affected me more than I realized. This was a new approach. I couldn't shake it off. So I had to absorb it before it consumed me. In a short time white writing emerged. I had a totally new conception of painting. The Orient has been the greatest influence of my life." This paragraph must be read together with the following: "Some critics have accused me of being an Orientalist and of using Oriental models. But this is not so, for I knew when in Japan and China--as I struggled with their sumi ink and brush in an attempt to understand their calligraphy--that I would never but be the Occidental that I am. But it was here that I got what I call the calligraphic impulse to carry my work on into some new dimensions...With this method I found I could paint the frenetic rhythms of the modern city, the interweaving of lights and the streams of people who are entangled in the meshes of this net." [5]

We know from Liu Guosong's apprenticeship works that he, using oil, had imitated the works of most of the important impressionist, post-impressionist, fauvist, cubist, expressionist, and abstract expressionist painters. Most cogent to our topic is the works of the latter. Not only has he confessed that he was inspired by Franz Kline's paintings consisting only large black brushstrokes of calligraphic impulse, he had also imitated one of Pollock's large paintings constructed by pouring, dripping-swinging, or let-flowing colors onto a huge canvas, allowing the resultant lines interweaving into a netlike vortex of energy. Abstract expressionist painting is also called Action Painting. The description of Pollock at work by Allan Kaprow, the founder of Happenings, is the most vivid. Let me summarize. It was as if the painter is doing a ritual. In front of an awe-inspiring huge white canvas, a painter driven along by an existential extremity, like a lone fighter in a huge arena, every high energy-driven action taken with the paint is a proclamation of an existential crisis. It is as if every brush, every dot, every line is the affirmation of his self.

In a sense, the painting is nothing but the traces left behind from violent actions, and actions and traces, like dancer and dance, have become one. [Here, since action itself is part of the artistic execution, the action itself is art. And thus, Kaprow invented Happenings. [6]

This description bears much resemblance to our discourse on Chinese calligraphy and the stories that go with it. In fact, in one of the lectures given by Liu Guosong, he offered, as an illustration of Pollock's actions, this story : A drunken monk calligrapher, grabbed some sugarcane remains after chewing, dipped it in ink without premeditation, and blasted it onto the rice paper, all energy and force intact. In both cases, there is improvised or accidental spontaneity, a moment, primitive and primary, unspoiled and unbrokered by thought. By this story, we can see Liu Guosong was very much in tune with the development of this line of new aesthetic turn, although he might not have fully understood the complexity in it. In 1960, in an essay, "The narrow valley of current painting scene–talking from the 15th Province-wide traditional Chinese painting show", he offered, in a rather positive tone, his historical overview of the painting development in the West:

> After the two World Wars in Europe, there was a pervasive sense of disorder and distress in matter of culture and beliefs. Modern (Western) paintings engaged in a frantic revolt against academic, traditional artistic styles in search of a new art, a new idea, a new form completely divorced from tradition. Although their search in metaphysics did not lead them successfully to the "real", or the "substantive", they found a certain depth of their mind. Likewise, although they did not find a new form completely divorced from tradition, they found a new feeling for

4 In 1944 Mark Tobey asked his friend Elisabeth Willis to show his *Bars and Flails* to Jackson Pollock who took time to study it and produced his famous *Blue Poles*. HistoryLink. Org Essay 5217 " Mark Tobey: Old Master of the Young American Painting ". In this Essay, it also records Pollock as saying that he had a deep impression of Tobey's netlike painting made of dense white lines and that this kind of real painting can only appear in New York.

5 Mark Tobey,"Aus Briefen un Gesprachen" Cat. Duddeldorfer Kunsthalle, 1996.

6 Allan Kaprow was also very much influenced by the Daoist, Zen Buddist John Cage. See my " *Daoism, Zen, and the American Avant-garde*: John Cage and Allan Kaprow,"

form. These two facts point to their relentless quest for the destruction of Nature's original form in order to establish something absolute, something subjective and abstract, toward a unified world of new belief, new culture. Their search went beyond Africa and reached the Orient. There, they found Chinese calligraphy to be more attuned to their desire. As a resultabstract painting was born. It is inevitable that the West and the East will interflow. The new cultural belief will come out of this confluence.[7]

As we have intimated in the beginning, the question of influence, in the context of intercultural encounter, is much more complex and complicated than the way we sort out the pieces by reasoning or by appealing to a moment's feeling. The unconscious working from a reservoir of cultural and aesthetic memories at the instant of the painter's execution easily outstrips his confessional telling. We suggest to juxtapose the works of Pollock and Kline against an example from Liu Guosong, *The Dance of Spiritual Vibration* (神韻之舞).

Admittedly, Liu's painting was spurred by Pollock and Kline, but neither of the latter will be able to achieve the horizon evoked by Liu's painting. One quick answer to this is that they have neither practiced the art of Chinese calligraphy, nor immersed in the art long enough to be fully aware of the hard and soft of the brush and the thick and thin of the ink in it that help generate thousands of fashions of emotive content as it is being played out on the fast absorbing rice paper. There is, of course, also mediumistic differences between ink and oil, each yielding very different textures. There is no suggestion here that they should throw themselves entirely into mastering Chinese calligraphy. Mark Tobey's account given above betrays the fact that the tangents of Chinese and Western paintings point to different representations. We simply should not privilege one medium over the other. Aside from the art of guiding the ink into rhythmic dances, there are important differences in the mindset, in what I would like to call an all-embracing *bosom or xionghuai* 胸懷 (a *sphere of consciousness* that embraces "a million things, a million changes"). Liu's work, at first glance, is just another abstract expressionist painting done in Chinese ink, or at least an echo to Pollock and Kline, but it can easily also be an example of misty *yun/shan/yan/*

shui (cloud/mountain/mist/water) landscape developed from Daoist-inspired Su Dongpo of the Southern Song.

2. *Yunshan yanshui* and the edge-dissolving aesthetic strategy

We need to retrace the visual development of this feeling to the Daoist of advocacy noninterference of and nonintrusiveness into Nature's flow, the aesthetic dimension which helps the Chinese modernists retain their Chineseness in their negotiation with the abstract paintings of the West.

The Daoist project began, originally, not as treatises on aesthetics as such, but as a critique of the framing functions of language in the feudalistic Zhou Dynasty's (12-6 B.C.) construction of Names or Norms (the Naming System) to legitimize and consolidate its power hierarchies. The Daoists felt that under the Naming System (such as calling the Emperor the 'Son of Heaven', investing *lords, fathers* , and *husbands* with unchallenged power over *subjects, sons,* and wives, and giving special privileges to first males over other males etc.) the birthrights of humans as natural beings were restricted and distorted. Lao Zi began his project with full awareness of this restrictive and distortive activity of names and words and their power-wielding violence. It was this awareness that opened up the Daoist reconsiderations of language and power, both a political and an aesthetic project. Politically, they intended to implode the so-called "Kingly Dao", the "Heavenly Dao" and the Naming System so that memories of the repressed, exiled and alienated natural self could be fully reawakened leading to recovery of full humanity with the understanding that humans, as only one form of being among a million others, have no perogative to classify the cosmic scheme. From the very beginning, the Daoists believed that the totalizing compositional activity of all phenomena, changing and ongoing, is beyond human comprehension. All conscious efforts to generalize, formulate, classify and order them will result in some form of restriction and reduction. We impose these conceptions, which, by definition, must be partial and incomplete, upon total phenomena at the peril of losing touch with the concrete appeal of the totality of things. Meanwhile, the real world, quite without human supervision and explanation, is totally alive, self-generating, self-conditioning, self-transforming and self-

7 *Wenxing* (文星) VII.3, 1961/1/1.

complete. Each form of being has its own nature, its own place; how can we take *this as subject* (principal) and *that as object* (subordinate)? How can we impose "our" viewpoint upon others as the right viewpoint, the only right viewpoint? "Not to discriminate *this and that* as opposites is the essence of Dao." Thus, only when the subject retreats from its dominating position--taking "I" from the primary position for aesthetic contemplation--can we allow the Free Flow of Nature to reassume itself. *It is no accident that most Chinese landscape paintings use aerial, mid-air, and ground perspectives simultaneously and freely. Front mountains, back mountains, front villages, back villages, bays in front of mountains, and bays behind mountains are seen simultaneously. This is because the viewers are not locked into only one viewing position. Not to be locked into only one viewing position is the rhetorical parallel of not to be locked into the framing function of the Naming system.* The concept of Western perspective is a result of chosen location and chosen direction according to the viewer/ painter's subjective interests, thus, a restrictive and limiting viewing. Chinese painters believe that to know the personality of the mountains, you have to travel months on end into the mountains, viewing them from near, from far, from the heights, from below, with clouds, without clouds, in spring, in autumn...so as to accumulate enough visual knowledge of the mountains. Thus, in their works, they change positions constantly to undo viewing restrictions, allowing several variations of knowledge to converge upon their consciousness. Take Fan Kuan's (11th C.) *Travellers in the Valley* (Fig. 11).

In this large vertical hanging scroll, several travelers, appearing very small, emerge from the lower right corner with large trees behind them. This means that we are viewing them from a distance. But behind the trees, a very distant mountain now springs before our eyes, huge, majestic and immediate as if pressing upon our eyes. We are given to view the scene simultaneously from two distances and from several altitudes. Between the foreground and the background lies a diffusing mist, creating an emptiness out of its whiteness, an emptiness which has physicality in the real world. *It is this whiteness, this void which helps to dissolve our otherwise locked-in sense of distances, engendering a free-floating registering activity.* One may also notice that the speck of human existence, the travelers in the lower right corner, instead of dominating Nature, merges with, and has become part of the Total Composition of all phenomena. This strategy is paramount in Chinese landscape paintings. Witness, for example, this frame which seems to suggest a perspective of the Western

kind, but this is only a small detail of the next frame, which occupies no dominating position.

In this full picture, we are drawn into the midst of a million things (views) at work in Nature in its immensity. We are invited to move freely across layer and layer of visual richness, now high, now low, now far, now near, to meditate. *Please remember this feeling of moving freely toward limitless space, which is closely related to the aesthetic-cultural staples of "jingjie 境界" (a world such as that evoked in Chinese poetry and painting), "fengfan 風範" (a mode or way of life that aspires to the free flow of Nature) ", and "xionghuai 胸懷" (a bosom or sphere of consciousness that embraces "a million things, a million changes" in the free-floating space that allows one not to be locked into one hegemonic system"). Please also understand that these terms are predicated on the condition of easy activity achieved only after deframing and not being locked into any concept.* The Daoist idea of "Let Nature be" in its fullest without human makeover is too obvious to need comment here. The use of emptiness as a negative space, a silent, meditative condition through which Nature emerges in its full brilliant innocence, is continually employed in Chinese landscape painting in general, in Daoist/ Chan (Zen) Buddhist paintings, in particular. The Chinese artist stresses the emptiness, the void, as the indispensable cooperator of the solid in the paintings.The negative space, such as the emptiness in a painting and the condition of silence with meanings trembling at the edge of words in a poem, is made into something vastly more significant and positive, and indeed, has become a horizon toward which Chinese aesthetic attention is constantly directed.

There are two directions in which the use of emptiness was developed in China, and both of these played an important role in the development of Japanese versions of Chinese suiboku paintings in the Muromachi Period. One is represented by the works of Su Dongpo's coterie, Mi Fu 米芾 (1012-1107) and his son Mi Youren's 米友仁 (1082-1165) (often referred to as the *yunshan* of the Mi's). In Mi Fu's *Pine-viewing in Spring Mountain* (Fig. 14),between the pines and pavilion in the foreground and the mountains in the background, there lies a huge stretch of rolling clouds to diffuse the distances, allowing mountains in the far distances, seen from aerial perspective, to appear closer. In Mi Youren's *Cloud-mountains*, his long scroll of *Unusual View of Xiao Xiang* and his *Cloud-mountains* (in Cleveland Museum), the clouds/mists, occupying more than half the total space in the paintings, seem to surge into endlessness. The cloud-mist is concrete and yet empty, concrete as an

object, a thing in Nature, empty, one feels, in the "field" of space within the painting, or empty as a "distant haze", a phrase Su Dongpo often used in his poetry and writings on art to describe this condition which he also linked to Wang Wei's line "Mountain color, between seen and unseen" (a phrase adopted frequently by later painters and theorists), and this sense of emptiness, a subversive emptiness, so to speak, that erases the lines and edges that define chosen viewing position and chosen viewing direction such as the use of perspective in Western paintings. Without the restrictiveness of framing, we are at once near and distant, distant yet near, high and low, low yet high, meditating and listening, as if in a trance, silence, stillness and the empty-yet-full condition of the totalizing Composition of a Million Things at work. The second type of use of emptiness is represented by the paintings of Ma Yuan (c.1150-1225) and Xia Gui (1190-1230), referred to as the Ma-Xia School. Ma Yuan's paintings are famous for his anchoring the scene (solid) on one corner (called Ma-Corner in art history) leading through mountain lines or tree shadows between seen and unseen into the mysterious Void and Stillness of the immensity of Nature. (Fig. 15).

In the subsequent paintings of *Eight Views of Xiao Xiang* by Daoist-inspired Chan (Zen) Buddhist painters like Mu Qi and Yu Jian, an expanding cloud-mist/ mist-vagueness now occupies more than three-fourth of the total painting space, making emptiness the primary object of our aesthetic contemplation. Witness Mu Qi's *Distant Shore: Returning Sails*. (Fig. 16)

It is not what one usually calls landscape painting. Only the shadows / shades of a few trees in one corner. The rest is endlessly stretching emptiness (visually speaking, negative space). Distant mountains slowly, or continue to dissolve into the mist, or shall I say, they are being dissolved by the mist. There, one feels energy riding through it. We now seem to see, or shall I say, *feel* two sails, seen, unseen, there, no there. There is wind, seen or, more correctly, felt, in the dusk as it were, rolling the mist into the infinite *wu* 無 or the condition of the total composition of things before naming. Take Yu Jian's *Mountain Town: Clear Sunlight*. (Fig. 17)

Witness the quick, unhesitating, spontaneous, expressionistic brushstrokes to capture the feeling of an object or moment in abbreviated luminous details. The fullness of stillness and emptiness highlighted by a few solid free-reeling strokes, all inspired by the Daoist idea of "less is more", "great music has no sound", " act not and nothing is not acted upon", has captivated almost all the Muromachi *suiboku* painters, many of whom were Zen Buddhists themselves, from Kamakura and from Kyoto, including Sesshu (1420-1505) and Mokuan (d.1492) and Sesson, have continuously developed Yu Jian's unhesitating, spontaneous, expressionistic brushstrokes as well as the empty-yet-full feeling of Mu Qi and Yu Jian. [8] (Fig. 18)

The *empty-yet-full* condition, in terms of artistic execution, is a challenge of an unusual nature. When the Chinese painters made emptiness/ mist-vagueness as their primary object for aesthetic contemplation, and when they want to scale up to the empyrean, roaming their eyes upon infinite things and beings, and when they ask themselves to achieve oneness in their sense and execution, intuition and expression, aside from making sure the energy fill and go through the lines, *the dancing of black ink must negotiate with the whiteness of the rice paper or silk, making the emptiness the energy that manifests in motion in the cosmos.* In Yu Jian's *Mountain Town: Clear Sunlight*, even without the accompanying inscribed poem, any viewer can feel the presence of rain and mist in the whiteness that seems to be overflowing the mountain town, this is because *this is a sort of negative construction, the strategy of using the (black) inked brushwork to bring out and elevate the (white) uninked paper or silk as the vivid , vivacious and vital rhythmic breath of the cosmos at work. This empty-yet-full* sublime void is something that we do not find in Pollock or Kline. Pollock's lines are the traces left on the canvas by his energy of individual explosion bordering anger and rage. Kline's makes us think of brusque structures of an industrial world. Neither of them, in fact, most of the abstract expressionists, do not use their colors or lines, though brimming with energy, to negotiate with the emptiness, the surrounding lifeworld, nor have they rise above to take in the larger world with a floating registering activity. We call the empty/nothing a sublimal void, because in the achieved Chinese painting, such as those we have seen, this emptiness is pulsating of vital breath of the lifeworld. Liu Guosong's *Dance of Spiritual Vibration* can be considered as advancing a further step from Yu

8 These works are very much on the forefront in books on Zen in the United States during the 1050's. For the Chinese influence on Japan, please read my *Ezra Pound and the Eight Views of XiaoXiang* (National Taiwan University Press,2008)

Jian. With one or two quick, unhesitating, spontaneous, expressionistic brushstrokes, Yu Jian suggests a bridge, and a village. Liu Guosong, free from the restrictive shapes defined by objects, his Chinese ink (black) brushwork moves and dances in the cosmic breath, and,using the technique of *feibai* (flying-white) [9] , turns the white in the paper into nature's surging misty mist or fog. If we put this painting side by side with his other Chinese ink abstract expressionist paintings of this period, this feeling is staggering. Take his *Cold Mountain: Level, Distant* (1969 Fig. 19).

In this large horizontal diptych, we seem to be watching the sublime workings of energy moving, splashing down, flowing on, or those of fog, of cloud, of snow, or here, a water-mirror, there, pounding cataracts..., or in *Eulogy for Rivers and Mountains* (Fig. 20) in which, prompted by the title of another painting of his, "Is it cloud? Is it fog?", we see here the white (fog? water? waterfall? snow?) surge and overflow mountain rocks(?), cliffs(?), precipices (?). Examples of this kind abound.

Interestingly, Liu's use of calligraphic lines as painting, appropriating their abstract (non-figurative) nature and their indeterminate associations, was first sparked by the painter's encounter with the American abstract expressionists. In China, although calligraphy has long been a highly revered independent form of art for thousands of years, but it has never been considered a painting as such. Although, calligraphic lines have been used as important textures for a painting, such as in painting orchids, bamboos, portraitures (such as the folds and lines in Shi Ke's robe-painting), and wrinkled creases found in strange rock formations, they are often used to complete the contour of a painted object. The idea of taking one part of a Chinese character brushed in a wild, cursive style as a full true-to-type (abstract) painting was possible only after Liu and his contemporaries came into contact with, and engaged in, tensional dialogues with modern Western paintings, with the abstract expressionists, in particular. Besides Liu, Zao Wouki and Lui Shou-kun before him, and many of his contemporaries, Xiao Qin, Zhuang Ze, and Zhu Ge, for example, each has, in his own way, tried to use calligraphy as his main aesthetic object. Liu Guosong once said about his new Chinese ink paintings, "In fact, I am not painting mountains and rivers (landscape), but in my paintings, one feels mountains and rivers." (See my *Dialogues with Contemporary Chinese Artists, p. 238)*. That is to say, he was creating painting by brushing calligraphic strokes. This is a very important decision. Because he was not consciously seeking the shapes of mountains, because he was able to unrestrainedly apply his brush of ink—"one sweep of heavy dark" (one of his titles)—now flying across, now sweeping in a slant, now twirling like a vortex, now crashing down pillarlike, now cliff-wall, teethlike cutting, now winds coming through like a sickle—free from the internalized demands for realistic formations of objects, as if for the first time, he has achieved a new unconstrained daubing. Because of the pulses and impulses driving the ink (black) to energize the otherwise passive paper (white) in forms of palpable breathing throughout, we are made to feel, from the dances of calligraphic lines and traces left behind, there, not there, the *tremelo* of mountains and rivers.This is why paintings like *Cold Mountain: Level, Distant* and *Eulogy for Rivers and Mountains* evoke the semblance of the *mist-vague mountains and rivers* landscape of Southern Song and those of Zen paintings, something unseen by the physical eye but deeply felt by the mind's eye. Liu has produced in the 1960's a huge amount of this high-flying dance of lines and the concomitant all-inclusive excursion of the eye into the workings of clouds and mists in the Eight Limits with echoes to and changes from the above two examples. They are, in order, *The Image of May* (1963), *Deep Clouds beyond Knowing* (1963), *Dance of The Image of Ink* (1963), *Scattering Mountain Sounds* (1964), *Dance of Spiritual Vibration* (1964), *Cold Mountain: Snowing over* (1964), *Mountain Ridgepole: White Clouds* (1964), *Improvisation of Autumn* (1965), *Unstopping Whirl and Twirl* (1966), *Autumn's Tour* (1966). *Song of Golden Autumn* (1966), *Snow Stone Picture*(1966), *At the edge of River: Straight down* (1967) , *Wind coming out* (1967), *Yellow Mountain* (1966), *Out of Gorge, Passing Beach* (1967), *Song of Wizard Moon* (1967), *Solitary Wind* (1967), *Eulogy of Mountains and Rivers* (1968), *Cold Mountain, Level, Distant* (1969) and more.

The ones indicated by are paintings of all calligraphic brushstrokes. (These "calligraphic- brushstrokes-alone-are-adequate" paintings are often placed in one of the two squares in his later design-oriented paintings to diffuse the mechanical monotony therein.)

9 See discussion of calligraphy above: "a stroke can sometimes skip part of the paper before ending onto another part, leaving a middle portion without any ink--and this is called *feibai* or "flying -white". However, what is broken is only the brush-stroke, the material dimension, so to speak, the energy that drives the stroke has never been disrupted".

A word about these titles, most of which have a ring of those of classical Chinese poetry, or have an echo to those used by traditional Chinese painters whose styles he set out to overturn. It is somewhat paradoxical here. Most abstract painters tend to use "Untitled No.XX" or just use numbers to name their compositions. This means they want the viewers to feel from the atmosphere created by the colors and lines something like the sensation (or poetic state) aroused by a poem, or, in the words of Van Gogh, "one may make a poem by arranging colors alone, in the same way that you can say comforting things in music". Liu Guosong is at heart a *xieyi* (寫意) painter whose aim is to generate something like poetic *feel* or state in his work. Thus, when he said "In fact, I am not painting mountains and rivers (landscape), but in my paintings, one feels mountains and rivers," he was not fully aware of the fact that his bosom has accumulated and internalized a whole reservoir of memories from classical Chinese poetry and paintings. He might not begin with any compositional blueprint, but the memories of poetic feelings from classical poetry and paintings, including certain effects of certain types of Chinese ink brushstrokes, including the unusual, strangely eye-catching "interest" of certain textures and spatial deployment of the solid and the empty, such as the idea of *empty-yet-full* we discussed above, would come hovering around the edge of his consciousness at the moment of his execution affecting the choices in his composition. Even those who had taken oil as their medium for expression, such as Zao Wouki, Xiao Qin and Zhuang Ze, cannot stop these memories from participating in their creation. In the case of Liu Guosong, as far back as 1960 when he did his first abstractions with plaster, ink and color on canvas, he was already appealing to these memories as aids for the benefit of the viewers with these titles, typically in 7-character classical lines: 〈滾滾黃河天上來〉 (pounding-rolling Yellow River falls from sky), 〈我來此地聞天語〉 (I came here to listen to heavenly words),〈如歌如泣的泉聲〉 (songlike, weeping-like fountain murmurs). He was giving guiding hints to the viewers, hoping to evoke the same poetic feel in them. One of these, titled with a famous line from Emperor Li Yu's (937-978)*ci* (song-lyric): "春花秋月何時了" (Spring flowers, autumn moons: when to end?), is a large plate consisting of only one dominant color: green, a unique green that one associates with certain ceramics, stretching in varying shades across the sky. With this line, are we to evoke the rest of the poem: " The past: how much is known?/Upon the tower last night, east winds blow again./ Native country: unbearable to look back amidst the bright moon./ Carved railings, jade inlays should still be there, / Only faces are changed./ How much sorrow do you have?/ The way a spring river eastward flows." Similarly, most of the

titles for his calligraphic abstract paintings listed earlier seem to have similar function. On the positive side, these titles provide an entrance into understanding the painting with a slant. On the negative side, they restrict the viewer from freer explorations. Some of the titles have been used many times before, and would evoke stock responses. Apparently, Liu guosong was aware of the problem.

One day in the early 1970's, I was asked to have dinner in his house (in Taipei). After dinner, he laid out several of his new paintings, and asked me to title them. At the time, I have been using some avant-garde language strategies and completed a series of landscape poems under the title " Sky Meditations". Here is one of them:

> Suddenly
> Lit up from silence
> Mountain
> Sheen
> Wrinkled by fast winds

So I titled one of his paintings *Mountain sheen wrinkled by fast winds* 《吹皺的山光》. Two more were offered: *Inside moon, mountain. Inside mountain, moon* 《月裏是山山裏月》 and *Scattering Mountain sounds* 《灑落的山音》. Whether these titles sit well with his paintings is not the key here. He clearly felt that titles lifted out of the old tradition easily fall into the commonplace. He was hoping to open up fresher imaginative space by using modernist poetic phrasings. The use of poetic lines, regardless from old or new, is to help evoke the right intended poetic feel. All this goes to show: he is through and through a *xieyi* painter.

3. Collaged Landscape: The search for textures; layering constructions

Now a word about Abstraction. The word is quite often taken to mean non-figurative in relation to figurative, but this is a more restricted meaning. For a lot of abstract painters, for Chinese abstract painters in particular, the distinction between form and formlessness is totally arbitrary. One can ask, for example, has atmosphere form or no form? The Chinese like to use the word yi (*feel* or feeling, sense-of-things) to represent water-feeling, autumn-feeling, or *xiang* (form) as in air-form (for atmosphere) and wind-form. None of the above is visible to the eye, but totally feelable and concrete. Thus, Lao Zi said, "To see and see not.../ continuous, it cannot be named, / and returns to nothingness.../ the condition of no shape, / the form of no

things...Dao as such / is seen, unseen / Seen, unseen/there is, in it something forming / Forming, unforming / there are, in it, things" (Lao, 14; Lao, 21). The Chinese painters always believe that to stick to form is a lower form of art; a higher form of art is to catch that sublime atmosphere open to imaginative excursion. Nature, in its vastness, is not to be measured by forms seen just by the naked eye; rather, it should be a feel for its continuous forming / unforming activity.

But, with their departure from literal representation of concrete objects toward the non-figurative, all abstract painters must face the question of constituting textures into an architecture of art. One of the staples of modernist art, to borrow a phrase from Edgar Allen Poe so highly revered by Baudelaire and Mallarmé, "at no one point in its composition is referable either to accident or intuition—that the work proceeded, step by step, to its completion with the precision and rigid consequence of a mathematical problem", an abstract painter has to attend to the spatial deployment of his colors and lines the same way. From post-impressionist Cézanne to Kandinsky to Kupka to Mondrian, attention to detail-building is paramount. One of Cézanne's *Mont Ste Victoire* paintings, (Fig. 20) which was the forerunner of analytical Cubism, is most instructive.

Expanding the juxtaposition of dots of colors to achieve new color sensations in pointilism to that of patches of colors, he slowly modulates these sensations to a certain heightened density and complexity, giving us a sense of sculptural, architectonic weight, leading to pictorial unification. Liu Guosong's interweaving of his colors, lines, and textures in his Chinese ink abstract paintings has clearly learned from Cézanne with a twist: the making and invention of his unique textures. His search for new textures began in 1962 in his two pieces submitted to the 2nd International Salon in Hong Kong, which won him First Award. In these vertical scrolls, we detect now dark now gray of white lines apparently created by folding the paper in irregular fashion before applying ink, evoking the effect of light casting levelly across sideways onto the uneven rock surfaces. Then, holding different clumps or balls of crushed paper of different angular concave and convex surfaces, he would dip them in dense dark ink and emboss it layer after layer on the lighter texture of irregular vertical fold-lines, giving the paper's thin surface a rock-heavy, rock-thick feel. Then comes to the now famous texture he, by chance, and unexpectedly discovered and invented, the most interesting irregular twists of white lines shown on the backside of the painted rice paper under light; these lines

are the paper "sinews" which the ink cannot penetrate. He first experimented by painting on the back surface of the rice paper, focusing on, and negotiating with the "sinews" and then pulled them out. The resultant textures are wonderfully rich, something the Chinese brush can never achieve. In a sense, these twisting patterns belong to self-so Nature, accidental and naturemade and can be classified as a sort of "found art" in the collages of Picasso. Because the backside of the rice paper cannot accommodate finer applications, Liu Guosong contracted a rice paper maker to make specially for him rims of new paper with "sinews", and more and larger "sinews" of his designation, on the frontside. It was on these "invented" (almost trademarked@Liu) paper that he painted some of the most staggering abstracts, such as those enumerated above.

Anybody confronting for the first time these calligraphic lines must be astounded at how he did them, wondering how he can achieve these rich varying patterns of twists within the ink of a brushstroke, which, following the demands of the energy that is driving it along, *must not and cannot*, at that juncture of time, leave the paper. If we now revisit the details in Liu's *Dance of Spiritual Vibration*, the twisting white textures in the lower part of the calligraphic stroke demand us, or put us in a position, to look at it closely. In the meantime, the whole picture puts us simultaneously at a highpoint in the sky to view, now high, now low, now distant, now close.....as the calligraphic strokes appear as mountain ridges now seen, now unseen in the surging mist, echoing the perceptual activity we discussed in great detail in the Section 2.

At about this time, Liu Guosong experimented profusely with his newfound textures. He would brush (quite often with Western type paint brushes, including the type used to clean gun-barrels) on the frontside, and on the backside, some with dominant black ink, some with dominant empty whiteness, some with colors. He would tear these into smaller pieces in the shapes of rocks or mountain peaks, and juxtapose them into a series of mountains or hills in layers with larger ones in the background, leaving a mist-infused empty middle trembling with mist-infused light. Or he would create collaged landscapes, layer after layer into thickly woven mysterious interiors of mountains. Or paper patches of different textures with different distances, now linked, now cut off, stretching into the distance where all distances disappear. Like Cézanne's modulation of colors, Liu Guosong's collaged landscape patches slowly build up a cubist sense of all times, that is, all memory fragments squeezed into a world either of no exit or a space into which

and out of each residual visual chord of feelings constantly move.

4. Science, Space Eye, Mathematical / Design Thinking

1968. The pictures transmitted back to Earth from the unmanned spaceship have totally subverted all our imaginations of, and writings about both the Earth and the moon. And the Earth, so closely connected with our body, breath, movements, and with millions of other coeval, coexisting ecosystems, is now but another moon, a mere circle, roaming in the Space. This de-familiarization leads to a shocking enlightenment, as we are reminded of something humankind has never experienced, darkly sublime, deep, impenetrable, yet touchable as if were, more real and solid as never before across vast Space. Scientific discoveries of this sort have always stimulated creative imagination. The discoveries made by Galileo of more celestial bodies in Space with his telescope, affirming Copernicus' thesis that the Universe was heliocentric rather than geocentric, (for which he was punished by the Roman Curia, because, indirectly, he had rendered the Christian construction of power hierarchy based on geocentric view totally arbitrary) have engendered the visual representation of many poets. Milton, for one, has used "the optick glass" to present vast mountains and rivers in his *Paradise Lost*. In Taiwan, in the 1960's, the experience of air travel has led Chen Qikuan to create a vertical landscape with the sun on one end and the moon on the other. The visual experience of space travel (as transmitted through the media) led Chen Tingshi move higher and higher to view " the Sun on a Spaceship" (title of one of his woodblock prints), echoing Liu Guosong, many of whose vast sublime representations of Space after Armstrong's landing on the moon have won significant affirmations from art critics of the West.

The view of *our* Earth (hustling, bustling, brimming with agonies and elations), now strangely quiet, cold and unfamiliar, necessarily stimulates the artist into philosophical musing. Before this, we have many challenges of Plato and God. Let us begin with Pater's famous statement in his book *The Renaissance* which says that it is "not the fruit of experience, but experience itself, [which] is the end,...to

burn always with this gem-like flame."[10] While ancient thought sought "to arrest every object in an eternal outline [Yip: Plato's Logos]," the modern spirit asserts that "nothing is or can be rightly known except relatively and under conditions....[Modern man becomes] so receptive, all the influences of nature and of society ceaselessly playing upon him, so that every hour in his life is unique, changed altogether by a stray word, or glance, or touch. It is the truth of these relations that experience gives us, not the truth of eternal outlines ascertained once for all, but a world of gradations."[11]

Following Pater, T. E Hulme's reflection is particularly relevant:

> The ancients were perfectly aware of the fluidity of the world and its impermanence . . .
> but while they recognized it, they feared it and endeavored to evade it to construct things of permanence which would stand fast in this universal flux which frightened them. They had the disease, the passion, for immortality. They wished to construct things which would be proud boasts that they, man, were immortal. We see it in a thousand different forms, materially in the pyramids, spiritually in the dogmas of religion and in the hypostatized ideas of Plato.[12]

After Nietzsche's proclamation that "God is dead", many philosophers continue the quest for answers. In the Space, now facing the concrete circulation of our Earth, the Moon, and other celestial bodies, how do we think, and what is thinking? Liu Guosong answers with his visual meditations, "Roaming on the Moon" and a series of views of the Earth from Space entitled: *Which is Earth?* (all 1969)

Looking out from the Spaceship at the endlessly emptily stretching cosmos, suddenly we seem to remember Cézanne's claim that the world is made of "cylinders, cones, and circles". Indeed, only circles are seen circulating in this endless Space. All the jungles, forests, huge mountains, long rivers, and gigantic buildings and monuments are reduced to a few calligraphic strokes of Liu Guosong's paintings. By chance, at about this time, Mondrian's design-oriented color squares became a

10 Pater, *The Renaissance* (London, 1922),pp.236-7.

11 Pater, *Appreciations* (London, 1924), pp.66-8.

12 *Further Speculation*, ed. Sam Hynes (Lincoln: Univrsity of Nebraska Press 1962) pp.70-71.

dominant part of design on walls of many city buildings. Liu first concentrated on circles with his varying calligraphic strokes suggestive of images of Earth viewed form Space. Later, he introduced squares (sometimes blank, sometimes with calligraphic strokes) to interplay with the circles. There are many design-oriented variations of this interplay between these squares and circle or circles. Whether the pairing of circle and square has its roots in ancient Chinese speculative view of seeing the sky as round and earth as square can be a subject for further investigation. I am tempted to bring out the metamorphoses of Mondrian color squares as a gauge to view those of Liu. The color squares in Mondrian came from a long series of metamorphoses from his painting *red tree*, which was formed (trunk and branches all recognizable) with *passionate* expressionist brushwork. This tree, in a series of demonstration by the artist, underwent several metamorphoses until they change from vertical and horizontal lines to *rational* and basically *cool* squares for new constructions of mathematical temperament. Later, when Mondrian looked back, he found them to be too static and stripped of energy and power. He decided to do a *dynamic* one, still using color squares as textures. This is his "*boogie woogie broadway*" that attempts to catch the flashing lights of the city moving left and right, up and down. (Fig. 26)

Liu Guosong's design-oriented circles and squares are also *rational* and cool, and, after sometime, he, too, felt them to be *too static* and *mechanical* despite his attempt to use calligraphic fragments (with association of the surging of memories) to defuse these effects. Like Mondrian, he wants to bring back *dynamism* to offset monotony, as disclosed in one of the titles of his paintings of this period: *motion*? *stillness*? In many of his large paintings of the movement of the sun or of the moon, he uses effectively the cinematic technique of *freezes* or *stop motion* such as those in his *The rising sun*, *The feeling of sun rising*, *Moon eclipse*, *Midnight sun 1*, *Midnight sun 2* and *Rhythmic movement of the moon*.

Take *Midnight sun* 1985 (Fig. 27) On less that one third of the lower portion of this 181.5 x 632.5 cm horizontal, long scroll is the outline of a slightly, slightly curved line reaching from one side of the painting surface to the other, forming what seems to be a small part on the circumference of the circular Earth. Within it are irregular calligraphic strokes with all the trademark textures of Liu's earlier paintings, suggesting we are looking out from the earth, or are we? The location for the viewers to look out is at best ambiguous, because if we see only a small chord of the circular Earth, we have to be hanging in mid-Space, hovering over it, as it were. And yet, we feel as if we are lying on our stomach upon the surface, waiting for a significant event to happen. Along the curve is a stretch of thin mist-infused light , imperceptably trembling on the edge. Beyond this misty light, on the larger portion of the rectangle, in the orange yellow, and earth yellow atmosphere, we see 7 suns of different gradations of hue, each a *frozen moment's epiphany*, riding over or across the Earth. This arrangement – to preset the camera to take in the sun's activity in 7 slots of time – is to allow us adequate time to meditate on / or to immerse us into, each of its happenings, because the Grand Workings of Space seems to be all within our reach, in a zone in which we tremble with the pulsation of the cosmos. No wonder Liu Guosong hangs his red seal of A Man from East, West, South, North high up in the sky; he is indeed the writer of a new Sublime Space. He constantly crosses borders, continuously transforms outside artistic ideas and strategies by localizing them, continuously subverts, and defamiliarizes his deadened tradition / s to effect now re-incarnations. On his returning road to tradition in his later paintings, he no longer needs to escape traditional ways of deployment, because he continuously experiment with the weaving and interweaving of new textures, many of which, we no longer can classify or enumerate here, because with his large continually renewing textures and strategies, he has reach the point that he can turn the rotten into the miraculous.

2012. 02.13

劉國松藝術散論

藝評家 / 賈方舟

如果我們將中國二十世紀的藝術與以往任何一個時代的藝術相比，就不難發現「融合」是二十世紀中國藝術最顯著的特徵。二十世紀以前，中國的畫家是在一個相對封閉的時空中成長、成熟的。從未有過像我們現在這樣的迷茫，困惑。那時的畫家相對單純，他們的思維是承傳式的，單向度的，沒有那麼多的藝術樣式作為參照，也不需要參照。文人畫家絕不肯去向民間藝術學點什麼。「揚州八怪」怪來怪去也還沒有怪出文人畫的圈子，只不過是對以「四王」為代表的「正統」的小小的叛逆而已。進入二十世紀以後就不同了，文化環境發生了翻天覆地的變化，異質文化的入侵或曰主動迎進，首先是從教育開始的。洋學堂的興起，首先改變了師徒授受的承傳方式，接著改變了繪畫學人的審美標準和審美趣味。莘莘學子留洋歸來，幾乎無一例外地投入到教育之中。從小就接受幾何體寫生練習的一代又一代，再回歸傳統，也難以剔除早年在血液中已經融入的造型觀念。面對世紀潮流，再強大的文化抵抗也會付之東流。因為，異質文化的觀念已經在這些小小的頭腦中生根。於是，與異質文化的「融合」便成為二十世紀中國藝術的必然。在這個過程中，不僅傳統藝術發生了變化，由西方移植來的油畫也不再是原汁原味了。也因為如此，真正能夠代表這個世紀的藝術家，也必然是那些在「融合」中富有成果、富有建樹的藝術家，那些具有「相容」精神的藝術家。我們考查一個藝術家是否在藝術上有所建樹，就是要看他在這樣一個變革時代的上下文關係中所處的位置，看他在傳統文脈上做出怎樣的延伸。以這樣的視角來看劉國松半個世紀以來所做的開創性的藝術實踐及其豐碩成果，看他對傳統水墨畫所做出的創造性轉化，看他對傳統文脈所做的新的延伸，就不難確認，劉國松在傳統繪畫向現代轉化過程中所做的開創性貢獻。

如果從傳統文脈看劉國松的抽象水墨，我們會發現，他的創造並非唐突之舉。早在水墨畫發展的初期，就已帶有濃重的抽象意味。《唐朝名畫錄》曾記載王洽作畫常在「醺酣之後，即以墨潑，或笑或吟，腳蹙手抹，或揮或掃，或淡或濃，隨其形狀，為山為石，為雲為水，應手隨意，倏若造化，圖出雲霞，染成風雨，宛若神巧，俯觀不見其墨汙之跡。」王洽對潑墨「隨其形狀」的偶然性的把握，其實就是以抽象手法為先導的一種意象創造活動；而用「腳蹙手抹」，已經是放棄了「毛筆」的「揮掃」。由於這種畫法過分地超前，不為當時的史家所重，認為其「非畫之本法」（《唐朝名畫錄》），張彥遠甚至認為「山水家有潑墨，亦不謂之畫」，因而「不堪仿效」。但這種近於抽象的畫法所具有的誘惑力卻隨著水墨性能的愈益發揮而有增無減。進入近現代，隨著西方抽象主義的勃興，這一潛在因素更得到進一步張揚，由潑墨而進於潑彩，如張大千、劉海粟所作的那樣。不過，在他們的畫中，「抽象」僅止於一種手法的借用，還構不成真正的抽象主義。抽象主義在水墨領域中的興起，首見於臺灣以劉國松為代表的一批畫家，正是劉國松率先開啟了抽象水墨的新畫風。

在我來看，抽象水墨的源頭，大體來自三個方面：一是從「筆法」中演展，如黃賓虹所提示的那樣，以筆法消解形象，以筆韻自身的價值取代形象的價值；二是從「墨法」中演展，從破墨、潑墨、潑彩到各種肌理、肌質的創造。使水性、墨性、紙性得以淋漓盡致地發揮，從水與墨的自然滲化中把握一種抽象神韻，如劉國松所提示的那樣；三是從水墨的點、線、面的綜合構成中演展，在這裡「水墨」只是作為材料被借用，而構成畫面視覺中心的，是這些形式元素和它們的構成關係，如吳冠中在後期一些作品中所展示的那樣。

劉國松作為五月畫會的一位創始人，在臺灣發起現代藝術運動已經是在半個世紀前的事。上世紀 60 年代中期，他已初步形成了自己的面貌。之後，他有機會在世界範圍內考查藝術、思考自己，視野得到進一步擴展，以至隨著現代科技的最新拓展將思維的觸覺伸向太空。而對宇宙時空的探索和表現，又使他的作品很自然地與傳統的道釋思想發生聯繫。但劉國松對傳統水墨畫的變革與推進並非全在形而上的層面上展開，或者說，首先不是在形而上的層面上展開，而是從水墨畫最基本的工具材料及其相應的技法、技巧的變革開始。劉國松早在 70 年代已經提出「革中鋒的命」，「革中鋒的命」就是放棄傳統的用筆規範，甚至放棄「筆」。因為在「筆墨」這一概念中，「筆」處於主導「墨」的地位。革了「筆」的命，「墨」就得到了徹底的解放。劉國松的「拓墨畫」、「漬墨畫」就是將「筆」的命革掉以後作出的作品。他的這種做法一直延續到今天，成為他的一種獨特的語言方式。今天劉國松已是功成名就，如果回顧一下他半個多世紀的藝術進程，我以為，他的獨特語言方式，既是他走向現代的「起點」，也是他取得成功的基本前提。

其實。對於中國畫的工具材料作必要的改進這一課題，早在本世紀初的第一代革新派畫家那裡已經提了出來。徐悲鴻在他那篇著名的〈中國畫改良之方法〉（1918 年發表）中就曾從物質角度對中西繪畫作過這樣比較：「西方之物質可盡術盡藝，中國之物質不能盡術盡藝. 以此之故略遜。」又說「中國畫通常之憑藉物，日生熱紙，目生熟絹。而八百年來習慣，尤重生紙，廓生紙最難盡色，此為畫術進步之大障礙」。主張中西融和的另一位革新派大師林風眠在1929 年發表的〈中國繪畫新論〉中則更加明確地提出：「對於繪畫

的原料、技巧、方法應有絕對的改進」。雖然兩位前輩對這一課題的提出都是以西方寫實繪畫作為參照系，都是為著轉向「自然真實方面的描寫」，然而，他們畢竟在革新中國畫的初始已經看到了這一技術性課題的重要，看到了一種合於時代的新形式的創立必須從藝術所憑籍的物質材料的改進開始。但由於種種條件的限制. 他們都沒有來得及在實踐上解決這一課題。而劉國松正是將這一理性認識引入實際操作與實驗過程，並且取得成效的第一人。

青銅不同於彩陶，泥塑不同於石雕，新材料的借用直接影響著新形式、新風格的創造。工具材料的變革與技法的創新對劉國松藝術風格的形成同樣產生了決定性的影響。因為任何種類的藝術，都有其風格形成的物質前提。愈是依賴於物質的藝術樣式，愈易於為物質特性所制約。正是這種物質特性（包括相應的技法技巧）決定了油畫與水墨畫的基本差異。在建築中，新風格、新形式的形成與新材料、新技術的採用更是密不可分。甚至可以說，新材料、新技術的採用，直接就意味著新風格、新形式的誕生。沿用原始的木石，何以建造現代的摩天大樓？然而在畫界，能夠悟通這一道理的人並不多，劉國松無疑是一位先行者。他之所以能在風格上對水墨畫作大幅度推進，正是基於他睿智地選擇了一個有利於創造新風格的物質媒介作為起點。

劉國松在藝術上成功的第二個因素，我以為就是他為自己的藝術所確立的定向：將意象的水墨畫推進到抽象的領域。對於水墨畫的未來發展，盡可以做出多種選擇，但就其整體走向而言不外三條路：一是由寫實一路達於極點 ─ 將意象藝術具象化；二是由寫意一路達於極點 ─ 將意象藝術抽象

化；三是拒絕向兩極延伸，仍在意象藝術的本位上發展。50年代的大陸畫家主要走的是第一集路，臺灣以劉國松為代表的一批新銳畫家走的是第二集路。而第三條路，無論是過去和現在、大陸與臺灣，都是一種較為普遍的選擇。從第一種選擇看，是在本世紀20年代已經開始，徐悲鴻所宣導的中國畫革新運動，即是以西方古典的寫實傳統和理性精神來改造中國的寫意傳統。以面向自然、面向生活取代單純的筆墨修煉，以嚴格的造型要求取代傳統繪畫的不求形似。這條寫實之路，就其精神而言與傳統文人畫是相背的。因此，它的推進具有相當大的難度。但這一歷史的選擇又有其必然性。到50年代，劉國松所作的反向選擇同樣也是歷史的必然。如果說具象之路使水墨畫回轉到一個「極點」，那麼，抽象之路作為水墨畫的另一個「極點」則是一個具有歸宿性的趨向。但這一趨向的出現臺灣比大陸早了整整三十年。因此，具象與抽象，既是水墨畫革新的兩個不同階段，也是水墨畫革新的兩個不同側面。這「兩極」取向，拓寬和延伸了水墨畫的表現領域，給水墨畫帶來新的生命活力。劉國松的貢獻不僅在於他將水墨畫引向抽象，而且還在於他同時將水墨畫引向現代、引向世界，使它匯入國際藝術潮流之中。

劉國松在藝術上取得成功的第三個因素，我以為是他在理論上的建樹。劉國松與他的同道所宣導的現代美術運動，由於帶著濃重的反叛色彩和挑戰姿態，曾經遭致傳統勢力的強大圍攻。勢單力薄的一群青年要抵禦這樣強大的阻力，要在這樣險峻的形勢下實行自己的藝術主張，談何容易。這就迫使他們一方面必須拿出有說服力的作品，一方面又要在理論上有所建樹。只有這兩個方面的同時進擊，才有可能使自己立於不敗之地。而劉國松在這兩方面都扮演著一個「先鋒」的角色。他一面進行著富有成果的實踐，一面又創造性地從理論上論證了這實踐的正確。他用「現代人的眼光與知識」，對傳統畫論中一些關鍵性的概念給予了全新的解釋。像「筆墨」、「技法」這些上千年來一直在信守的陳規，經他機智的「現代轉譯」，立刻與傳統相溝通，使這些理論難題迎刃而解。理論上的疏通與創建，不僅使劉國松從僵化保守的傳統規範中得以順利解脫，而且由於他是從基本概念上闡明了中西繪畫在本質上的一致性，從而才撥開了傳統畫論的迷霧，重立筆墨新規範，重建水墨新原則，從而展示了中國現代水墨畫柳暗花明的前景。

On the Art of Liu Kuo-Sung

Art Critic / Fangzhou Jia

A very apparent characteristic of twentieth-century Chinese art, compared to that of preceding periods,was its synthesis of Western art.In pre-twentieth century China, *wenrenor* literati artists developed in a relatively closed society, unexposed to a multitude of influences as we are today. As such, their thinking was relatively speaking simple, traditional and one-directional. For these artists, styles of art that existed as alternative frames of reference were few and far between. Those that did exist, for example folk arts, were simply not considered worthy of study. Even styles of 'alternative' art did not stray far from accepted cultural boundaries. One such school, the Eight Eccentrics of Yangzhou School, wasonly a minor evolution of the established Four Kings School of the time.

This all changed in the twentieth century.China experienced a cultural upheaval withan invasion of heterogeneous culture (that some say was actively invited in), which took off with the rise of schools of Western studies. The traditional master-student system of passing on knowledge was impacted, influencing aesthetic standards and tastes of Chinese artists. A large number of art students traveled abroad to study Western art with most becoming art teachers after returning. New generations of Chinese artists were now being trained in Western techniques making it hard for them to shed the influence of Western art theories when practicing traditional painting. In the face of this historical trend, even the strongest cultural resistance would prove futile.

The seeds of heterogeneous culture were thus planted in the minds of young artists andthe synthesis of diverse culture became an inevitable phenomenon of twentieth-century Chinese art.Traditional art was changed and even transplanted Western oil painting began to take on a 'Chinese flavor'. Chinese artists whose work best represented this historical trend were those who took on board this phenomenon of synthesis. By comparing an artist's output before and after thistransformative period and by judging how much of a step forward he made from traditional art allows us to assess his overall artistic contribution.Over the past five decades, Liu Kuo-Sung has produced innovative works and played a major contributing role in advancing traditional ink and wash art. The huge advances he made intraditional painting clearly reveal the extent of his modernizing contribution.

Liu Kuo-Sung's abstract works might in fact be viewed as a natural development of the traditional school of Chinese ink and wash. Early on in the art's development, there were examples of paintings that were very abstract in feel. In Zhu Jingxuan's Famous Tang Paintings, there are mentions of the artist Wang Qiawhile intoxicated rendering details such as rocks and clouds with great skill using ink splash and unrestrained sweeps of his hands and feet. Wang Qia's mastery of the 'free shape' of ink splash might be viewedas a kind of impressionist style inspired by abstract techniques. The use of his hands and feet to apply ink was abandoning the brush but his extreme avant garde style was largely ignored by historians who did not consider it a proper form of painting. Chang Chanyuan even believed that the work of landscape artists who practiced splash ink could not be considered paintings, and he could not stand the imitation of such art. However, the appeal of using abstract-like techniques was to become more popular not less as more took up ink and wash.

In the modern period, Western abstract art's popularity led to increased knowledge of abstractionism. The abstract potential of ink and wash painting was further realized when Chinese artists began developing techniques such as *bocaior* 'color splash' from *bomoor* 'splash ink'. The works of Chang Da-chien and Liu Haisu best exemplify this style. However, these artists merely borrowed abstract techniques and their paintings were not truly abstract. It was a group of Taiwanese artists represented by Liu Kuo-Sung who were the first to fully embrace abstract concepts in ink and wash, and it was Liu who was at the fore front of this new abstract wave.

The development of abstract ink and wash occurred in three areas. The first was brush technique. Huang Binhong championed the use of brush technique to 'eradicate' form, believing a painting's worth could be derived not from the form but the brush work. The second was ink technique. Artists developed new ways of applying ink. Techniques evolved from *pomo* (broken ink) to *bomo* (splash ink) and eventually to *bocai* (color splash). Paintings featuring various grains and qualities of ink were produced. There was much development in the way water, ink and paper were combined. Artists began mastering ink's natural properties of absorbing water to produce abstract works. Liu Kuo-Sung's paintings were an exemplar of this. The third was the way in which artists used dots, lines and blocks of ink to arrange their pieces. Here, ink acted merely as a medium. The emphasis was in the compositional relationship of these elements. The later output of Wu Guanzhong is the best examples of this style.

Liu Kuo-Sung was a founding member of the Fifth Moon Art Association, the group that got the modern art movement rolling in Taiwan more than 50 years ago. Liu began to develop his own distinctive style in the mid 1960s. Later foreign travels gave him the chance to view art from other countries and the time for personal reflection expanding his horizons. Advances in technology also directed his interest towards space. Liu's works on space and time were related conceptually to traditional Taoist and Buddhist ideas. However, he was not focused towards the metaphysical in his pursuit to transform and advance traditional ink and wash. Or more precisely he was not at first. Initially, his focus was the physical instruments and materials used to make ink and wash painting and the transformation of their associated techniques and skills.

As early as the 1970s, Liu Kuo-Sung developed the concept of the 'revolutionary life force'. It talked of abandoning traditional restrictions on how to use the ink brush and even abandoning the brush altogether. In *bimo* or Chinese ink and wash theory, the brush controls the ink. In Liu's theory, by emancipating the life force of the brush, the ink is completely set free. Liu's *tuomo* paintings (ink rubbings) and *zimo* paintings (steeped ink) were based on this concept. Liu has continued using this technique to this day and it has become a hallmark of his art. Reviewing Liu's artistic development over the past half century, his distinct modern style has without doubt contributed to his success and accomplishments today.

In the first few decades of the twentieth century, a group of early reformist artists explored the necessity of developing the tools and materials used in Chinese painting. In "Methods for Improving Chinese Painting" written in 1918, Xu Baihong compared the materials of Western and Chinese art. The materials used in Western art he concluded allowed Western artists to get the most out of their art form. However, Xu argued that Chinese art was limited in this respect and therefore that it was not as advanced as Western art. Chinese painting was also limited by the materials it used he believed. The unprocessed Xuan paper that had been used in Chinese art for over eight hundred years was not designed for getting the most out of the ink. This represented a huge obstacle when it came to developing painting techniques, he argued.

Lin Fengmian was another reformist artist who advocated synthesizing Western and Chinese painting. In "A New Argument on Chinese Painting" published in 1929, Lin stated in more obvious terms that there needed to be a complete overhaul of the materials, techniques and methods used in Chinese painting. Xu and Lin were writing with Western realist art in mind and advocated the adoption of the methods of natural realism. Nevertheless, they recognized at this early stage the importance of developing technique and skill in order to reform Chinese painting and creating a new style of art in keeping with the times. However, due to a multitude of limiting factors they failed to put what they preached into practice. Instead, Liu Kuo-Sung was the first artist to realize these theories and achieve results.

Just as copper has different properties to ceramics and clay sculpture is not the same as stone sculpture, so there is a direct relationship between new materials and the way new forms and styles of art are created. Similarly, advances and innovations in the tools, materials and techniques used in ink and wash painting had a decisive influence on the development of Liu Kuo-Sung's new style of art.

Every style of art is defined at a basic level by the materials used to produce it. Styles of art that are more dependent on their medium are more restricted by it. The fundamental differences between oil and ink and wash are decided by each style's respective medium and associated techniques and skills. In architecture, new styles and forms are even more closely dependant on new materials and techniques. You might even go as far to say that using new materials and techniques directly gives rise to new styles and forms. After all, how could modern sky scrapers be built if we had continued to use wood and stone?

This was a concept that few artists at Liu Kuo-Sung's time understood butpioneering Liu without doubt grasped this concept. That he was able to make such great stylistic steps forward in ink and wash painting was down to his prescient decision to experiment with media that enabled the creation of new styles.

Another factor behind Liu Kuo-Sung's success was the direction in which he developed, toward abstractionism and away from impressionism.In the 1950s, ink and wash painting evolved in three main directions. The first was in a realist direction. The ultimate realization of this direction would see impressionist ink and wash developing into a figurative art. The second direction was towards abstractionism while the third denied both directions and stuck to the impressionist style. The majority of mainland Chinese artists plumped for the first route butin Taiwan a group of pioneering artists led by Liu chose the second. The third route was taken up by numerous artists on both the mainland and in Taiwan (continuing on the same path has often been a popular choice whether we are talking about then or even today).

A number of artists involved in XuBeihong's Chinese painting reformist movement had taken the first route in the 1920s. This movement sought to advance China's impressionist tradition by applying Western classical realist traditions and rational thinking. It advocated doing away with rote practice of ink and brush techniques, instead drawing inspiration from nature and life, and replacing traditional art's emphasis on not reproducing form to abiding by strict requirements of form. Conceptually, this impressionist direction was directly at odds with the values of traditional art, and its advancement consequently faced huge resistance. Historically speaking, however, it was an inevitable development.

In the same way, Liu Kuo-Sung's anti-traditional choice was historically inevitable. If we consider the figural path as one pole of development, then abstractionism represented the other pole, and at the same time an ultimate destination for ink and wash painting. In Taiwan, artists embarked on this route three decades earlier than mainland artists. The figural and abstract version of ink and wash could thus be said to represent at once two different stages and two different sides of reformation of the art form. These two poles expanded and extended the styles of ink and wash, invigorating the art.Liu's contribution was more than developing ink painting in an abstract direction. He brought ink and wash towards modernity and into the world, placing it at the centre of international art trends.

The final factor behind Liu Kuo-Sung's success was that the firm theoretical basis behind his art. Traditional society put up huge cultural resistance to the modern art movement led by Liu and his fellow reformists. It was no doubt a struggle for this group of young artists to resist such pressure and promote their modernizing position. This struggle encouraged them to produce works that were powerful enough to stand up on their own merit and to build upa sturdy conceptual basis. With these two firm foundations, they were able to establish a defensible position for their movement.

Liu Kuo-Sung was one of the first to forge ahead against this cultural resistance by producing works of outstanding power and developing strong theories to back them up.

Drawing on modern points of view and new knowledge,he re-interpreted key concepts of traditional painting,including outmoded brush and ink conventions, methods and techniques that had been abided by for centuries. He started a conversation with traditional aspects of society and was easily able to provide an swers to theoretical challenges. Liu's new theories set him free from rigid traditional norms. They justified mixing Western and Chinese media, which extraditingLiu from the restrictions of traditional art and allowed him to establish new norms and principles for ink and wash. It is no exaggeration to say that for the art of Chinese ink and wash painting in the modern era, Liu's endeavors had effectively shone a light at the end of the tunnel.

作品圖版 Plates of Artworks

作品賞析　王月琴
Artwork description　Janet Wang

一、學生時期　Student Period

水墨現代化之父劉國松的藝術之途，精彩、曲折中帶著傳奇。1938年父親抗日陣亡，與母親逃亡於四川、湖南，勝利後在武昌讀初二時，利用裱畫店裁剩的紙和不用的筆，一口氣畫了近八十張畫。隻身來台就讀師大附中高二，以同等學歷考入師大藝術系，國畫受教於林玉山、黃君璧、溥心畬等名師，奠定深厚的根基。「一切的藝術來自於生活」，虞君質老師這句話使得劉國松對於那些與生活脫節的文人畫漸漸失去興趣，二年級開始接觸水彩與油畫，全力鑽研西方繪畫領域，期間受益最深的老師有朱德群與廖繼春。這次展出學生時期12件作品，從最早的1949年《媽媽，您在哪裡?》到1960年《一寸山河一寸血》，包含水彩、水墨、油畫、複合媒材，兼具東、西方美學表現。

Liu Kuo-Sung, the father of ink painting modernization, has traveled a brilliant, circuitous artistic path colored with legend. After his father was lost in the war of resistance against Japan in 1938, he successively fled with his mother first to Sichuan and then to Hunan. Upon the cessation of the war, as a junior high school sophomore he utilized scraps of paper from a frame shop and discarded brushes to make nearly 80 paintings in one creative burst. Following relocation to Taiwan alone, he entered National Taiwan Normal University's affiliated senior high school as a sophomore, continuing to attend university in the fine arts department at NTNU, where he studied traditional Chinese painting under such noted professors as Lin Yu-shan, Huang Chun-pi, and Po Hsin-yu, solidifying a substantial foundation. Teacher Lu Chun-chih's assertion that "all art comes from life" so resonated with Liu that his interest in aloof Literati painting steadily waned. In his second year at university he took up watercolor and ink painting, absorbing himself in the realm of Western painting, gaining particular inspiration and insight from associations with artists Chu Te-chun and Liao Chi-chun. This segment of the exhibition features 12 works from Liu's student period, ranging from 1949's *Mother, Where Are You?* to 1960's *One-inch Blood for One-inch Homeland*, running the gamut from watercolor to ink painting, oils, and mixed media, and already exhibiting both Oriental and Western approaches.

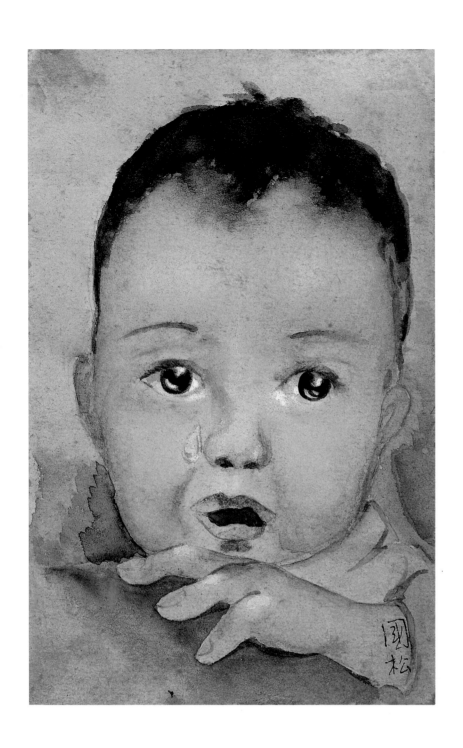

媽媽，您在哪裡?
Mother, Where are You?
1949
水彩 Watercolor
13.8 × 8.8 cm

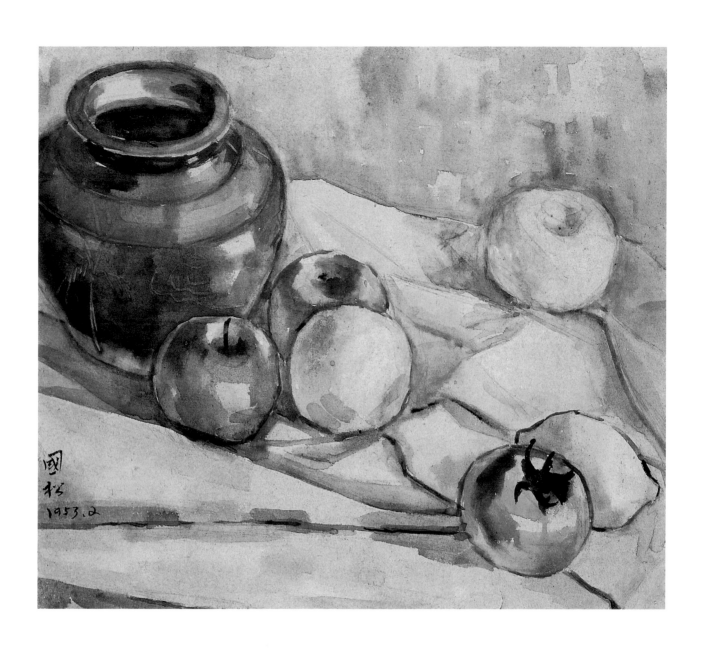

這幅仿北宋筆法的花鳥是大學一年級的作品，可以看得出劉國松在師大求學時期，鑽研古畫的臨摹，為傳統水墨打下紮實的功底，以及他在繪畫上嚴謹認真的態度。畫中用筆頓挫有力，線條細緻勁健，暈染濃淡合宜，雖然是臨摹之作，起伏轉折之間充份展現早期傳統繪畫的紮實基礎。

Liu Kuo-Sung painted this Northern Song 'flower and bird' reproduction piecein his first year of university. During his time at Taiwan Normal University, Liu made reproductions of period paintings, developing a strong foundationin traditional ink and wash and cultivating his serious attitude to painting. The brush is used with strength, thelines rendered finely yet with spirit and the use of blotting is well-balanced, neither too dark nor too light. Although this is a reproduction, it is clear evidence that Liu had developed a solid foundation in traditional painting early on.

花鳥
Flowers and Bird
1952
水墨、紙本 Ink on paper
66.5 × 34 cm

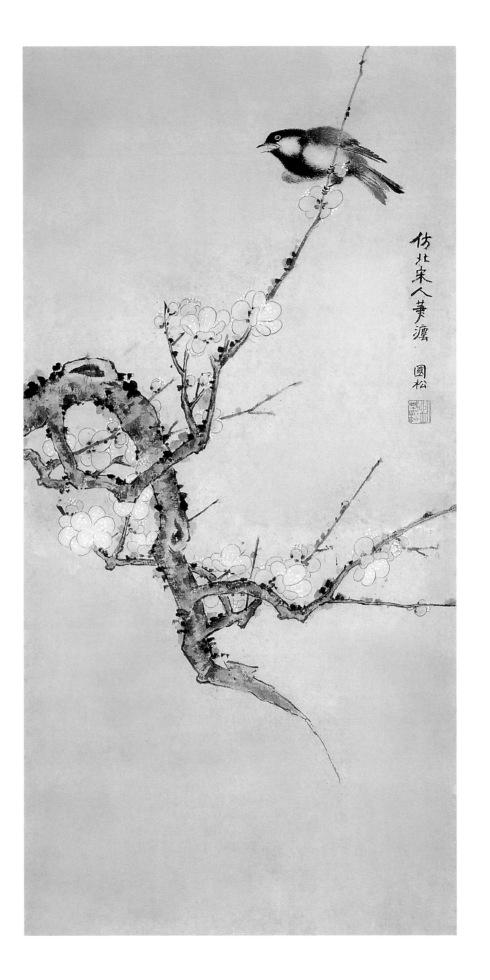

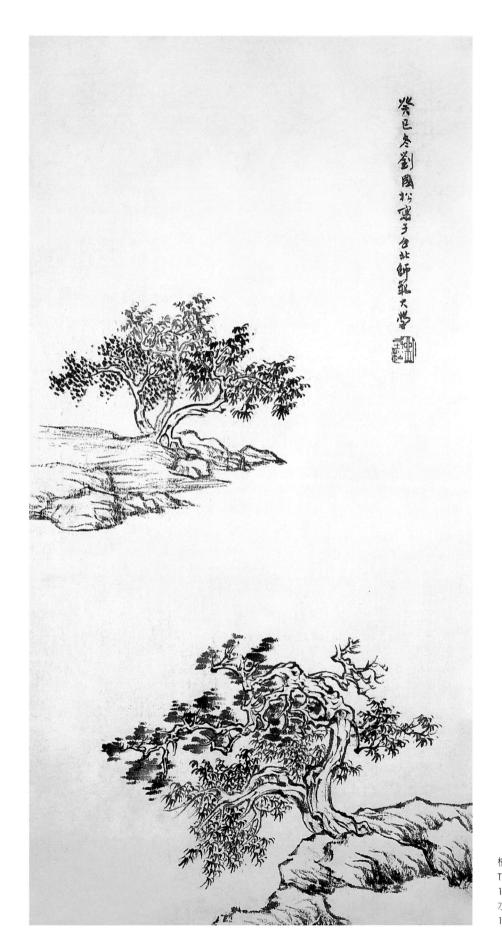

樹石圖
Trees and Rocks
1953
水墨、紙本 Ink on paper
19.5 × 29.5 cm

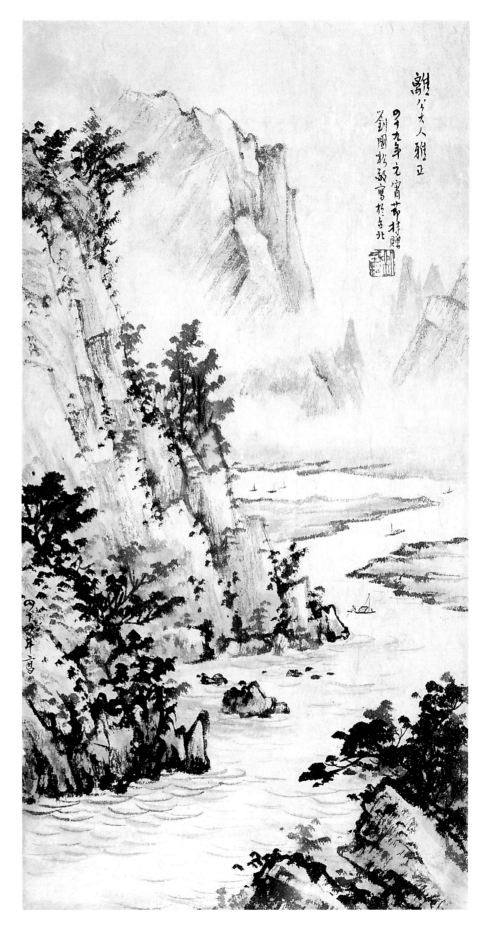

山水
Landscape
1954
水墨、紙本 Ink on paper
56.5 × 30.5 cm

又夢塞尚
Dream again about Cézanne
1954
水彩 Watercolor
33.2 × 28.5 cm

小妹
Little Sister
1954
水彩 Watercolor
38.4 × 28.8 cm

裸女
Naked Girls
1954
水彩　Watercolor
38.5 × 48.5 cm

靜物
Still Life
1957
油彩、畫布 Oil on canvas
33 × 45.5 cm

褪了色的玫瑰花
Faded Roses
1958
油彩、畫布 Oil on canvas
46 × 36 cm

這幅1956年的水彩作品，帶著傳統水墨山水畫的筆法，以線條勾勒山形，以點苔法作坡面，以濃淡渲染上色，特別在樹幹的筆觸上看到書法線條的運筆力道，樹葉的「個字點」與「介字點」畫法揉合了傳統水墨繪畫的基礎。在這個時期的西畫薰陶，成為劉國松藝術發展的關鍵，使他從傳統出發又突破傳統，一連串的創新實驗，以及中西合璧的創意，成就了無可取代的藝術突破與表象。

This watercolor piece, completed in 1956, was produced using traditional ink and wash landscape painting techniques. The contours of the mountain forms are delineated with lines, and the sloping areas rendered with calligraphy dotting, while color and shading are applied with washes. The brush strokes of the tree trunks in particular reveals skillful and powerful calligraphy line work, whilethe 'ge' and 'jie' dotting forming the tree leaves are essential calligraphy strokes. This work was completed during a key period in Liu Kuo-song's development when he was exploring Western painting styles. From a traditional starting point he broke free of traditional painting mores andstarted to produce a series of creative and experimental works combining Eastern and Western influence.

基隆後山
Rear Mountain in Chi-lung
1956
水彩 Watercolor
76 × 53 cm

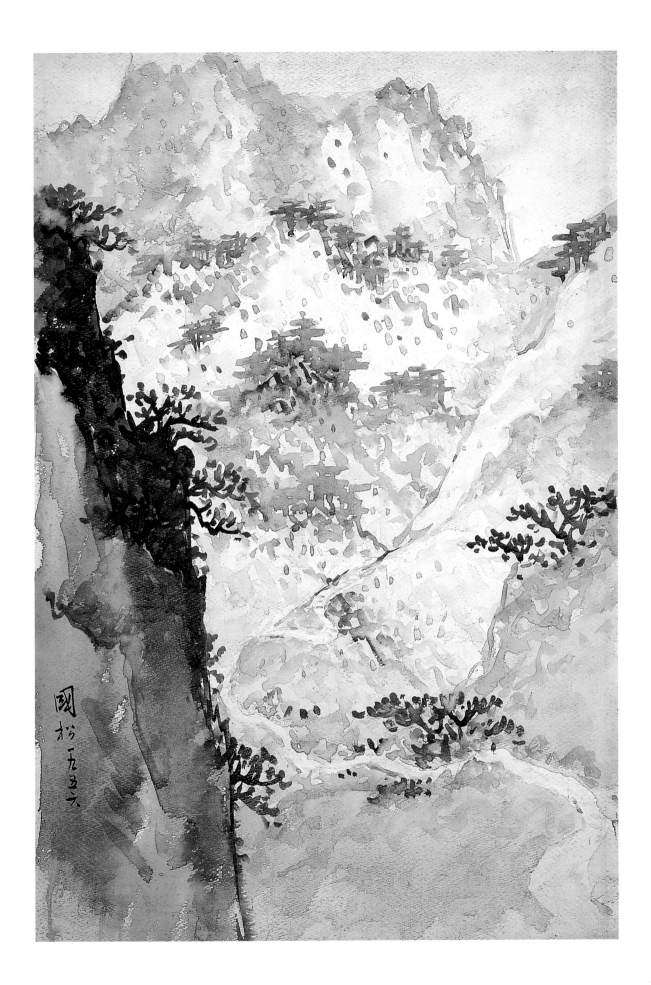

國松 一九五六

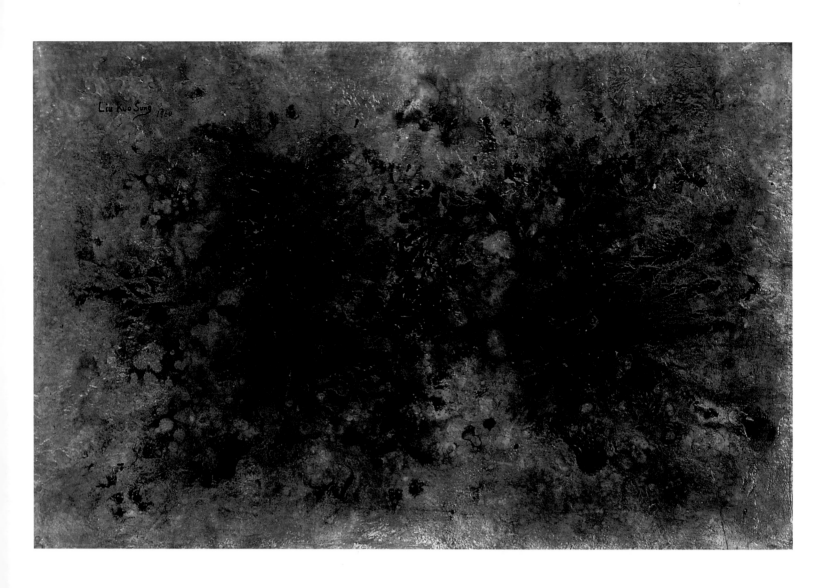

一寸江山一寸血
One-inch Blood for One-inch Homeland
1960
複合媒材 Mixed media
67.5 × 105 cm

二、狂草抽象系列　Calligraphic Abstraction Series

「模仿新的，不能代替模仿舊的；抄襲西洋的，不能代替抄襲中國的。」1960年第四屆五月畫展之後，28歲的劉國松有所領悟，要把水墨畫帶入一條嶄新的途徑。經過1961-1962兩年陣痛實驗期，嘗試了如《夜色泠蒼松》畫中的紙拓、板拓，1963年和紙廠研發了手工製作的國松紙，在紙筋粗厚的紙上，以大筆觸掃過畫面，把石恪《二祖調心圖》中的狂草筆法帶入畫中，再加上花青染色，等墨色完全乾後，撕去墨下的紙筋，以抽筋剝皮皴的技法留下白色的線條，表現獨一無二的狂草式抽象，不但拓寬了中國文人畫的領域，並正式開啓水墨現代化之途。這種可控制的偶然效果，成為半個世紀以來鮮明、獨特的技巧。1966年劉國松獲得美國洛克菲勒三世基金會獎助金，開始他在藝術歷程上的環球之旅，並於1968年當選台灣十大傑出青年。

"Imitating the new cannot take the place of imitating the old; copying Western things cannot replace copying Chinese things." Having reached this realization following the fourth joint exhibition of the Fifth Moon Group in 1960, the 28 year-old Liu Kuo-Sung resolved to take ink painting on a completely new path. Following a two-ear teething period of experimentation from 1961-62, Liu attempted rubbings on paper and slate like Winter Pine at Night, and in 1963 in collaboration with a paper mill developed hand-made "Kuo-Sung paper." Using sweeping, large brush strokes across the coarse paper, Liu introduced the rhapsodic calligraphic style of *Two Zen Masters in Contemplation*, infusing colors, and peeling strands of paper away after the ink dried to leave white lines. This unique rhapsodic abstraction not only broadened the realm of Chinese Literati painting, but also formally paved the way for the modernization of ink painting. Such controllable random effects formed a distinctive, readily identifiable new technique used extensively over the next half century. A grant from the John D. Rockefeller III Foundation in 1966 enabled the artist to embark upon his artistic journey around the globe, and in 1968 he earned selection as one of Taiwan's Top 10 Outstanding Youths.

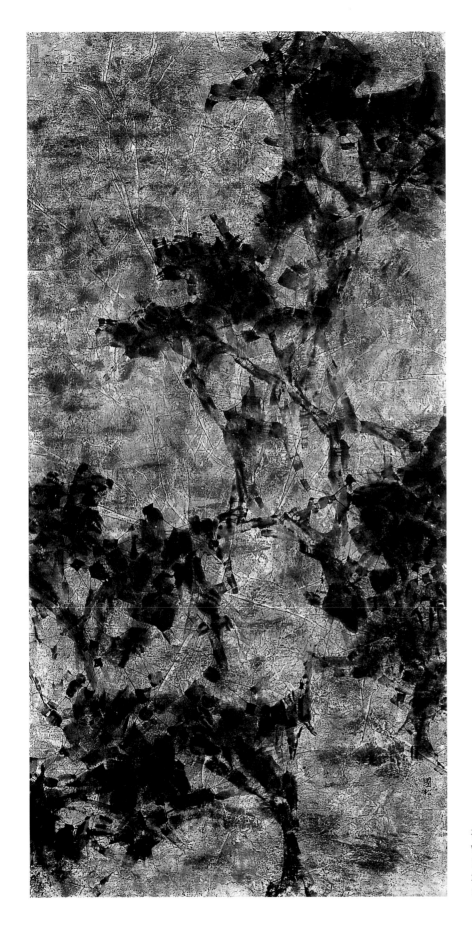

夜色泠蒼松
Winter Pines at Night
1961
水墨、紙本 Ink on paper
136 × 68.3 cm

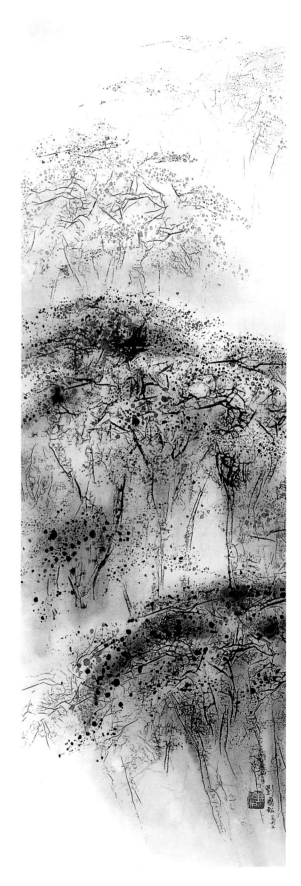

消夏
Summer Trees
1962
水墨、紙本 Ink on paper
86.5 × 27.5 cm
倫敦水松石山房收藏
Shuisongshi Shanfang Collection, London

這幅畫以拓墨法與裱貼技法來表現山水意境，畫的三分之二以上用紙拓的效果，構成在狂草筆法之前的抽象意境，當中以自然留白表現瀑布、流水，遠處層層疊疊的山峰與雲霧交錯，再以摺紙痕跡拓印墨色的線條變化，表現山石中的枝幹與肌理層次，並加上黃、綠渲染以透出光感；近景以綠、黃局部裱貼，襯托群峰起伏的層次感，豐富了整體的構圖與色彩。此畫呈現了繁複而細膩，剛強且秀麗的山水意境，不依賴筆觸而能創造細膩自燃的線條，表現了水墨創新精神，下半部的裱貼細節把遠、近之景做了鮮明的對照，整體渾然天成，是不可多得的精彩之作。

This landscape was produced using ink rubbing and collage. More than two thirds of the piece is formed from paper rubbings. This pre-kuangcao(wild cursive) abstract picture features the use of liubai or 'white space' to render waterfalls and running water.Layers of clouds and peaks intermingle in the background. Folded paper marks and rubbed ink create grained patterns rendering the barren trunks and details of the mountains. Yellow and green ink creates light effects. Sections of the foreground are done with green and yellow collage creating the effect of rising and falling mountain peaks, adding to the composition and coloring of the work. Thispowerfully beautiful landscapeis complex and refined. The meticulous and natural-looking line work was completed without relying on brush strokes, a technique in ink painting. The lower section of the painting is rendered in collage creating a clear contrast between the background and foreground. Seen as a whole, thepiece is a work of the highest quality and rare excellence.

陰山
Yin Mountain
1962
水墨、紙本 Ink on paper
70 × 34.5 cm
倫敦水松石山房收藏
Shuisongshi Shanfang Collection, London

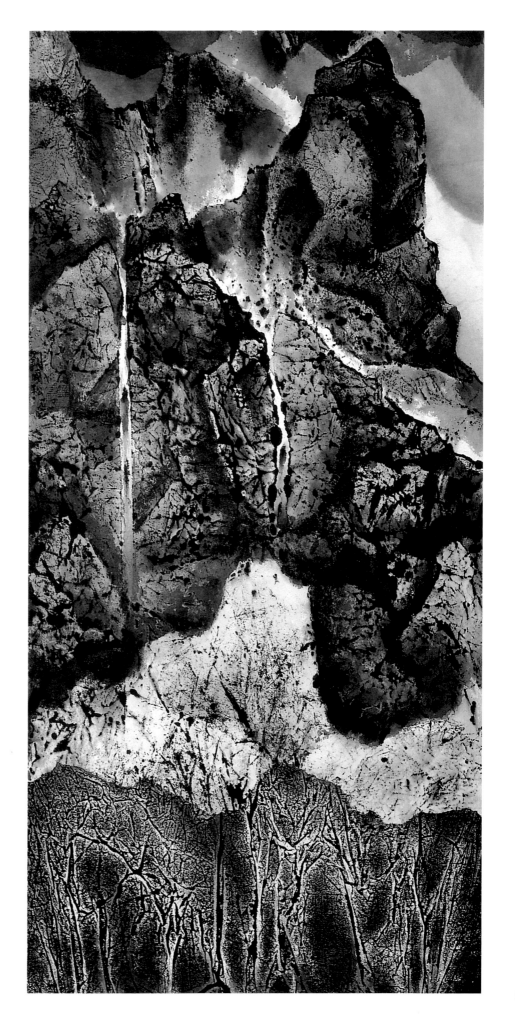

這件作品使用了當時剛研發成功的手工紙—粗厚的國松紙，以凌空俯瞰的視野作為構圖角度，大筆觸刷出中國式大山水的抽象意境，畫中以當年軍隊刷砲筒的砲刷子當筆來使用，刷出黑白狂草的粗壯線條，砲刷岔口刷出的分岔線巧妙地成為裝飾線，為構圖增加神來之筆的偶然效果，書法狂草式的飛白展現劉國松破繭而出的毅力，同時以獨特的抽筋剝皮皴技法表現肌理。此畫構圖簡潔明快，虛實中的大片留白，增加視野的廣度與景觀的深度，墨色濃淡變化，渲染深淺合宜，線條曲折多端，筆意或斷或連的當中，突顯留白的美學概念，成為此期代表性的作品之一，現收藏於香港藝術館，是劉國松第一件被藝術館收藏的作品，開啟了中國狂草抽象繪畫的新風格。

The piece makes use of a new thick hand-made paper that had just been invented at the time. Rendered in large brush strokes, the abstract work depicts a Chinese style landscape seen from above. The work was painted with a gun barrel brush producing wild, thick black and white streaked lines. The shape of the hairs of the brush produces a white streaked effect seen in the painting. Creasing and scrunching of the paper creates further textured effects. The arrangement of the painting is simple yet potent with a large area of misty white space increasing the width of the angle of view and depth of the landscape. Shading of the ink and thickness of the washes is just right. The twist and turn of the lines accentuate the effect of the white spaces. This was a hallmark of Liu's work during this period. The piece is now in the collection of the Hong Kong Museum of Art and is the first work of Liu Kuo-Sung to have been collected by the museum and have kicked-off a new era of wild cursive abstract painting.

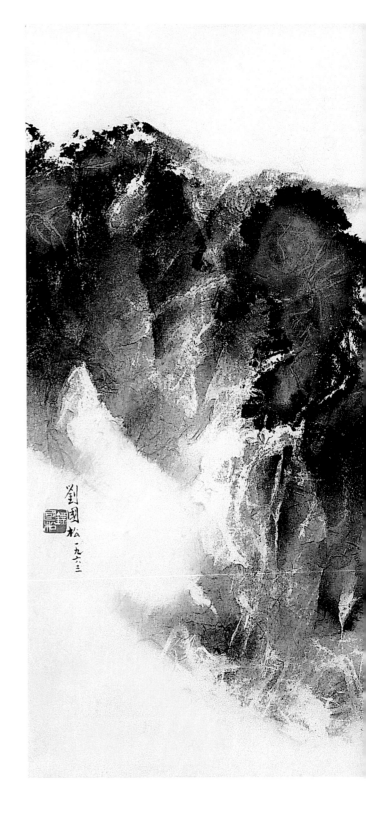

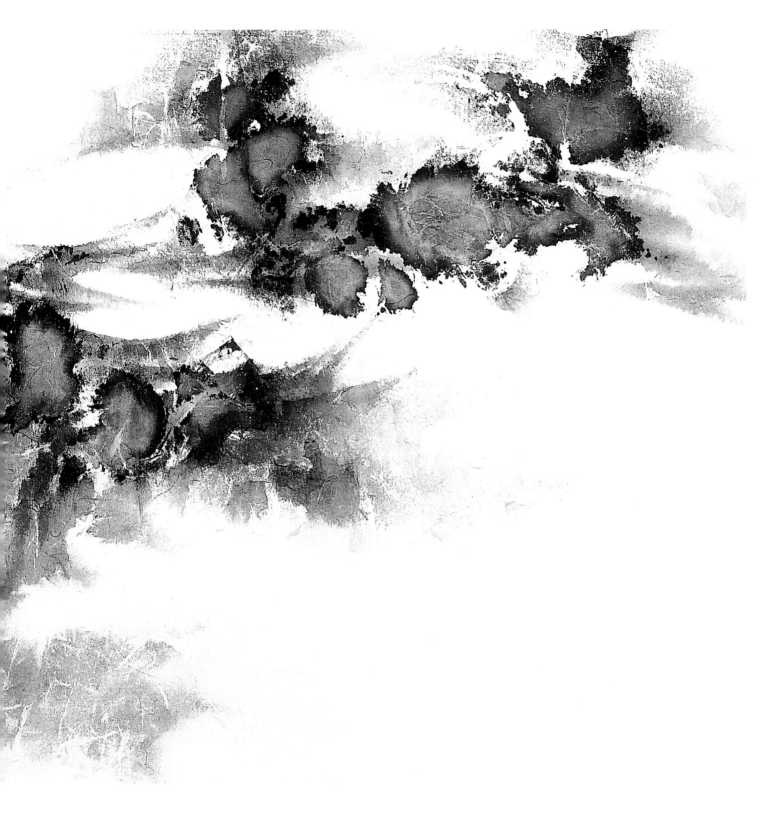

雲深不知處
Clouds Amidst Deep Mountains
1963
水墨設色、紙本　Ink, Color on paper
53.6 × 85.8 cm
香港藝術館典藏
Hong Kong Museum of Art Collection

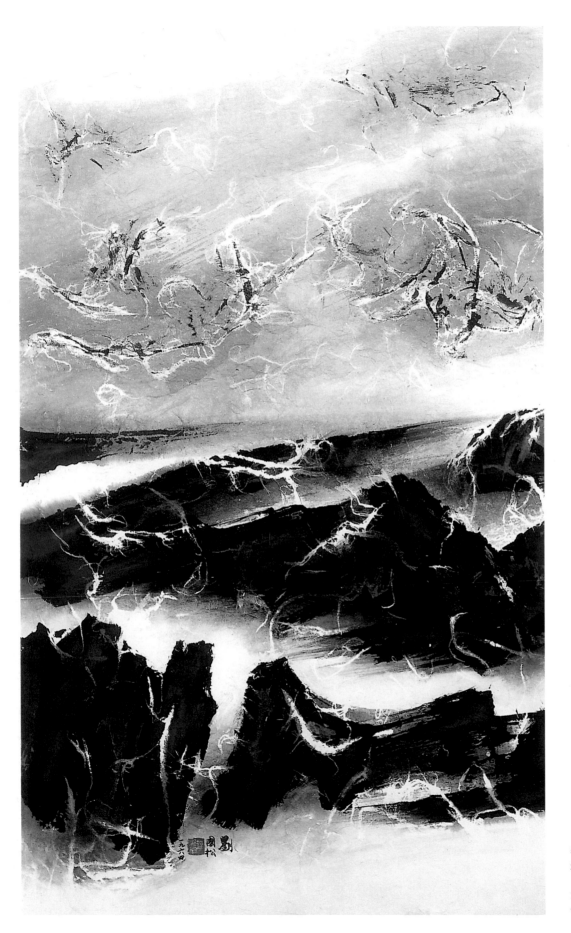

嶺上煙雨
Smoke and Rain on the Hill
1964
水墨設色、紙本 Ink, color on paper
93.5 × 58 cm

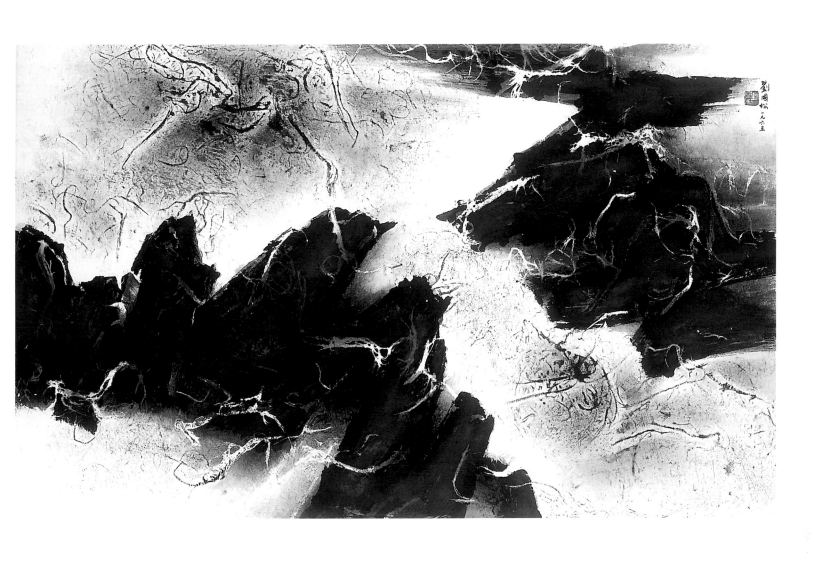

迤迤邐邐
How It Trails
1965
水墨設色、紙本 Ink, color on paper
58 × 95.1 cm

這件1965年的創作，先以大筆掃出狂草式的墨色，再以抽筋剝皮皴的技法在大面積的墨色中撕下紙筋，留出白色的線條，經心佈局的白線成為畫龍點睛的關鍵，畫面上從左至右大片留白的構圖呈現虛實之間的力道，整體以黑、白、灰色調為主，表現浩瀚磅礴的大器，當中又以花青渲染，營造遠近、濃淡的層次，呈現山、雪、雲、霧之間的飄逸與奧妙，鋪陳中國山水的精神，帶來東方抽象畫的意境，顯現渾然天成的美學神韵。

In this piece,completed in 1965, ink was first applied in a kuangcaoor wild cursive style using a large brush. Strips of paper were then creased, ripped and scrunchedleaving white lines in the black ink. The white line running across the centre is a key element and injects the art work with life. The large white strip running across the centre of the piece has an elemental power to it. Black, white and gray are the main colors used, creating a sense of boundlessness. Mean while, washes of cyanine bluehelp emphasize perspectives of near and far and contrasts of light and dark, bringing out the elegant and subtle features of the mountains, snow, clouds and mist. This fine example of Chinese abstract art is very must a Chinese landscape in spirit, and has abundant aesthetic charm.

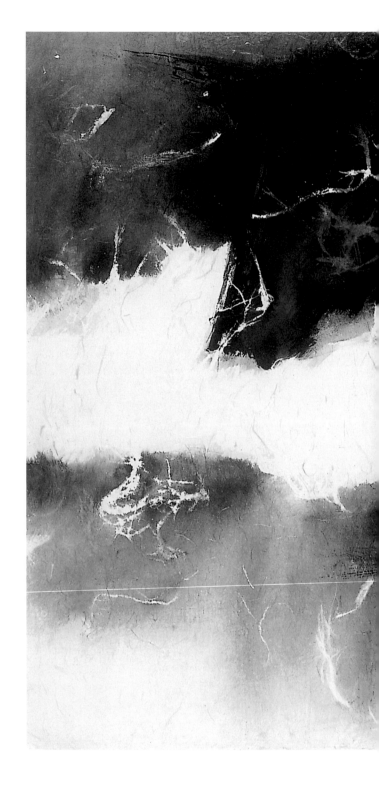

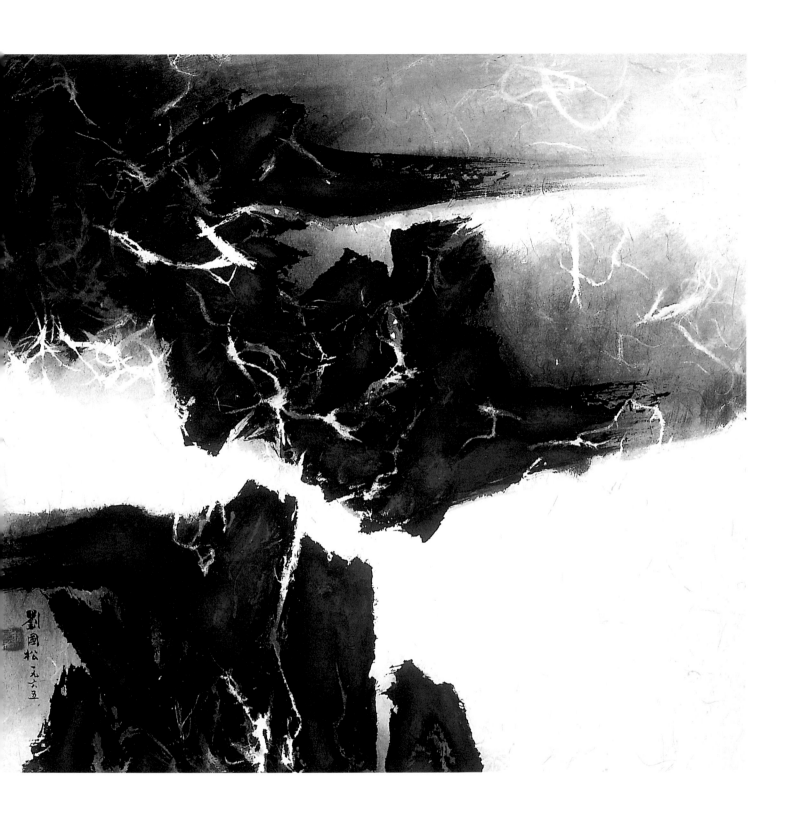

望中
In the View
1965
水墨設色、紙本 Ink, color on paper
57.6 × 94.9 cm

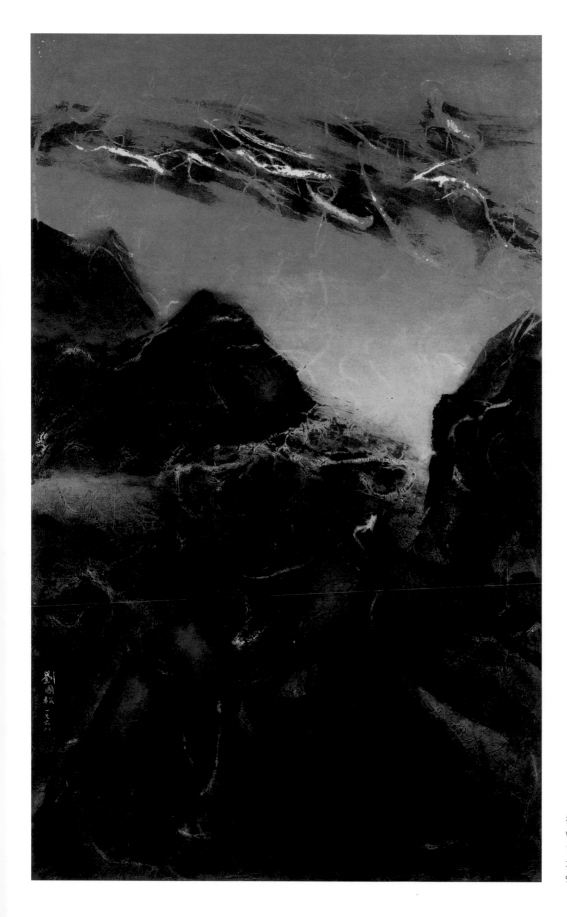

行空
Walking in the Sky
1968
水墨設色、紙本 Ink, color on paper
94.5 × 85.3 cm

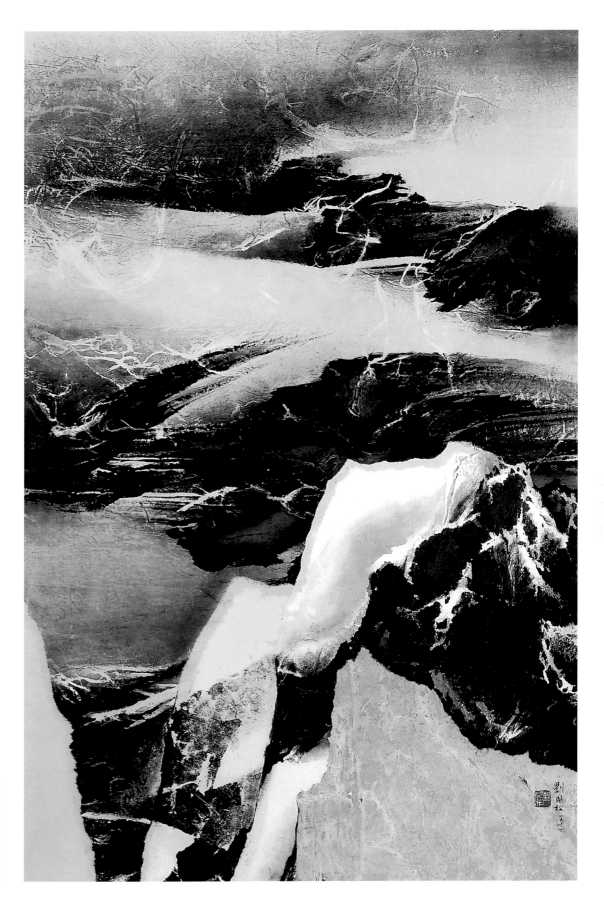

峰迴路轉
Zigzag Landscape
1966
複合媒材 Mixed media
86 × 59 cm
香港藝術館典藏
Hong Kong Museum of Art Collection

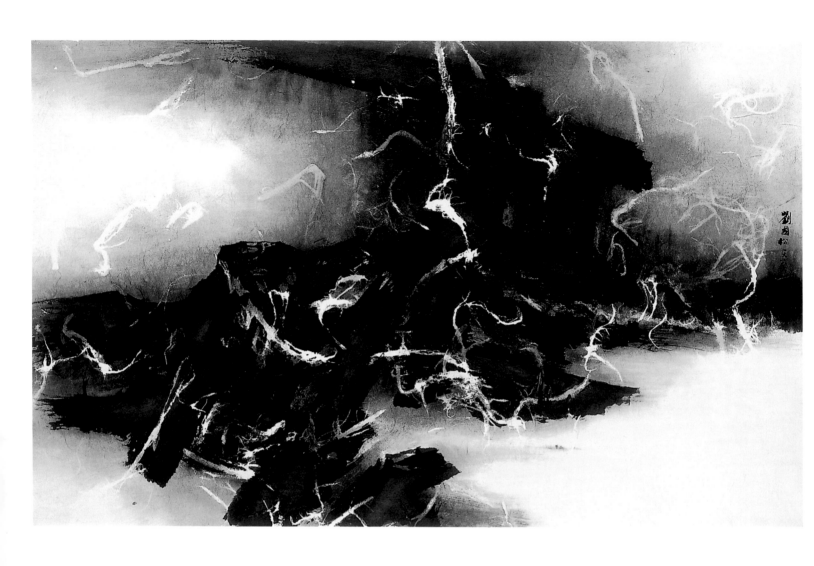

若出其中
Emerging from Inside
1966
水墨設色、紙本 Ink, color on paper
58.5 × 95.3 cm

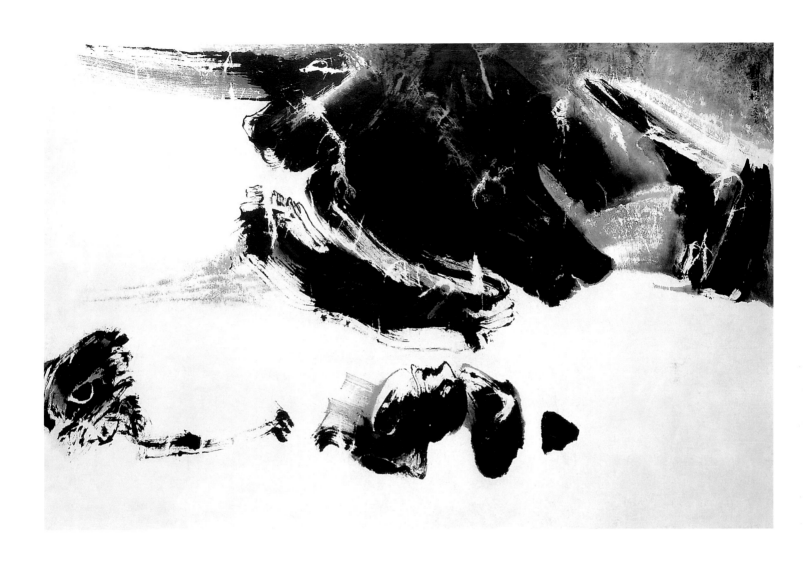

倚石圖
Leaning on the Rock
1967
水墨設色、紙本 Ink, color on paper
59.6 × 91.6 cm

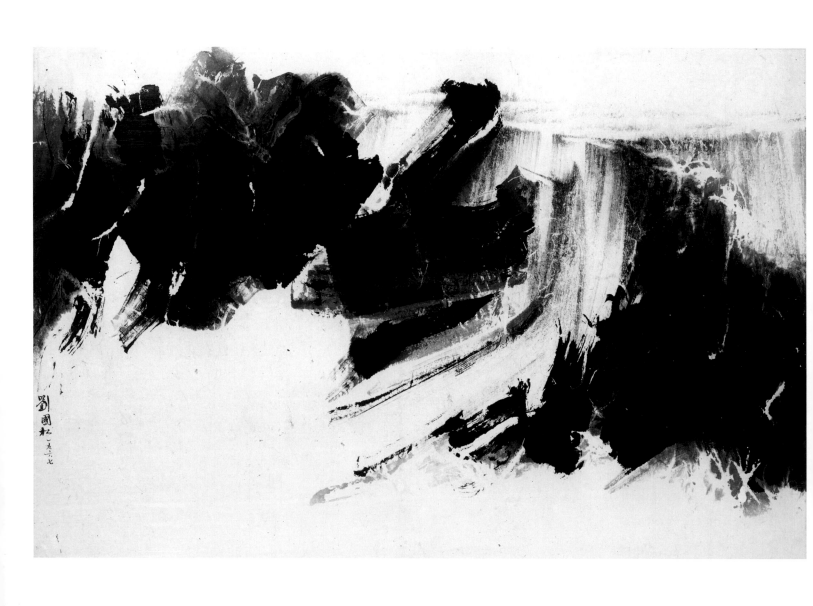

臨流直下
And Down Goes the Water
1967
水墨設色、紙本 Ink, color on paper
60.4 × 93 cm

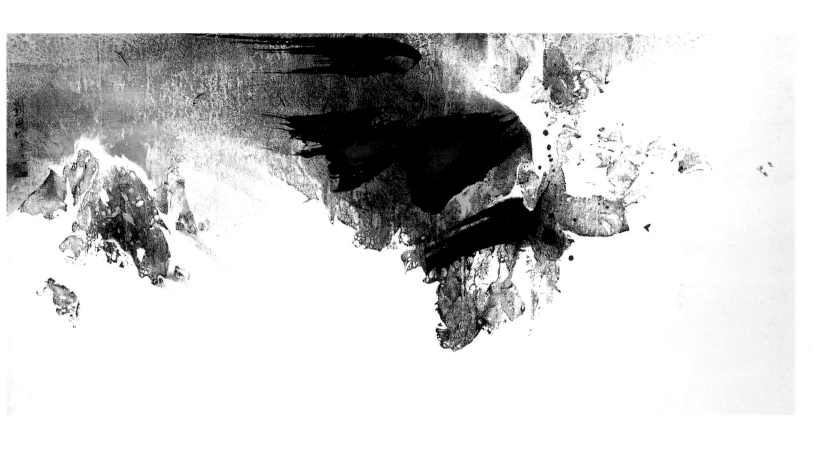

踏雪圖
Walk in Snow
1969
水墨設色、紙本 Ink, color on paper
45.3 × 95.5 cm

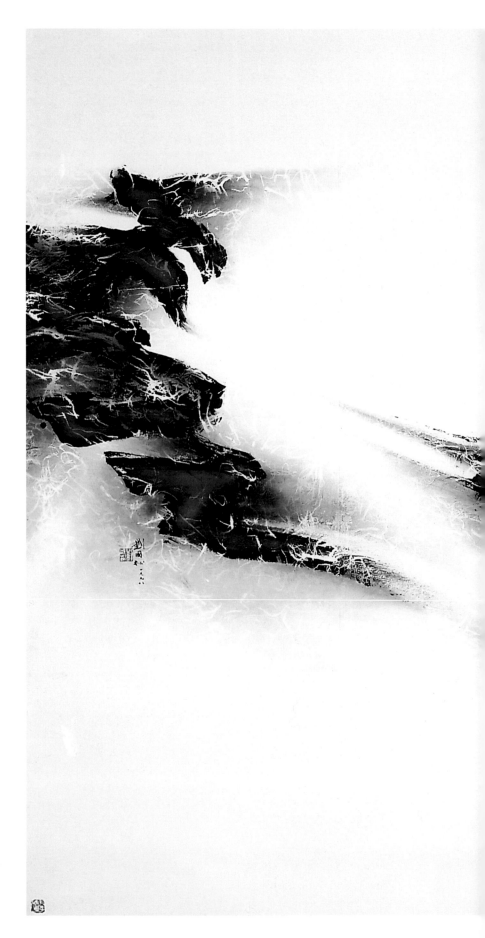

宇宙即我心
Universe is My Heart
1998
水墨設色、紙本 Ink, color on paper
225 × 360 cm
私人收藏
Private collection

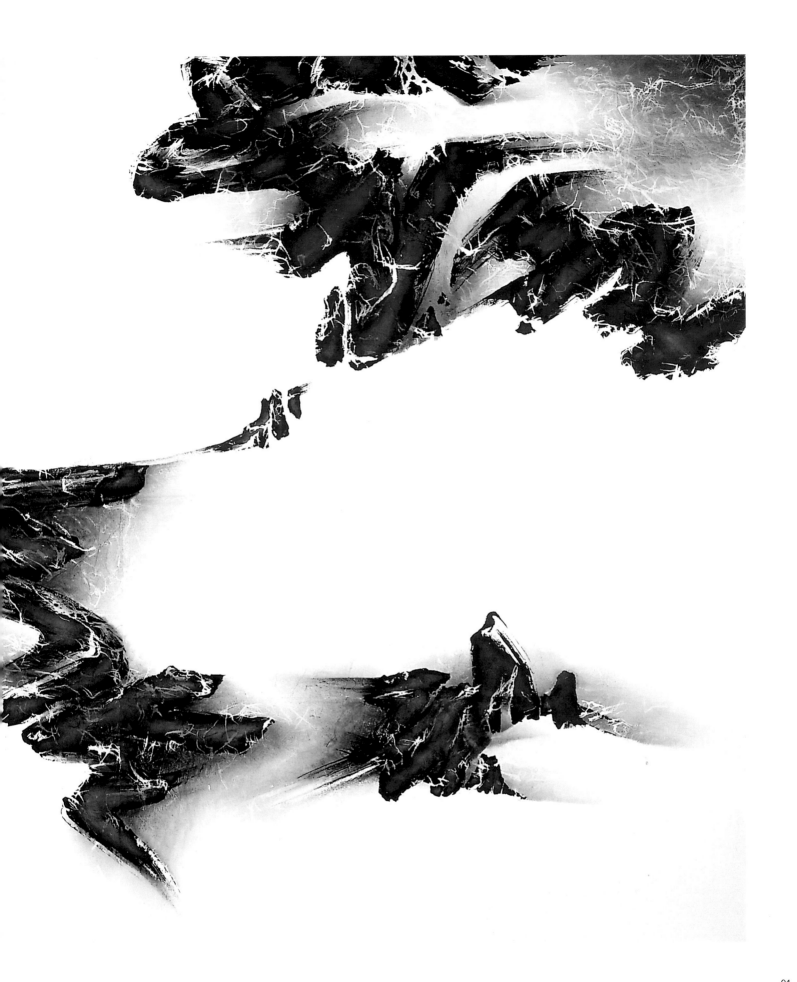

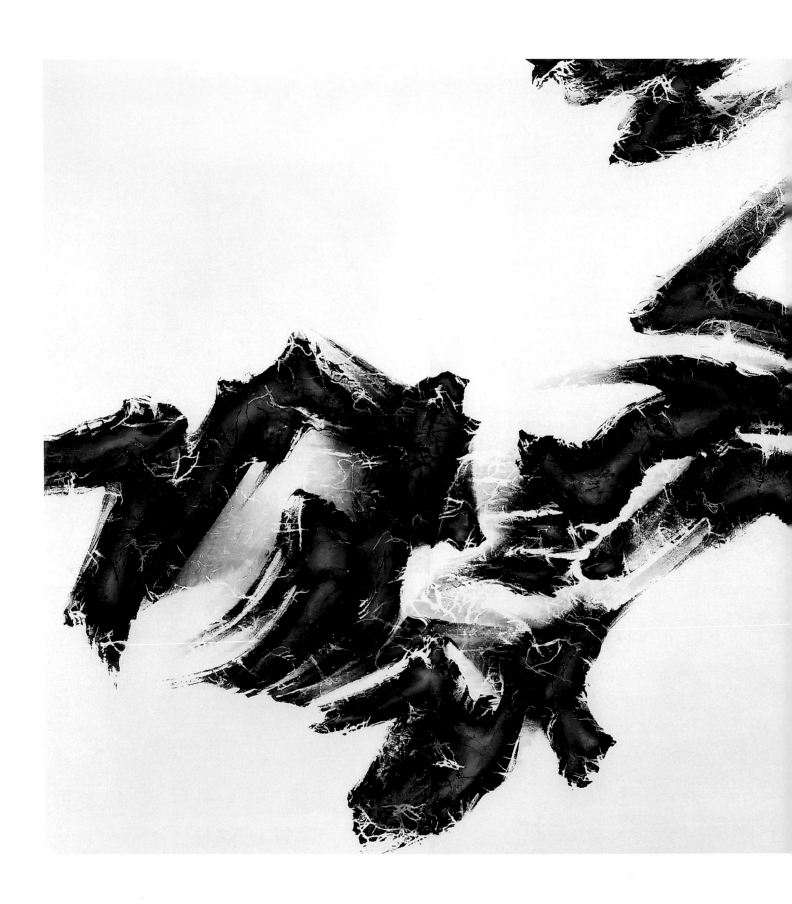

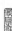

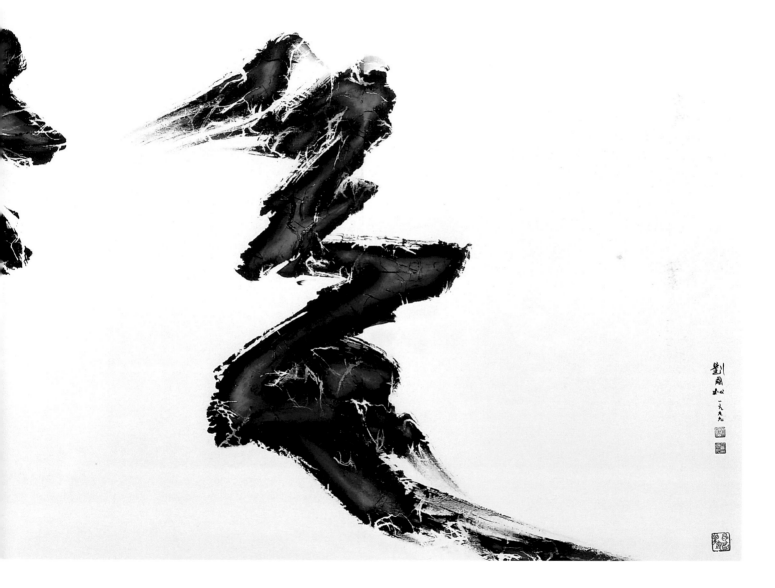

宇宙即我心之 6
Universe is my Heart No. 6
1999
水墨設色、紙本　Ink, color on paper
186 × 366 cm

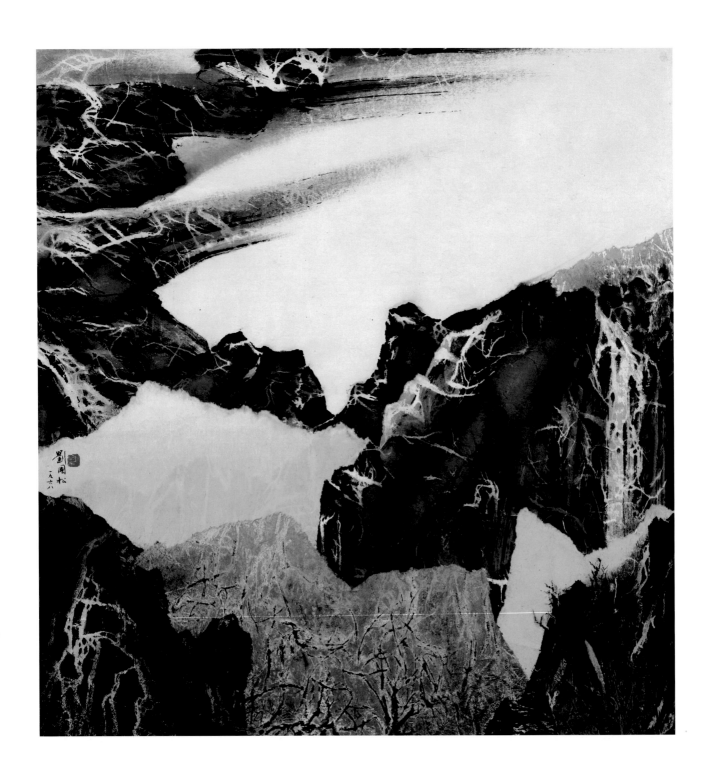

山外山
Mountain beyond Mountains
1968
水墨設色、拼貼紙本 Ink, collage on paper
99.3 × 94.5 cm
國立台灣美術館典藏
National Taiwan Museum of Fine Arts Collection

三、太空系列　Space Series

太空畫的發想源於1968年，美國太空船阿波羅八號繞過月球拍攝的地球照片，帶給劉國松重大的啟發。中國人向來以「天圓地方」形容地球，真實照片裡看到的卻是圓形的地球和一個圓弧形的月球表面，這個奇特的景觀激發起藝術家無限的想像。同時，劉國松深受范寬《谿溪山行旅圖》的影響，圖的上方矗立著高聳壯碩的山形宛如巨碑，與下半部橫向流過的溪水，形成一個「且」或「旦」字，以此創作了《矗立》系列，之後在畫的上半部加上方形構圖，創作了《窗裡窗外》。

有一年在元宵節看花燈時，被走馬燈吸引，於是在方形中加上了圓，創作了《元宵節》，後來又把《端午節》、《中秋節》圓形背後的方框去掉，畫的下半部以弧形表現寬廣的宇宙觀，內部以狂草抽象式的大筆觸表現肌理，花青染色，抽筋剝皮皴帶來白線留白，以此成了太空系列的雛型，構圖上除了上下垂直的結構，還有左右對稱的排列，以及一字排開的橫向大連屏，其中加入裱貼、噴槍、轉印、拓墨等技巧。經過《窗裡窗外》《端午節》等一次又一次轉換的過度期，太空系列從1969年的《地球何許?》一直延續到現在。

Liu Kuo-Sung's space paintings were inspired by the photographs taken from Apollo 8's first orbit around the earth in 1968. Chinese have used "the heavens are round and the earth is square" to describe our planet and the universe, yet actual photographs revealed a round earth and curved moon surface, which sent the artist's imagination soaring. Meanwhile, strongly influenced by Fan Kuan's Travelers Amid Streams and Mountains, the upper portion of the image is dominated by a robust mountain shape, towering like an enormous pillar. Together with the flowing stream below, it forms a Chinese character like 且(even, both, and) or 旦 (dawn, day). This work formed the genesis of the *Towering* series, and by adding a square composition to the upper portion later led to *Inside and Outside the Window*.

One year during the Lantern Festival (translator's note: the Lantern Festival is held on the fifteenth day of the Chinese New Year), Liu found himself strongly drawn to rotating lanterns. This led him to add round shapes to rectangular ones to create Lantern Festival. In the subsequent Dragon Boat Festival and Mid-autumn Festival, the rectangular frame was removed from behind the round shape, the lower portion of the picture expressed an expansive vision of the universe with curved forms, whilst the inside expresses texture with rhapsodic abstract large brush strokes, colorful accents, and white lines left by peeling paper cords. Forming the prototype of the Space series, the vertical structure of upper and lower portions is complemented by symmetrical right and left alignment and a large horizontal dividing line, and employs such techniques as collage, airbrushing, transfer, and ink rubbing. After an initial transitional period of one transformation after the other with such works as *Inside and Outside the Window* and *Dragon Boat Festival* the Space series has continued from 1969's *Which is Earth?* through the present.

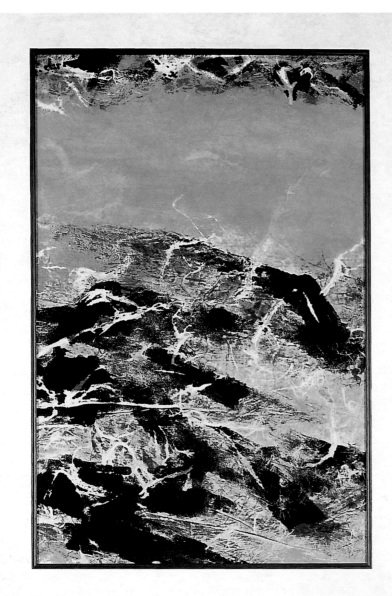

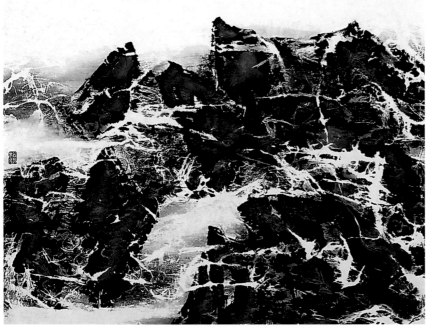

窗裡窗外
Inside and Outside the Window
1968
複合媒材　Mixed media
152.2 × 73.2 cm
黃國杰先生收藏
Huang Kuo-Chieh collection

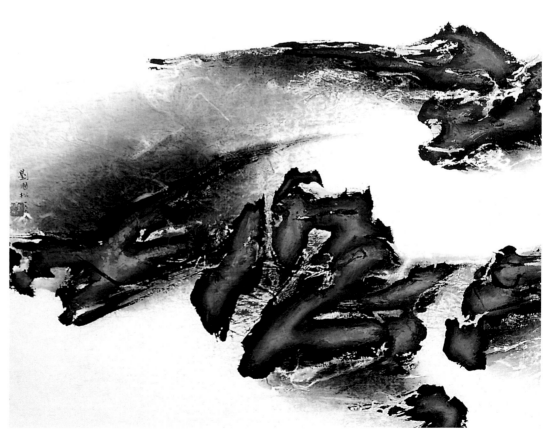

端午節之 2
Dragon Boat Festival No.2
1969
水墨設色、拼貼紙本
Ink, collage on paper
114 × 70 cm

劉國松太空畫的雛型從《地球何許?》這一系列開始發展,畫的下方以
大筆觸的書法線條加上抽筋剝皮皴法,表現虛實交錯的意境,有單純黑
白的對比,有墨彩兼具的肌理表現,以圓弧形代表星球表面的遼闊視
野,弧形上方則以裱貼法襯托球體的圓形輪廓,彷彿太空船攝影鏡頭下
的地球顯像,也有神話裡嫦娥奔月、玉兔搗藥、吳剛伐木的幻影,到底
哪個是地球?留給觀者無限遐思,成為此畫的精神,也是劉國松太空畫
的思維精髓。這個系列的第一張畫獲得美國「主流國際美展」繪畫首
獎,受到鼓勵之後的四年間,劉國松畫了三百多張太空畫,至今仍然以
太空畫持續推出不同題材的新作。

This was a piece in one of Liu Kuo-Sung's early space series. The
bottom of the painting has been produced using large brush strokes
and paper ripping to create a mysterious atmosphere and a simple
contrast of black and white. The painting features marbling patterns
of ink and color. A disc represents the extensive field of view of
the globe's surface. Collage has been used above the globe to
emphasize its form. It appears like an image of the earth shot from
the window of an orbiting space craft but also phantoms of Chinese
moon legends, such as the lady in the moon, the Moon Rabbit and
Wu Gang the Woodcutter. Is it the earth or the moon? This painting
inspires wild and fanciful thoughts in the viewer. This was a feature
of Liu's space inspired paintings. This piece won a prize at a major
American art show. Liu painted three hundred more space paintings
in the following four years. Today Liu continues to produce works on
different topics under the theme of space.

地球何許?之 41 Which is Earth? No. 41
1969
水墨設色、拼貼紙本 Ink, collage on paper
125.3 × 75.3 cm

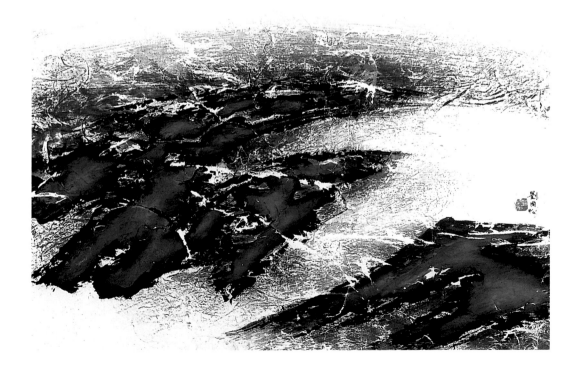

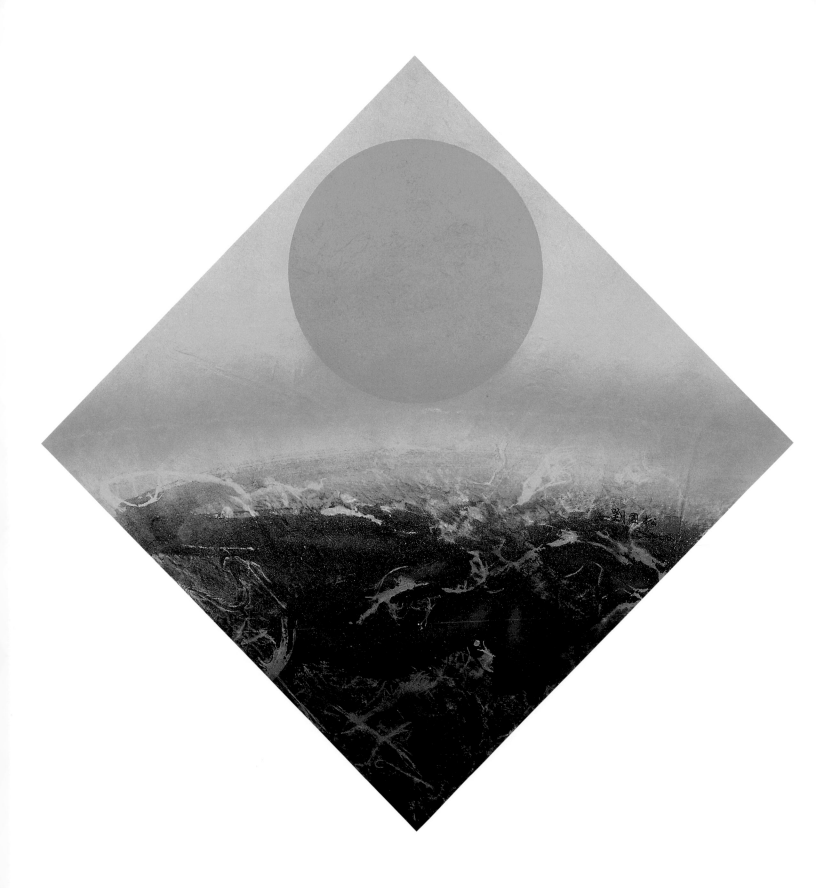

月之蛻變 (A)
Moon's Metamorphosis A
1970
複合媒材 Mixed media
55.5 × 55.5 cm

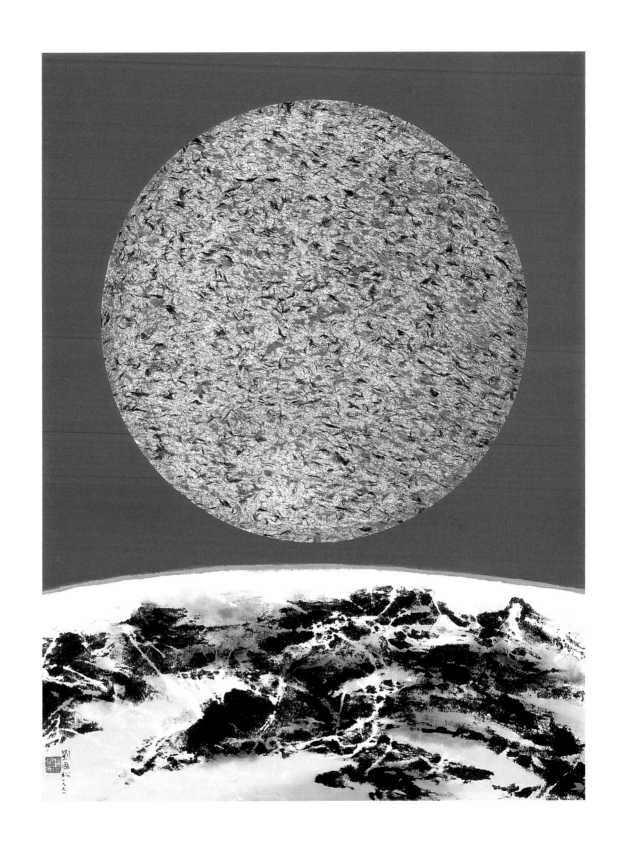

日之蛻變之 3
Moon's Metamorphosis No. 3
1971
複合媒材　Mixed media
81 × 60 cm

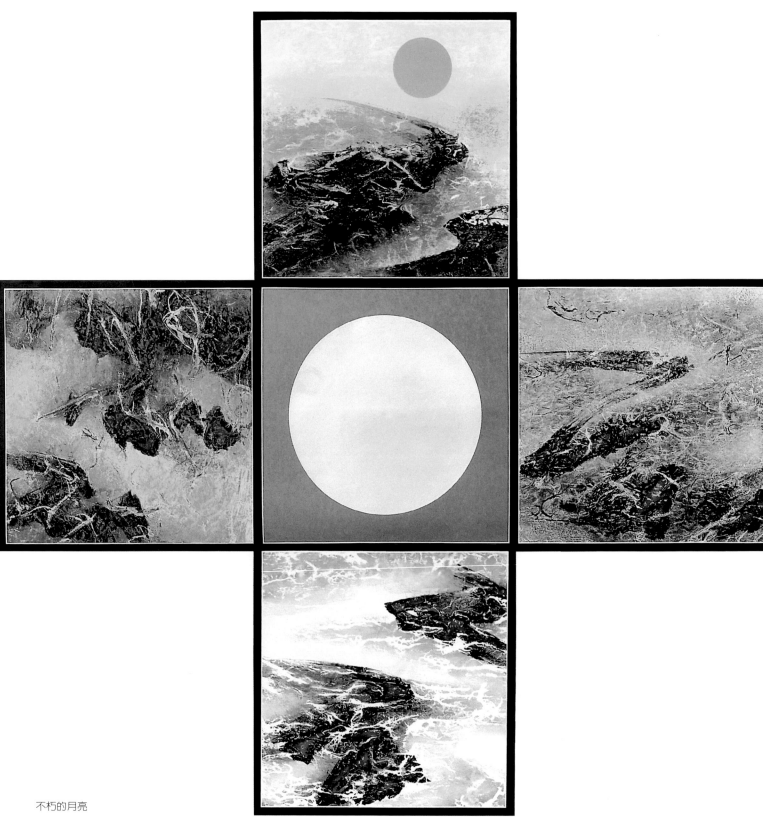

不朽的月亮
A Moon for all Seasons
1971
複合媒材　Mixed media
50 × 50 cm × 5 pieces
香港藝術館典藏
Hong Kong Museum of Art Collection

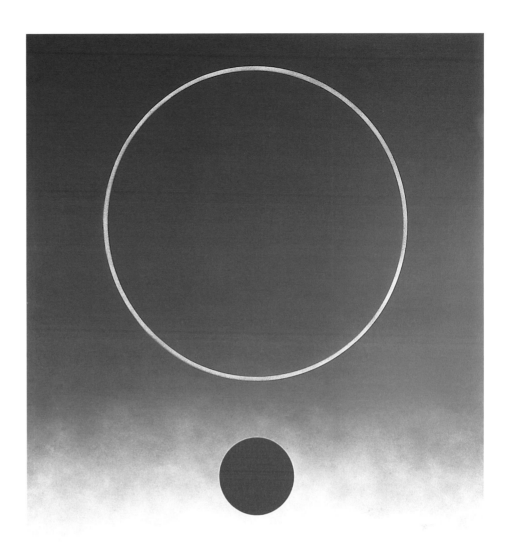

環中
Central Ring
1972
複合媒材 Mixed media
171.3 × 91.6 cm

此畫以上下垂直的構圖表現宇宙變化，描繪地球與太陽的互動，以及太陽在時間與空間上產生的變化，從二元、三元，再到多元的結合，強調宇宙動態的運作。畫面三分之一的下半部以狂草抽象表現粗獷、自在的空間，三分之二的上半部以噴槍法由上而下漸次改變圓的造型，藉以描繪太陽在時間轉移變化中的微妙狀態，表現了時間刻度下的日落景觀。

This work depicts the setting sun with a series of globes arranged in a vertical manner, describing the relationship between the earth and the sun, and the influence of the sun on time and space. By showing the sun in different positions as it traverses the sky, the painting emphasizes the dynamic workings of the universe. The bottom third of the pieceis an uninhibited and free space done using the kuangcao wild cursive abstract style. The top two thirdsof the work were done using a spray paint gun. The shape of the discs gradually change as they go lower representing the subtle changes of the sun during the day and depicting a sunset in progress.

日落的印象之 8
Impression of Sunset No. 8
1972
複合媒材　Mixed media
186 × 46.5 cm
國立台灣美術館典藏
National Taiwan Museum of Fine Arts Collection

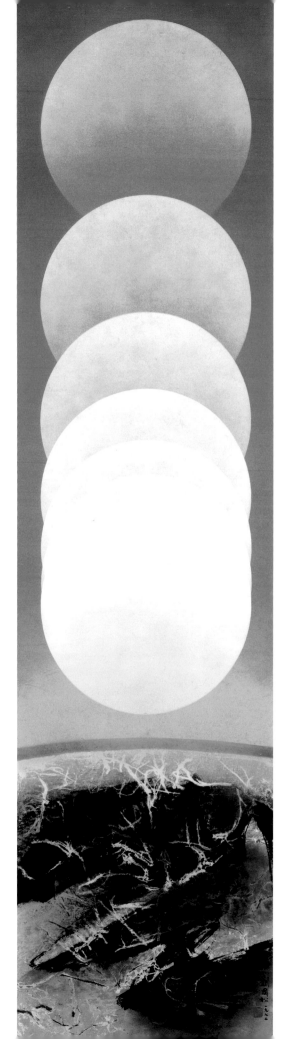

這是藝術家帶著自畫像意味的作品，也可以視為他在藝術歷程上的軌跡。畫面上以三個星球為主要構圖，兩個圓形置中上下排列，主題「一個東西南北人」以海報裁剪後的方形印刻文字置於最上的圓形裡，刻意留著四個白色邊緣，呈現陰文篆刻的特色，下部狂草書法大筆觸再染上橙色背景，圓弧線作為 1/3 和 2/3 的劃分，並以噴槍形成黃色的漸層效果，突顯橙色與上半紅色交界處的諧調光暈，中間以單純米黃的圓形調和上、下繁複細節，整體畫面帶著硬邊藝術、平塗色彩的特點，將抽象水墨意境與抽象表現主義融合為一。這幅畫上的七個字「一個東西南北人」，代表了劉國松為藝術創新所經歷的輾轉過程，同時蘊含了異中求同的藝術融合。

The work is composed of three discs with two discs placed one above the other. The title of the piece "A Man of East, West, South and North" is inscribed inside the upper most disc. The four white edges are deliberately left and remind us of a carved seal. At a large brush has applied ink in a wild kuangcaowild cursive fashion and orange washes applied. Lines have been scrapped on the lower disc and a spray gun used to create the subtle layering effect. This emphasizes the halo effect where the orange and the red of the top disc meet. The middle disc is painted in a simple cream color. The painting shares characteristics with hard edge art and hiranuri coloring (even application of color over an under-painting). The title which is inscribed on the piece represents the many twists and turns Liu Kuo-Sung experienced on the journey of his art career.

一個東西南北人之 18
A Man of East, West, South and North No. 18
1972
複合媒材　Mixed media
181 × 91 cm
陳連春先生收藏
Leon Chen collection

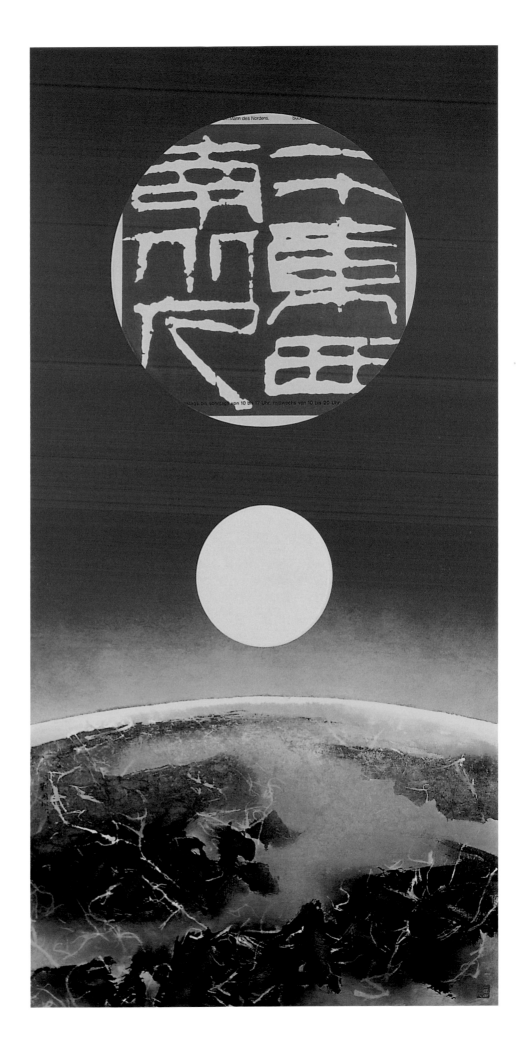

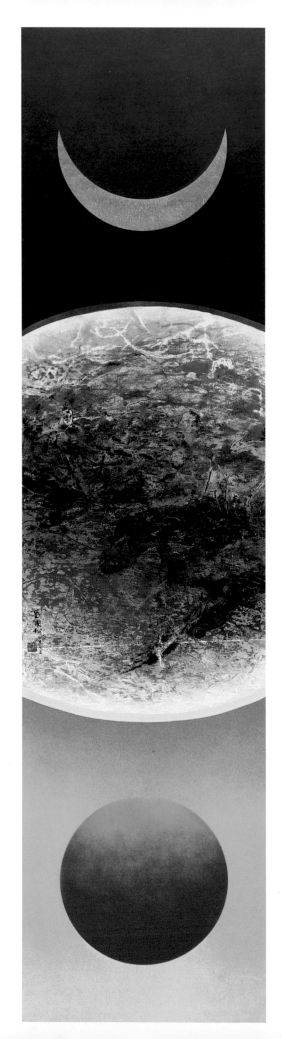

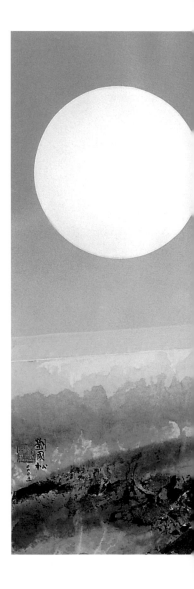

陰陽圖
Ying and Yang
1973
複合媒材 Mixed media
185 × 46 cm
童培炎先生收藏
Tung Pei-Yeng collection

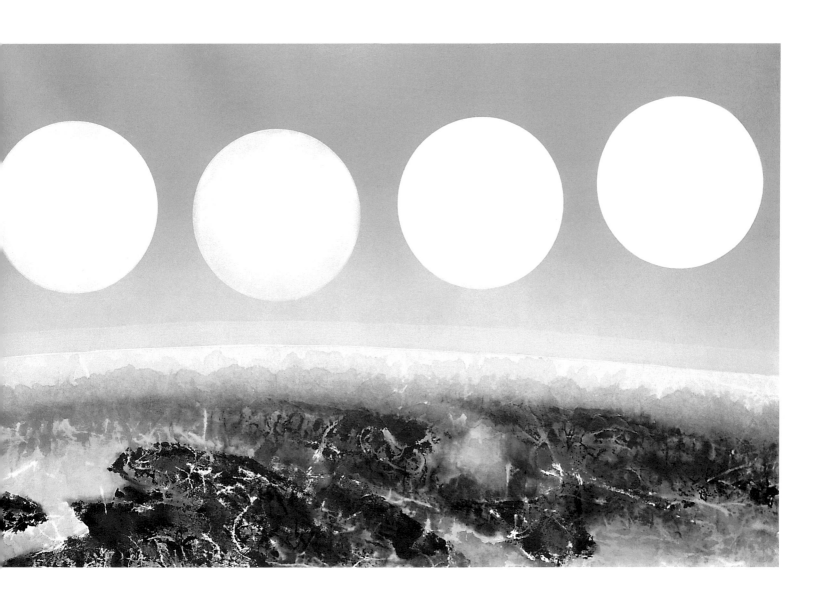

滿月圖
Full Moon
2005
複合媒材 Mixed media
70 × 139.5 cm
周欽俊先生收藏
Chou Chin-Chun collection

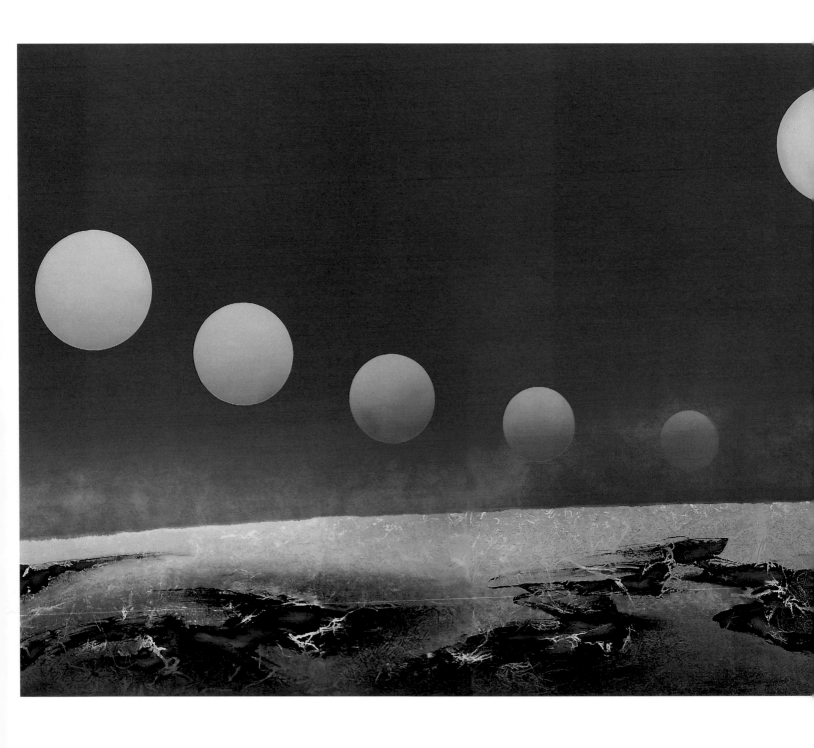

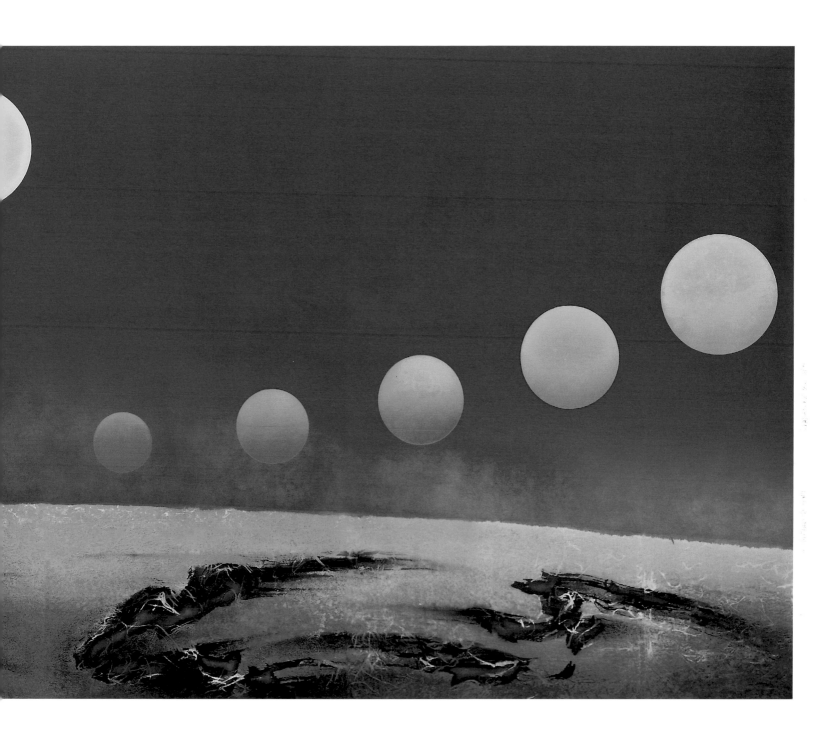

動耶?靜耶?
Moving? Staying?
1998
複合媒材 Mixed media
185 × 478 cm
香港藝術館典藏
Hong Kong Museum of Art Collection

1968年劉國松在瑞典看到終日不落的太陽,受到很大的啓發,以此現象描繪太陽運行軌跡的系列創作,《來去自如》即為其中的一幅。此畫採取三連屏的橫向構圖排列,以噴槍法處理太空背景與星球主體的色調,色彩勻淨、漸層,成功表達了時間在空間上的移轉與運行。寬達四米的畫面上,九個大小不同的太陽依序排列,中心處又以一個圓,顯現日、月、地球三者的緊密關係。整個畫面幾近重複、對稱的構圖,單調中另有玄機,看似工整卻帶著微妙的變化,以狂草抽象表現地球肌理,延展的弧形帶著混沌的氣勢,如盤古開天的宇宙初始,獨特的佈局帶來一股無形的氣魄,引導觀者在靜默中進入冥想,彷彿浩瀚宇宙的神秘結構就在眼前運轉,夸父追日、后羿射日的中國神話,與天文物理、天體力學融合在一個畫面。於是,感性與理性結合,藝術與科學觀念銜接,就在同一個畫面完成。

In 1968, Liu Kuo-Sung travelled to Sweden and was inspired by the midnight sun to produce a series of works depicting the sun's orbit of which "Coming and Going" is one. This work has a composition of three horizontal layers. The background behind the suns and the stars were applied using a spray paint gun. The subtle layers of color succeed in depicting the shifting of time in space. Nine suns of varying sizes are positioned across the four-meter wide canvas. Another smaller circle in the centre of the piece represents the moon and by extension the close relationship between the sun, moon and earth. The composition is almost repetitive and symmetrical. There are mysterious principles in the simplicity. The work which appears ordered changes subtly. The earth is rendered using a kuangcao wild cursive abstract style. The arch of the earth has a primal power to it like the earth at its earliest formation. The unique arrangement has a formless imposing energy to it that induces the viewer into silent meditation as if the secrets of the universe were revolving in front of his eyes. Chinese fairy tales such as Hou Yi who shot the sun with an arrow and astrophysics and celestial mechanics seems to be combined in one image. In this piece, emotionality and rationality combine and art and scientific concepts meet.

來去自如
Coming and Going
1999
複合媒材　Mixed media
180 × 448 cm
香港藝術館典藏
Hong Kong Museum of Art Collection

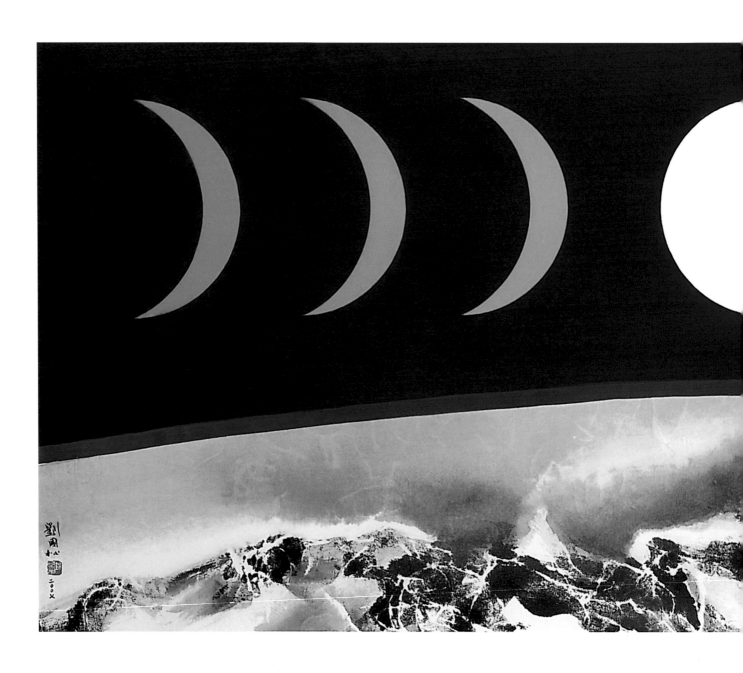

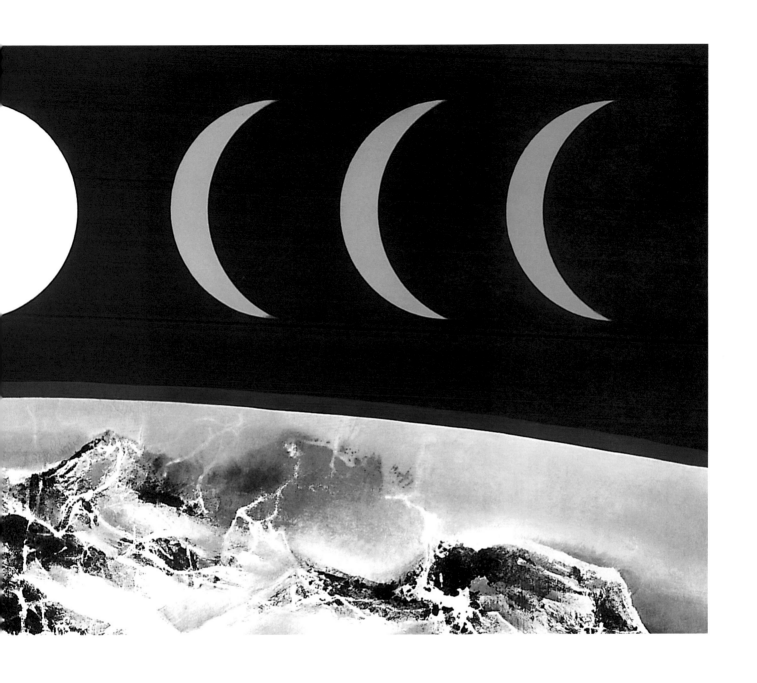

日月相照
The Sun and the Moon
2007
複合媒材 Mixed media
72 × 182 cm

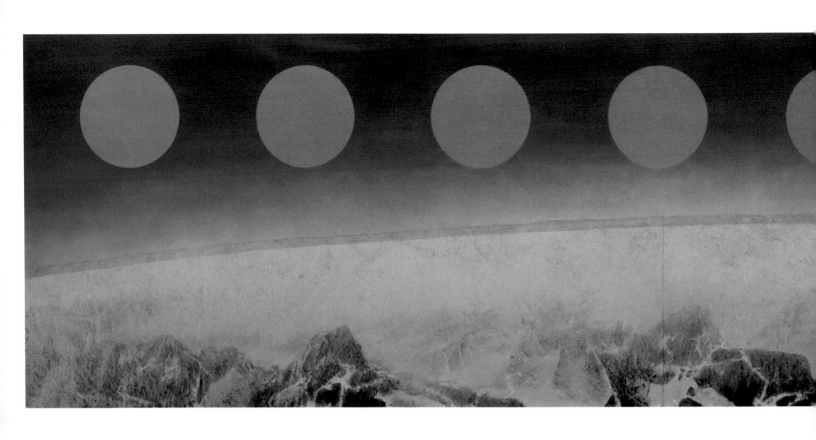

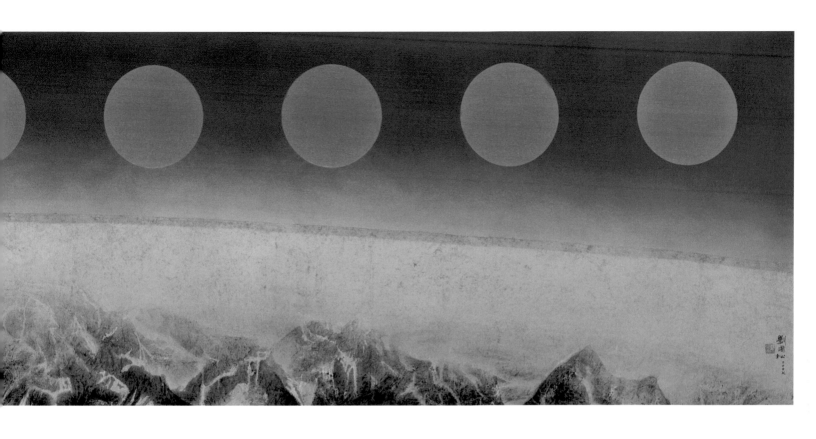

九日在天
Nine Suns in the Sky
2007
複合媒材 Mixed media
65.5 × 293 cm
國立台灣美術館典藏
National Taiwan Museum of Fine Arts Collection

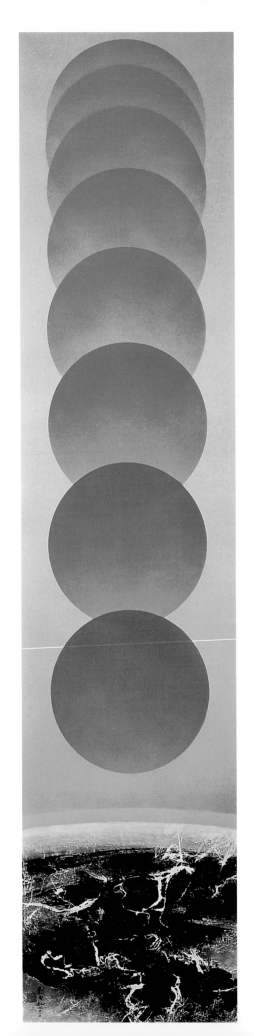

太陽來了
Sun is Coming
2010
複合媒材 Mixed media
181.6 × 41 cm

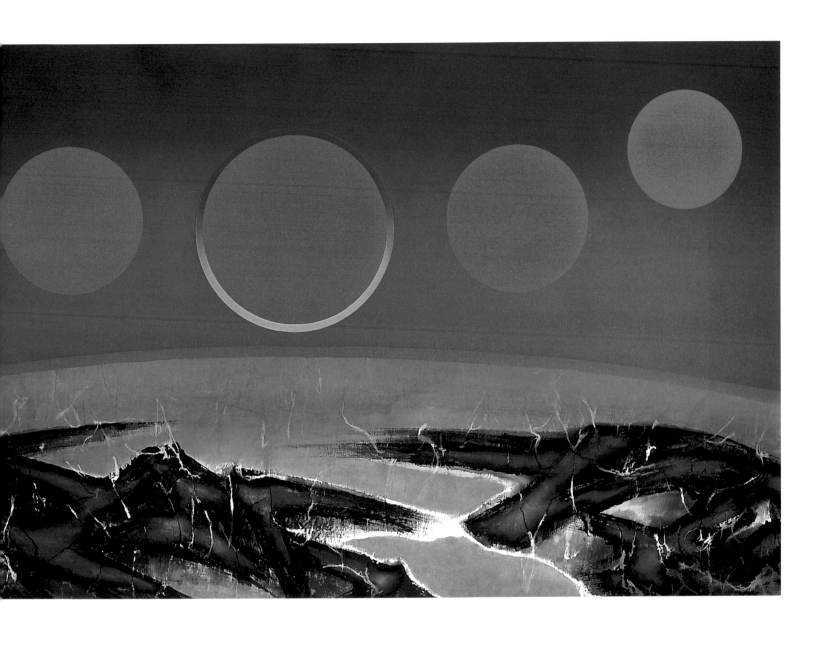

日之蛻變
Sun's Metamorphosis
2008
複合媒材 Mixed media
99 × 179.5 cm

此畫延續太空系列的架構，下半部弧形內以大筆揮灑、大片留白，表現狂草書法的抽象意境，抽去紙筋後留下白線，表現細節、肌理；上半部以對稱於兩邊的弦月為虛擬情境，深邃的黑色太空中，以裱貼法將神舟六號的特寫影象與左右相呼應，紅色的圓形與弦月等距且置中，再以六個代表光環的同心圓圈，把畫面上、下、左、右四個元素串連起來，其中的圓形、圓環、弦月都以噴槍上色，畫的上半部表現硬邊造型藝術，細膩、均勻、純淨的噴槍色彩，與下半部的粗獷、揮灑、空靈成為鮮明的對照，多種元素在上下迥然不同的意境中融合為一，構成一幅具有時代意義的創作。

This is a piece in the artist's space series. The disc at the bottom has been applied with sweeps of a large brush and there are large areas of white space showing the abstract influences of the kuangcao wild cursive style. Creases in the paper have created white lines which render details and grain. At the top half of the work, two half moons echo each other at either side sitting amid deep, black space. The Shenzhou-6 space craft has been rendered in collage and sits at the centre of the red disc and the half moons. A concentric circle of six rings of light links up the four elements at the top, bottom, left and right. The circle, rings and half moons have been painted with a spray gun. With it's even, pure application of spray paint the top half of the piece has been done in the hard edge style. It forms an obvious contrast with the thick and broad, sweeping brush strokes of the bottom half. The different elements above and below form a united whole in this historically relevant work of art.

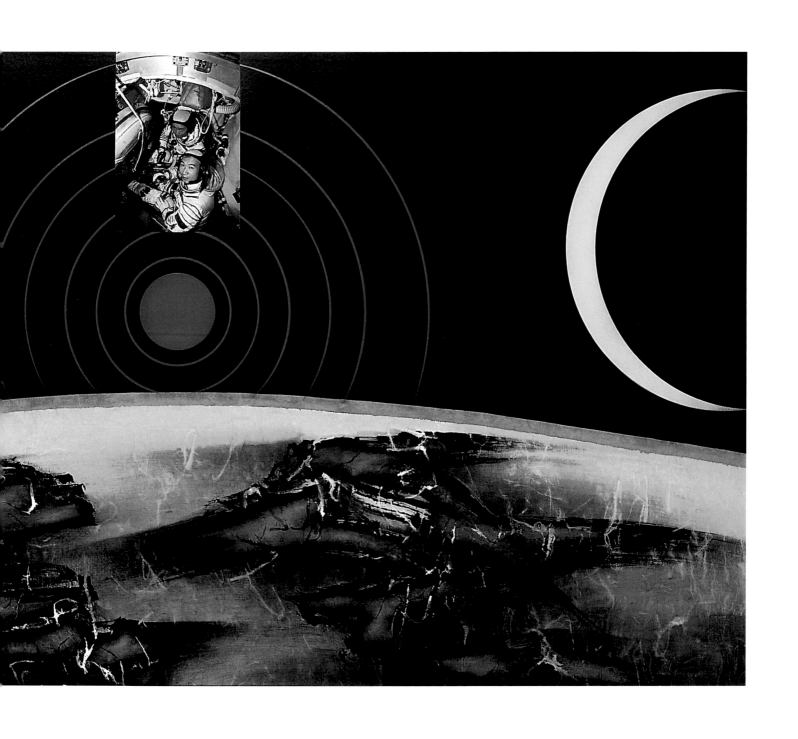

匯報：神舟六號之 5
Report: Shenzhou-6 Spaceship No. 5
2008
複合媒材 Mixed media
98 × 182 cm

四、水拓系列　*Water Rubbing Series*

中國古畫技巧中以水畫最難，劉國松從洗筆的水盆中得到靈感，花了五、六年的時間研究水拓法，從水盆換到澡缸，嘗試大面積的作品。水拓法先將筆沾上墨汁甩在水上，由於水的表面張力，每次甩出的墨點在水面上不相連，點與點之間會形成白線，墨汁在水面上佈滿後，以手指捏著宣紙兩端，將紙慢慢放在水面上，放紙的速度快，拓印的墨就濃些，放得慢就淡些。拓墨後的紙呈現各種形狀的墨塊與白線，再以此加上細節或染上顏色，也可以噴灑松節油，使得水、墨、油在水面上產生變化多端的肌理、流動的紋路，以及巧奪天工的留白。1974年《錢塘潮》仍然擺脫不掉月亮的影子，1976年《屹立與流動之間》以水拓法、裱貼法同時表現在畫面上，到了1981年的《遠眺北麓河》就完全以水拓技法完成構圖。

Water painting is the most difficult of Chinese painting techniques. Drawing inspiration from the brush bath he used to wash his brushes, Liu Kuo-Sung spent five to six years working on his novel water rubbing technique, substituting a bathtub for small basin to apply the technique on large works. Water rubbing involves wetting the brush with ink and flicking it over the water. Due to the surface tension, the ink dots on the water remain separated, leaving white lines between them. Once ink has covered the surface, the paper is gripped on its ends and slowly placed on the surface. When it is dipped quickly the rubbed ink is thicker; when it is dipped slowly it is lighter. The dipped paper takes on ink blotches of various forms and white lines, to which detailing or coloring is added; or some turpentine can be sprayed on so that the water, ink and oil produce varying textures and flowing patterns on the surface as well as cleverly placed blank spaces. *The High Tide of Qiantang River* (1974) could not escape the shadow of the moon, *Between Unmovable and Flowing* (1976) featured a combination of water rubbing and collage, and *View of Beilu River* (1981) was composed entirely using water-rubbing techniques.

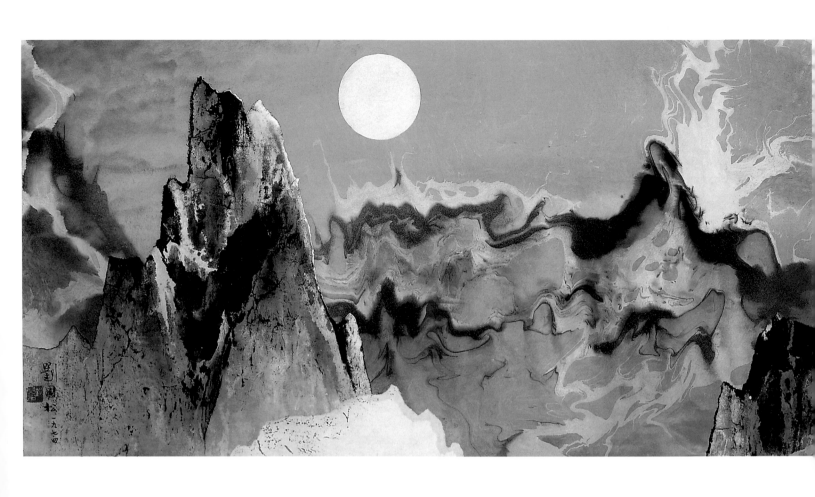

錢塘潮
The High Tide of Qiantang River
1974
複合媒材 Mixed media
45 × 87.5 cm

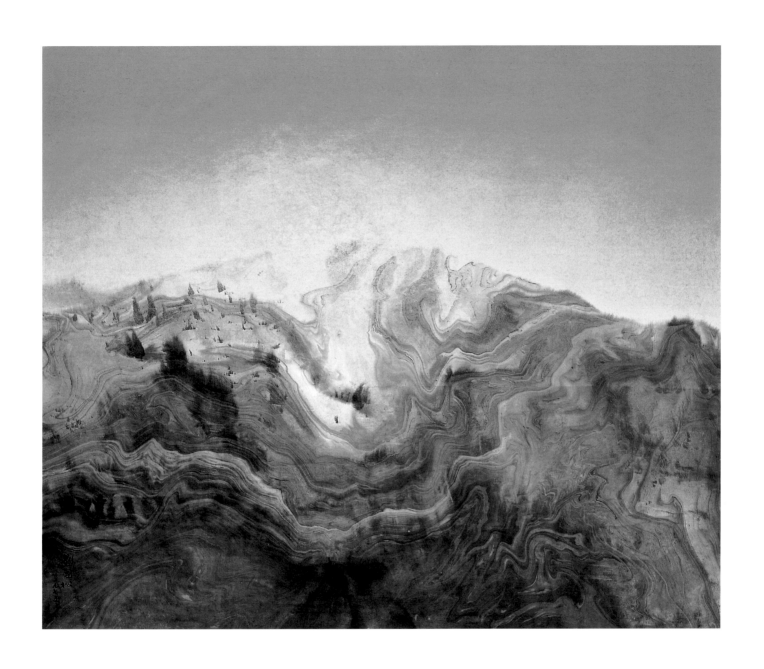

日出東山頭
Sunrise from the East Mountain
1975
複合媒材 Mixed media
57.2 × 68.7 cm

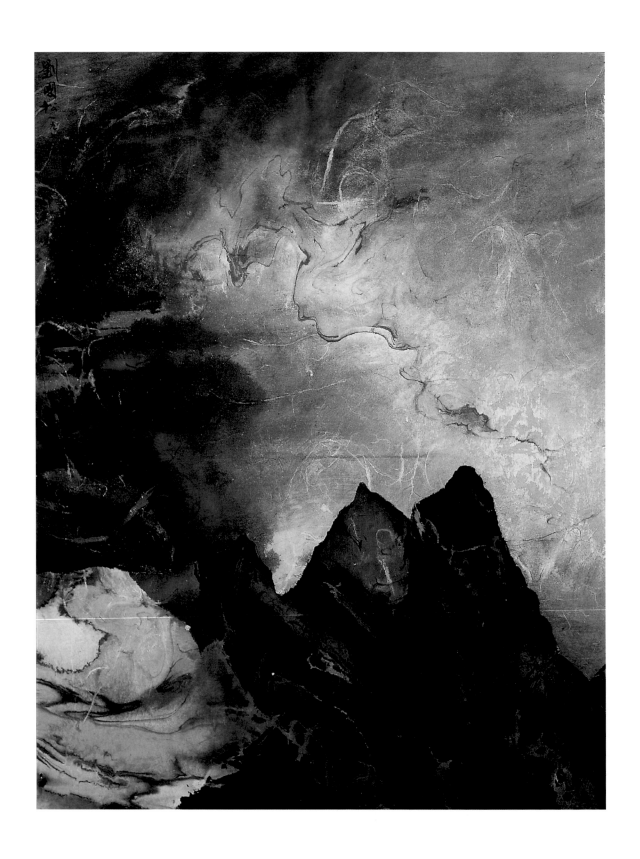

屹立與流動之間
Between Unmovable and Flowing
1976
複合媒材　Mixed media
60.2 × 46.6 cm

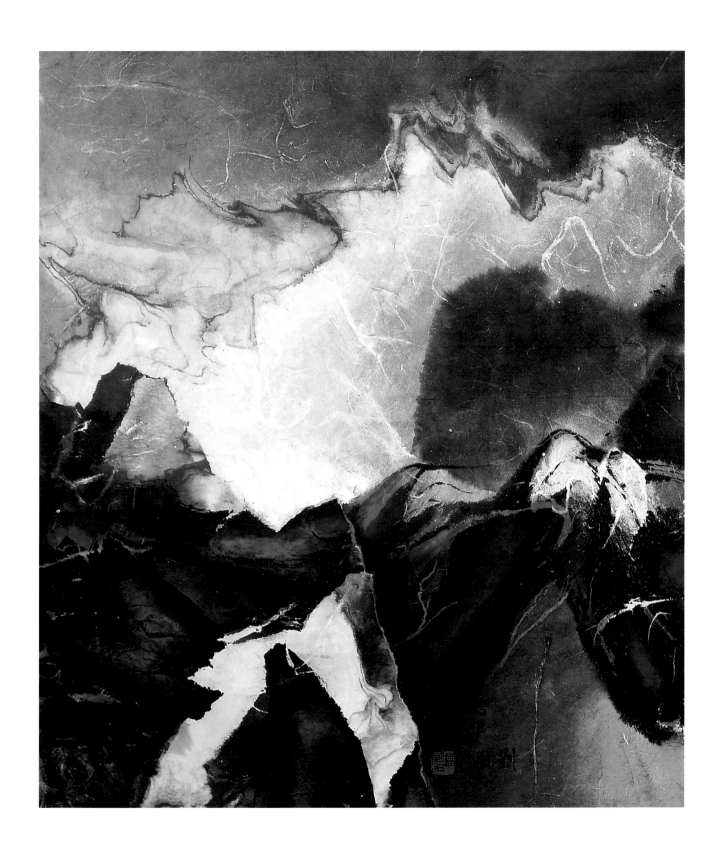

漂浮的山嶺
Floating Mountains
1976
複合媒材　Mixed media
54.7 × 48 cm

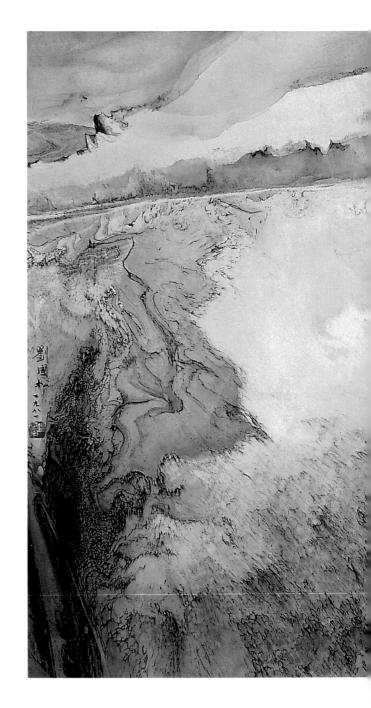

此畫完全以水拓法完成，描繪河川在高原上的奇景。北麓河為通天河支流，河床多為砂礫石，兩岸有沙漠戈壁分布，山水雲霧縹緲其上，虛實空靈的玄機，凌空俯瞰的視野，在細膩的肌理佈局中，彷彿河床穿越隧道、山谷，縱橫於四千米的山區，奔流於遼闊的高原上。此畫雖然拋開筆的包袱，出神入化之中更勝於筆意，豐富的構圖帶動視線由畫的中下方近景開始，至左下方深邃的藍，再轉向右拉至中央的褐色紋理，最後停在右上方的三角處，深遠的天際與近處生動變化的景致互為呼應。畫中以左上到右下一片白色蒼茫，串起四個不同的焦點，巧手佈局之下使得整個畫面渾然一體，抽象意境的自然神韻在此表露無遺。

This piece depicting a river on a plateau was produced using shuituo or water rubbing. Beilu River is a tributary of Tongtian River. The river bed is mostly gravel with deposits from the Gobi desert on both riverbanks. Clouds and mist float above creating a mystical atmosphere. The unusual angle of view and the detail of the marbled patterning seem to show the river passing through tunnels, valleys and across four thousand miles of mountainous terrain, rushing out onto the open plateau. Although this painting shuns the brush, it evokes a spirit and form that supersedes anything that could be produced with a brush. In the busy composition of the work, the eye is drawn first from the foreground at the lower centre to the deep blue at the lower left, then right toward the brown marbled patterning in the centre, before finally resting on the triangular section at the lower right. The distant horizon and the movement in the near ground echo each other. A swathe of white sweeps from the upper left to the lower right bridging the four different focal points. Deft arrangement creates a piece that works well as a whole.

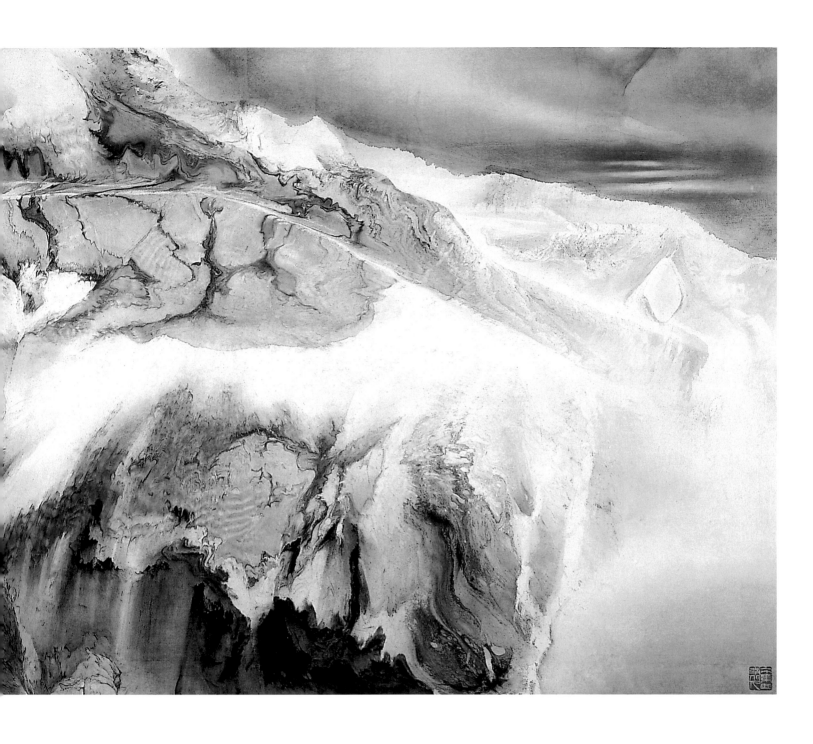

遠眺北麓河
View of Beilu River
1981
水墨、紙本　Ink on paper
70 × 128.5 cm
倫敦水松石山房收藏
Shuisongshi Shanfang Collection, London

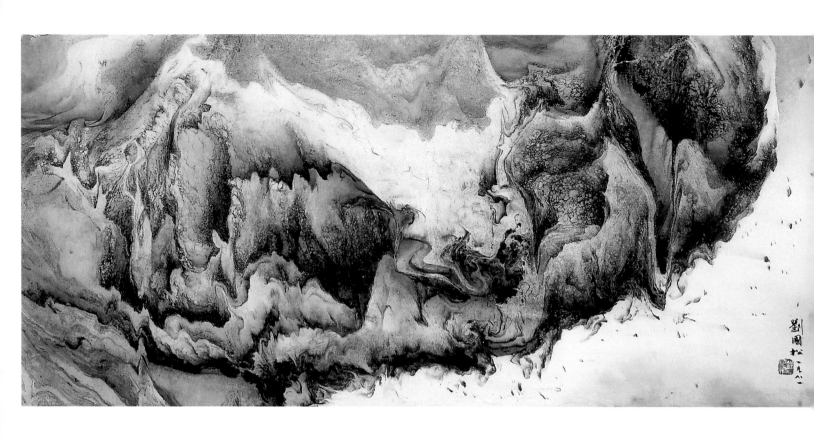

歸帆
Penetrating Promontory
1981
水墨、紙本 Ink on paper
42 × 91.5 cm
倫敦水松石山房收藏
Shuisongshi Shanfang Collection, London

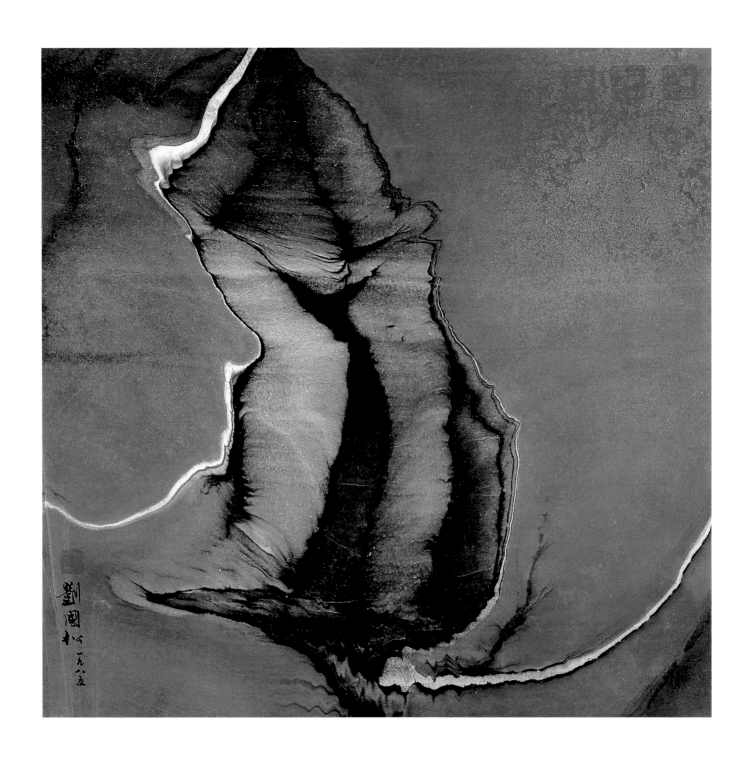

混沌之初
And the Earth was Void and without Form
1985
水墨、紙本 Ink on paper
48.6 × 50 cm
倫敦水松石山房收藏
Shuisongshi Shanfang Collection, London

源於中國水畫的水拓法，處理上十分困難，宣紙遇水或太濕、或破裂，都要放棄重來，其中必須掌握墨彩在水面的張力，準確拿捏畫紙對墨的吸附力，利用各種方式產生變化多端的肌理、流動的紋路、適度的留白。此畫以水拓法表現大自然獨特的景觀，山、水、雲、雪之間的微妙變化，在畫面上呈現行雲流水的動感，水墨、宣紙間渾然天成的交融，形成筆鋒不可及的玄妙之境，以水拓法拓印後再以渲染和局部勾勒構成溪流、瀑布、枝椏、石岸…等細膩景觀，再以裱貼法安排在下角的山峰，使之與右半部柔和的雲雪互為呼應，由底部的層峰向上仰望，揭開天池神秘的面紗，從大片柔美的雲霧中透露出自然造化的美景。這是劉國松駕輕就熟的水拓作品，抽象水墨的意境在畫中表露無遺。

The technique of shuituo or water rubbing, which was used to produce this piece, requires great skill. The paper must not become too wet or split after touching the water otherwise the work must be started again. The artist must master manipulating the ink on the water's surface, and holding the paper just right so that it soaks up the ink correctly. There are also numerous techniques for producing the dynamic grains, flowing marbling patterns and the right amount of 'white space'. This work of art depicts a natural scene of mountains, water, clouds and snow. It captures the feeling of movement of the clouds and water. The deft use of ink and paper encapsulates the wonder of a scene that one would struggle to replicate using a brush. Washes of ink and in some places brush work were used to produce the details of rivers, waterfalls, leaves and rocks. The mountain peaks at the lower left corner were done with collage, which contrasts and compliments the soft clouds and snow on the right hand side. Aveil of sky hangs above the peaks rising from the bottom of the painting. The large soft misty cloud reveal a beautiful natural scene. This unabashed abstract ink and wash piece shows Liu Kuo-Sung's mastery of the shuituo technique.

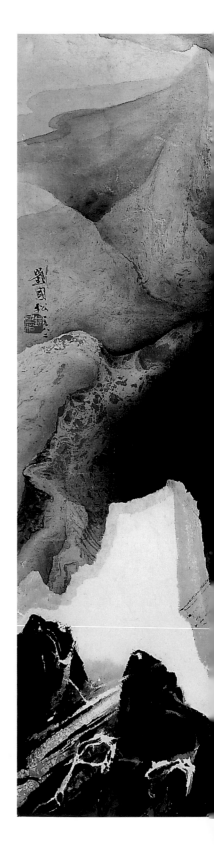

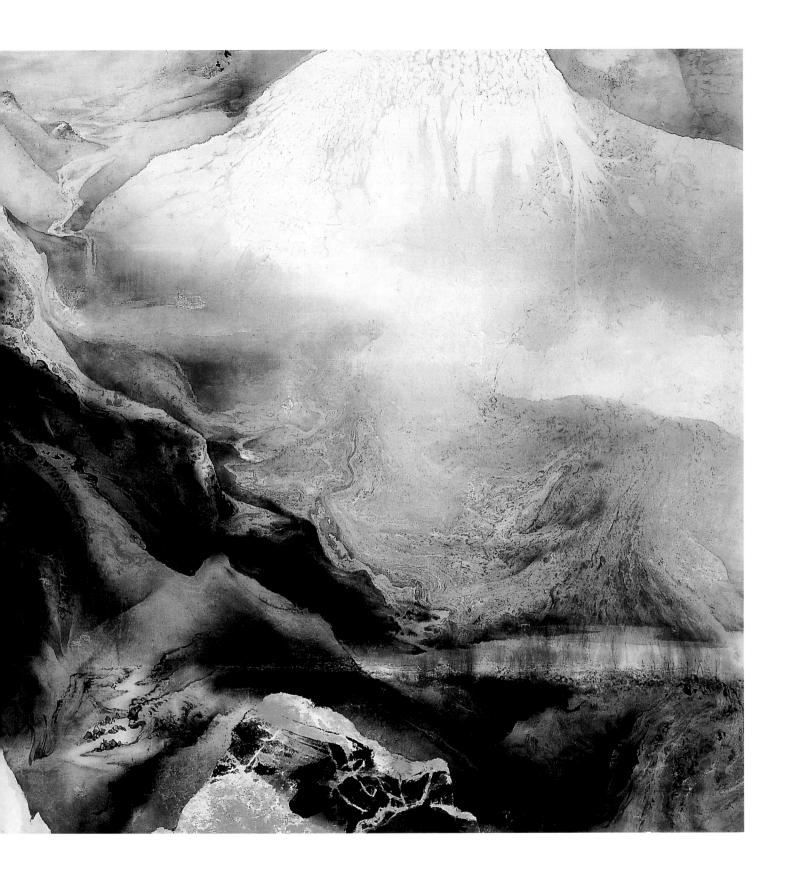

天池
Heaven Lake
1982
水墨、紙本 Ink on paper
71.5 × 93.5 cm

這件作品成功地以水拓法表現自然雪景，先在水面上滴上顆粒較粗的墨汁，由於水的張力形成大小不同的墨塊，選擇局部區塊適度噴上松節油，讓墨塊中產生許多白點，再用松節油滴入墨塊四周，使墨塊和白點又產生移位變化，再用一張宣紙覆於水面上，同時拓下墨色移動後的紋路，在紙上留下變化多端的肌理，隨後再作進一步的構圖聯想。此畫先以噴灑出現大小不同的白色點狀，根據濃淡、大小、形態不等的墨色，劃分為不同的聚集區塊，再以渲染完成細部構圖，最後在點、線、面的結合下，表現如棉絮般的積雪。過程中，水盆的大小決定畫面上拓印的範圍，墨汁原料的不同，墨色傾倒在水上的速度、角度不同，紙張放置在水面的角度和方向，手指捏著紙張的位置，紙張對墨色的吸附力，水的溫度…等，都影響水拓效果。

This landscape of a snowy scene was produced using shuituo or water rubbing. Thick droplets of ink are dropped onto water, and the tension of the water causes the ink droplets to concentrate in different sizes. Turpentine is sprayed onto certain areas leaving 'white spaces' of water without ink. Turpentine is also dripped around concentrations of ink causing the ink and 'white spaces' to shift in position. A sheet of Xuan paper is then placed on top of the water to take a 'rubbing' of the myriad patterns and formations. Further work is then done on the paper. In this piece, white circular shapes of different sizes were first produced by spraying with turpentine. Depending on the thickness, size and shape of the ink globules in the water different size areas of ink were produced on the paper. Washes were used to complete the details. Dots, lines and blocks of ink are combined to produce the effect of layers of snow. In the water rubbing process, different effects are achieved depending on numerous factors including the size of the water pan (which determines the area of the rubbing), the type of ink, the speed and angle the ink is poured onto the water, the angle and direction the paper is placed onto the water, whether the thumb is used to press onto the paper, how absorbent the paper is, and the temperature of the water.

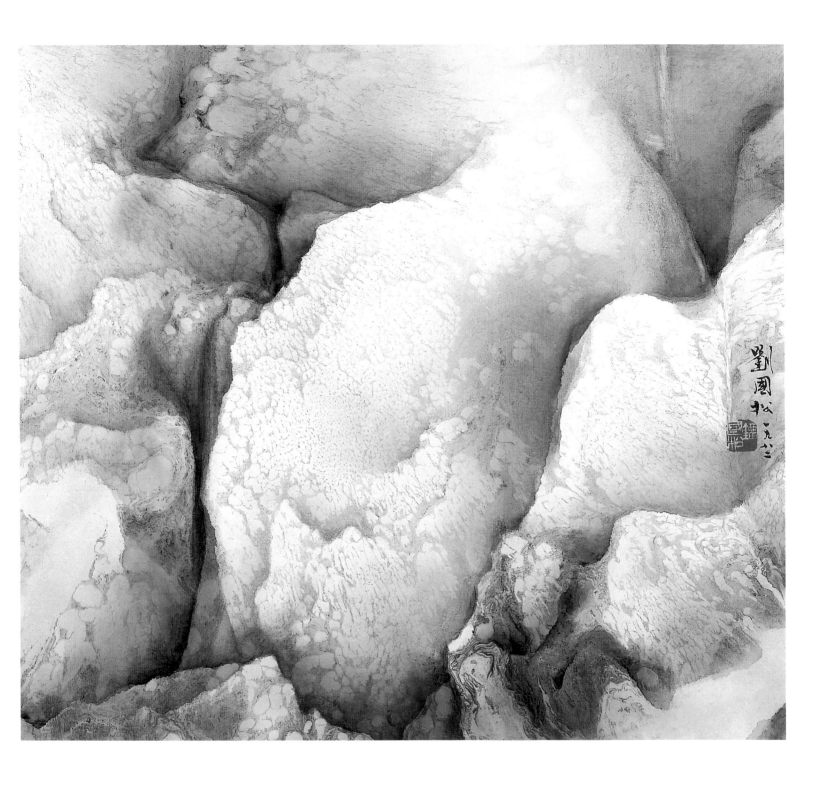

白雪是白的
White Snow is White
1982
水墨、紙本　Ink on paper
39.2 × 44.5 cm
倫敦水松石山房收藏
Shuisongshi Shanfang Collection, London

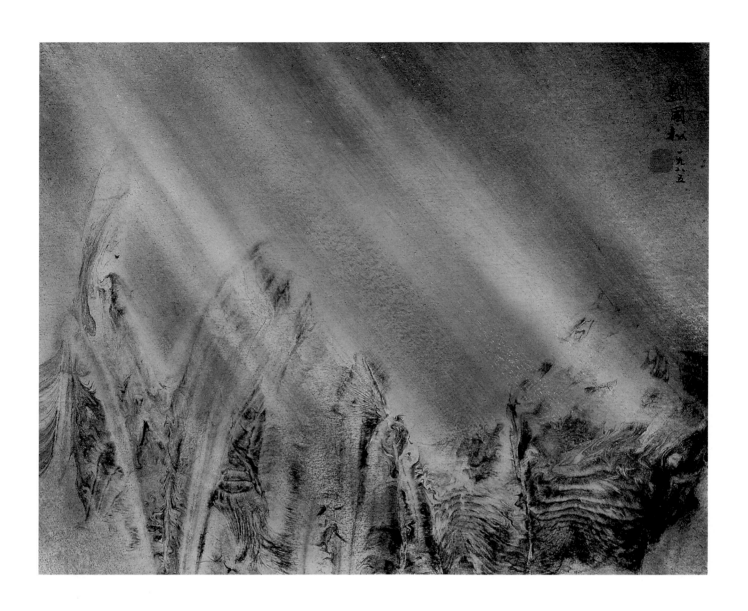

夜雨戰芭蕉
Battle of Evening Rain and the Banana Trees
1985
水墨、紙本　Ink on paper
43 × 56 cm
倫敦水松石山房收藏
Shuisongshi Shanfang Collection, London

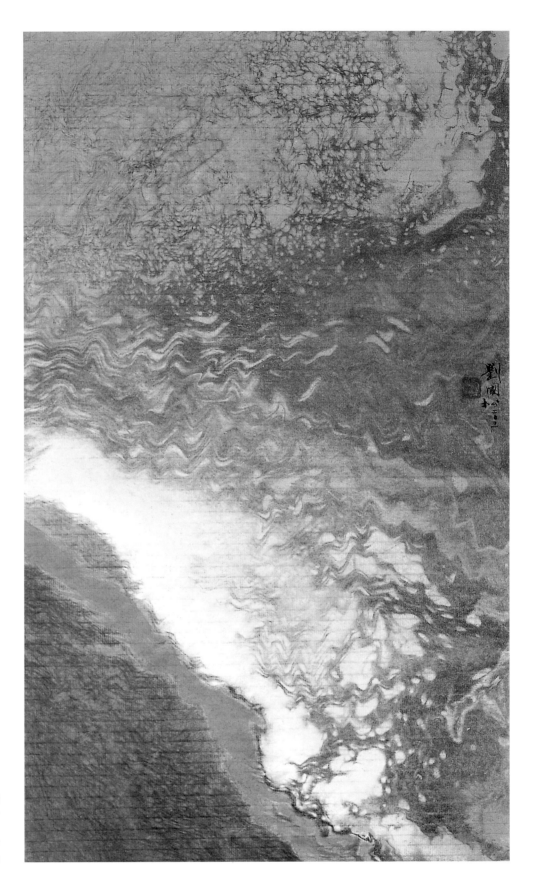

魚兒與水花共舞
Fishes Dancing with Water
2001
水墨、紙本 Ink on paper
68.5 × 41.5 cm

水拓法的特別之處在於將墨、水、油三者各自的特性巧妙結合、延展，並且發揮於極致。此畫先用墨滴灑在一大盆清水上，讓浮在水面上的墨點自然地散開、流動，形成各種造型，除了墨汁還使用了壓克力彩，為了改變墨彩流動的位置，使用松節油噴灑在水面上，從左右兩個方向將分散兩邊的墨點向中間擠壓，形成右側山石微妙的線形紋路，再把畫紙平鋪在水面上吸附已形成的造型，視覺上的層層肌理由中間擴展至邊緣，水拓之後再加上暈塗、渲染，如圖的上方一片深隧的遠景，自中景的山谷處向後延伸，直到沒有盡頭的遠方。此畫無論在構圖、佈局、線條、動感、留白上，全然駕輕就熟而至爐火純青的境界。

The unique characteristic of shuituo or water rubbing was that it combined ink, water and paint. To produce this piece, ink was first dripped on to a large pan of clear water. The drops of ink disperse, flow and form into all kinds of shapes on the water's surface. Apart from ink, acrylic paint is also added to the water.Turpentine is also sprayed on the water to alter the position of where the ink and paint flows. The spots of ink that would disperse to the left and right sides are pushed to the centre, a process which created the mountain form on the right hand side with its wonderful pattern of lines. A sheet of paper is placed directly onto the water to soak up the shapes formed by the ink and paint. The ink is slowly soaked up and the granular patterns spread from the centre to the edges of the paper. After the water rubbing is complete, glazes and washes are applied. The background area at the top of the work has been produced in this manner. The valley in the mid-ground seems to extend back to an undefined point. In terms of composition, lines, effects of movement and white spaces this piece is shows Liu Kuo-Sung's mastery of the technique and is near perfection.

吹皺的山光
Mountain Light Blown into Wrinkles
1985
水墨、紙本　Ink on paper
40 × 26.5 cm
倫敦水松石山房收藏
Shuisongshi Shanfang Collection, London

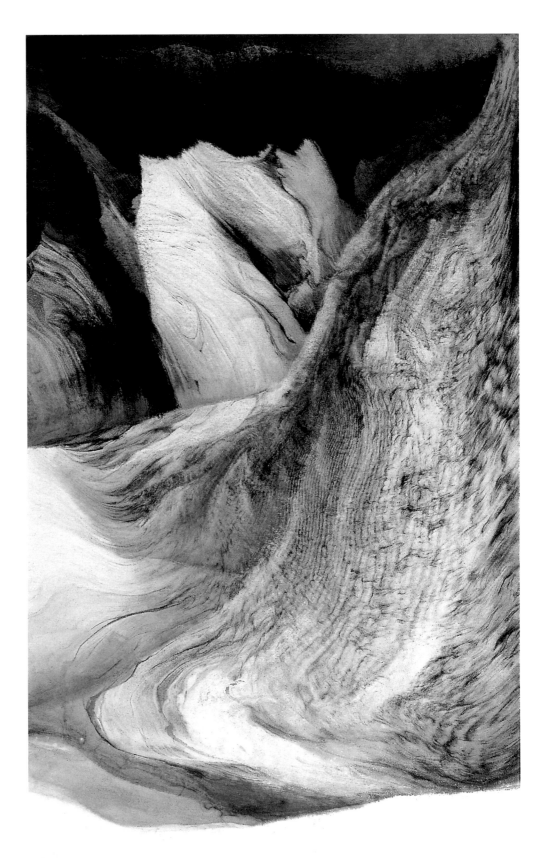

五、漬墨系列　Steeped Ink Series

漬墨法運用了墨的滲透性，掌握水墨在紙上產生的各種變化，以此應運而生的自然效果取代以筆所雕琢出的畫痕，使得整體呈現渾然天成的靈氣。劉國松的漬墨法可以用於宣紙，以及描圖紙，紙張不同技法也不同，產生的效果也大異其趣。

若以宣紙為媒介，先把兩張紙疊在一起平放在板上，兩張紙不用太平整，中間保留一點空氣，以手灑水打濕畫紙，或以噴壺、噴槍打濕，使兩張畫紙自然貼合，紙遇濕在中間產生氣泡，此時可以用乾排筆調整氣泡位置，再滴下墨汁、顏料、水，等墨色完全乾後，將兩張紙揭開，通常用下面那張繼續佈局、構圖。最早的漬墨畫是1986年的《山耶?荷耶?》，自然的肌理在引導與安排下產生虛實相生的效果，以漬墨法將山水、荷影的意象發揮得淋漓盡致。

劉國松以描圖紙捕捉九寨溝水波之美，繪製時先把一張描圖紙平鋪於板上，先將紙打濕再以墨、水彩塗灑在紙上作為初步構圖，再用另一張描圖紙覆於其上，以排筆來回塗刷後，揭開兩張紙，取上面一張繼續染色或描繪細節。描圖紙不吸水，遇濕產生橫向的紋路，描圖紙的厚度決定水紋的寬度，紙愈厚紋路愈寬，塗刷在上面一張紙的力道決定墨色的濃淡，刷得重墨色就濃些，劉國松以此漬墨法表現九寨溝的水色豔瀲，以及水波的動、靜之美。

The steeped ink method utilizes the capacity of ink for penetration to control ink's variations on the paper, and use the naturally resulting effects in place of the marks shaped with a brush to produce an ethereal feel. Liu Kuo-Sung's steeped ink method can be used on rice paper or tracing paper; technique is adapted to each type of paper to create widely varying effects.

If rice paper is used, two sheets are placed flat together on a board, but not so as to leave no space between them. The paper is then wetted with splashes by hand, or sprayed on to make the sheets cling together. Naturally occurring bubbles that form when paper becomes wet can be smoothed out with a dry, broad brush before dripping ink, colored paint, or water on it. After the ink has dried completely the two sheets are separated and normally work continues on the lower sheet, such as adding additional compositional elements. The natural texture of Liu's earliest steeped ink painting, *Mountain? Lotus?* (1986), leads the eye and produces tension between tangible and intangible forms, bringing out the landscape and lotus forms to perfection.

Liu Kuo-Sung captured the beauty of water ripples for the Jiuzhaigou series on tracing paper, making a rough composition by applying ink and watercolors after wetting the paper, then placing another sheet of tracing paper over it, running a broad brush over the top sheet, and separating the sheets before continuing to apply color or flesh out details on the top sheet. Tracing paper is non-absorbent, producing horizontal patterns when wetted. Their width is determined by the paper's thickness – the thicker the paper, the wider the streaks – and the more pressure is applied to the top sheet the darker the impression becomes on the paper. Liu Kuo-Sung utilized this steeped ink technique to particular effect in his Jiuzhaigou series to express the shimmering brilliance, movement and stillness of water.

山耶?荷耶?
Mountain? Lotus?
1986
水墨、紙本 Ink on paper
68 × 88.5 cm

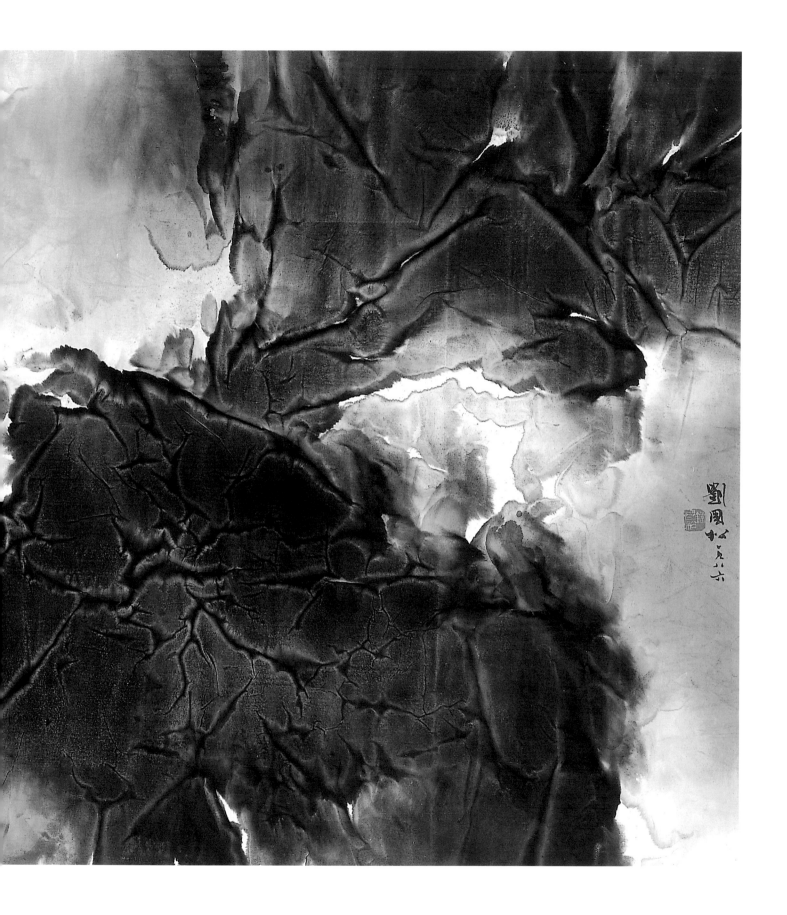

這件以漬墨法完成的作品，先把兩張宣紙鋪在平板上，用噴霧器在紙上噴水以打濕畫紙，產生大小不同的氣泡和凹凸的表面，再將墨色點灑於紙面上，氣泡將墨打散再匯聚於凹處，墨與水結合後再聚集、流動、擴散、滲入下面的宣紙上，造成變化莫測的構圖，等宣紙完全乾後把上下兩張紙分開，選取下面一張宣紙繼續繪製。此畫以青、綠、黃的光感融入墨色，朦朧中透出晴朗的光源，輕柔飄逸又朝氣蓬勃，在一片綠意盎然的雲霧中帶著詩意，引人無限聯想。畫面當中由下向右以弓形向邊緣延伸，以漬墨留下的印痕夾著戲劇性的強度和張力，在雲霧間如雨還晴，似煙若風；中間底部及左側近處，再補以幾處墨色，山石上的枝葉與空山靈雨互為呼應，整個畫面剛柔並濟，感性中帶著理性，偶發中仍見寫意的情境，是劉國松現代抽象山水的審美與精神表象。

This work was producing using zimo or ink blotting. Two pieces of paper were first laid flat on top of each other and sprayed to make them wet. This created bubbles of different sizes and an uneven, bumpy surface on the paper. Ink was then sprinkled on the paper and pooled in the depressions created by the bubbles. The ink mixes with the water pooling, flowing and spreading out and is soaked into the piece of paper underneath producing a composition of random patterns. After drying completely, the two sheets were separated and the top sheet discarded. Greens and yellows mixed into the black ink create a source of light that bursts out of the murk at once gentle and vigorous. The exuberant green mist is charming and enchanting. The eye is drawn from the bottom of the paintingand towards the right edge in a bow-like arc. The shape formed by the ink that has seeped through after the blotting process holds dramatic strength and tension. Inside the cloud it appears as if the rain is clearing. The black shapes at the centre of the bottom of the piece and the left hand side depict vegetation atop the peaks, whichecho the rain that hangs above. The painting is perfectly balanced, emotional and rational in equal parts, random yet still impressionist. This was the aesthetics and spirit of Liu Kuo-Sung's modern abstract landscapes.

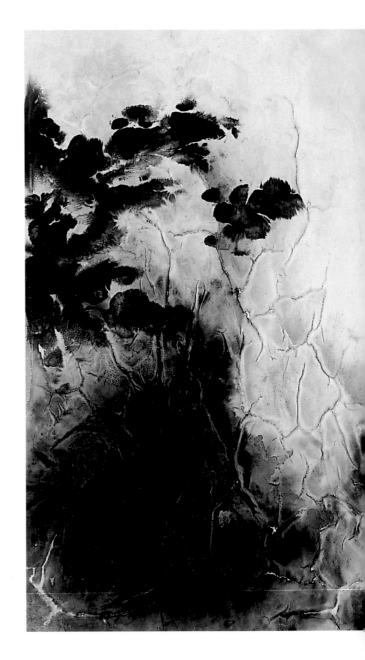

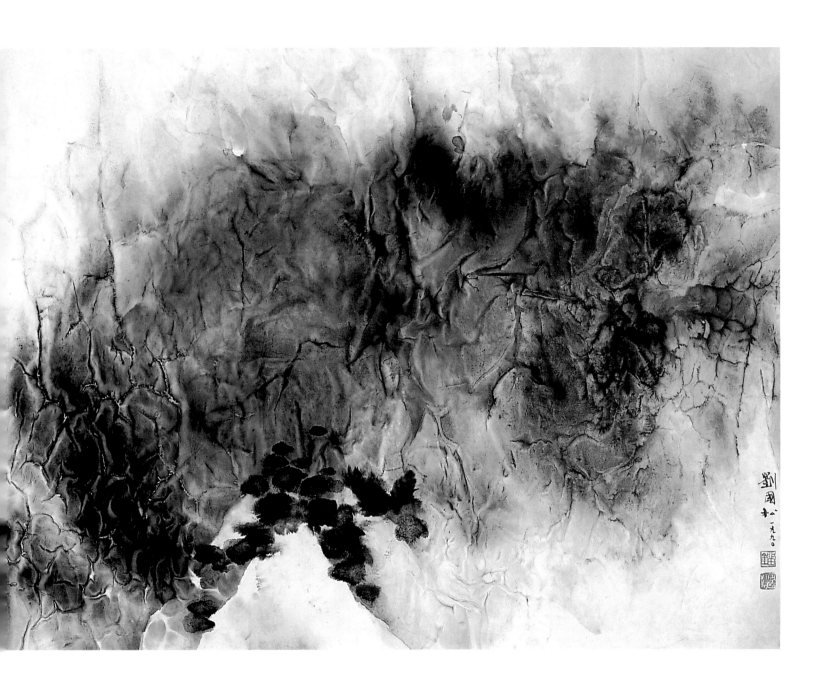

春山煙樹
Trees in the Mist on the Spring Hill
1990
水墨、紙本　Ink on paper
69 × 137.5 cm

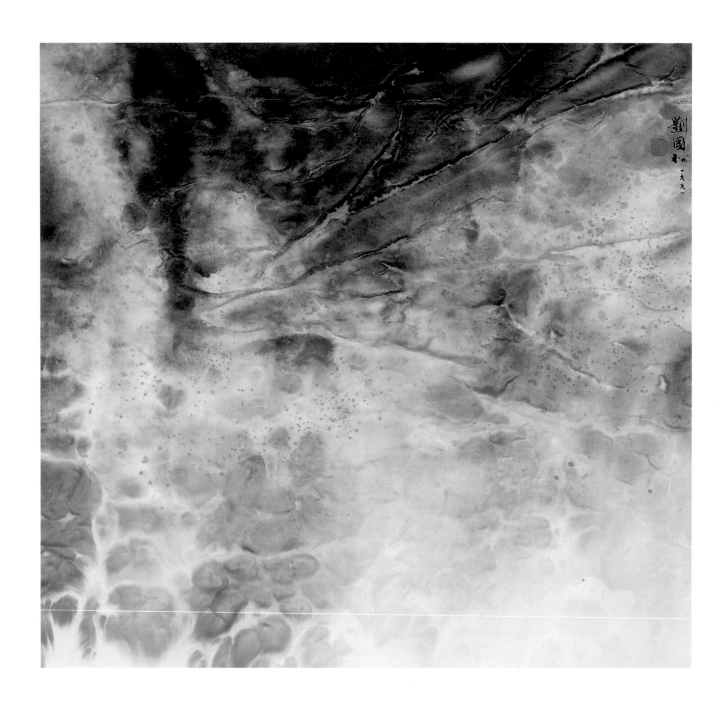

鎔岩
Magama
1991
水墨設色、紙本 Ink, color on paper
64 × 68.5 cm

冬夜細雨
Light Rain at Night of Winter
1992
水墨設色、紙本 Ink, color on paper
66.5 × 69.5 cm

星宿海：天上黃河系列
Constellation Sea: The Heavenly Yellow River Series
1995
水墨設色、拼貼紙本　Ink, collage on paper
102 × 77.5 cm

自由魂
The Soul of Freedom
1996
水墨設色、拼貼紙本　Ink, collage on paper
75 × 161 cm

冬之變奏
The Variations of Winter
1999
水墨設色、拼貼紙本　Ink, collage on paper
17.5 × 17.5 cm × 10 pieces

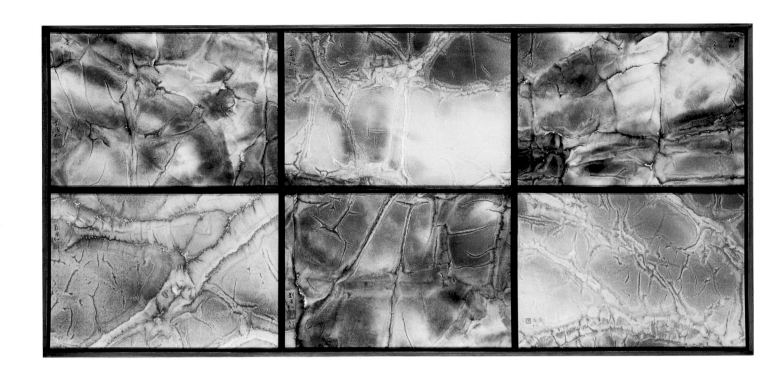

太虛之初
The Early Universe
1999
水墨設色、拼貼紙本　Ink, collage on paper
60 × 137 cm

此畫以分割後再統合的構圖，表達音樂節奏感的主題，利用色彩的明暗和色調的冷暖，把音符的特性轉換為視覺上的美感，爵士樂獨特的風格在畫中以藍色作為主導，突顯藍調爵士樂的憂鬱、淒苦的特質，黑色代表早年來自非洲的黑人種族地位與沉重的生活狀態，以紫色表現浪漫的音樂氛圍，黃色穿梭其中，時而跳動、時而高亢的音符；多元的色彩在九宮格的分割畫面上彼此緊密銜接，無論從上、下、左、右、對角的串聯極富變化，充滿井字遊戲的趣味，把音樂上的啓承轉合、抑揚頓挫，發揮得淋漓盡致，呈現繪畫與音樂之間絕妙叢生的意境。

This piece has been divided up into parts which have been placed back together again to form a whole. Its main theme is the rhythm of jazz music. Dark and light color as well as cold and warm tones are used to turn jazz music rhythms into a visual medium. The unique style of jazz is depicted here mainly with blue to show the sadness and hardship of blues jazz. Black represents the position and history of the Africans who invented jazz. Purple represents a romantic musical atmosphere. The yellow that streaks across the painting represents the pulsing beats. The many colors in the nine separated sections of the paintingcombine into one. And whether from above, below, left, right or from the corner they link in a full dynamic mix like a game of tick, tack, toe. The piece is an incisive and vivid representation of jazz music.

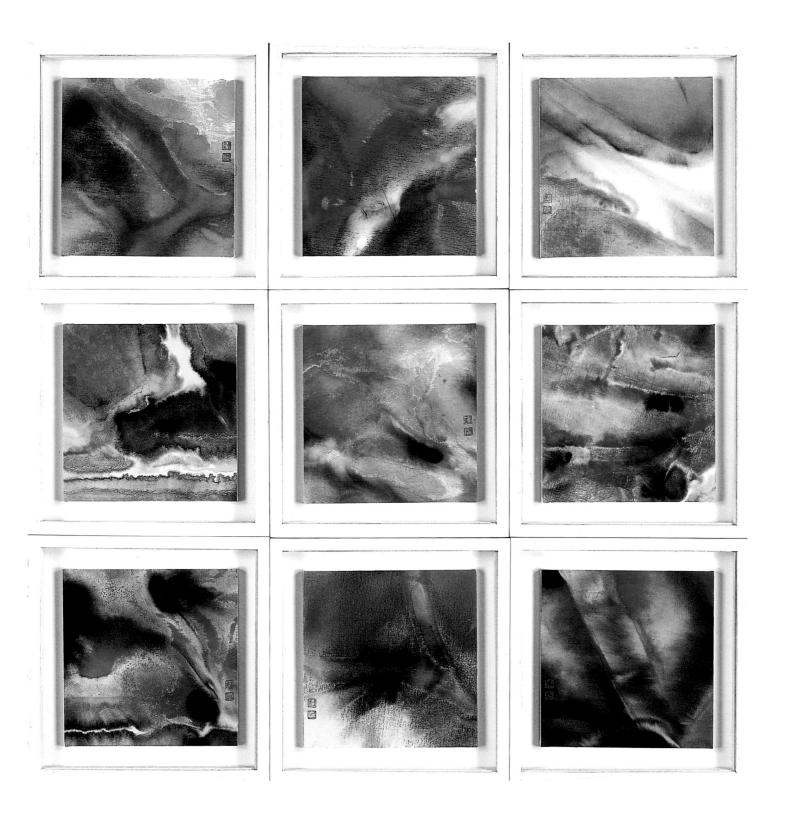

爵士樂
Jazz
1999
水墨設色、拼貼紙本　Ink, collage on paper
59 × 59 cm

此畫以噴霧法營造或濃、或淡、或自然留白的效果，形成變化莫測的構圖。
畫中濃郁的色彩變化為鮮明的風格，黃、綠、橙、藍色彩的多樣性，表現四
季色調的視覺效果，畫面以紙拓法、漬墨法完成主要構圖與肌理，再以噴槍
將墨點噴灑在畫面上，密密麻麻的墨點覆蓋於大片色彩之上，濃郁中還著重
微妙的色調變化，樹林、山峰、溪谷、雲霧等繁複的層次、豐富的肌理、斑
斕的色彩，融合漬、拓、噴、染不同的技巧，呈現獨特的點、線、面效果。

This piece was produced using a spray paint technique rendering color
thick in some places and light in others while also leaving natural-looking
white spaces to create a dynamic composition. The changes in the
intense colors produce a dazzling style. The many variations of yellows,
greens, oranges and blues visually reproduce the effect of color changes
in the four seasons. Paper rubbing and ink blotting techniques were used
to complete the main structure and patterning in the piece. Black dots
were then applied using a spray paint gun. The dots cover large areas of
color emphasizing the subtle color changes. Ink blotting, rubbing, spray
paint and washes have all been used in a combination of dots, lines, and
areas of color to depict the complex layers, rich grains and bright colors
of the trees, peaks, gorges and clouds.

四季系列之 27
Four Seasons Series No. 27
2000
水墨設色、拼貼紙本　Ink, collage on paper
15 × 30 cm × 4 pieces

此畫以漬墨法的技巧，描繪水色天光為主題，構圖上專注於水波、水流的變化，以及光影折射之美來取景，成為獨特的造型與構圖。繪製時先以一張描圖紙鋪在平板上，經過構圖、佈局、上色，描圖紙沾濕後產生許多凹凸不平的橫向紋路，此時再以另一張描圖紙鋪在上面，用排筆刷過圖面，把下面那張紙上的紋路拓印在上面的描圖紙上，過程中會因為紙張的重量、厚度，排筆刷過的輕重力道、紙張橫放或直放的方向，產生不同的紋路效果，兩張描圖紙通常選用上面的那張為成品，再渲染上色以增加水色山光的色彩變化。畫面上以水平線條構圖為主體，加上紙的折痕產生自然垂直的倒影，拓墨法印染在較薄的描圖紙上，形成細膩清晰的水波痕跡，再揉合藍、綠、紫、褐、黃的色彩，呈現巧奪天工般的美景。

This piece was produced using a zimo or ink blotting technique. The main theme of the work is the color of water and natural light. The unique workdepicts the changes in the ripples and flows and reflections of light on the water's surface. To produce the painting, a sheet of paper was placed flat on a board and the painting composed and paint applied. The paper was made wet producing a bumpy uneven surface of horizontal lines. A second sheet of paper was then placed on top of the first and a brush used to brush over the surface and a rubbing of the lined patterns on the sheet below produced. In the rubbing process, various lined effects are produced depending on such factors as the weight and thickness of the paper, the strength used with the paint brush and whether the paper is placed horizontally or vertically. In this process, the bottom sheet is normally discarded and the top sheet used to be the work of art. Washes of color are applied to the top sheet to complete the effect of the color changes in the water's surface. This painting is composed mainly of horizontal lines with vertical creases in the paper forming reflections in the water. The ripples in the water are so distinct because the rubbing was done on a thin piece of paper. Blends of blues, greens, purples, browns and yellows complete the exquisitework of art.

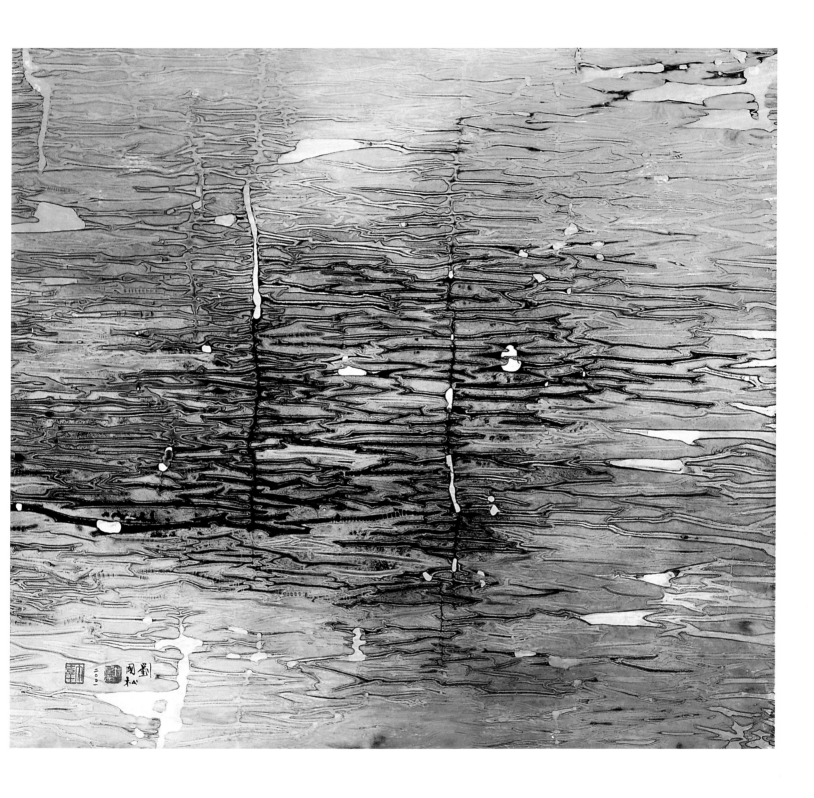

漪：九寨溝系列之 13
Ripples: Jiuzhaigou Series No. 13
2001
水墨設色、紙本　Ink, color on paper
71 × 79 cm
香港藝術館典藏
Hong Kong Museum of Art Collection

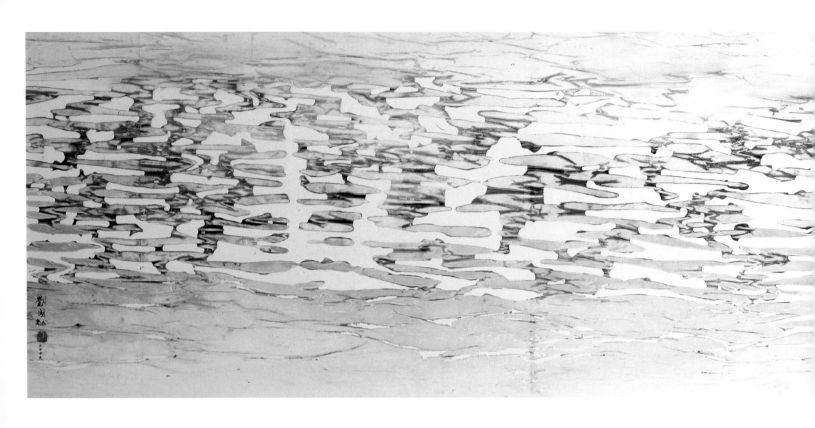

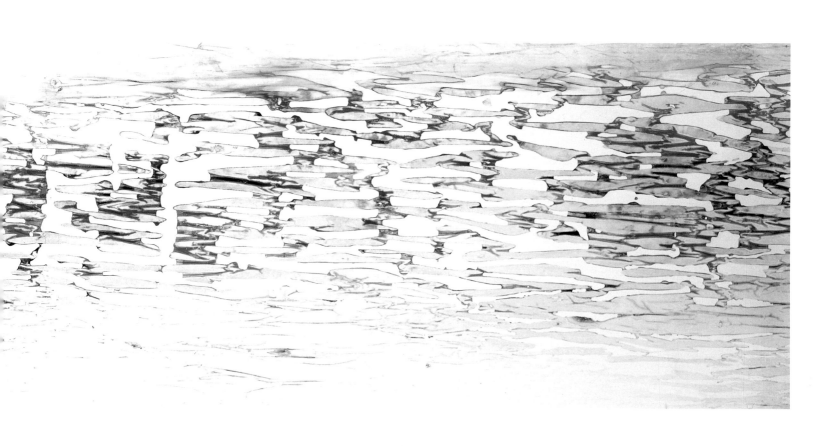

臥龍海秋波：九寨溝系列之 149
Autumn Waves at Woulong Sea: Jiuzhaigou Series No. 149
2004
水墨設色、紙本 Ink, color on paper
64 × 293.1 cm

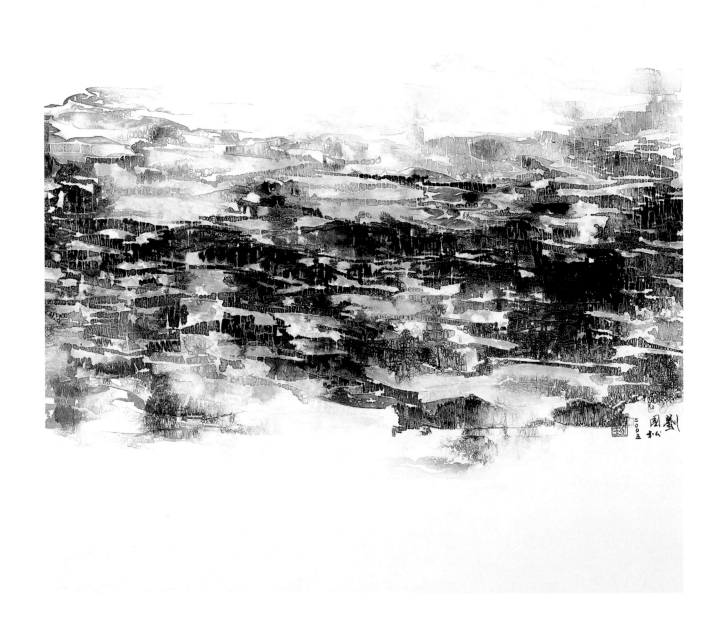

羌寨：九寨溝系列之 73
Stockaded Village of the Qiang: Jiuzhaigou Series No. 73
2005
水墨設色、紙本　Ink, color on paper
77.4 × 75 cm

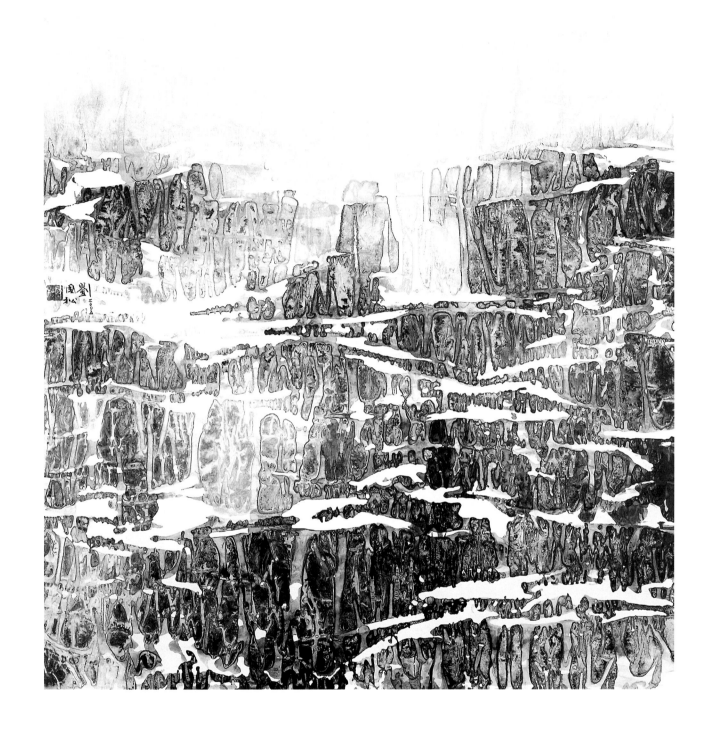

石林之冬
Stone Forest in Winter
2005
水墨設色、紙本　Ink, color on paper
88 × 84.6 cm

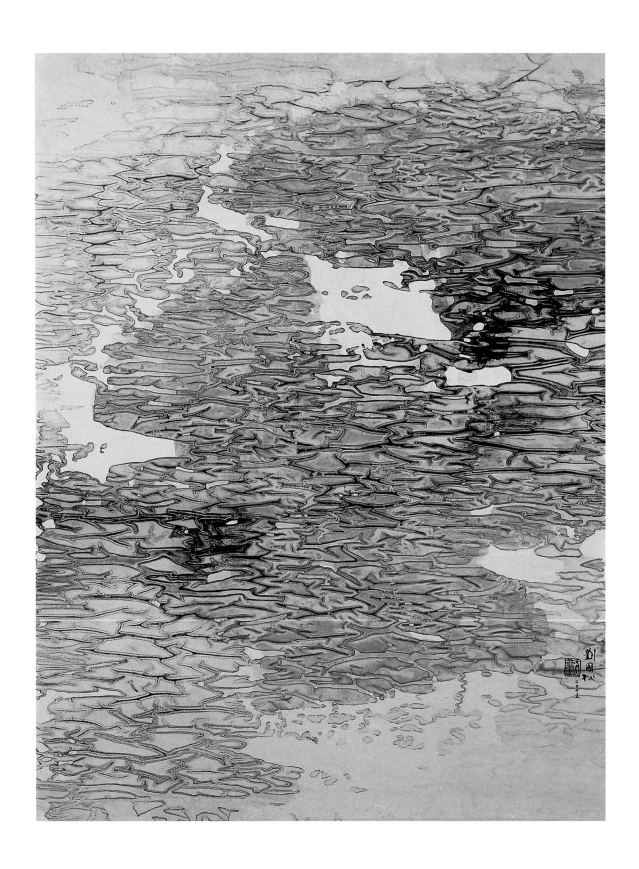

瀨：九寨溝系列之 91
Ripples: Jiuzhaigou Series No. 91
2005
水墨設色、紙本 Ink, color on paper
89.2 × 68 cm

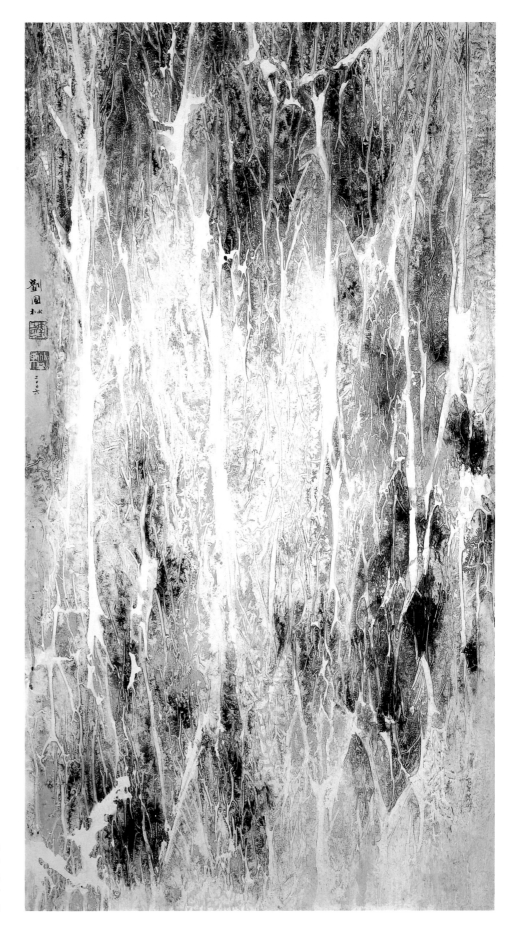

諾日朗瀑布：九寨溝系列之 89
Nuobulang Falls: Jiuzhaigou Series No. 89
2006
水墨設色、紙本 Ink, color on paper
166.8 × 91.3 cm

林泉相映：九寨溝系列之 114
Reflection of Forest in the Water: Jiuzhaigou Series No. 114
2007
水墨設色、紙本 Ink, color on paper
48.5 × 177.5 cm

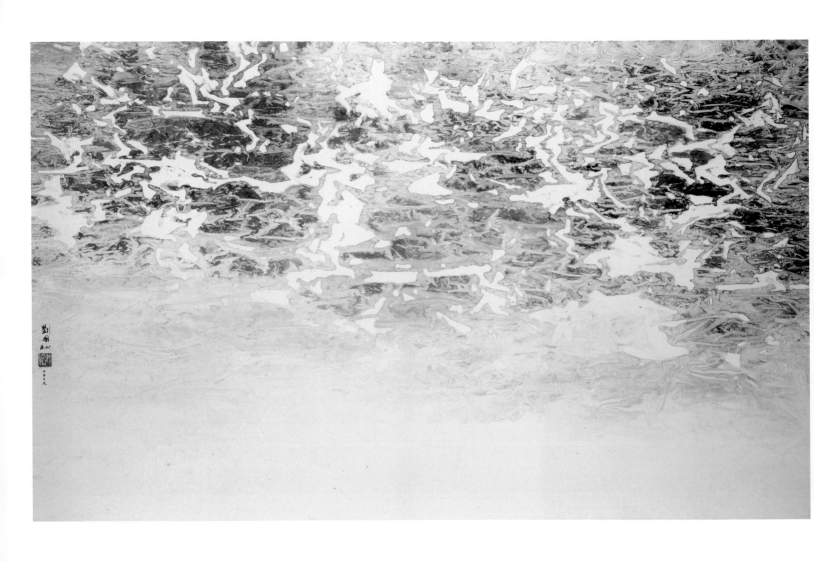

秋影：九寨溝系列之 166
The Shadow of Autumn Trees: Jiuzhaigou Series No. 166
2009
水墨設色、紙本　Ink, color on paper
89 × 150.4 cm

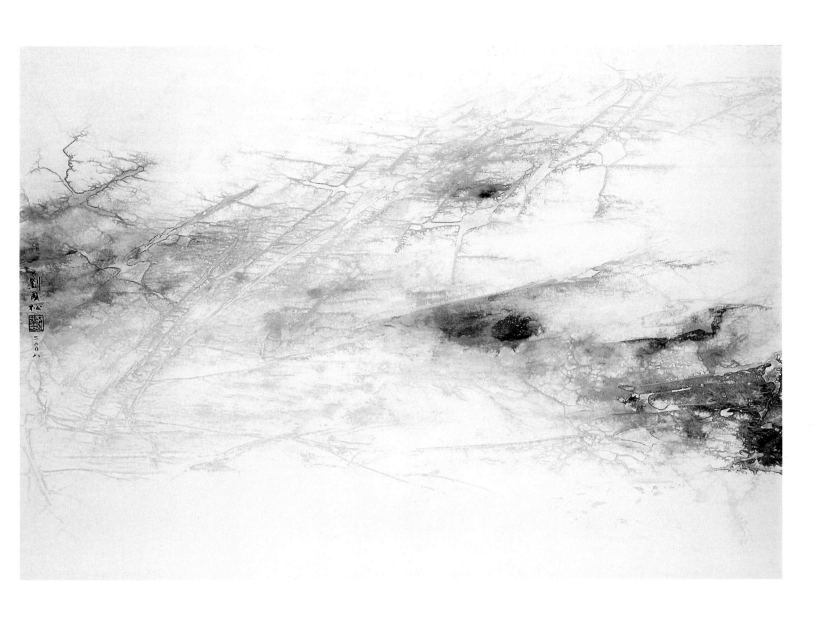

冰封的大地：九寨溝系列之 146
Snow Scenery: Jiuzhaigou Series No. 146
2008
水墨設色、紙本 Ink, color on paper
66.5 × 98.3 cm

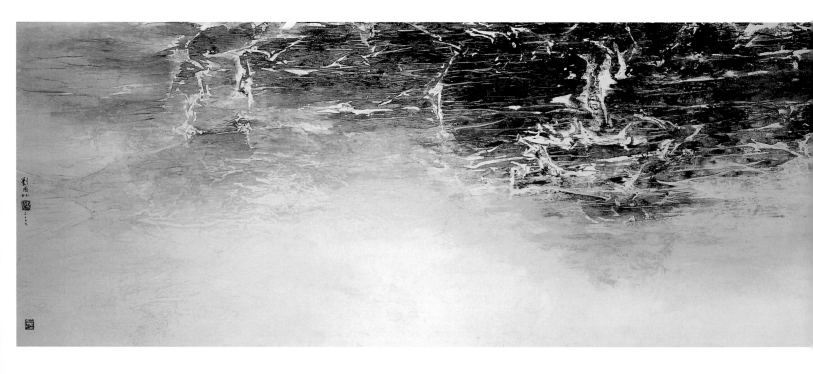

此畫採用漬墨法，先把一張描圖紙平鋪在板上，跟據構圖安排在紙上塗刷墨色，紙碰到水性顏料產生大小不同的橫向紋路，再把第二張描圖紙放在上面，用排筆來回刷過，把下面紙張上的紋路，以及凹凸不平的留白，完全拓印在上面的紙上，當中因為排筆刷過的力道不同產生不同效果，筆刷較重處的色彩較為濃厚，輕輕刷過的部份色彩相對較為淡薄，上下兩張紙經過漬墨法處理後，通常選用上面的一張，再根據畫面需要補上渲染之色。此畫以上半部構圖，三分之一到二分之一的留白，在虛實相生中表達空靈的美感，畫面上春、夏、秋、冬的景致美不勝收，詩歌般的抒情意境湧入心頭；黃、綠、橙、紅、灰、黑，微妙的色彩變化如交響樂的婉轉起伏、澎湃激盪，令人如痴如醉。

This piece was produced using a zimo or ink blotting technique. A sheet of tracing paper was first placed flat on a board and a wash of ink applied. Horizontal marbled lines of different sizes were produced when the paper came into contact with the water-based paint. A second sheet of tracing paper was then placed on top of the first and a broad paint brush brushed back and forth across the paper. This produced a rubbing of lines and white spaces from the grain and bumps of the sheet below. Various effects were produced according to the strength applied to the brush. For example, the color is darker where more strength was appliedand lighter where less strength was applied. After this process, the bottom sheet is then normally discarded and color washes applied as needed. One to two thirds of the piece is left white. The depictions of the four seasons are extremely beautiful and fill the heart with poetic emotion. The subtly changing yellows, greens, oranges, reds, greys and blacks at once undulate gently, at once surge and flow, hypnotising the viewer.

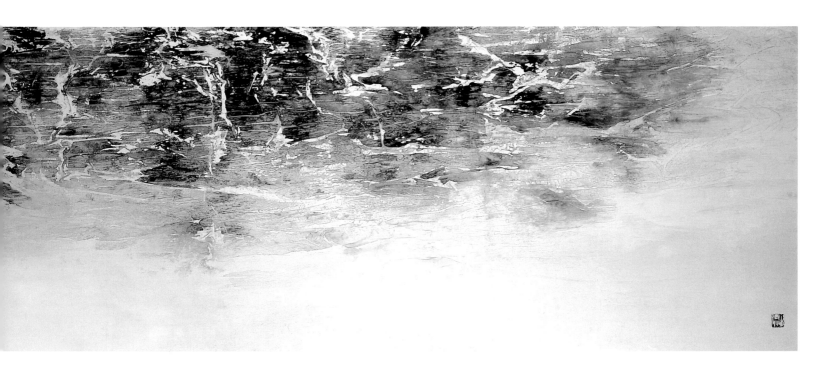

臥龍海四季印象：九寨溝系列之 145
Impression of Four Seasons of Lake: Jiuzhaigou Series No. 145
2009
水墨設色、紙本 Ink, color on paper
188.5 × 456.4 cm

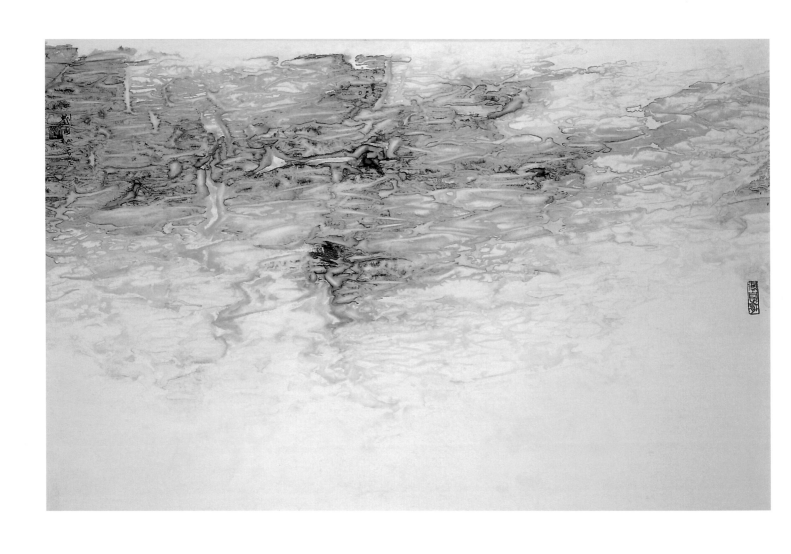

雪之垠：九寨溝系列之 162
The Limits of Snow: Jiuzhaigou Series No. 162
2009
水墨設色、紙本 Ink, color on paper
85.4 × 132 cm

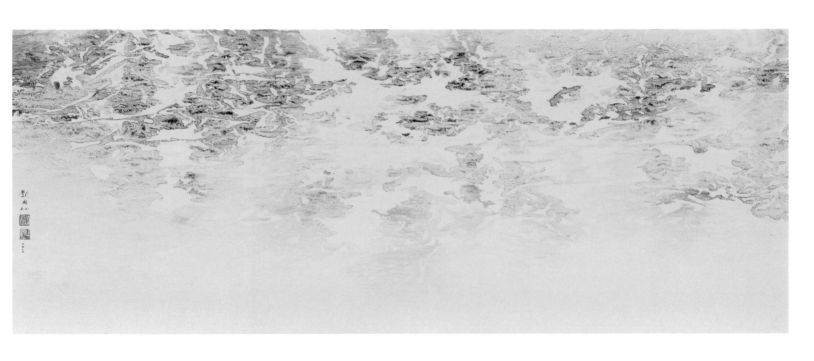

冰雪交融春將至：九寨溝系列之 186
Melting Snow and Ice Is Harbinger of Spring: Jiuzhaigou Series No. 186
2010
水墨設色、紙本 Ink, color on paper
86 × 227 cm

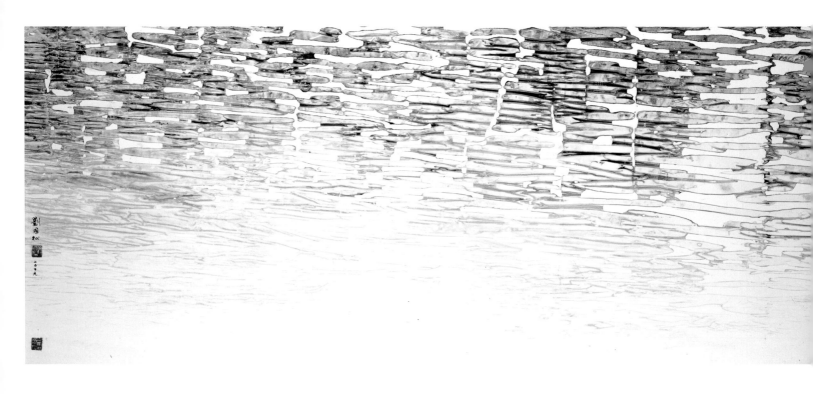

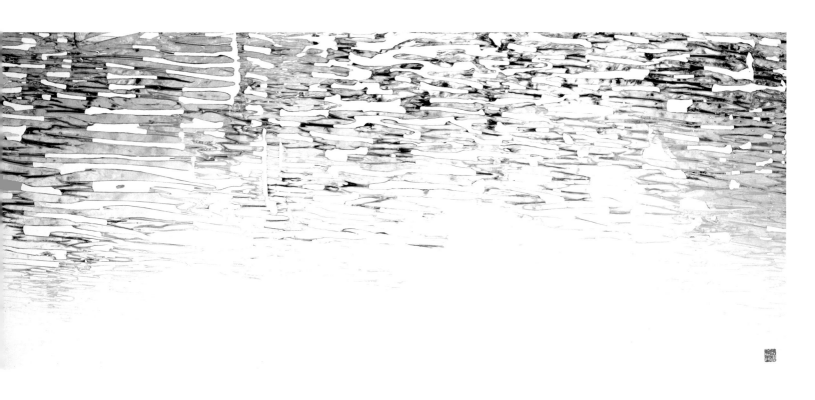

日一日(春波盪漾熊貓海) ：九寨溝系列之 153
Day by Day"Spring Waves Rippling at Panda Sea": Jiuzhaigou Series No. 153
2007
水墨設色、紙本　Ink, color on paper
78.1 × 387.6 cm
北京中國美術館典藏
National Art Museum of China Collection, Beijing

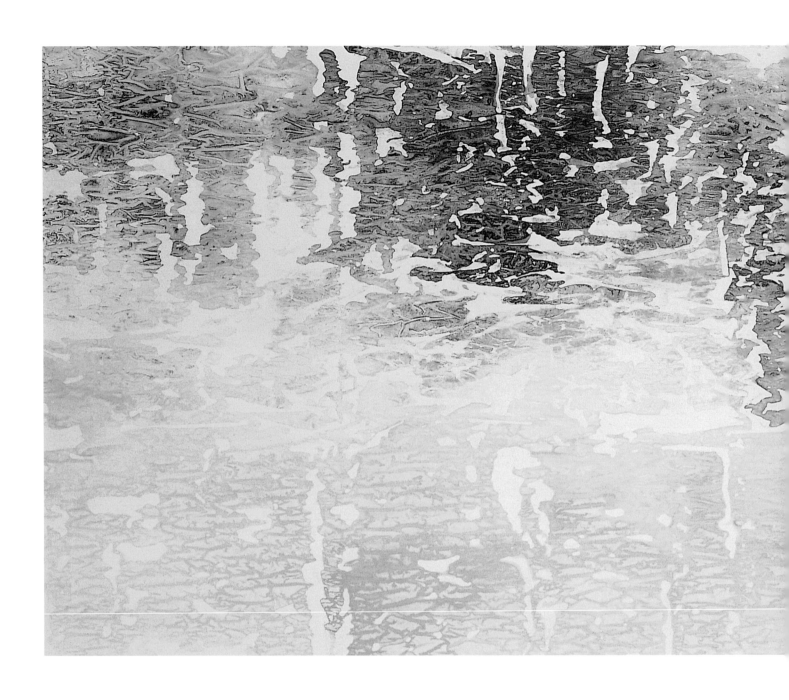

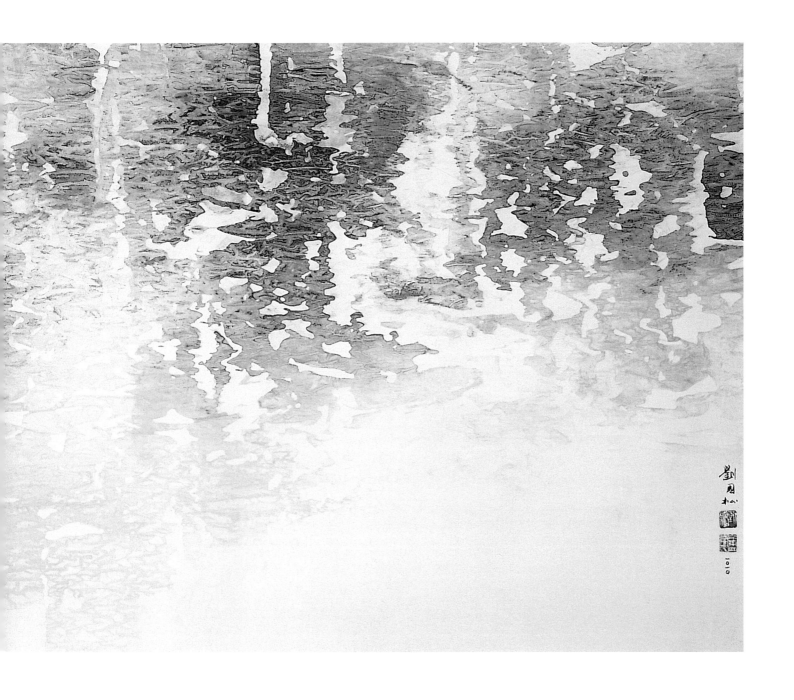

微風掃過五花海：九寨溝系列之 185
Five-flower Lake in the Breeze: Jiuzhaigou Series No. 185
2010
水墨設色、紙本　Ink, color on paper
87 × 226 cm
香港龍圖文化科技有限公司
Longtu Technolgy Limited Collection, Hong Kong

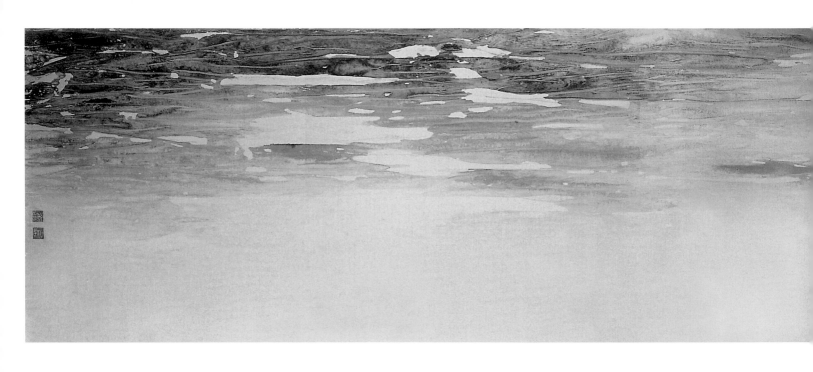

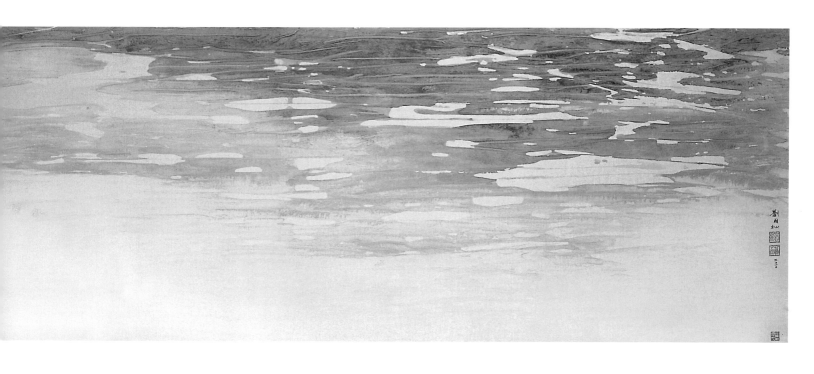

靜海秋影：九寨溝系列之 184
An Autumn Scene of Mirror: Jiuzhaigou Series No. 184
2010
水墨設色、紙本 Ink, color on paper
87.5 × 463 cm

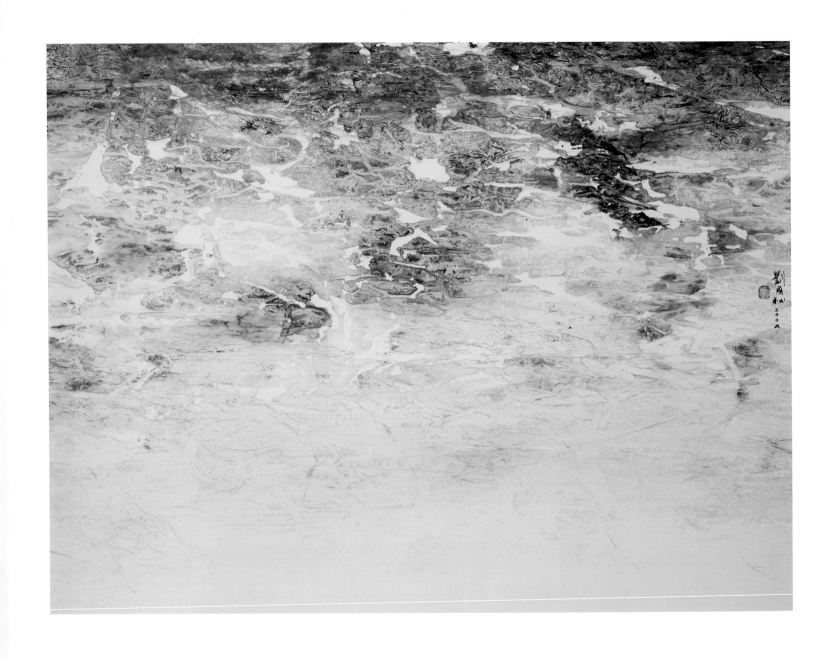

冰釋後的老虎海：九寨溝系列之 111
Tiger Cake under Ice Broth: Jiuzhaigou Series No. 111
2007
水墨設色、紙本 Ink, color on paper
78.5 × 106.3 cm

六、西藏組曲系列　Tibetan Suite Series

劉國松從糊燈籠的雲龍紙得到靈感，把粗厚的紙筋壓製在紙的上面，成功研發了國松紙，西藏組曲的系列充分利用這種手工紙的特點，加上獨一無二的抽筋剝皮皴技法，以「白線」代替了傳統筆墨的黑線，拓寬了中國文人畫的領域。西藏組曲的繪製可以利用紙的正、反兩面，先在紙的正面刷上墨，此時把紙翻過來，背面因紙筋把墨擋住而產生許多條白線，紙筋稀疏的地方墨色就透過來，在紙的背面可以用乾筆輕輕刷過，紙筋分佈的地方則會留下黑線。正面塗墨後可以加上花青染色，等墨色完全乾後撕去紙筋露出白線。西藏組曲因紙筋分佈的不同來構圖，手工特製的紙每一張都不同，帶來不同的畫面。

Deriving inspiration from the paper used to make lanterns, Liu Kuo-Sung compressed thick strands of paper on paper to develop his unique "Kuo-Sung paper." This is extensively used to great effect in the Tibetan Suite series, which in combination with his totally individual use of peeling away the strands and pieces to leave white lines in place of conventional black ink lines applied with a brush, expanded the realm of Chinese Literati painting. In the Tibetan Suite, one or both sides of the paper can be used. First, ink is brushed on the front side, then the paper is turned over, and white lines are produced by the blocking of ink by the paper strands. Black ink seeps through where strands are sparser, and a dry brush can be applied over the reverse side, leaving dark lines where the paper strands are placed. Color can be applied after dark ink is applied to the front side, and once it has dried completely the paper strands are peeled away, revealing white underneath. Works in the Tibetan Suite are composed by varying placement of paper strands over handmade paper, each sheet unique, to create highly varied pictures.

此畫由左側氣勢磅礡的山峰開始，先在紙的背面以大筆刷上墨色，再抽去紙筋留下白線的堅挺脈絡，正面以局部渲染的青、藍烘托山勢的寂靜、肅穆，近景以描繪群山橫向延伸，突顯左側奇險的山勢，有直入天際的壯麗之景，宛如神龍穿梭其上。自下而上的山峰稜角分明，與近處覆蓋白雪山坡之間剛柔並濟，充份描繪群山與霧雪的自然原貌。不論由左而右，從前景向後遠望，每一個角度都帶來不同的景觀。

The eye is initially drawn to the lofty, majesticpeak on the left side of the piece. Swaths of ink were applied to the back of the paper with a large brush andthe paper creased to create a strong veined effect of white lines. On the front of the paper, washes of green and blue ink emphasizethe tranquility of the mountain forms. They extendacross the foreground with the precarious peak jutting out on the left seemingly extending into the heavens like a dragon god winding its way up. The peakwith its distinct craggy protrusions contrasts with the smooth snow covered slope. The piece is an excellent representation of a misty, snowy mountain landscape. Whether the left or right of the painting or the foreground or background, each spot in the painting provides a unique view.

沉入山的呼吸裡
Sinking into Mountains Breath
1985
水墨設色、紙本 Ink, color on paper
178.5 × 95.5 cm
倫敦水松石山房收藏
Shuisongshi Shanfang Collection, London

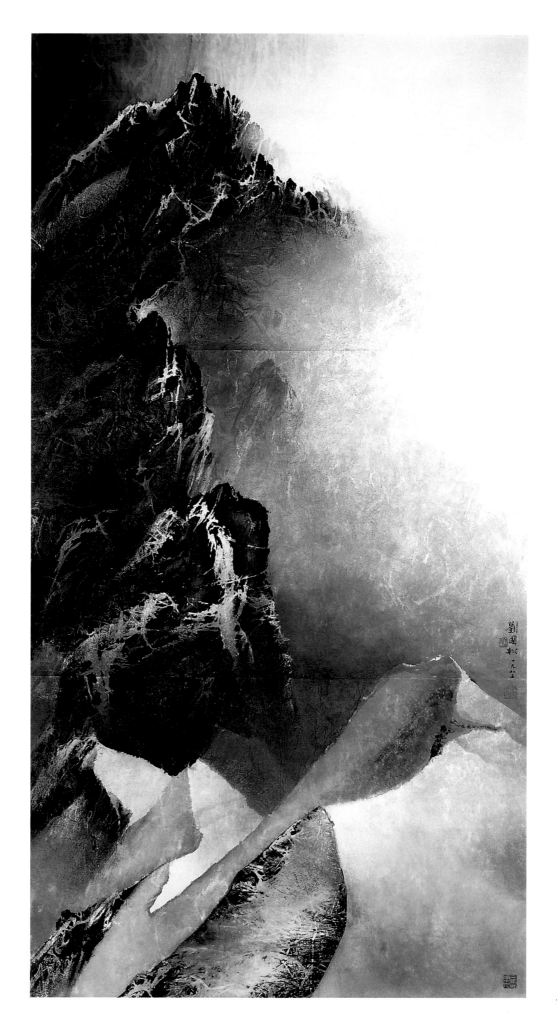

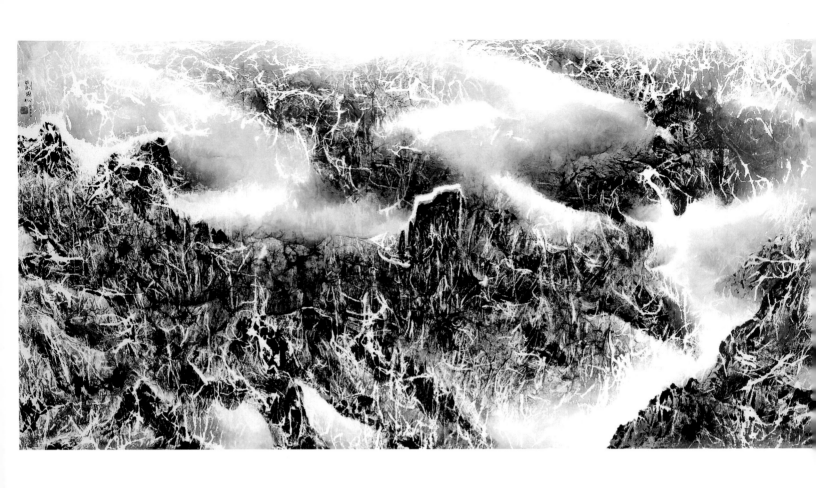

雲樹銀枝：西藏組曲之 16
Silvery Woods Amidst Cloudy Mountains: Tibet Siries No. 16
2000
水墨設色、紙本　Ink, color on paper
91 × 182 cm
香港藝術館典藏
Hong Kong Museum of Art Collection

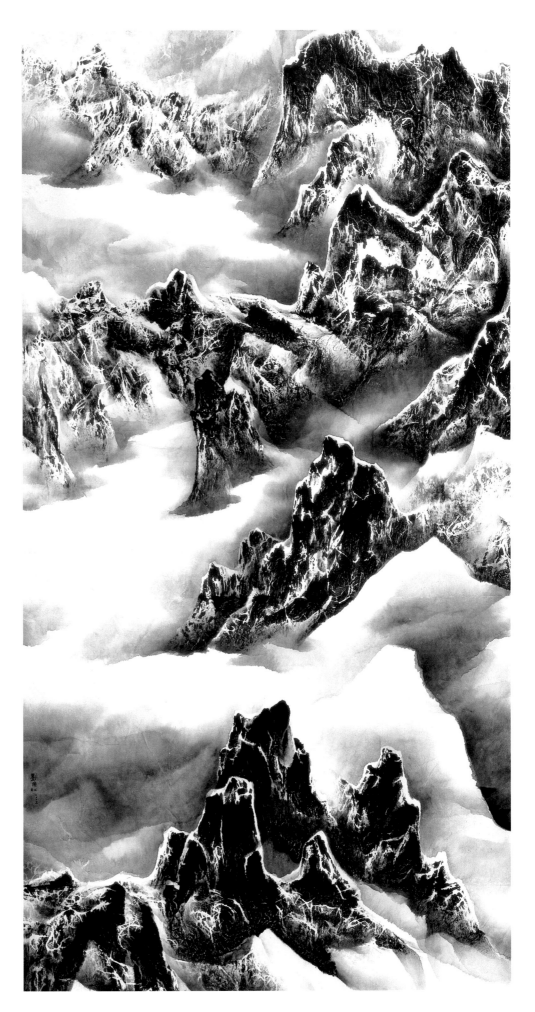

雲與山的遊戲
Clounds and Mountains in Play
2003
水墨設色、紙本 Ink, color on paper
346 × 183 cm
香港龍圖文化科技有限公司
• Longtu Technolgy Limited Collection, Hong Kong

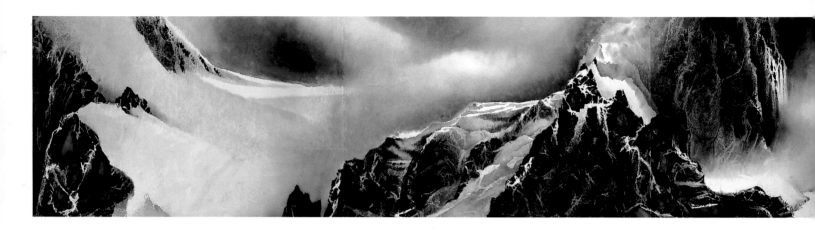

為了畫這幅長卷，劉國松自製了大小形狀各異的畫筆，先以粗筆加上濃墨揮灑在紙上，然後撕下紙筋，白色迂迴的紋路穿過墨色，使畫面變得輕盈生動，再以抽象筆意安排各種不同的造型，冰川峭壁、沼澤窪地、飛瀑奔泉之間的一石一木都細心經營，拓、印、漬、染加上抽紙筋，於是山坡、谷地、溪流、瀑布、雲海、霧氣等大自然的變化，在起伏轉折、抑揚頓挫中，帶著音符悸動和戲劇張力，傾瀉而下又緩緩升起。這幅畫以春天詩情畫意的浪漫開始，進入鬱鬱蒼蒼的盛夏，再至豐厚濃郁的秋景，最後在冰川縱橫、肅靜冷冽的隆冬結束，不論構圖、造形、色彩、線條、肌理都顯出兼容並蓄的意境。

To paint this scroll, Liu Kuo-Sung specially produced his own paint brushes of variousshapes and sizes. He first used a thick brush to apply swathes of thick ink to the paper. Then he made rips in the paper to produce white veined patterning across the black ink simultaneously lightening and animating the piece. He then painted different abstract shapes, carefully producing every element, including stones and trees, and geological features such as glaciers, precipices,marshes, depressions, waterfalls and springs, which seem to contain a musical rhythm and dramatic tension as they rise and fall across the painting. Usingink techniques such as rubbing, stamping, blotting and applying washes as well as paper creasing, Liu brings to life the slopes, gullies, rivers, waterfalls, clouds and misty air. The scroll begins romantically with a charming spring scene. Spring becomesverdant summer, which changes into a richautumn and ends with a barrenwinter scene. Liu composes the piece and uses forms, colors, lines and marblingin such a way that each scene stands out.

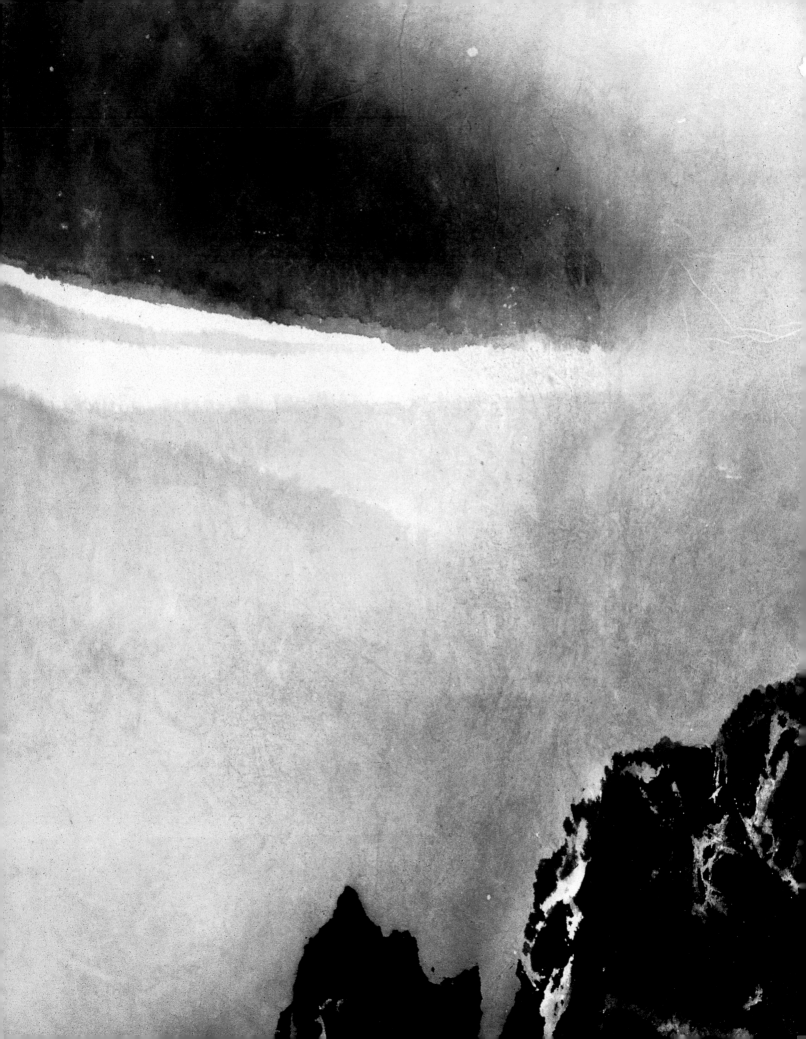

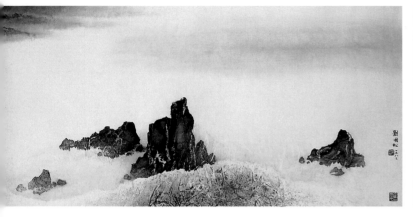

四序山水圖卷
Four Seasons Handscroll
1983
水墨設色、紙本 Ink, color on paper
58.7 × 846.6 cm
水松石山房收藏
Shuisongshi Shanfang Collection

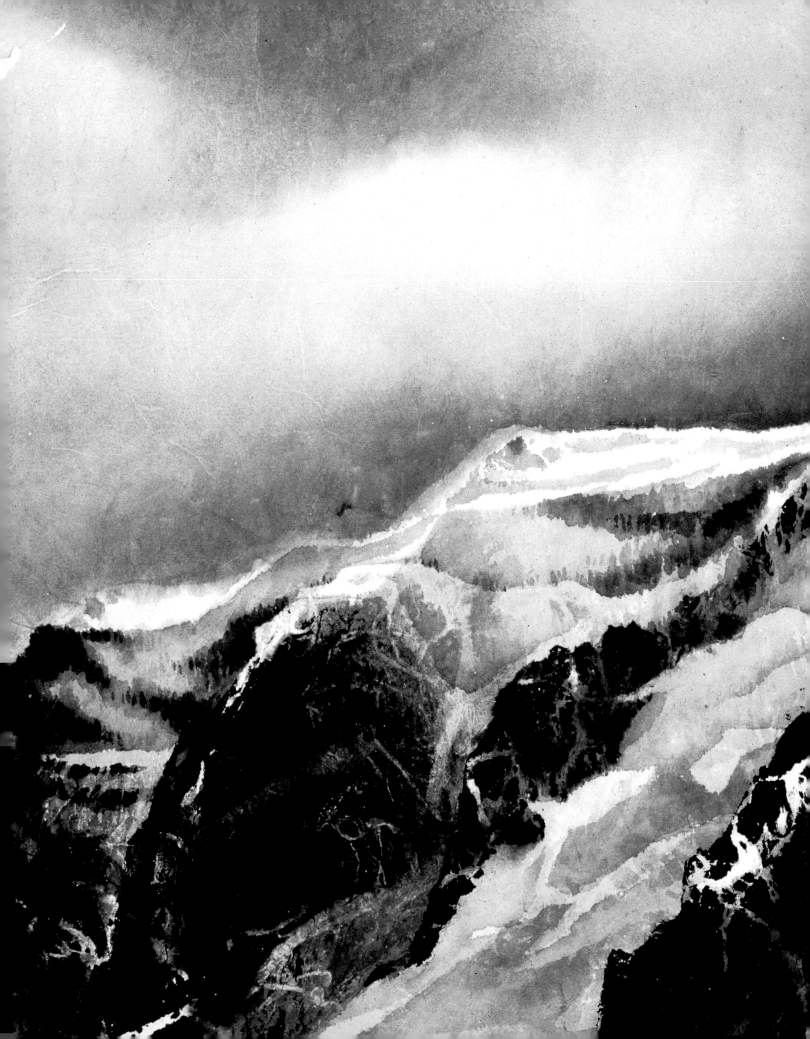

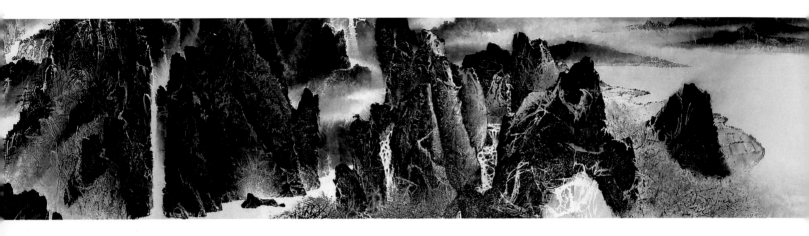

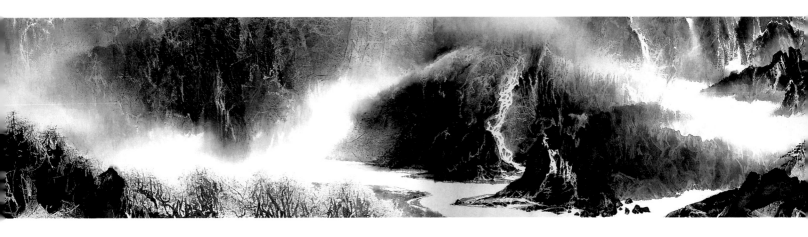

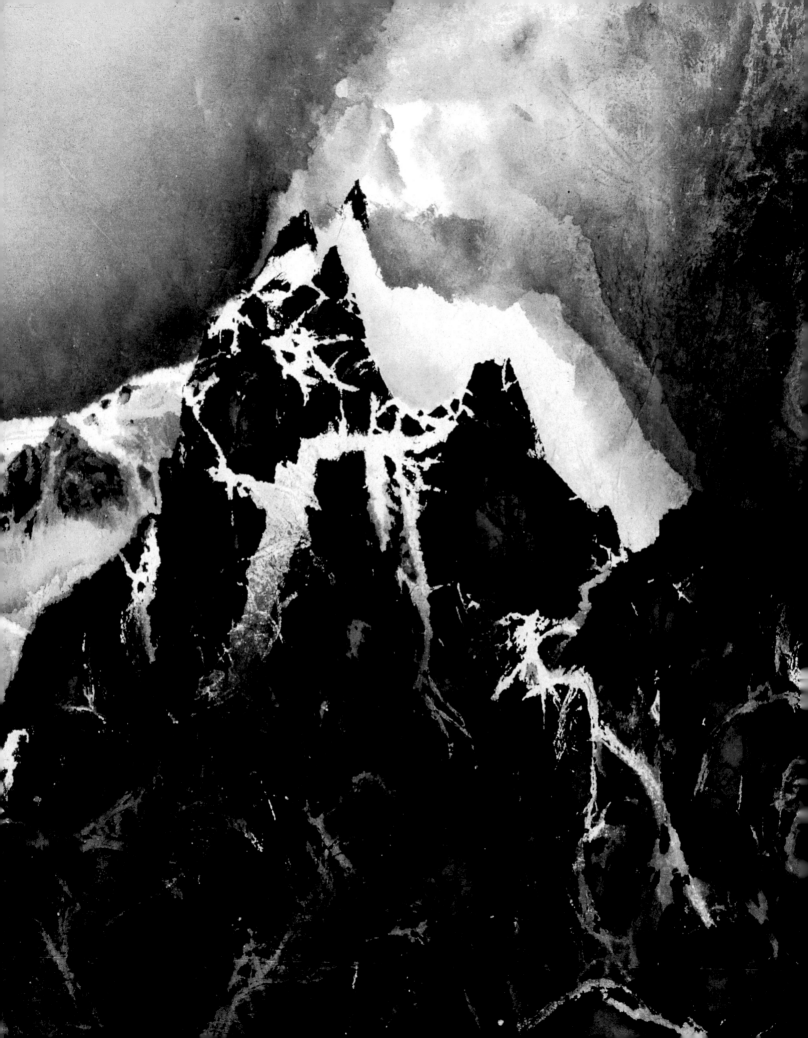

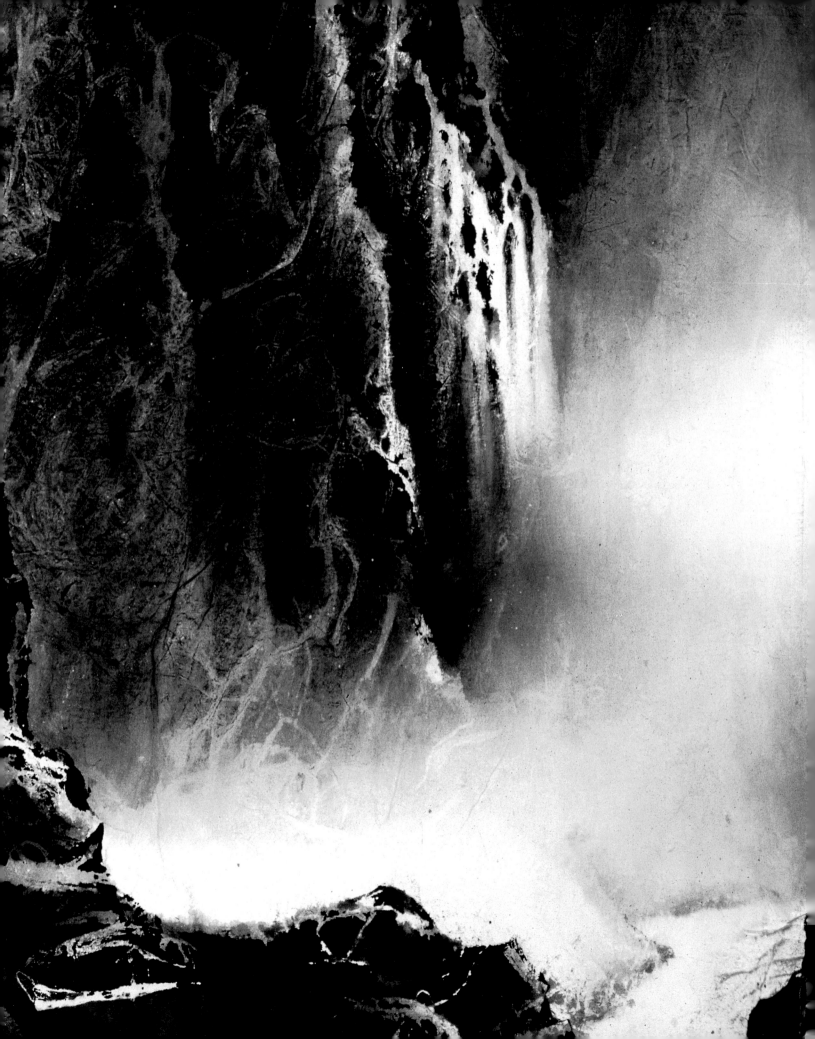

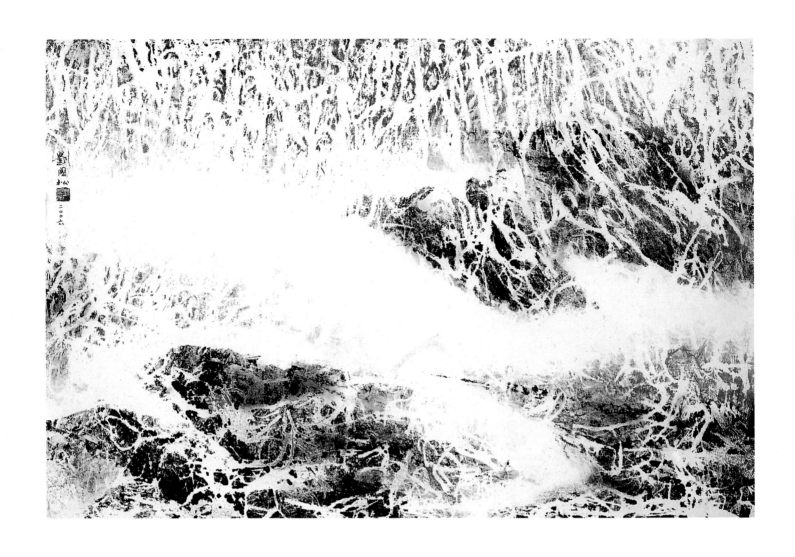

銀色大地：西藏組曲之 87
Silvery Land: Tibet Siries No. 87
2006
水墨設色、紙本 Ink, color on paper
61 × 93 cm

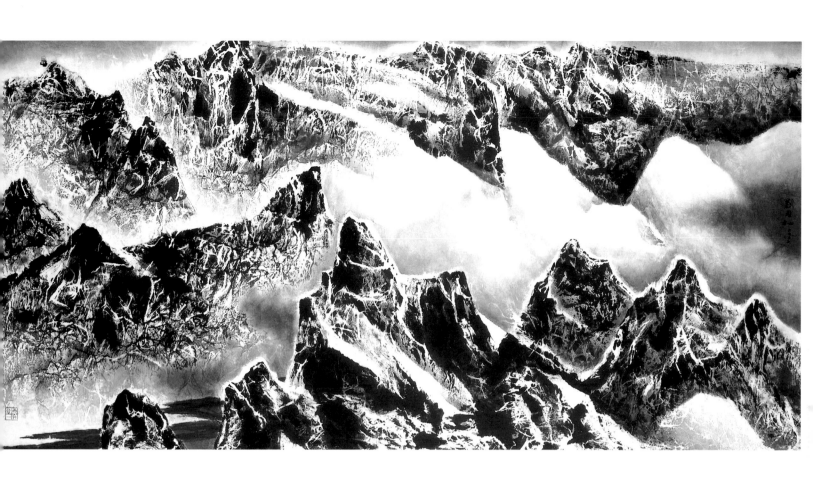

費利崎河谷：西藏組曲之 90
Pheriche Valley: Tibet Siries No. 90
2007
水墨設色、紙本　Ink, color on paper
93.5 × 186.5 cm

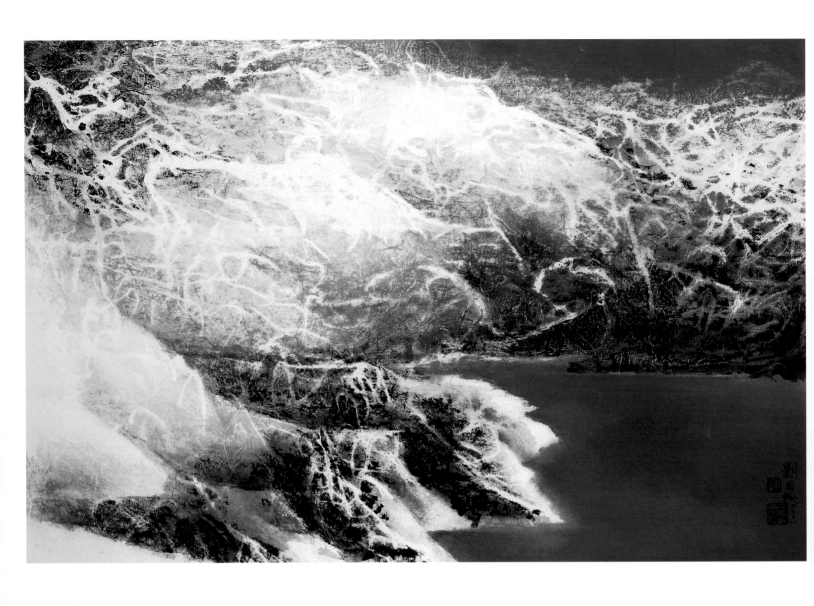

雪清圖
Snow Fresh
2008
水墨設色、紙本 Ink, color on paper
61 × 93.6 cm

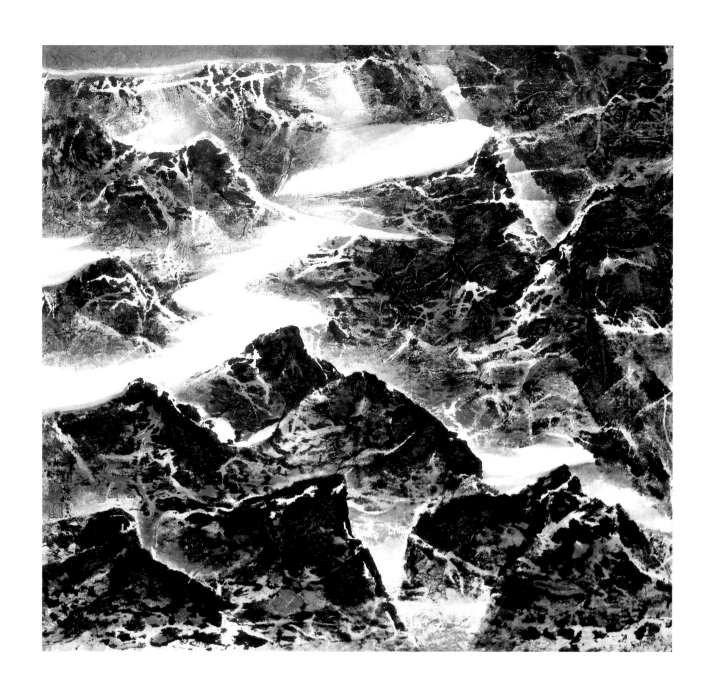

雪照千山動：西藏組曲之 99
Snow-lit Qian Mountain: Tibet Siries No. 99
2008
水墨設色、紙本 Ink, color on paper
85.7 × 91.8 cm
香港龍圖文化科技有限公司
Longtu Technolgy Limited Collection, Hong Kong

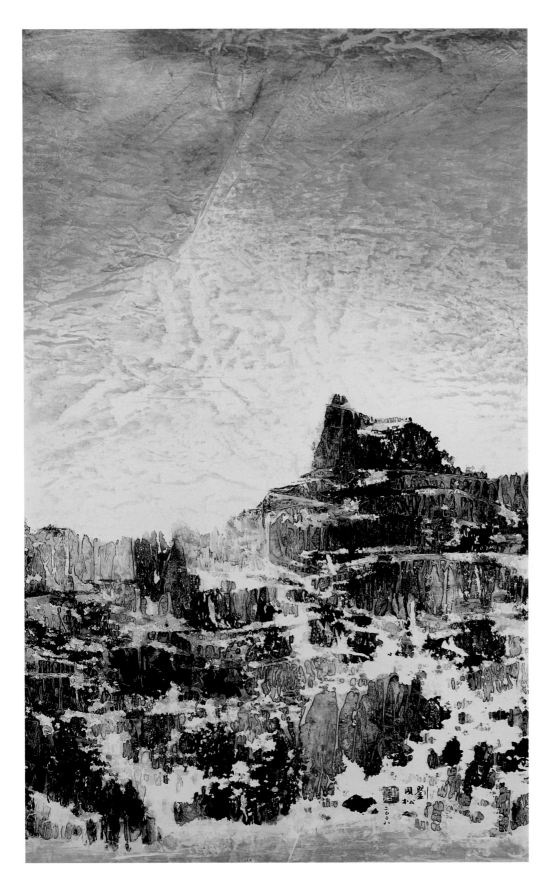

雪山下的土林
The Earth Forest Nestles
under the Snow Hill
2008
水墨設色、紙本 Ink, color on paper
89.8 × 56 cm

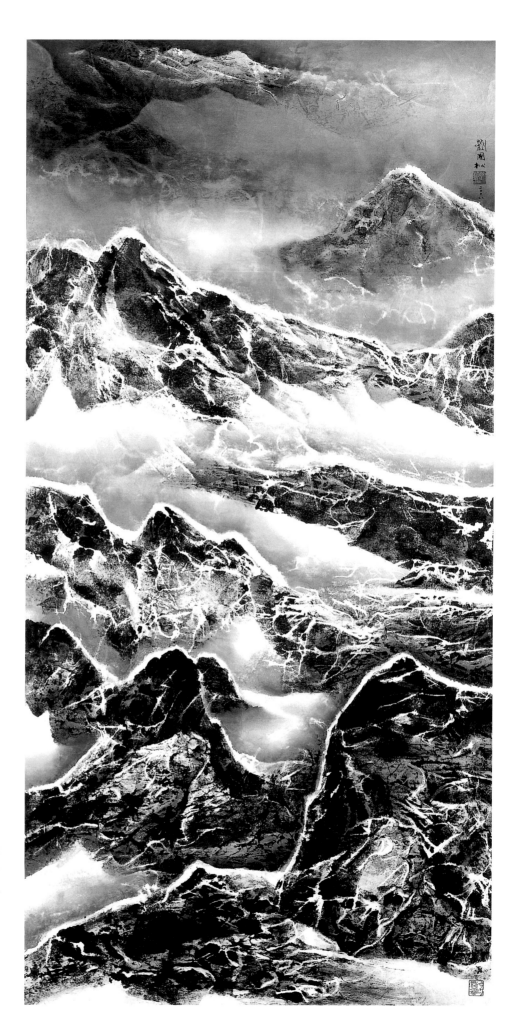

頂上乾坤：西藏組曲之 102
The Mountain Top: Tibet Siries No. 102
2008
水墨設色、紙本 Ink, color on paper
187.5 × 95 cm

大雪中：西藏組曲之 117
Heavy Snow: Tibet Siries No. 117
2009
水墨設色、紙本　Ink, color on paper
94 × 186 cm
香港藝術館典藏
Hong Kong Museum of Art Collection

這件作品採用西藏雪景的佈局繪製，表現撕去紙筋後的白線張力。創作時先以國松紙的背面上色，畫面分為下、中、上三段，上墨後再抽去紙筋留下白線，呈現山峰的脈絡、肌理，再於紙的正面渲染、描繪細節，突顯山峰的造型以及冰川的流向，整個構圖表現西藏高原的雄偉、壯闊，冷冽的空氣中透著超脫、粗獷的景致。此畫除了峭拔的雪山群峰，還有高原、縱谷間的湖泊，這裡的湖水藍中透著青綠，像絲綢般密實發亮，在聳立的山谷中靜靜地淌漾。劉國松以此畫作為二十一世紀全球暖化的關懷，喚起人類共同的關切。

This Tibetan landscape is a good example of Liu Kuo-Sung's technique of using white lines created by paper folding to create tension. Color was first applied to the back of the paper. The painting is divided into three sections: lower, middle and upper. After the application of ink, white lines were made in the paper using creasing, producing the outline and marbled texture of the mountain peaks. Washes of ink were applied to the front of the paper and the details added in, for example the shape of the peaks and the flow of the glacier. Theoverall composition of the pieceshows the majesty and vastness of the Tibetan plateau.

消失的冰河：西藏組曲之 161
Vanishing Glacier: Tibet Siries No. 161
2011
水墨設色、紙本 Ink, color on paper
188 × 94.5 cm

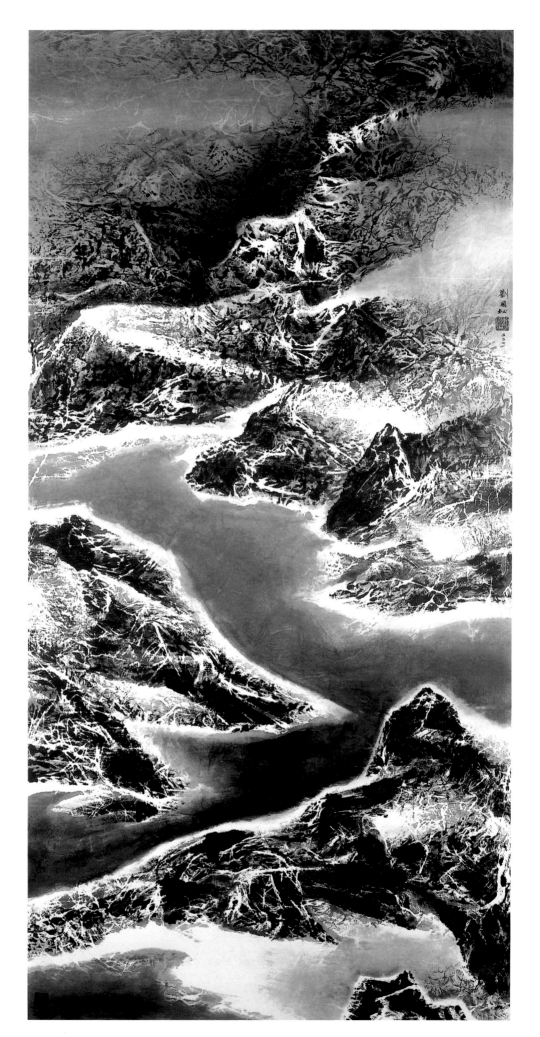

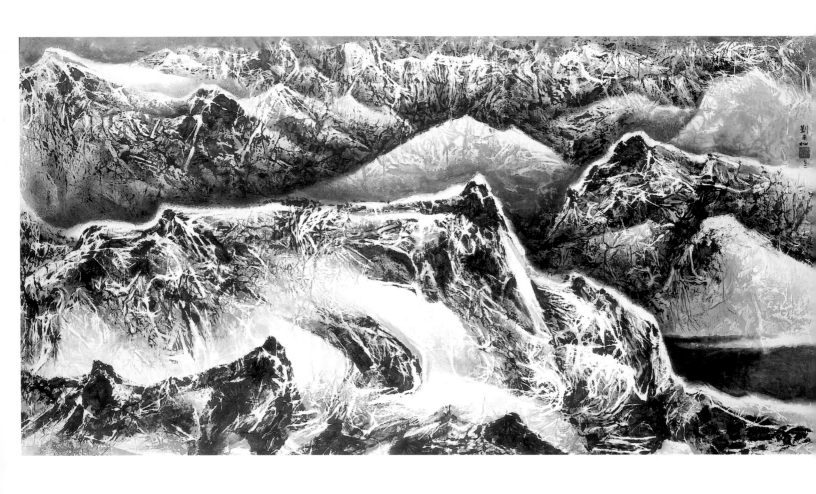

羅布崎：西藏組曲之 168
Lobuche: Tibet Siries No. 168
2011
水墨設色、紙本 Ink, color on paper
94.2 × 183.8 cm

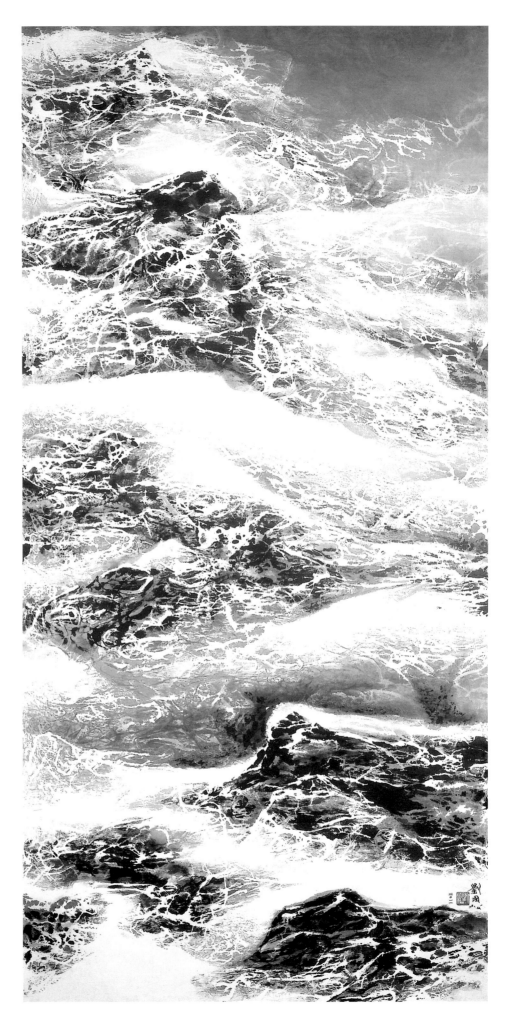

雪線之舞：西藏組曲之 162
Dancing of Snow Lines: Tibet Siries No. 162
2011
水墨設色、紙本 Ink, color on paper
185.3 × 92 cm

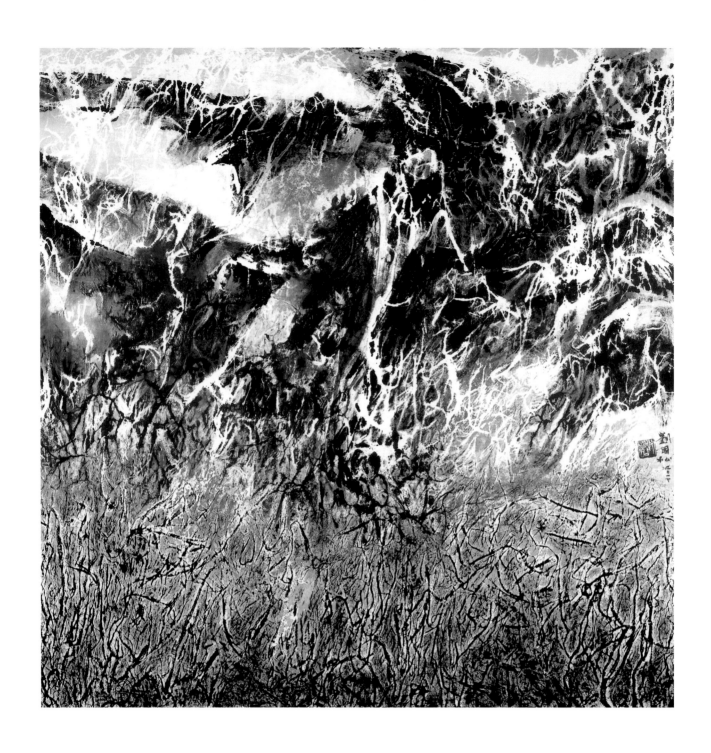

雪枝下的春意：西藏組曲之 163
Spring Feeling beneath Snow Branch: Tibet Siries No. 163
2011
水墨設色、紙本 Ink, color on paper
91.9 × 91.2 cm

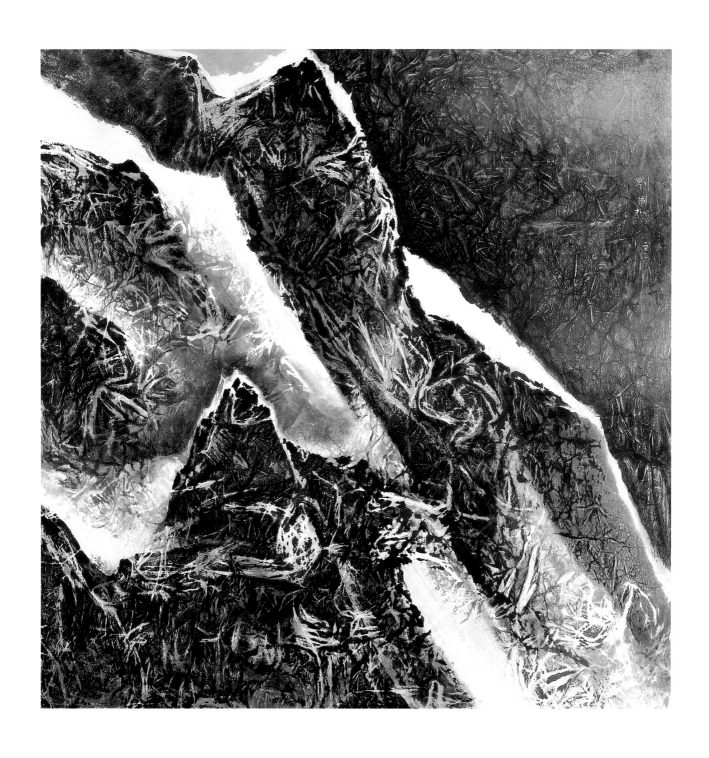

玉山的傳說
Legends of Jade Mountain
2011
水墨設色、紙本 Ink, color on paper
94.8 × 93.5 cm

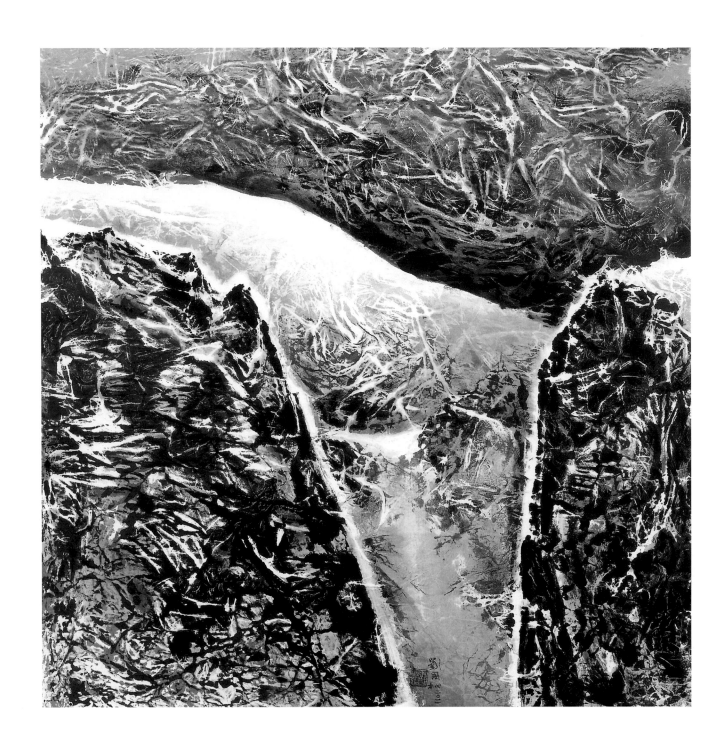

網山的白線：西藏組曲之 165
White Lines Netting the Mountain: Tibet Siries No. 165
2011
水墨設色、紙本　Ink, color on paper
93.5 × 95 cm

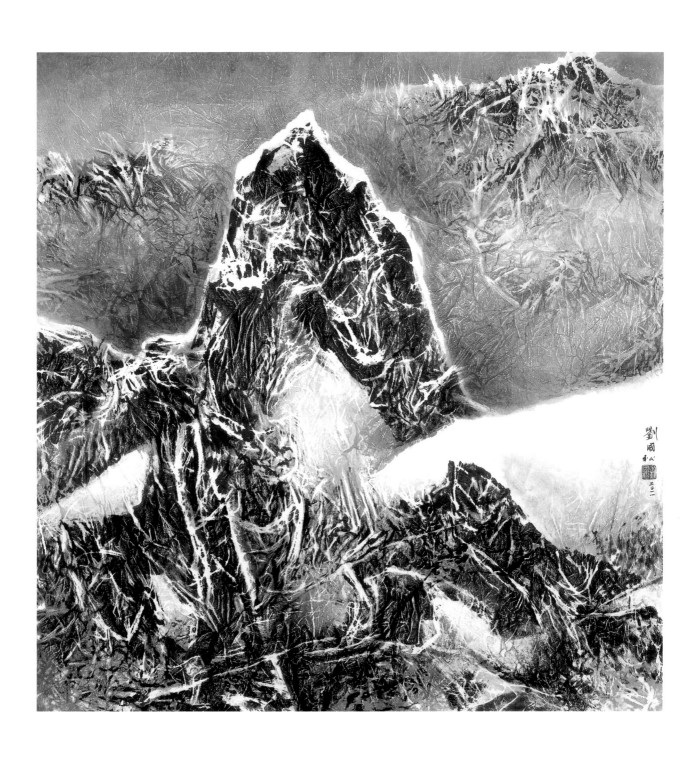

屹立于冰雪之中：西藏組曲之 199
Unmovable Whether by Snow or by Ice: Tibet Siries No. 199
2011
水墨設色、紙本 Ink, color on paper
94.8 × 92.8 cm

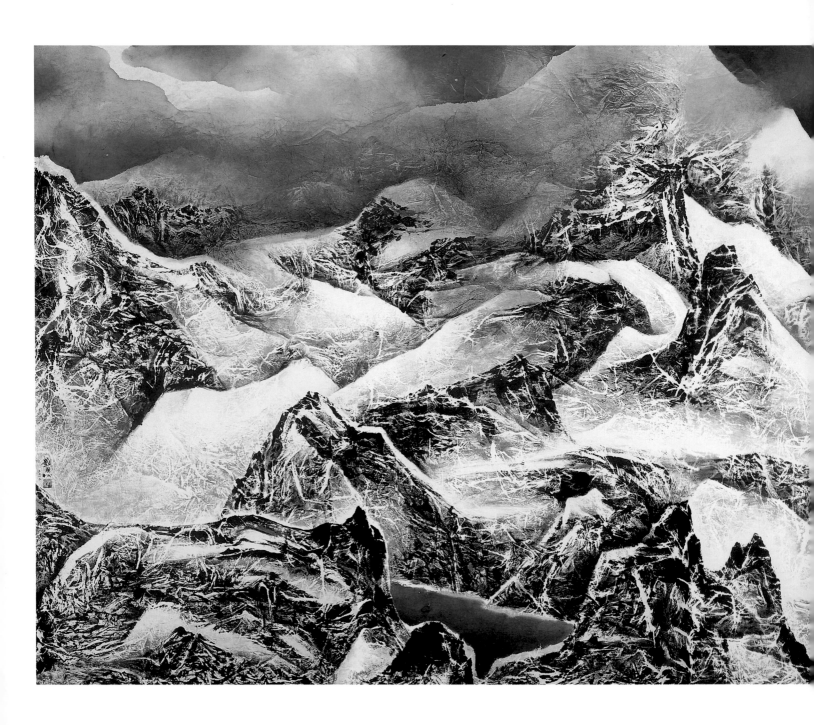

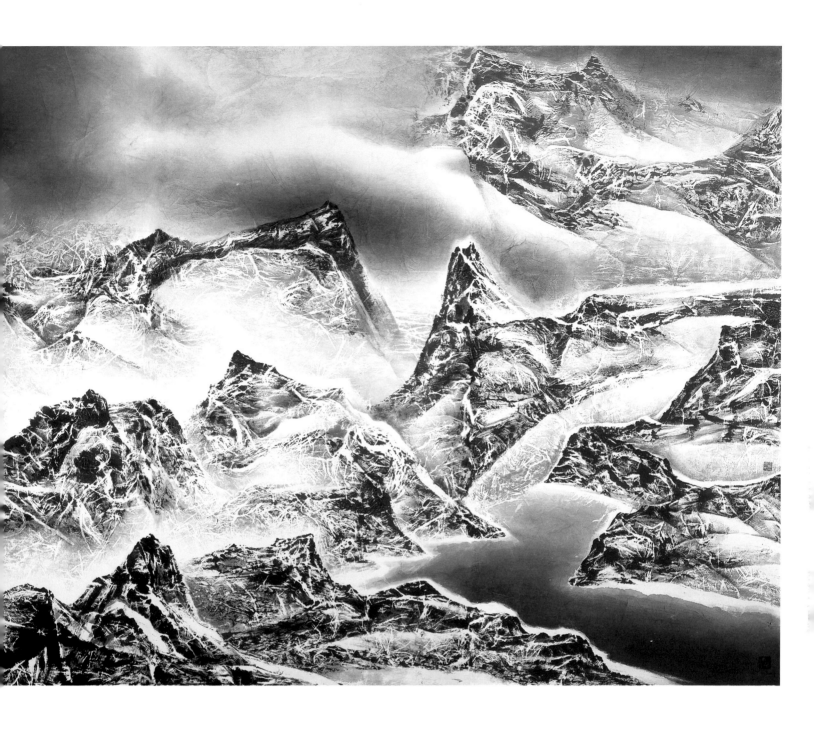

雪網山痕皆自然 A：西藏組曲之 181
Snow's Net Mountains Lines are all Natural A: Tibet Siries No. 181
2012
水墨設色、紙本 Ink, color on paper
188 × 463 cm

年表　Chronology

年表

1932　4 月 26 日生於安徽蚌埠，原籍山東青州。

1938　父親於抗日戰爭中陣亡。與母親流亡於湖北，陝西，四川，湖南，江西等地，歷經艱難，妹妹於逃亡中夭折。

1946　抗日勝利後，定居於湖北武昌。

1948　考入南京國民革命軍遺族學校。

1949　隻身隨遺族學校到台灣，後分至台北省立師範學院（今台灣師範大學）附屬中學高一就讀。

1950　發表新詩及短篇小說於《自由中國》與《中學生》等雜誌上。

1951　以同等學歷考進台灣師範學院美術系。

1954　在《聯合報》發表首篇評論文章〈為什麼把日本畫往國畫擠？—九屆全省美展國畫部觀後〉。

1956　台灣師範大學美術系第一名畢業，並於校內舉辦「四人聯合西畫展」。
　　　在廖繼春老師的鼓勵下成立「五月畫會」。

1957　代表台灣參加日本東京「亞洲青年美展」。
　　　首屆「五月畫會」於台北舉辦，掀起了台灣現代藝術運動。

1958　開始大量撰寫藝術理論文章，鼓吹現代藝術。

1959　參加巴西「聖保羅國際雙年展」，法國「巴黎青年雙年展」，被法國費加羅日報評為天才。
　　　思想由全盤西化轉為中西合璧，開始採用石膏在畫布上打底，在油畫中加入水墨趣味。
　　　受廖繼春老師的推薦，赴台南成功大學建築系擔任郭柏川的美術助教。

1960　應聘擔任中原大學建築系講師。
　　　參與《筆匯》月刊的編輯工作。

1961　與黎模華女士結婚。
　　　受建築界材料理論影響，放棄油彩與畫布，重回紙墨世界，倡導「中國畫現代化」運動，並開發各種拓墨技法。
　　　撰文反駁徐復觀〈現代藝術的歸趨〉一文，引發「現代繪畫論戰」。

1963　發明粗筋棉紙「劉國松紙」，並藉此創造出自我獨特畫風。
　　　作品《雲深不知處》為香港藝術館收藏，也是作品首次為美術館收藏。

1964　「當代中國繪畫展」非洲十四個國家巡迴展。

1965　首次個展於台灣藝術館舉辦。
　　　「亞洲先進藝術家畫展」亞洲十大城市巡迴展出。
　　　論文集《中國現代畫的路》由台北文星書店出版。
　　　應意大利羅馬現代美術館之邀，參加「中國現代藝術展」。

1966　第二本論文集《臨摹‧寫生‧創造》由台北文星書店出版。
　　　經李鑄晉推薦，獲美國洛克斐勒三世基金會（The JDR 3rd Foundation）兩年環球旅行獎。
　　　應美國加州拉古拉美術館之邀，舉行在美之首次個展。
　　　赴愛荷華大學學習銅版畫 3 個月，隨後在美各地旅遊參觀4

個月，並在紐約旅居 9 個月。還多次赴各地參加「中國新山水傳統」在美國主要美術館巡迴展的開幕式。
　　　第一本《劉國松畫集》由台北歷史博物館出版。

1967　應諾德勒斯畫廊之邀，舉行首次紐約個展，獲紐約時報名藝術評論家肯乃德（John Canaday）好評，並與該畫廊簽約，成為代理畫家。
　　　應美國密蘇里州堪薩斯市納爾遜美術館邀請舉行個展。
　　　五月初離開紐約赴歐州旅遊參觀五個月，十月返回台灣。

1968　當選台灣「十大傑出青年」。
　　　發起成立台灣「中國水墨畫學會」，繼續鼓吹中國畫之現代化。

1969　受美國「阿波羅 8 號」宇宙飛船由月球背面拍回地球照片之影響，開始《太空畫》系列之創作，首幅《地球何許？》獲美國「主流『69』國際美展」繪畫首獎。
　　　台北歷史博物館主辦「劉國松畫展」，並出版李鑄晉著英文版《劉國松—一個中國現代畫家的成長》。
　　　應美國加州史丹佛大學美術館之邀，參加「二十世紀中國繪畫的發展」展出。

1970　應美國威斯康辛史道特州立大學藝術系之邀，擔任客座教授一學期。
　　　應邀為日本大阪世界博覽會繪製巨作《午夜的太陽》。
　　　德國科隆東方藝術博物館和法蘭克福博物館合辦「劉國松畫展」巡迴展，並出版《劉國松—一個中國現代畫家的成長》德文版。
　　　應美國芝加哥藝術俱樂部之邀，參展「書法的陳述」。

1971　應聘香港中文大學藝術系任教，遷居香港。
　　　個展於美國檀香山美術學院與俄亥俄州辛辛那提市塔虎脫博物館。

1972　出任香港中文大學藝術系主任，並首創「現代水墨畫」課程。
　　　香港藝術中心舉辦「劉國松畫展」。

1973　創辦「現代水墨畫文憑課程」於香港中文大學校外進修部，推廣現代水墨創作。
　　　著名英國藝術史蘇利文《東西方藝術之會合》（The Meeting of Eastern and Western Art）在英國出版，對劉國松給予重要評價。
　　　參加由國際電話電報公司主辦在各國著名博物館巡迴展出的「國際美展」。
　　　開始全力探索水拓畫技法。

1974　發表〈談繪畫的技巧〉一文，提出「革中鋒的命」、「革筆的命」之理論，引發大規模的討論。
　　　參加日本東京上野之森美術館「亞細亞現代美術展」。
　　　參加美國耶魯大學美術館「當代中國之繪畫與書法展」，並巡迴著名大學美術館展出一年。

1975　法國出版的《抽象藝術》一書，收錄其作品《地球何許？》。

應美國愛荷華大學藝術學院之邀，擔任客座教授一年。

參加日本東京上野之森美術館「第十一屆亞洲現代美展」。

1976　於香港中文大學籌辦及主持第四屆亞洲國際美術教育會議，並當選國際藝術教育協會亞洲區會長。

辭系主任一職，專心教學與創作。

蘇利文著《中國美術簡史》（A Short History of Chinese Art）由美國柏克萊加州大學出版，將其列入創新一派。

發表論文著作《溥心畬書畫稿》，出版於香港中文大學藝術系叢書第二冊。

1977　當選英國國聯 8 位畫家的亞洲區代表，前往加拿大參加「國際版畫代表作」之創作。

參加香港藝術館「今日香港藝術展」。

1978　應聘擔任台北市美術館籌備委員會委員。

紐約大學教授諾考瓦（Conrad Schirokauer）著《中國與日本文化簡史》（A Brief History of Chinese and Japanese Civilizations）大學教科書將其列為中國現代藝術之代表，並在書中引用其理論文章並刊印其畫作。

1979　獲國際靜坐協會完美獎。

參加美國聯合國舉辦的「藝術家 79 展覽」。

1980　應愛荷華州——伊利諾伊州藝術評議會之邀，任訪問藝術家 1 年。並於各大學美術學院，教育電視台及美術館巡迴演講及教授繪畫。

1981　應邀赴北京參加北京中國畫研究院之成立大會並參展。隨後赴南京，上海，杭州參觀訪問。

參加法國巴黎塞紐斯基博物館「中國現代繪畫趨向展」。

應邀赴巴林國巴林市參加「第一屆亞洲藝術展」展出及開幕活動。

1982　英國出版的希諾考瓦《現代中國和日本》（Modern China and Japan）視其為中國代表畫家參加菲律賓馬尼拉大都會博物館「香港當代美展」。

1983　個展於北京中國美術館與南京江蘇省美術館，並應中央美術學院之邀公開舉辦三個演講，隨後 3 年巡迴展於全國 18 個重要城市，北到哈爾濱，西至蘭州，烏魯木齊。

1984　北京人民美術出版社出版《劉國松畫輯》。

參加北京「第六屆全國美展」，與李可染同時獲得「特別獎」。

參加香港藝術館「二十世紀中國繪畫展」。

1985　首次應法國「五月沙龍」之邀，作品《沉入山的呼吸裡》參加該沙龍在巴黎大皇宮的展出。

應北京中央工藝美術學院之聘前往該校講學兩周，教授現代水墨畫。

周韶華著《劉國松的藝術構成》由湖北美術出版社出版。

1986　赴敦煌與絲綢之路考察。

水拓畫達於成熟境地，開始漬墨畫的探索與試驗。

參加漢城韓國文化館「第十屆亞洲運動會亞洲現代水墨畫展」

1987　8 月前往西藏旅遊，成為創作《西藏山水》系列之靈感泉源，畫風為之一變。

參加日本東京都美術館「國際水墨畫展」並獲頒特別獎。

參加加拿大溫哥華市美術館「當代中國繪畫展覽」。

參加比利時布魯塞爾市政廳主辦之「中國現代畫展」。

1988　參加北京中國畫研究所「國際水墨畫展」和「水墨畫研討會」，發表論文〈當前國畫的觀念問題〉。

參加日本福岡市美術館「第三屆亞洲國際美術展覽」。

參加漢城韓國美術館「東方現代彩墨展」。

1989　應邀擔任北京「全國現代書畫大賽」評審委員。

應美國運通銀行之邀，繪製五層樓高之大畫《源》（1952 厘米 x 366 厘米）。

參加韓國漢城大都會藝術博物館「第四屆亞洲國際美術展覽」。

1990　大型回顧展由台北市立美術館舉辦，並出版畫冊。

1991　獲李仲生現代繪畫文教基金會「現代繪畫成就獎」。

1992　應邀出席台北市美術館「東方美學與現代美術」學術研討會，發表〈先求異，再求好〉教學理論。

「六十回顧展」於台中市台灣省立美術館舉辦。

10 月自香港中文大學退休，返台中定居，並任東海大學客座教授。

1995　赴法國參加巴黎台北新聞文化中心「台灣當代水墨畫展」。

1996　應邀擔任台南藝術大學造型藝術研究所所長。

台北歷史博物館邀請舉辦「劉國松研究展」，並出版蕭瓊瑞著《劉國松研究》與李君毅編《劉國松研究文選》。

陳履生著《劉國松評傳》由廣西美術出版社出版。

1997　應邀參加上海美術館舉辦之「中國藝術大展」及研討會。

1998　台灣唯一的藝術家應邀赴紐約參加古根漢美術館舉辦之「中華五千年文明藝術展」的展出，並參加開幕式。並參加該展於西班牙畢爾堡古根漢美術館的開幕式。

應德國文化中心之邀赴歐洲參觀考察，並參加「展望 2000—中國現代藝術展」。

德國 Edition Global 出版之大學教科書《Bruchen und Bruche: Chinas Malerei im 20. Jahrhundert》用劉國松作品《千仞錯》作封面，內文大量介紹了其對當代中國繪畫的影響。

論文集《永世的痴迷》由山東畫報出版社出版。

自台南藝術大學退休。

1999　應台北市中山國家藝廊之邀舉辦「宇宙即我心」個展。

蕭瓊瑞與林伯欣合著《台灣美術評論全集：劉國松卷》由台灣省立美術館出版。

應邀赴巴黎製作《畫中有詩》版畫集。余光中特別為劉國松的畫創作六首詩一併印出，同時出版《詩情畫意集》。

2000 應邀赴成都現代藝術館參加「世紀之門」藝術展覽。

應邀赴西藏大學講學，並前往珠穆朗瑪峰，出藏後左耳突然失聰。

在紐約 Goedhuis Contemporary 畫廊舉辦個展。

《劉國松・余光中：對影叢書—文採畫風》由河北教育出版社出版。

2001 應邀赴紐約參加「無限中華」藝術大展，並訪問華盛頓、舊金山等地。

赴四川九寨溝旅遊，深受原始自然境觀的感動，開始實驗用建築描圖紙結合漬墨技法創造了一系列九寨溝的波光水影作品。

應成都現代藝術館的邀請，舉辦「西疆擴遠—劉國松畫展」

2002 「宇宙心印—劉國松七十回顧」於新竹智邦藝術中心，北京國家歷史博物館，上海美術館，廣東美術館及台北京華城盛大巡迴展出。

作品《石頭的玄學》(The Metaphysics of Rocks) 被收入美國 Wadsworth Group 出版的大學教科書《東方文化史》中。

當選台灣師範大學「傑出校友」。

李君毅編《劉國松談藝錄》由河南美術出版社出版。

2003 「造化心源」於台灣台中文化中心展出。

「劉國松七十回顧展」於香港漢雅軒展出。

2004 「劉國松的宇宙」應邀於香港藝術館展出，並出版大型畫集。

出任香港中文大學訪問學人。

獲台南藝術大學頒發「榮譽教授」證書。

美國 Thomson 出版社的大學教科書《現代東亞簡史》用了劉國松的「石頭的玄學」及其理論文字。

2005 台灣創價學會主辦的「現代的衝擊：劉國松畫展」於新竹藝文中心，台中藝文中心，景陽藝文中心與鹽埕藝文中心巡迴展出。

美國亞利桑那州立大學舉辦「劉國松師生展」。

出席英國牛津大學主辦之「現代中國藝術學術研討會」。

「劉國松：創作回顧」於新加坡泰勒版畫院展出。

受神舟六號升空的感動，開始創作《神舟六號》系列作品。

2006 「心源造化：劉國松創作回顧展」由杭州浙江省博物館、浙江西湖美術館與湖南省博物館主辦展出。

10 月 14 日應美國哈佛大學之邀，演講《我的繪畫理念與實際》，並參加賽克勒博物館舉辦之「中國新山水畫展」的開幕活動。

由張家界遊覽之後，又創作一系列張家界作品，山水巨幅《天子山盛夏》隨後被故宮博物院收藏。

2007 出席瑞士蘇黎世理伯博物館新館開幕活動。

「宇宙心印：劉國松繪畫一甲子」由北京故宮博物院主辦於武英殿展覽館展出，之後也在上海美術館和廣東美術館展出

林木著《劉國松的中國現代畫之路》由四川美術出版社出版。

張孟起與劉素玉合著《宇宙即我心：劉國松的藝術創作之路》由台北典藏藝術出版。

2008 獲台灣第十二屆國家文藝獎。

在法國巴黎 Galerie 75 Faubourg 開個展。

赴北京參加當代藝術館舉辦的「水墨演義」開幕活動及上上美術館「水墨主義」的展出。

2009 「宇宙心印：劉國松繪畫一甲子」巡迴展於湖北省博物館、寧夏博物館、重慶中國三峽博物館與合肥亞明藝術館。

被聘為客座教授至西南大學與四川美院講學。

2010 在英國倫敦 Goedhuis Contemporary 畫廊個展，作品《日月浮沉》為大英博物館收藏。

應邀赴成都四川大學講學。

赴北京參加兩岸漢字藝術節。

獲台灣師範大學講座教授聘書。

獲世界藝術文化學院頒發榮譽博士學位。

2011 蕭瓊瑞著《水墨巨靈——劉國松傳》由台北遠景出版社出版。

「劉國松創作大展—八十回眸」於北京中國美術館展出。

應邀於中央美院作專題演講。

應邀在澳門舉辦之「海峽兩岸學術研討會」上作專題演講。

應邀以嘉賓身份參加北京全國文聯代表會議。

獲中國藝術研究院頒發「中華藝文終生成就獎」

參加辛亥革命一百周年藝術展於北京國家博物館與中國美術館。

2012 「一個東西南北人—劉國松80回顧展」於台灣國立台灣美術館展出。

獲獎與榮譽

1965	台北市第五屆全國美展評審委員
1966	榮獲美國洛克斐勒三世基金會兩年環球旅行獎
1968	當選國際青年商會台灣十大傑出青年
1969	美國瑪瑞埃他學院主流六九國際美展繪畫首獎
1972	巴西聖保羅國際雙年展台灣參展評審委員
1976	當選聯和國教文組織國際藝術教育協會亞洲區會會長
1977	被選為英國國聯八位代表畫家的亞洲區代表前往加拿大參加「國聯版畫代表作」之創作
1978	台北市立美術館籌建委員
1979	獲國際靜坐協會完美獎
1984	獲北京第六屆全國美展特別獎
1986	獲東京都美術館國際水墨畫特別獎
1991	獲李仲生現代繪畫文教基金會現代繪畫成就獎
2002	當選台灣師範大學「傑出校友獎」 應聘出任香港中文大學訪問學人
2004	獲台南藝術大學頒發榮譽教授證書
2005	受聘上海多倫現代美術館名譽館長
2006	10 月應美國哈佛大學之邀請演講「我的創作理念與實踐」
2007	北京故宮博物院舉辦「宇宙心印：劉國松繪畫一甲子」大型回顧展
2008	獲台灣國家文藝獎
2010	獲台灣師範大學講座教授聘書 獲世界藝術文化學院頒發榮譽博士學位
2011	獲中國首屆中華藝文獎「終生成就獎」

收藏機構

亞洲

台中市國立台灣美術館
台北市國立歷史博物館
台北市立美術館
台北市國立國父紀念館
台北市台灣藝術教育館
高雄市立美術館
香港藝術館
香港中文大學文物館
澳州墨爾本國立維多利亞美術館
菲律賓馬尼拉大都會博物館
馬來西亞吉隆坡藝術博物館
北京故宮博物院
北京中國美術館
上海美術館
廣州廣東美術館
廣東深圳何香凝美術館
重慶市三峽博物館
江蘇省美術館
浙江省博物館
湖北省博物館
湖南省博物館
安徽亞明藝術館
山東省美術館
山東省博物館
青島市美術館
青島市博物館
成都現代藝術館
寧夏博物館
甘肅省美術館

美國

芝加哥美術館
俄亥俄州克利佛蘭州博物館
舊金山亞洲藝術博物館
密蘇里州肯薩斯市納爾遜美術館
紐約亞洲美術館
亞利桑那州鳳凰城美術館
拉布拉斯州歐馬哈市賈斯林美術館
佛羅里達州諾頓美術館
加州聖地牙哥美術館
加州蒙特利半島美術館
德州達拉斯現代美術館
西雅圖美術館
科羅拉多州丹佛市美術館
科羅拉多州科羅拉多泉藝術中心
麻州皮博迪埃塞克斯博物館
麻州康橋哈佛大學薩克拉博物館
麻州康橋哈佛大學法格博物館
肯薩斯州肯薩斯大學史班塞美術館
明尼蘇達州明尼蘇達大學美術館
亞利桑那州吐桑市亞利桑那大學博物館
加州史丹佛大學坎特爾藝術中心
猶他州婁根市猶他州立大學美術館
肯薩斯州威其塔州立大學烏瑞奇美術館
佛羅里達州聖彼得斯堡市普利市拜特蘭學院美術館
紐約坎東市聖勞倫斯大學美術館
加州惠特爾市雷歐社學院美術館

歐洲

英國倫敦大英博物館
英國布里斯朵市美術館
德國法蘭克福博物館
德國科隆東方美術館
德國柏林博物館
德國斯都加林都美術館
瑞士蘇黎世萊特堡博物館
意大利麥辛那大學美術館

主要個展

1965　台北藝術館

1966　美國加州拉古拉藝術協會美術館
　　　美國肯薩斯州立大學美術館

1967　美國紐約市諾德勒斯畫廊
　　　美國密蘇里州肯薩斯市那爾遜美術館
　　　美國喬治亞州雅典市喬治亞大學美術館

1968　美國華盛頓州西雅圖美術館
　　　美國俄亥俄州辛辛那提市塔虎脫博物館
　　　菲律賓馬尼拉市陸茲畫廊

1969　美國德州達拉斯市現代美術館
　　　台北歷史博物館國家畫廊
　　　美國印地安那州諾特丹市聖瑪麗學院藝術館

1970　德國科隆東方藝術博物館
　　　美國拉布拉斯卡州歐馬哈市賈斯林美術館
　　　美國加州聖地牙哥市美術館

1971　德國法蘭克福博物館
　　　英國倫敦莫士畫廊
　　　英國布里斯朵市美術館

1972　美國鹽湖城猶他州立大學美術館
　　　美國猶他州婁根市猶他州立大學美術館
　　　美國猶他州普柔佛市布瑞根揚大學藝術博物館
　　　德國漢堡市漢斯胡普勒爾畫廊

1973　香港藝術中心
　　　美國加州聖地牙哥市美術館
　　　紐約市開樂畫廊

1974　美國加州卡邁爾市拉克畫廊

1975　美國科羅拉多州科羅拉多泉藝術中心
　　　美國加州洛杉磯市喜諾畫廊

1976　美國肯薩斯州威其塔市烏瑞奇美術館
　　　美國俄亥俄州雅典市州立大學美術館

1977　美國新罕普什州普利茅斯市新罕普什州大學美術館
　　　美國加州洛杉磯市奧西丹脫學院美術館

1978　澳洲墨爾本市東西畫廊
　　　澳洲北阿德萊市格林赫爾畫廊
　　　澳洲帕斯市邱吉爾畫廊

1979	澳洲坎培拉市劇場畫廊
	德國法蘭克福博物館
1980	美國肯薩斯州威其塔市烏瑞奇美術館
	美國亞利桑那州吐桑市亞利桑那州立大學美術館
	美國加州蒙特利市蒙特利半島美術館
	美國俄亥俄州雅典市俄亥俄州立大學美術館
1981	美國俄亥俄州哥倫布市立文化藝術中心
	美國科羅拉多州波爾市科羅拉多大學美術館
	美國加州哥斯塔梅沙市安德瑞畫廊
1982	美國猶他州婁根市諾拉依科哈瑞森博物館
1983	北京中國美術館
	江蘇省美術館
	黑龍江美術館
	武漢市湖北省美術陳列館
	廣州市廣東畫院
1984	上海美術館
	山東省美術館
	杭州市浙江展覽館
	煙台市展覽廳
	福州市五一廣場中央展覽廳
1985	香港藝術中心
	澳門市政廳賈梅士博物館
1986	陝西西安市美術家協會畫廊
	甘肅蘭州市少年宮
	新疆烏魯木齊市展覽館
	重慶市文化宮
	四川重慶西南大學美術展覽館
1987	湖南長沙市湖南省國畫館
	山西太原市山西大學美術館
1988	山東濰坊博物館
1989	德國布瑞曼市烏伯西博物館
1990	台北市立美術館
1992	台中省立美術館
1994	台北龍門畫廊
1996	台北歷史博物館
	高雄積禪五十藝術空間
1997	廣東深圳何香凝美術館
	台中現代藝術空間

1998	台中現代藝術空間
1999	台北國父紀念館"中山國家畫廊"
200	台灣中央大學藝文中心
	美國紐約古豪士畫廊
2001	成都現代藝術館
2002	「宇宙心印：劉國松七十回顧展」
	北京中國國家博物館
	上海美術館
	廣東美術館
2003	台中市立文化中心
	山東青島博物館
	香港漢雅軒畫廊
2004	香港美術館
	台灣創價學會主辦台灣巡迴展
2005	新加坡泰勒版畫學院
	台北市中央研究院
2006	浙江省博物館
	湖南省博物館
2007	「宇宙心印：劉國松繪畫一甲子」
	北京故宮博物院
	上海美術館
	廣東美術館
2008	法國巴黎法寶 75 畫廊
2009	「宇宙心印：劉國松繪畫一甲子」
	湖北省博物館
	寧夏博物館
	重慶中國三峽博物館
	安徽亞明藝術館
	國父紀念館"中山國家畫廊"
2010	英國倫敦 Goedhuis 畫廊
	台灣新北市市府藝廊
2011	「劉國松創作大展—八十回眸」
	北京中國美術館
2012	「一個東西南北人—劉國松80回顧展」
	台灣國立台灣美術館

Chronology

1932 Born on April 26, in Bangbu, Anhui province.

1938 Father died in the war against Japan. During the war Liu traveled with mother and sister to Hubei, Shanxi, Sichuan, Hunan, Jiangxi, and many other places; sister died due to sickness.

1946 When war ended, family settled in Wuchang, Hubei province.

1948 Qualified and admitted to Nanjing National Revolutionary Army Orphan School.

1949 Moved with his school to Taiwan and entered affiliated high school of the Taiwan Provincial Teachers' College (now Taiwan Normal University).

1950 Published poetry and short stories in "Free China" and "High School Student" magazines.

1951 Passed the entry exam and admitted into the Fine Arts Department of Taiwan Normal University.

1954 Published first essay "Why squeeze Japanese paintings into a Chinese painting exhibition? --- Thoughts after viewing the 9th Taiwan Art Exhibition Chinese Painting Section" on United Daily News.

1956 Graduated 1st from the Fine Arts Department of the Taiwan Normal University, and organized "Western Paintings of Four Artists" exhibition at the school.

Founded the "Fifth Moon Group" with the encouragement of his professor Liao Jichun.

1957 Represented Taiwan and participated in "Young Asian Artists" in Tokyo.

The first exhibition of the "Fifth Moon Group" opened in Taipei, and initiated a new art movement in Taiwan.

1958 Began to write articles about art theory to advocate modern Chinese art in Taiwan.

1959 Participated in Brazil's Sao Paolo Bienal and France's Paris Youth Bienale. Described as "genius" by France's Le Figaro Newspaper.

Turned away from complete Westernization to adopt a cultural position in which "the East and the West are merged". Began to use plaster models on canvas, and to add elements of ink painting to oil paintings.

Worked at the Architecture Department of Tainan Cheng Gong University as teaching assistant for Professor Guo Bochuan.

1960 Joined Chung Yuan University as lecturer for the architecture department.

Participated in editorial work at Pen Review magazine.

1961 Married to Ms. Lee Mohua.

Influenced by architectural theories, he abandoned oil and canvas, and returned to the world of ink and paper, leading the "Modern Chinese Painting Movement" and developing new painting techniques.

Wrote an article in response to Xu Fuguan's "The Retrogressive Trend in Modern Art", and set off the "battle over modern painting".

1963 Pioneered the use of rough fiber cotton paper, and invented "Liu Guosong Paper" which inspired a new painting style.

His work "Clouds Know no Emptiness" was collected by the Hong Kong Museum of Art, the first time his work is being collected by a museum.

1964 Participant of "Modern Chinese Paintings" exhibition tour in 14 counties in Africa.

1965 First solo exhibition at the Taiwan Museum of Art in Taipei.

Participant of "Asia Pioneer Artist" exhibition tour in 10 cities in Asia.

Collected essays "The Road to Modern Chinese Painting" published by Wen-Hsing Bookstore, Taipei.

Invited to participate in "China Modern Art" exhibition organized and held at Galleria del Palazzo delle Exposizioni in Rome, Italy.

1966 Second collection of essays "Copying, Drawing, Creating" published by Wen-Hsin Bookstore, Taipei.

Recommended by Li Zhujin, was the first Taiwan artist to win the John D. Rockefeller III two-year travel grant to travel the world.

First US solo exhibition held at Laguna Beach Museum of Art in California.

Studied printmaking at the University of Iowa for three months, traveled around US for four months, and then lived in New York for nine months.

First catalogue "Paintings by Liy Kuo sung" published by Taipei National Museum of History.

1967 First New York solo exhibition at Rhodes Gallery, and received good review from New York Times art critic John Canaday. Represented by Rhodes Gallery.

Invited by the Nelson-Atkins Museum of Art in Kansas City, Missouri to hold a solo exhibition.

Left US for Europe and spent 5 months in Europe. Returned to Taipei in October.

1968 Named Taiwan's "Ten Outstanding Youths".

Founded Taiwan's "Chinese Painting Study Society", and continued to advocate the modernization of Chinese painting.

1969 Influenced by pictures of the earth taken from the moon by the American Apollo 8 spacecraft, began painting the "Space Series"; the first work in the series "Which is Earth?" won the first prize at the "Mainstream '69" in US.

Solo exhibition "Paintings by Liu Kuo sung" held at the Taiwan National Museum of History, and at the same time "The Growth of a Modern Chinese Artist" by Professor Li Chu-Tsing (English version) was also published by the museum.

Invited by Stanford University Art Museum to participate in the "The Development of 20th Century Chinese Painting".

1970 Taught at the University of Wisconsin - Stout for a semester as visiting professor.

Invited to create a massive painting "The Midnight Sun" for the International Expo in Osaka, Japan.

Museum fur Kunsthandwerk, Frankfurt, and Museum fur Ostasiatische Kunst, Cologne, jointly held the touring exhibition "Painting of Liu Kuo-sung", and published "The Growth of a Modern Chinese Artist" in German.

Invited by The Arts Club of Chicago to join the "Calligraphic Statement" exhibition.

1971 Moved to Hong to teach at the Fine Arts Department of Chinese University of Hong Kong.

Participant of "Fifth Moon Group Exhibition" at Honolulu Academy of Hawaii and The Taft Museum in Cincinnati, Ohio.

1972 Appointed Chairman of the Fine Arts Department at the Chinese University of Hong Kong; created "Modern Chinese Ink Painting" curriculum.

"Paintings of Liu Kuo-sung" exhibition at Hong Kong Art Center

1973 Created "Modern Chinese Ink Painting" courses for the Chinese University of Hong Kong Extension curriculum for diploma to foster creative works of modern Chinese ink painting.

British art historian Michael Sullivan published "The Meeting of Eastern and Western Art" in England, positively assessing Liu's work.

Participated in "International Art Exhibition" tour at major museums organized by ITT.

Began extensive experimentation with ink rubbing.

1974 Published essay "Discussion on Painting Techniques" and introduced his hugely controversial theories of "overturning the centre tip" and "overturning the brush".

Participated in "Asia Modern Art Exhibition" at Ueno No Mori Art Museum in Tokyo, Japan.

Participated in "Contemporary Chinese Painting and Calligraphy" exhibition at Yale University Art Gallery; exhibition tour at various museums and galleries in the United States.

1975 "Abstract Art", was published in France, included Liu's painting "Which is Earth?".

Taught at University of Iowa for a year as visiting professor.

Participated in "11th Asian Contemporary Art Exhibition" at Ueno No Mori Art Museum in Tokyo, Japan.

1976 Organized and chaired the Fourth Asian International Art Education conference at the Chinese University of Hong Kong; elected as Asian representative to the International Art Education Association.

Resigned art department Chairman post and devoted his time to pedagogy and painting.

Michael Sullivan's "A Short History of Chinese Art" published by the University of California, Berkeley, and named Liu as an innovator for Chinese art.

Published essays "The Art of Pu Xinyu" in the second volume of Chinese University of Hong Kong Art Department Journal.

1977 Chosen as the only Asian representative among the eight official painters of the British Commonwealth, and participated in creating "Commonwealth Print" in Canada.

Participated in "Hong Kong Art Today" exhibition at the Hong Kong Art Museum.

1978 Member of organizing and planning committee for Taipei Fine Arts Museum.

New York University professor Conrad Schirokauer published "A Brief History of Chinese and Japanese Civilizations", and named Liu as a representative figure in Taiwanese art and quoted from Liu's essays and also included Liu's works.

1979 Received fulfillment prize from the International Meditation Society.

Participated in "Artists '79" exhibition held at the General Assembly Building of the United Nations headquarters in New York.

1980 Invited by the Iowa-Illinois Art Critics Association as visiting artist for a year, delivering lectures and master classes at various colleges and universities, education television programs, and museums.

1981 Invited to Beijing for the inauguration of the Chinese Painting Research Institute and exhibited his works.

Participated in "Peinture Chinoises Traditionnelles" at Musée Ceruschi in Paris, France.

Participated in "The First Exhibition of Asian Art" in Bahrain City, Bahrain.

1982 Conrad Schirokauer's "Modern China and Japan" published in England, named Liu as the key figure of modern Chinese art.

Participated in "Contemporary Hong Kong Art" at the Metropolitan Museum of Manila, Philippines.

1983 Solo exhibitions at National Art Museum of China in Beijing and Jiangsu Provincial Art Museum in Nanjing; gave 3 public lecture by the invitation of Central Academy of Fine Arts; Liu's solo exhibition tour continued in 18 different cities throughout China for the next three years.

1984 "Paintings by Liu Kuo-sung" published by Beijing's People's Art Publishing House.

Participated in Beijing's "Sixth National Art Exibition", and won the "Special Achievement Award" together with Li Keran.

Participated in Hong Kong Art Museum's "20th Century Chinese Paintings Exibition".

1985 Liu's was invited by France's "May Painting Salon" to include Liu's painting "Deeply inside the Mountain's Breath" as part of the salon exhibition in Paris.

Invited by the China Institute of Arts and Handicraftss with a short visiting professorship and taught modern Chinese ink painting at the institute.

Zhou Shaohua's "The Construction of Liu Kuo-sung's Art" was published by Hubei Fine Arts Publisher.

1986 Visited the Silk Road and it's surrounding areas.

Having mastered ink-rubbing techniques, started to experiment and explore with light ink techniques.

Participated in "Modern Asian Ink and Color Paintings Exhibition - 10th Asian Games Arts Festival" at Korean Culture Center, Seoul, Korea.

1987 Visited Tibet and since created a new style and the "Tibetan Landscape Series".

Participated in "Exhibition of International Art of Suiboku" at the Tokyo Metropolitan Art Museum in Japan.

Participated in "Contemporary Chinese Painting Exhibition" at the Vancouver Art Gallery in Canada.

Participated in "Chinese Modern Painting Exhibition" at Brussels City Hall in Belgium.

1988 Participated in the "International Ink Painting Exhibition" and "Ink Painting Research Conference" organized by the Chinese Painting Institute in Beijing; Liu also published essay "Conceptual Questions in Contemporary Chinese Painting".

Participated in the "3rd Asian International Art Exhibition" at the Fukuoka Art Museum, Japan.

Participated in "Oriental Color & Ink Painting's Exhibition" at the Korean Art Gallery in Seoul, Korea.

1989 Panel judge for the "National Modern Painting Competition" in Beijing.

Commissioned by the American Express Corporation and painted a five-story mural titled "Source" (1952cm x 366cm).

Participated in "The Fourth Asian International Art Exhibition" at Seoul Metropolitan Museum of Art, Korea.

1990 Major retrospective exhibition at the Taipei Fine Arts Museum, and catalog published.

1991 Received the "Modern Painting Achievement Award" from the Li Zongsheng Modern Painting Cultural and Education Foundation.

1992 Invited to participate at the "Eastern Aesthetics and Modern Art Symposium" at the Taipei Fine Arts Museum; published pedagogical theory of "First Be Different, Then Be Refined".

"Retrospective at 60" exhibition held at Taiwan Museum of Art in Taichung.

Retired from Chinese University of Hong Kong, moved to Taichung, Taiwan; joined Donghai University as visiting professor.

1995 Participated in "Taiwanese Contemporary Ink Painting Exhibition" at the Taiwanese Cultural Representative Office in Paris.

1996 Appointed head of Fine Arts Research Institute at the Tainan Fine Arts University.

"Liu Kuo-sung Research Exhibition" at Taipei National Museum of History; Hsiao Chong Ray's "Liu Kuo-sung Research" was also published by Taipei National Museum of History.

Chen Lusheng's "A Study of Liu Kuo-sung" was published by Guangxi Fine Arts Publisher.

1997 Invited to participate in "Chinese Art" exhibition and conference at the Shanghai Art Museum.

1998 The only artist from Taiwan invited to participate in " China : 5000 Years" exhibition at the Guggenheim Museum in New

York and Bibao.

Invited by the German Cultural Institute, traveled through Europe and participated in "Expectation 2000 : Chinese Modern Art Exhibition".

Edition Global in Germany used Liu's painting "High Cliff" as the cover of the university textbook "Bruchen und Bruche: China Malerei im 20. Jahrhun dert", and also wrote about Liu's influence in contemporary Chinese painting.

Liu's collection of essays "Obsessed Forever" published by Shangdong Pictorial Publisher.

Retired from Tainan Fine Arts University.

1999 Solo exhibition "The Universe and My Heart" at the Zhongshan National Gallery in Taipei.

"Anthology of Taiwan Critical Writing: Volume of Liu Kuo-sung", jointly written by Hsiao Chong Ray and Lin Po-shin, was published by Taiwan Museum of Fine Arts.

Invited to Paris to produce "Poetry in Painting" prints collection, and published a book with six poems specially written for this collection by Taiwan poet Yu Kwang-Chung.

2000 Participated in "Gate of the New Century" exhibition at the Chengdu Art Museum.

Invited to lecture at Tibet University; visited Mount Everest and since lost hearing in his left ear.

Solo exhibition at Goehuis Contemporary in New York.

"Liu Kuo-sung – Yu Kwang-Chung: Reflexion and Elegance" published by Hebei Education Publishing House.

2001 Invited to New York to participate in "China Without Limits" exhibition, and also visited San Francisco, Washington DC.

Visited Jiuzaigu and moved by the beauty of nature, started to experiment with light ink techniques to express the beauty of Jiuzaigu.

"The West is Vast: Paintings by Liu Kuo-sung" exhibition at Chengdu Art Museum.

2002 "The Universe in the Mind: A Retrospective of Liu Kuo-sung at 70" exhibition toured among China History Museum in Beijing, Shanghai Art Museum, Guangdong Museum of Art and various venues in Taipei.

Liu's work "The Metaphysics of Rocks" was included in the "Eastern Culture History" textbook published by the US Wadsworth Group.

Awarded "Outstanding Alumi" by the Taiwan National Normal University.

"Collected Essays of Liu Kuo-sung's Talk of Art", edited by Lee Chun-yi, was published by Henan Art Publisher.

2003 Solo exhibition "Heart of Creation" at the Cultural Center of Taiwan in Taichung.

"Liu Kuo-sung at 70" exhibition at Hanart T.Z. Gallery in Hong Kong.

2004 "A Universe of His Own" exhibition at Hong Kong Museum of Art, and exhibition catalog published.

Awarded "Honorary Professor" by the Tainan Fine Arts University.

Liu's painting "The Metaphysics of Rocks" and his theoretical writings was included in the university textbook "Modern History of East Asia", published by Thomson Publisher in US.

2005 Organized by Taiwan Soka Association, "Modern Impact: Liu Kuo-sung Exhibition" held at Hsinchu Art Center, Taichung Art Center, Chingyang Art Center and Yangcheng Art Center.

"Paintings by Liu Kuo-sung and his students" exhibition at Arizona State University.

Participated at the "Modern Chinese Painting" symposium at the Oxford University in England.

Exhibition "Liu Kuo-sung : A Retrospective View" at Tyler Print Institute in Singapore.

Moved by China's successful launch of spacecraft Shenzhou #6, started to paint a new "Shenzhou-6 Series".

2006 "Rhythm of Mind" exhibition at Zhejiang Provincial Museum, Westlake Museum and Hunan Provincial Museum.

Invited by Harvard University to participated in "New Chinese Paintings" exhibition and to deliver a speech.

After visiting Zhangjiajie, created a new " Zhangjiajie Series". Liu's work "Tianzishan in Summer: Zhangjiajie Series No.9" was collected by the Beijing Palace Museum.

2007 Invited to attend opening ceremony for the new building at the Museum Rieterg, Zurich, Switzerland.

"Universe in the Mind: 60 Years of Paintings by Liu Guosong" exhibition at the Wuyingdian Hall of the Palace Museum, Shanghai Museum of Art and Guangdong Art Musuem.

"Liu Guosong's Road to Modern Chinese Painting", written by Lin Mu, was published by Chengdu Sichuan Fine Art Publishing House.

"The Universe and My Heart: Liu Guosong's Road to Art Creation", written by Zhang Meng-Qi and Liu Su-Yu, was published by Taiwan Art & Collection Group.

2008 Awarded Taiwan's "National Award for Arts", presented by Taiwan President Ma Yin-Jiu

Solo exhibition at Galerie 75 Faubourg in Paris.

Attended the opening ceremony for the "Romance of Ink" exhibition at the Modern Art Gallery and participated in "Inkism" at the Shangshang Art Musuem in Beijing.

2009 "Universe in Mind: Liu Guosong 60 Years of Paintings" exhibition at Hubei Provincial Museum, Ningxia Provincial Museum, Chongqing China Three Gorges Museum and Hefei Yaming Museum.

Invited as "Lecturing Professor" and taught at Southwest University and Sichuan Art College.

2010 Solo exhibition at Goedhuis Contemporary in London, England. Liu's work "The Sun and the Moon was collected by the British Museum.

Lectured at Sichuan University.

Invited to participated in the inaugural "Chinese Character Festival" in Beijing.

Awarded "Chair Professor" by Taiwan National Normal University, highest honor in education in Taiwan.

Awarded "Honorary Doctorate" by the World Academy of Arts & Culture and World Congress of Poets.

2011 "The Spirit of Ink Painting – Biography of Liu Guosong", written by Hsiao Chong Ray, published by Taiwan Vista Publishing.

"A Creation Exhibition by Liu Guosong – Looking back at 80" exhibition at the National Art Museum of China, Beijing.

Invited by China Central Academy of Fine Arts as keynote speaker.

Invited as keynote speaker at the "China-Taiwan Academic Conference" in Macau.

Invited as "Guest of Honor" at the National Arts Association Conference in Beijing.

Awarded China Arts Award "Lifetime Achievement Award" by the Chinese National Academy of Arts.

Invited to participate at the "China Xinhai Revolution 100 Years Anniversary Arts Exhibition" at the National Museum of China and National Art Museum of China.

2012 Invited to participate at the "A Man of East, West, South and North - Liu Kuo-Sung 80th Birthday Retrospective Exhibition" at the National Taiwan Museum of Fine Arts.

Awards and Honors

1965 One of the judges of The Fifth National Art Exhibition, Taiwan.

1966 First artist from Taiwan to receive the John D. Rockefeller III Foundation grant to travel around the world for two years.

1968 Named Taiwan's "Ten Outstanding Youths" .

1969 Awarded First Prize for painting at Mainstream '69, Marietta, Ohio USA.

1972 Member of Taiwan selection committee for Taiwan entries to Bienal de Sao Paulo, Brazil.

1976 Elected as Asian representative to the International Art Education Association.

1977 The only Asian artist among the eight official painters for Commonwealth Print Portfolio , University of Alberta, Canada.

1978 Member of organizing and planning committee of Taipei Fine Arts Museum.

1979 Received fulfillment award by the International Meditation Society, Hong Kong.

1984 Awarded Special Achievement Prize at the 6th National Art Exhibition, Beijing, China.

1986 Received special prize at the Exhibition of International Art of Suiboku, Tokyo Metropolitan Museum, Japan.

1991 Received the "Modern Painting Achievement Award" from the Li Zhongsheng Foundation.

2002 Awarded "Outstanding Alumni" by Taiwan National Normal University.

Invited by Chinese University of Hong Kong as visiting scholar.

2004 Awarded "Honorary Professor" by the Tainan Fine Arts University.

2005 Appointed as Honorary Director for Shanghai DuoLen Museum in China.

2006 Invited by Harvard University and gave speech on "My Innovation Theory and Practice".

2007 "The Universe In The Mind: A Retrospective Of Liu Guosong's 60 years of paintings" exhibition held at The Palace Museum in Beijing.

2008 Awarded Taiwan's " National Award for Arts", presented by Taiwan President Ma Yin-Jiu.

2010 Awarded "Chair Professor" by Taiwan National Normal University.

Awarded "Honorary Doctorate" by the World Academy of Arts.

2011 Awarded China Arts Award "Lifetime Achievement Award" by the Chinese National Academyof Arts.

Selected Public Collections

Asia

Taiwan Museum of Fine Arts, Taichung
National Museum of History, Taipei
Taipei Fine Arts Museum
National Dr. Sun Yat-Sen Memorial Hall, Taipei
Kaohsiung Museum of Fine Arts
Hong Kong Museum of Art
The Chinese University of Hong Kong Art Museum
National Gallery of Victoria, Melbourne, Australia
Metropolitan Museum of Manila, Philippines
National Art Gallery, Malaysia
The Palace Museum, Beijing
National Art Museum of China, Beijing
Shanghai Art Museum
Guangdong Provincial Art Museum, Guangzhou
He Xiangning Art Museum, ShenZhen
Three Gorges Museum, Chongqing
Jiangsu Provincial Art Museum, Nanjing
Zhejiang Provincial Museum, Hangzhou
Hubei Provincial Museum, Wuchang
Hunan Provincial Museum, Changsha
Ya Ming Art Museum, Hefei
Shangdong Provincial Art Museum, Jinan
Shangdong Provincial Museum, Jinan
Qingdao Art Museum
Qingdao Museum
Chengdu Modern Art Museum
Ningxia Museum, Yinchuan
Gansu Provincial Art Museum, Lanzhou

USA

Art Institute of Chicago
Cleveland Museum of Art
Asian Art Museum of San Francisco
Nelson-Atkins Museum of Art, Kansas City, Missouri
Asian House Art Gallery, New York
Phoenix Art Museum
Joslyn Art Museum, Omaha, Nebraska
Norton Museum of Art, West Palm Beach, Florida
San Diego Museum of Art
Monterey Peninsula Museum of Art, Monterey, California
The Dallas Center for Contemporary Art
Seattle Art Museum
Denver Art Museum
Colorado Springs Fine Arts Center, Colorado Springs, Colorado
Peabody Essex Museum, Salem, Massachusetts
Arthur M. Sackler Museum, Harvard University Museums
Fogg Art Museum, Harvard University Museums
Spencer Museum of Art, University of Kansas
Weisman Art Museum, University of Minnesota
The University of Arizona Museum of Art
Iris and B. Gerald Cantor Center for Visual Arts, Stanford University
Chase Fine Arts Center, Utah State University
Ulrich Museum of Art, Wichita State University
Florida Presbyterian College, St. Petersburg, Florida
St. Lawrence University Art Gallery, Canton, New York
Rio Hondo Junior College Art Gallery, Whittier, California

Europe

British Museum, London, England
Bristol City Museum and Art Gallery, Bristol, England
Museum fur Kunsthandwerk, Frankfurt, Germany
Museum fur Ostasiatische Kunst, Cologne, Germany
Museum fur Ostasiatische Kunst, Berlin, Germany
Linden-Museum, Stuttgart, Germany
Museum Rieterg, Zurich, Switzerland
Universia degli Studi di Messina, Italy

Selected Solo Exhibitions

1965 Taiwan Museum of Art, Taipei, Taiwan

1966 Laguna Beach Museum of Art, California, USA
Museum of Art, University of Kansas, Lawrence, Kansas, USA

1967 Lee Nordness Galleries, New York, USA
Nelson-Atkins Museum of Art, Missouri, USA
Georgia University Art Gallery, Athens, Georgia USA

1968 The Seattle Art Museum, Seattle, Washington, USA
The Taft Museum, Cincinnati, Ohio, USA
The Luz Gallery, Makati, Rizal, The Philippines

1969 The Dallas Center for Contemporary Art, Texas, USA
National Museum of History, Taipei, Taiwan
St. Mary 's College Art Gallery, Nortre Dame, Indiana USA

1970 Museum fur Ostasiatische Kunst, Koln, Germany
Joslyn Art Museum, Omaha, Nebraska, USA
San Diego Museum of Art, California USA

1971 Museum fur Kunsthandwerk, Frankfurt, Germany
Hugh Moss Ltd., London, England
Bristol City Museum and Art Gallery, England

1972 Art Museum At the University of Utah, Salt Lake City, Utah USA
Utah State University Art Gallery, Logan, Utah USA
Brigham Young University Museum, Provo, Utah USA

Galerie Hans Hoeppner, Hamburg, Germany

1973 Hong Kong Art Centre, Hong Kong

San Diego Museum of Art, California USA

Frank Caro Company, New York, USA

1974 Laky Gallery, Carmel, California USA

1975 Colorado Springs Fine Arts Centre, Colorado USA

M.M. Shinno Gallery, Los Angeles, California USA

1976 Ulrich Museum of Arts, Wichita, Kansas USA

Museum of Ohio University, Atnens, Ohio USA

1977 Plymouth State College Art Gallery, University of New Hampshire, Plymouth, New Hampshire USA

Occidental College Art Gallery, Los Angeles, USA

1978 East and West Art Gallery, Melbourne, Victoria, Australia

Greenhill Galleries, North Adelaide, South Australia

Churchill Gallery, Perth, Western Australia

1979 Play House Art Gallery, Canberra, Australia

Museum fur Kunsthandwerk, Frankfurt, Germany

1980 Ulrich Museum of Arts, Wichita, Kansas USA

University of Arizona, Tuscon, Arizona USA

Monterey Peninsula Museum of Art, Monterey, California USA

Museum of Ohio University, Atnens, Ohio USA

1981 Columbus Cultural Arts Center, Columbus, Ohio USA

UMC Fine Art Gallery, University of Colorado, Boulder, Colorado USA

Galerie Andree, Costa Mesa, California USA

1982 Nora Eccles Harrison Museum of Art, Logan, Utah USA

1983 National Museum of Fine Arts, Beijing, China

Jiangsu Provincial Art Museum, Nanjing, China

Heilongjiang Provincial Art Gallery, Harbin, China

Hubei Provincial Art Exhibition Gallery, Wuhan, China

Guangdong Art Institute Gallery, Guangzhou, China

1984 Shanghai Museum of Art, China

Shangdong Provincial Art Gallery, Jinan, China

Zhejiang Exhibition Hall, Hangzhou, China

Fuzhou May 1st Plaza Central Hall, Fuzhou, China

1985 Hong Kong Arts Centre

Museu Luis de Camoes, Leal Senado de Macau

1986 Art Gallery of Shanxi Artists Association, Sian, Shanxi, China

Youth Palace, Lanzhou, Gansu, China

Urumqi City Exhibition Hall, Urumqi, Xinjiang, China

Cultural Palace, Chongqing, Sichuan, China

University Art Exhibition Hall, SouthWest University, Chongqing, Sichuan, China

1987 National Painting Museum of Hunan Province, Changsha, Hunan, China

University Art Gallery, Shanxi University, Taiyuan, Shanxi, China

1988 Weifang Museum, Weifang, Shangdong, China

1989 Ubersee-Museum, Bremen, Germany

1990 Taipei Fine Arts Museum, Taiwan

1992 National Museum of Art, Taichung, Taiwan

1994 Lung Men Art Gallery, Taipei, Taiwan

1996 National Museum of History, Taipei, Taiwan

G. Zen 50 Art Gallery, Kaohsiung, Taiwan

1997 He Xiangning Art Museum, Shenzhen, China

Modern Art Gallery, Taichung, Taiwan

1998 Modern Art Gallery, Taichung, Taiwan

1999 National Dr. Sun Yat-Sen Memorial Hall, Taiwan

2000 Art Center, National Central University, Taiwan

Goehuis Contemporary, New York, USA

2001 Chengdu Contemporary Art Museum, Chengdu, Sichuan, China

2002 "The Universe in the Mind: A Retrospective of Liu Kuo-sung at 70" Tour in China

National History Museum, Beijing, China

Shanghai Art Museum, Shanghai, China

Guangdong Musuem of Art, Guangdong, China

2003 Cultural Centre of Taichung, Taiwan

Shangdong Qingdao Museum, China

Hanart TZ Gallery, Hong Kong

2004 Hong Kong Museum of Art

Taiwan Exhibition Tour organized by Taiwan Soka Association

2005 Singapore Tylor Print Institute, Singapore

Academia Sinica, Taipei

2006 Zhejiang Provincial Museum, Hangzhou, China

Hunan Provincial Museum, Changsha, China

2007 "The Universe in the Mind: 60 Years of Painting By Liu Guosong"

Palace Museum, Beijing, China

Shanghai Art Museum, Shanghai, China

Guangdong Museum of Art, Guangzhou, China

2008 Galerie 75 Faubourg, Paris, France

2009 "The Universe in the Mind: Liu Guosong 60 Years Retrospective Exhibition"

Hubei Provincial Musuem, Wuhan, China

Ningxia Museum, China

Three Gorges Museum, Chongqing, China

Ya Ming Art Museum, Anhui, China

National Dr. Sun Yat-Sen Memorial Hall, Taipe

2010 Goehuis Contemporary, London, England

Taipei City Government Art Gallery, Taiwan

2011 "A Creation Exhibition by Liu Guosong – Looking back at 80"

National Art Museum of China, Beijing

一個東西南北人— 劉國松 80 回顧展

A Man of East, West, South and North: Liu Kuo-Sung 80th Birthday Retrospective Exhibition

指導單位 / 行政院文化建設委員會	Supervisor / Council for Cultural Affairs of China,（Taiwan）
主辦單位 / 國立台灣美術館	Organizer / National Taiwan Museum of Fine Arts
發行人 / 黃才郎	Publisher / Tsai-Lang Huang
編輯委員 / 張仁吉、蔡昭儀、崔詠雪	Editorial Committee / Jen-Chi Chang, Chao-Yi Tsai, Yeong-Shuei Tsuei
王婉如、薛燕玲、林晉仲、陳碧珠	Wan-Ju Wang, Yen-Ling Hsueh, Cahin-Chung Lin, Bi-Ju Chen
梁伯忠、楊媚姿、劉木鎮	Bor-Jong Liang, Mei-Tzu Yang, Mu-Chun Liu
策展人 / 李君毅	Curator / Chun-Yi Lee
主 編 / 蔡昭儀	Chief Editor / Chao-Yi Tsai
撰文 / 李君毅、薛永年、葉維廉、賈方舟、王月琴	Writers / Chun-Yi Lee, Yong-Nian Xue, Wai-Lim Yip, Fang-Zhou Jia, Janet Wang
執行編輯 / 王美雲	Executive Editor / Mei-Yun Wang
美術編輯 / 曲秀娥	Graphic Designer / Hsiu-E Che
翻譯 / 葉維廉、李君毅、涂景文、林占美	Translators / Wai-Lim Yip, Chun-Yi Lee, David J. Toman, James Laughton-Smith
出版單位 / 國立台灣美術館	Publisher / National Taiwan Museum of Fine Arts
地址 / 40359 台中市五權西路一段二號	Address / 2, Sec. 1, Wu-Chuan W. Road, 40359, Taichung, Taiwan
電話 / 04-2372-3552	TEL / +886-4-2372-3552
傳真 / 04-2372-1195	FAX / +886-4-2372-1195
網址 / www.ntmofa.gov.tw	Museum Website http://www.ntmofa.gov.tw
製版印刷 / 禾順彩色印刷製版股份有限公司	Printer / Her-Shuen Enterprise Co., Ltd
出版日期 / 中華民國101年3月	Publishing Date / March, 2012
GPN / 1010100578	GPN / 1010100578
ISBN / 978-986-03-2130-2	ISBN / 978-986-03-2130-2
定價 / 新台幣700元	Price / NT $ 700